THE ART OF MAGIC The Gathering®

ZENDIKAR

The Art of *Magic: The Gathering®*
Zendikar
Perfect Square Edition

www.MagicTheGathering.com

Credits—Wizards of the Coast
Writing: James Wyatt, with an appendix by Mark Rosewater
Based on Prior Work by: Doug Beyer, Jennifer Clarke Wilkes, Nik Davidson, Kelly Digges, Brady Dommermuth, Jenna Helland, Matt Knicl, Adam Lee, Ari Levitch, Cormac Russell, and Richard Whitters
Art Director: Dawn Murin
Cover Art: Adam Paquette
Magic Creative Team Leads: Jenna Helland and Colin Kawakami
Magic R&D Leads: Aaron Forsythe (senior director), Mark Rosewater (set design), Mark Globus (product design), Erik Lauer (development), and Ken Troop (director of operations)
Brand Management: Elaine Chase (senior director), Mark Purvis (director), Brian Trunk, Adam B. Colby, Liz Lamb-Ferro, Matthew Danner, Andrea Goffin, and April Glass
Project Managers: William Ansell, Andy Smith
Magic Senior Art Director, R&D: Jeremy Jarvis
Magic Senior Creative Art Director: Matt Cavotta

Credits—VIZ Media
Lead Designer: Sam Elzway
Lead Design Support: Fawn Lau
Additional Design Support: Brianna Depue, Hiroko Kobayashi
Senior Editorial Director: Elizabeth Kawasaki
Senior Editor: Joel Enos

Published by VIZ Media, LLC
P.O. Box 77010
San Francisco, CA 94107

10 9 8 7 6 5 4 3 2 1
First printing, January 2016

CONTENTS

Tazeem © Aleksi Briclot

PREFACE

If you've been playing Magic for a while, you might remember the first card releases set on Zendikar in 2009–10: *Zendikar*, *Worldwake*, and *Rise of the Eldrazi*. If you're playing the game now, you probably have cards from the latest Zendikar expansions, *Battle for Zendikar* and *Oath of the Gatewatch*. Taken together, these five card products tell the grand story of this world and its beleaguered people. The names, flavor text, and especially art of over a thousand cards have given Magic players a picture of the incredible world where this story unfolds and the terrible threats that world faces. Online articles and short stories further reveal the amazing events behind the cards.

This book reveals, more comprehensively than ever before, the secrets and stories of Zendikar. It represents a look behind the scenes at the work that undergirds all those cards, articles, and tales. The Creative team, the writers and artists who are responsible for the story of Magic, create a detailed guide to each world, which helps direct and inspire the dozens of artists, game designers, and writers who create cards and tales set in that world. Now this book serves the same purpose—to inspire you.

The Magic Creative team is pleased to offer you this in-depth look at a vibrant and detailed world. It's a showcase for the breathtaking art appearing on cards, previously seen only in tiny boxes barely two inches wide. And it's a venue to tell the exciting stories of Zendikar—how it became a prison plane for three of the most dangerous creatures in all the Multiverse and what happened when they broke free.

And so we proudly welcome you to a world of adventure, of peril, and of horrible monsters ready to devour the entire plane. Welcome to Zendikar!

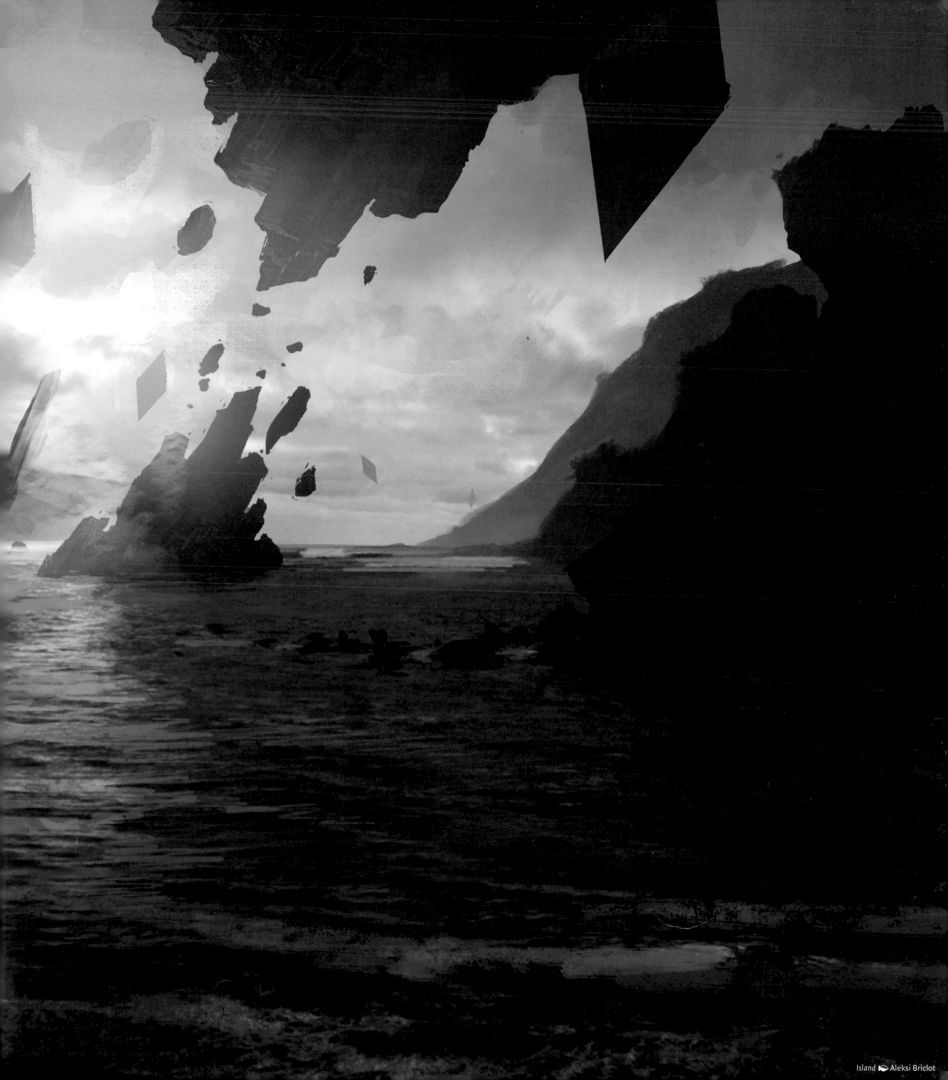

Island ► Aleksi Briclot

What is *Magic: The Gathering*®?

Magic: The Gathering® is a tradable card game (TCG) where players build collections of cards, assemble decks, and battle against each other. Abstractly, the game represents a duel between powerful mages, each casting mighty spells and summoning monstrous creatures in an effort to defeat the other. These mages are called Planeswalkers because they possess the rare ability to travel from plane to plane within a vast Multiverse, and their great power comes from their ability to draw on magic from all those planes.

PLANESWALKERS AND THE MULTIVERSE

The Multiverse is a boundless expanse of worlds. These worlds, called planes, are as different from each other as one living being is from another, varying in size and shape, inhabitants and environments, and even the laws of physics and magic. The existence of magic, though, is a common factor that unites all the known planes.

For most inhabitants of any given plane, that plane is the full extent of existence. Esoteric speculation might posit the existence of other worlds, but such concepts are only theoretical. Only a handful of people on any given world knows the reality: that all the planes are suspended together in a void called the Æther, or—more poetically—the Blind Eternities. Only one person in a million is born with the potential to travel from one plane to another, and only a fraction of those with the potential actually manage to ignite their sparks and become Planeswalkers.

Often, this happens as a result of a great crisis or trauma. A near-death experience could ignite the spark, as could a life-changing epiphany or even a revelatory meditative trance. But once their sparks are ignited, Planeswalkers gain the rare ability to open a pathway through the Blind Eternities and pass from one plane to another.

The life of a Planeswalker is a life of choice and self-determination unrestricted by the boundaries of world or fate. Most Planeswalkers dedicate themselves to some personal mission as they explore the secrets of the Multiverse. Often, they discover the depths of their own souls in the process.

*"Planeswalking cannot be taught.
Either you see the doors or you do not."*
—Nissa Revane

PLANES OF THE MULTIVERSE

The full extent of the Multiverse is unknowable. Among the countless planes, these are only a small sample.

Dominaria

Home to the volcanic continent of Shiv, the time-shattered isle of Tolaria, and the cold mountains of Keld, Dominaria is the setting for some of the Multiverse's most brutal conflicts and home to some of its most powerful mages.

↣ James Paick

Innistrad

On this plane, humanity is terrorized by vampires, werewolves, zombies, and ghouls. For centuries, the archangel Avacyn and her hosts protected the beleaguered humans, but then she disappeared. Avacyn has finally returned, but what new evils have come with her?

↣ Jung Park

New Phyrexia

Once known as Mirrodin, this metallic plane has been transformed by the vile Phyrexian corruption. Its natives fought and lost the war for their world and now struggle to survive each day.

↣ Tomasz Jedruszek

Ravnica

This worldwide cityscape holds countless grand halls, decrepit slums, and ancient ruins. Ten guilds maintain an uneasy peace in governing the various aspects of life in the majestic city.

↣ Richard Wright

Shandalar

Rich with mana, Shandalar is a place where magic flows freely. Planeswalkers seek out this plane for its plentiful, powerful magic.

↣ John Severin Brassell

Theros

Theros is ruled by an awe-inspiring pantheon of gods. Mortals tremble before them, feel the sting of their petty whims, and live in terror of their wrath.

↣ Jung Park

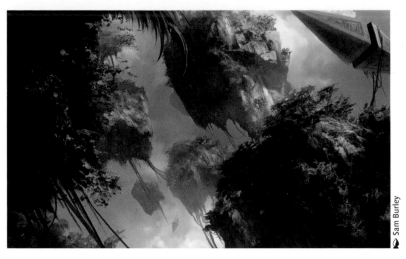

Sam Burley

Zendikar

This land of primal mana was lethal before the Eldrazi that were bound there escaped from their prison. Now colossal predators from the Æther are devouring everything in their path.

The Colors of Magic

All the planes of the Multiverse are suffused with mana, the energy that fuels magic in all its forms. Mana is intricately linked with the physical world, and different types of terrain produce different "colors" of mana. Most mages specialize in the use of one or perhaps two colors of mana and the particular types of magical effects that mana can create.

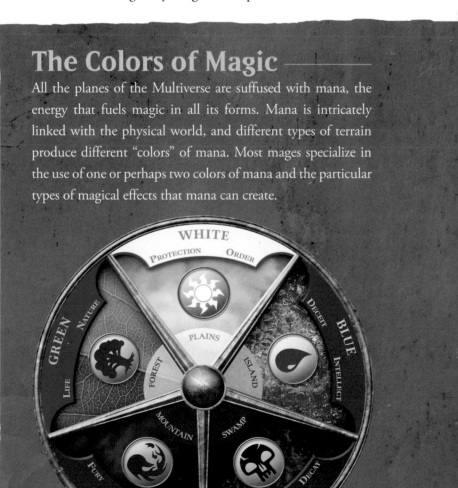

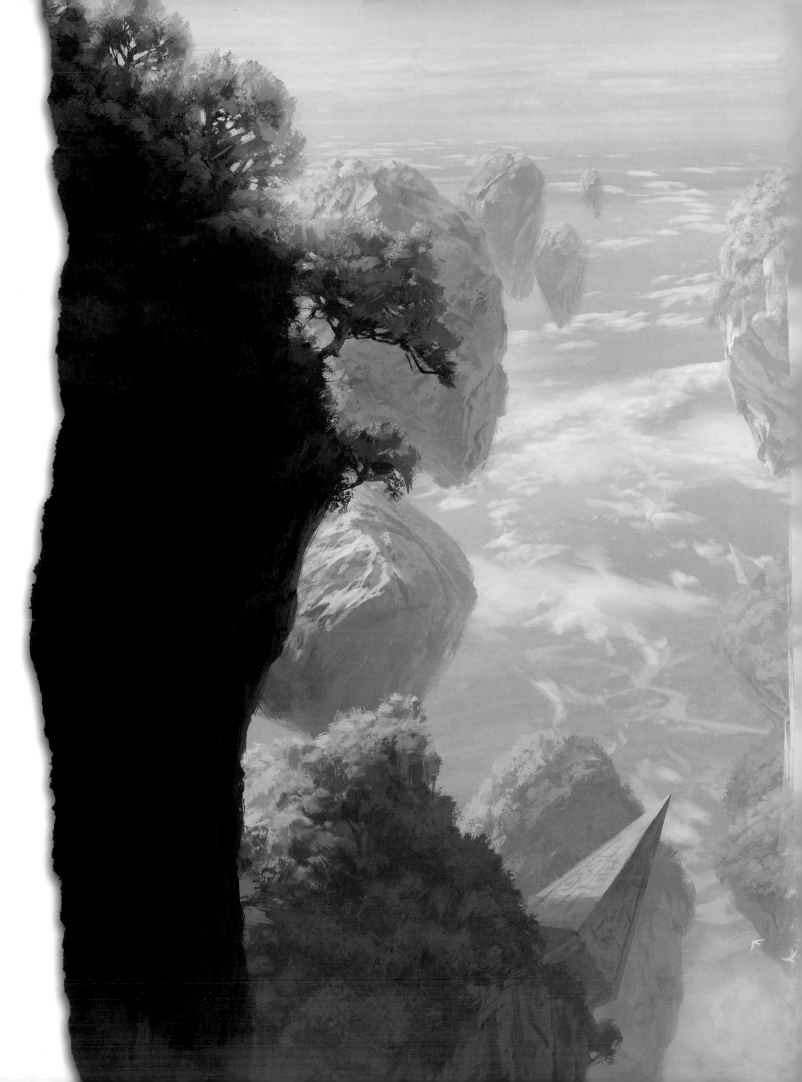

The World of Zendikar

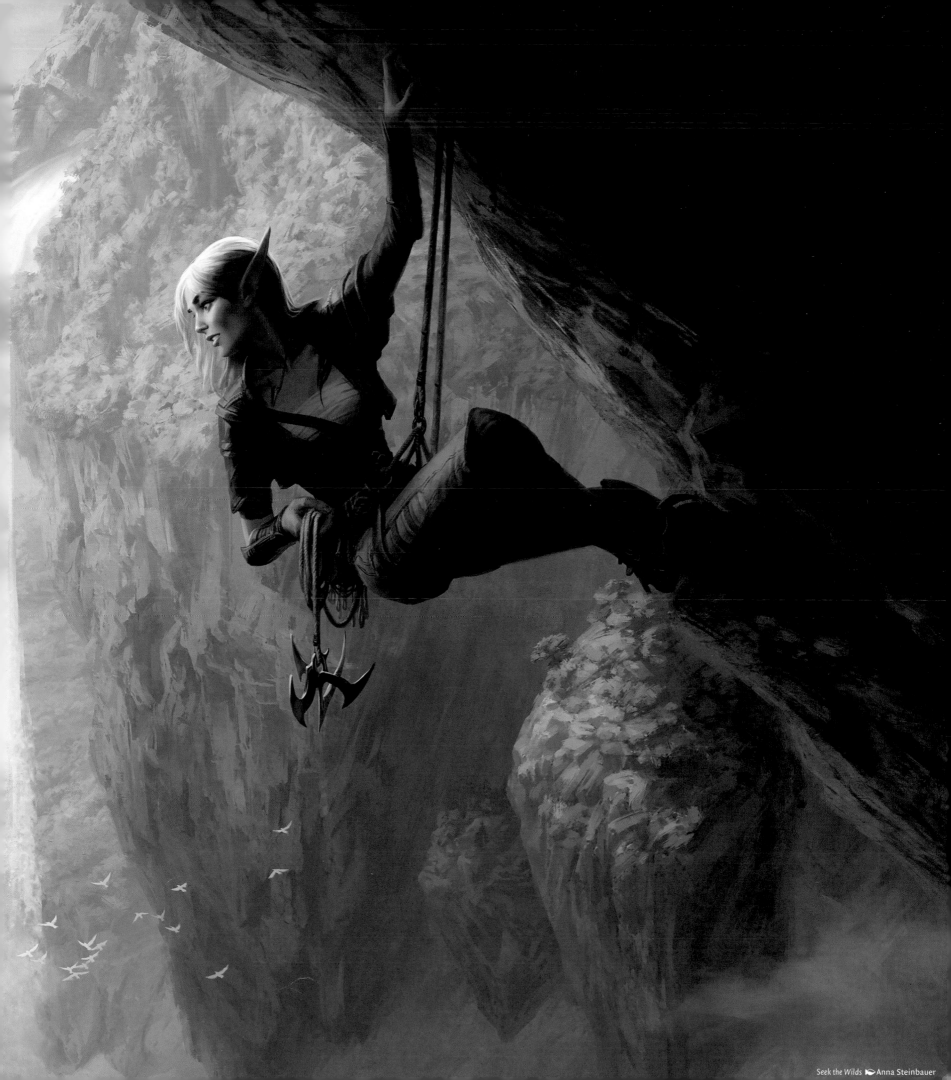

◆ THE WORLD

Zendikar is a dangerous world of lethal risks and priceless rewards. From the perspective of its inhabitants, it is a hostile place that seems to be actively trying to kill the creatures that have the audacity to live there. The danger is unrelenting: precarious terrain, cunning predators, natural disasters on a massive scale, and the Roil—the unpredictable ripples of change that wash through the land—all present a constant challenge to survival. Even the mana that suffuses the land is wild and hard to tame—it feels almost alive to those who wield it and sometimes causes the land itself to manifest magical effects much like spells. It is a plane of deadly peril, but the denizens of the plane grow up strong and resilient, prepared for the dangers of the only world they know.

> "Why fight the world when you know who will win?" —Nissa Revane

Planeswalkers, though, have a larger perspective. To them, the dangers of Zendikar take on a different meaning. Ages ago, three alien beings of tremendous power were imprisoned on Zendikar in an effort to prevent them from consuming the entire Multiverse, plane by plane. But the presence of these Eldrazi within the plane is like a festering infection within a living body. Zendikar isn't trying to exterminate all the creatures that inhabit the plane—it's trying in vain to destroy the Eldrazi. Its inhabitants just happen to get in the way.

After centuries trapped in their magical prison, though, the Eldrazi have been freed. The other dangers of Zendikar pale in comparison to the rampaging of the three titans and the numberless broods they spawn. Civilization on Zendikar, always fragile and tentative, now teeters on the brink of destruction, and the plane itself seems threatened with extinction.

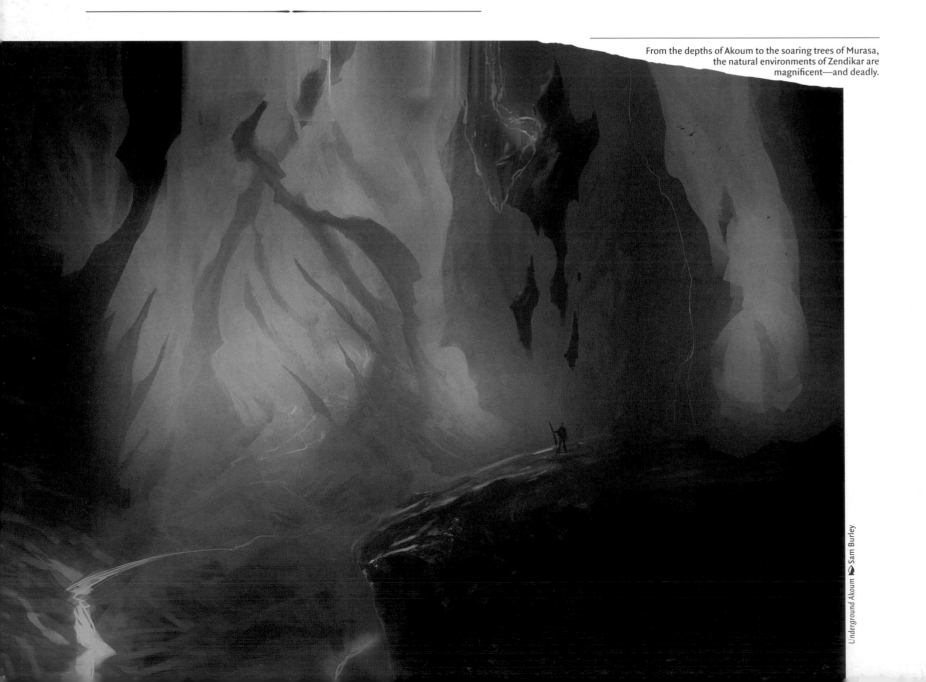

From the depths of Akoum to the soaring trees of Murasa, the natural environments of Zendikar are magnificent—and deadly.

Underground Akoum ◆ Sam Burley

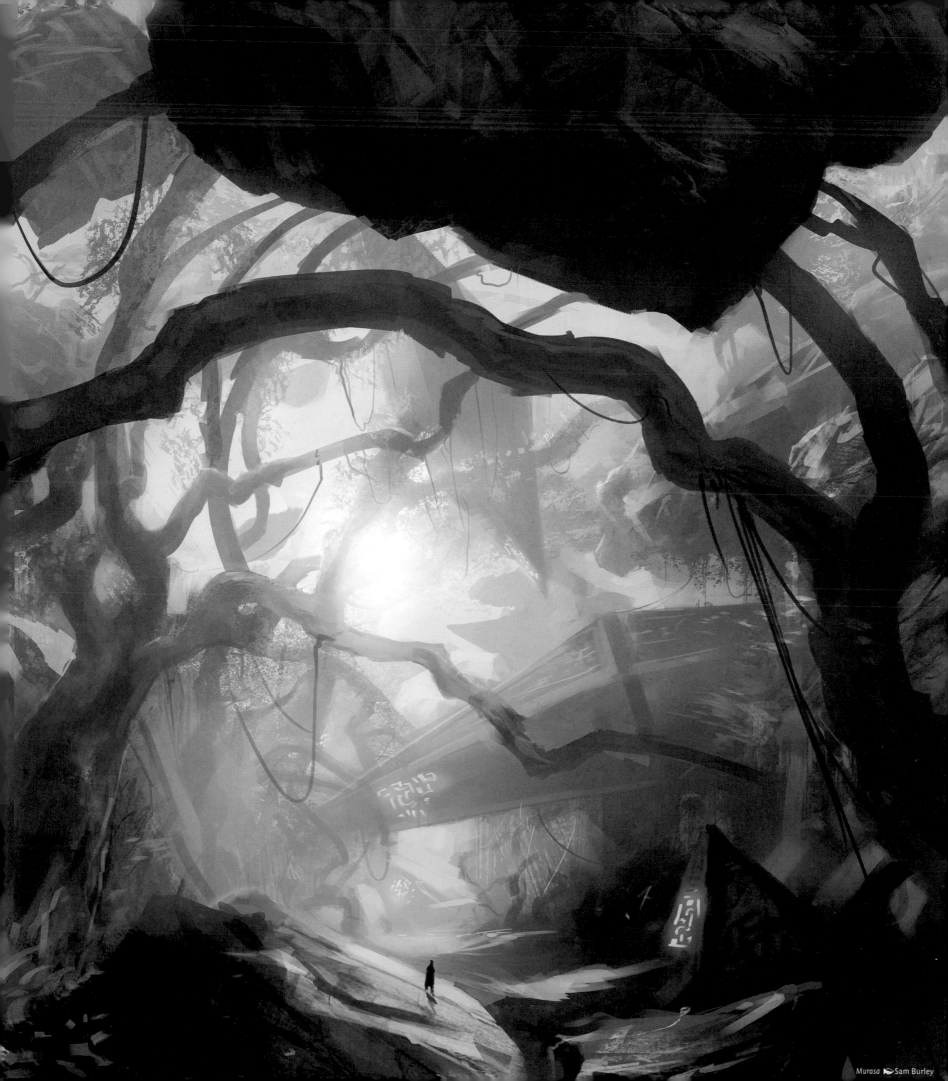

Murasa 🔖 Sam Burley

THE ROIL

Zendikar's terrain is racked with violent and erratic changes. The land itself seems alive, and its surface and botanical life often writhe as though in pain, causing tectonic chaos, extreme weather, and sudden destruction. Waves of geological upheaval sometimes wash across the world, leaving nothing unchanged in their wake. All this volatility is collectively referred to as "the Roil."

The Roil always seemed to be a natural phenomenon, one of the peculiar characteristics of Zendikar that was perhaps tied to its unique mana, the hedrons, or its own fierce ecology. Planeswalkers recognized this volatility as what kept Zendikar dangerous and untamed—free of large cities, sophisticated commerce, and other trappings of well-developed civilization.

The rise of the Eldrazi intensifies the Roil, and it soon becomes clear that the Roil is Zendikar's own effort to fight off the Eldrazi. The violent upheaval sometimes seems to target the Eldrazi broods, leading some survivors to try to follow the Roil as a means of protection against swarms of Eldrazi, but the Roil's movements are too unpredictable to follow—and it's all too easy to get caught in its tempests when it suddenly shifts direction.

The Roil's effects are violent, enormous, and extreme. They include the following:

- **ROCK CRAGS.** Large boulders and shards of rock erupt from the earth, then subside when the Roil shifts away. These spikes vary in size—from large hills to gigantic peaks. The crags can uproot forests and destroy settlements.
- **DUST STORMS AND TORNADOES.** Winds generated by the Roil can kick up dust, debris, and vegetation and turn them into a fierce, scouring wave or a devastating funnel cloud.
- **TIDAL WAVES.** Over large bodies of water, the Roil creates tidal waves that can crash into the high cliffs and flood the forests beyond, or whirlpools that can suck a boat to the bottom of the sea.
- **SINKHOLES.** Ground that has been disrupted by the Roil often opens into sinkholes, as large sections of land unexpectedly plummet into the ground.
- **GAS GEYSERS.** When the earth is displaced, geysers of noxious, sulfurous gas can erupt from underground. Some of these geysers are toxic and can kill nearby life.
- **METEORIC GROWTH.** Because the Roil is magical in nature, it can affect biology as well as geology and meteorology. Under the influence of the Roil, a tangle of undergrowth can double its size in a day. Occasionally this growth persists; usually it dies down after the effects of the Roil pass.
- **TECTONIC UPHEAVAL.** At its strongest, the Roil can dislodge entire plates of earth and create new ridges and peaks. These dramatic upheavals send shock waves through the entire continent and can change miles of landscape in mere minutes.

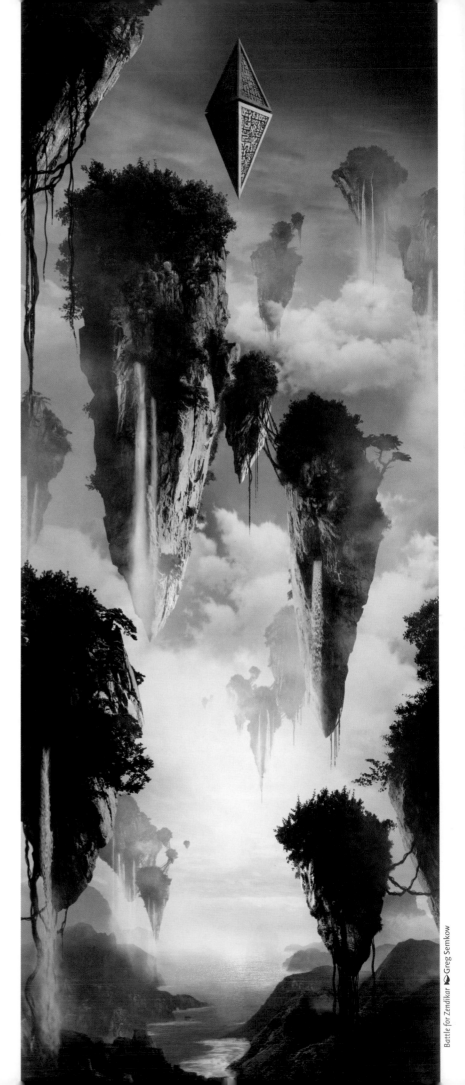

Occasionally the Roil takes on a literal life of its own. Elementals—animated forces of land and nature—are common enough on Zendikar, but when the Roil itself animates as an elemental, the result is a living vortex that devours everything in the vicinity, even the souls of the living.

Most of Zendikar's inhabitants have no way to predict the approach of the Roil, though many animals seem to be able to sense its approach earlier than most humanoids. Flocks of birds might fly screeching out of the trees, or herds of oxen might stampede toward shelter. The Roil sends powerful tremors through water, so swimming creatures—including the merfolk—often have more warning of its approach than those confined to land.

> "The Roil is destructive but not random.
> It's Zendikar's way of revealing secrets."
> —Ilori, *merfolk falconer*

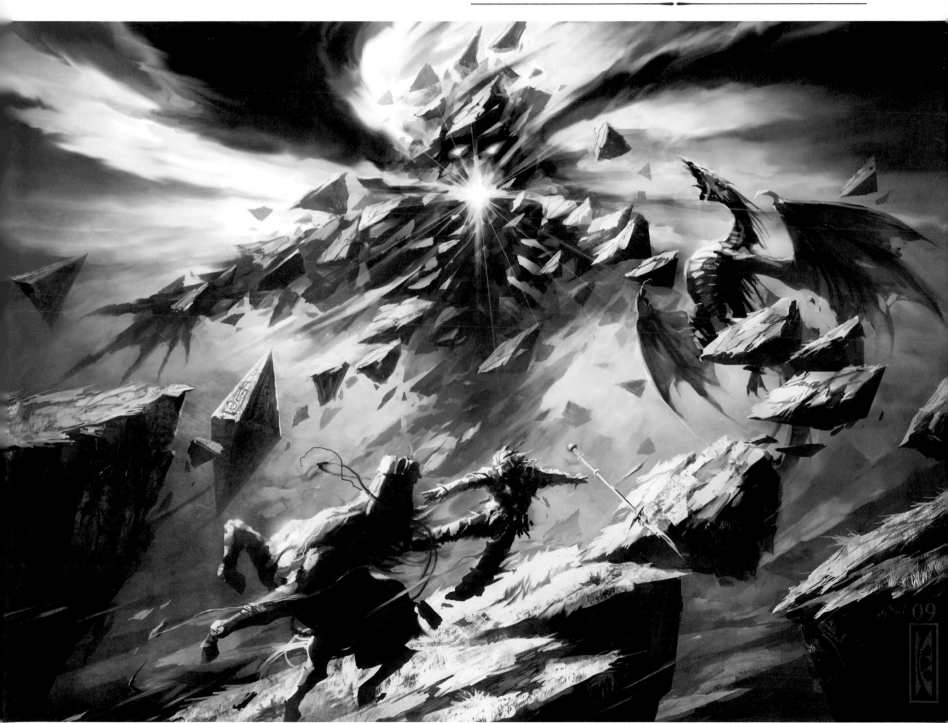

Roil Elemental ▸Raymond Swanland

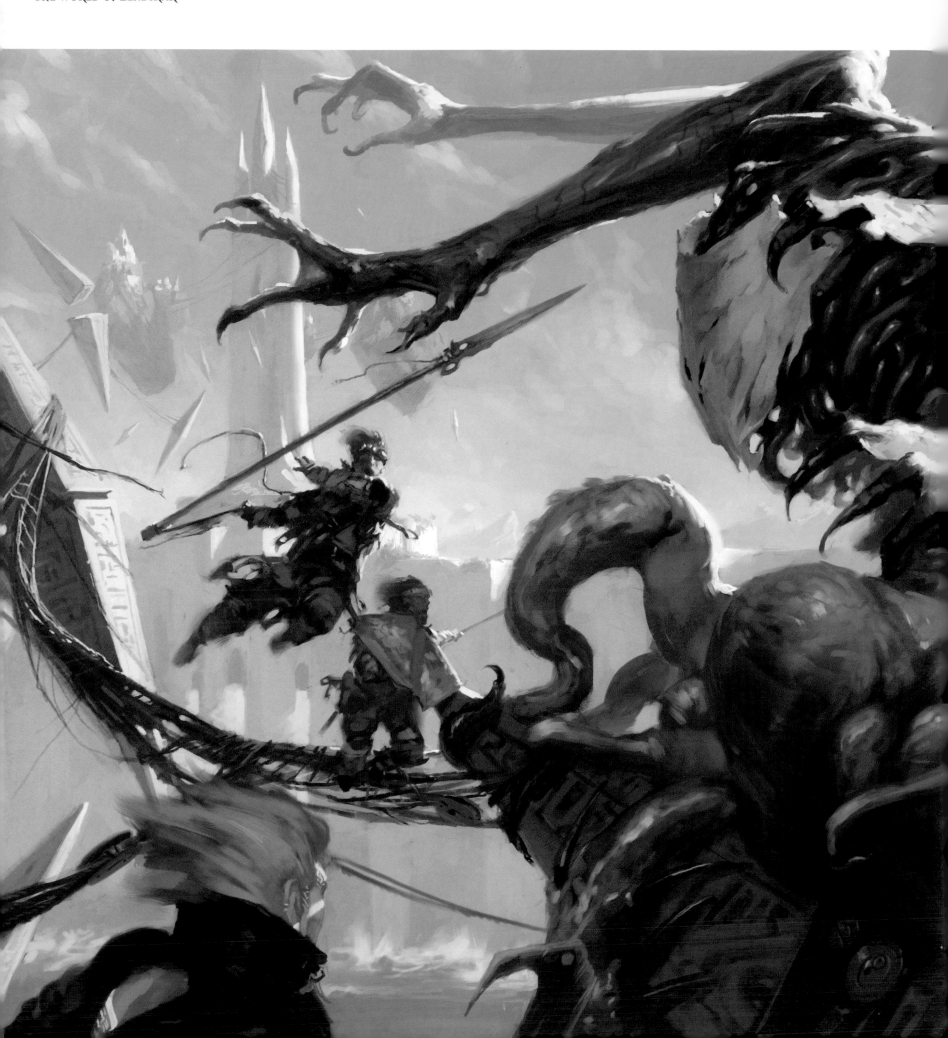

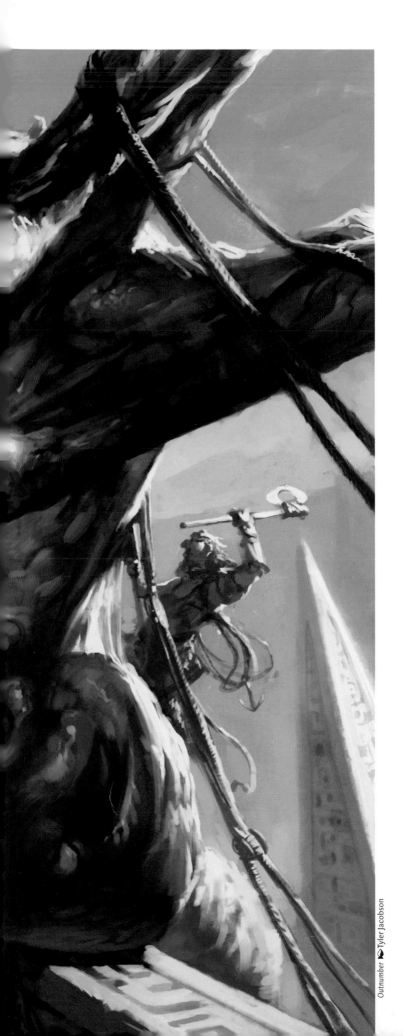

Outnumber ♦ Tyler Jacobson

◆ From *The Invokers' Tales*

As long as we have walked this world, we have known it as a harsh and unforgiving place. Our feeble villages and tiny encampments stand only at the whim of the Roil, and our hunters and farmers survive only until some rampaging beast brings them low. We live in an angry world, and we are well acquainted with death.

We thought Zendikar's rage was kindled by its explorers and plunderers. But the world had sensed the stirrings of the Eldrazi. It was their presence, their alien energies radiating from deep within their prison, that provoked the world to lash out in a desperate effort to cleanse itself. The world was not hostile to us—we were beneath its notice and presented no danger. It was hostile to the beings that sought to consume it.

None know how long the Eldrazi slumbered in their prison. We can only guess, based on the ancient ruins that commemorate their presence, how many eons they lay entombed. The ancients worshiped them out of fear and passed their devotion down through the ages, painting portraits of benevolent gods who watched us with kind concern. But what we knew as Emeria, Ula, and Cosi were not divine beings at all, but a cruel trick, and a grave error. Their names are distortions, half-forgotten memories of the alien titans themselves. Emrakul, Ulamog, and Kozilek are their names, and now they are among us.

What caused their arising? We cannot know, not any more than we can learn where they came from or how they first became imprisoned. From far away across the jagged heights of Akoum's mountains, some witnesses watched the peaks transform, crumbling into dust as the earth shook. Then the ancient masters themselves, towers of rapacity, rose and began their calamitous feast.

They did not come alone. Shortly after the titans arose, the brood lineages unfolded across the world, each patterned after one of three progenitors, each a study in mindless consumption. These broods are as inscrutable as the titans, apparently unmoved by compassion or reason, and driven only by a hunger that has nothing to do with physical feeding. Where they pass, the world is rendered lifeless, drained of mana and vitality, utterly spent. When valiant warriors stand in their path, the destruction is no less complete.

Life as we know it dangles on the brink of extinction. We must show the strength they would steal from us.

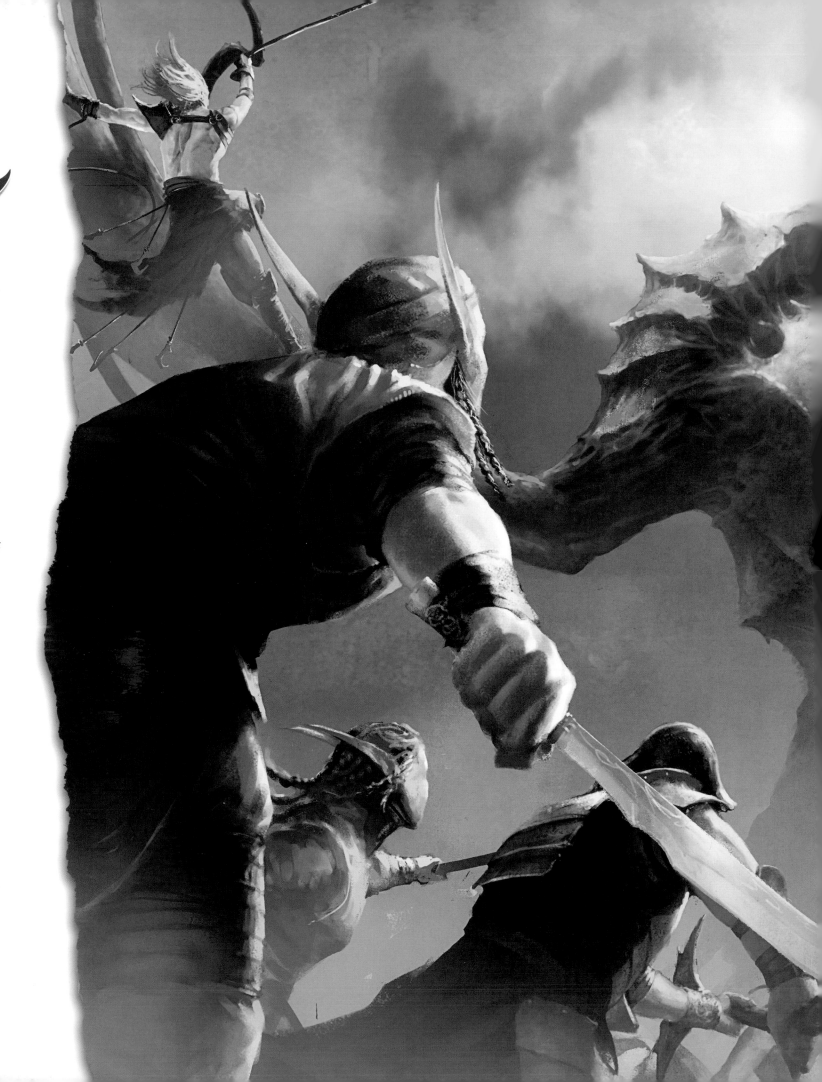

THE BINDING OF THE ELDRAZI

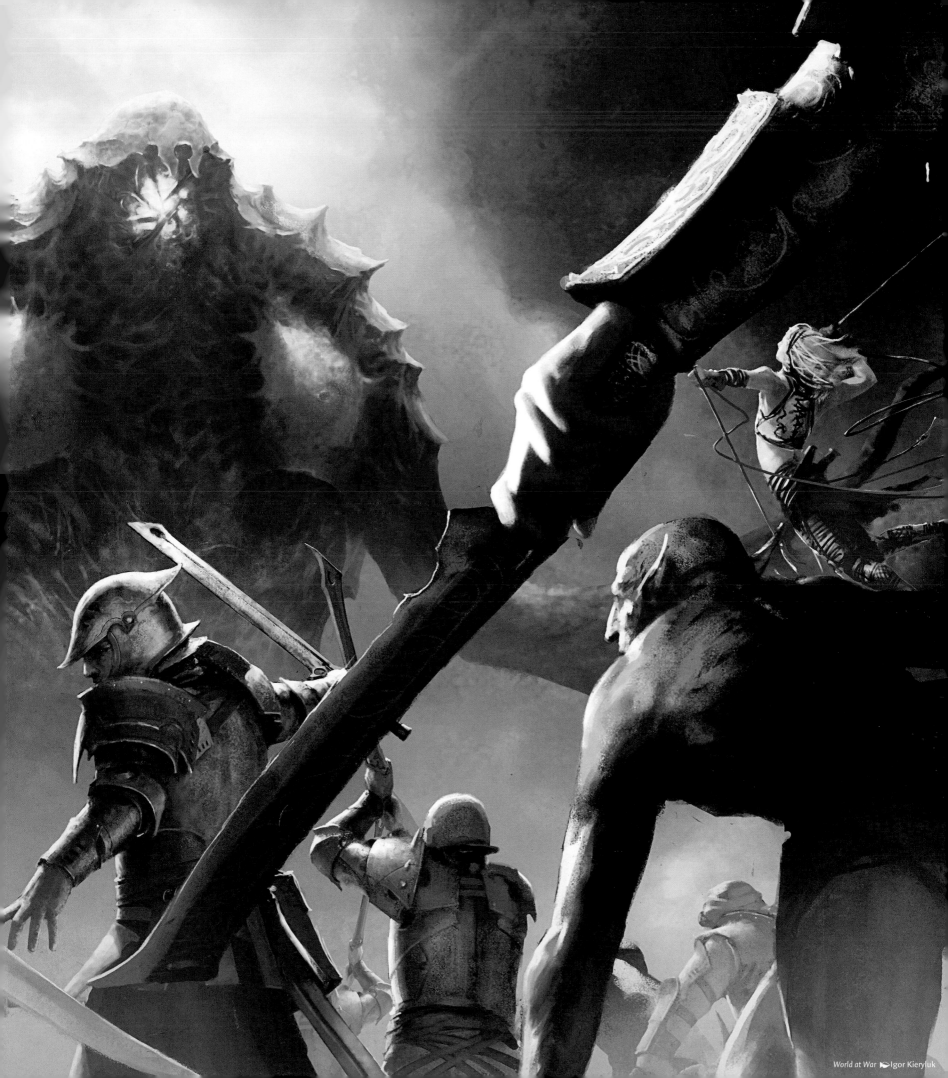

World at War 🔊 Igor Kieryluk

TITANS OF THE BLIND ETERNITIES

The Eldrazi are a race of interplanar beings that once traveled from plane to plane through the Æther. They fed on the mana and life energy of the planes, leaving lifeless husks in their wake as they moved from one world to the next. Their origin is unknown and their nature is poorly understood, and if they have thoughts or goals beyond simply feeding, their minds are utterly inscrutable. Even their magic transcends the categories of spells and classifications of mana and recognizes no distinction between the mana of one land and that of another.

Three monstrous Eldrazi titans were bound on Zendikar in eons past: Ulamog, Kozilek, and Emrakul. No one can say for sure whether more titans exist somewhere in the vast Multiverse, but these three have power enough among them to threaten countless planes. In their true forms, these titans are huge, alien leviathans made up of an immaterial substance akin to the Æther. The ancient Planeswalkers forced them into material forms in order to bind them on Zendikar, and now that they are free, their first priority is amassing enough energy to leave Zendikar and return to their astral forms.

Drowner of Hope ◗ Tomasz Jedruszek

> "Whatever the Eldrazi's purpose is,
> it has nothing to do with something
> so insignificant as us."
> —Nirthu, *kor missionary*

Multitudes of lesser creatures—drones, spawn, and more powerful servitors—seem to emanate from the titans when they are active, much as clouds of vapor emanate from boiling water. Each titan has its own brood lineage, which shares certain common features. The people of Zendikar have named the various kinds of lesser Eldrazi, but they appear in such multifarious variety that they are difficult to categorize.

Some speculate that the lineages of lesser Eldrazi are extensions of their titan sires, extending the titans' will and reach across the plane, harvesting mana and life energy that is then channeled back to the titan. In effect, the great multitudes of lesser Eldrazi are organs of the titans, serving sensory and digestive functions for these alien beings.

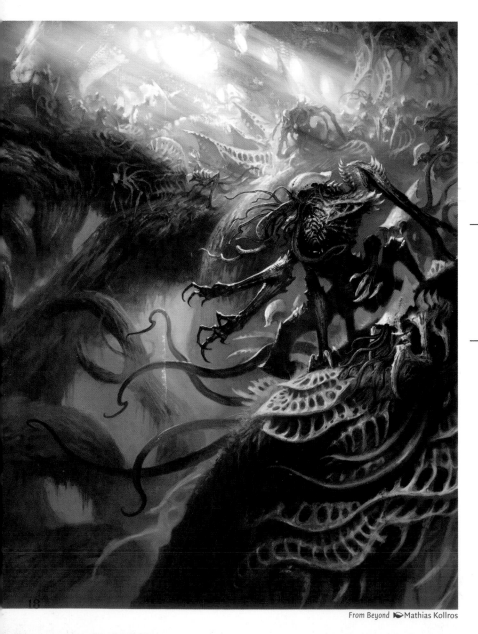

From Beyond ◗ Mathias Kollros

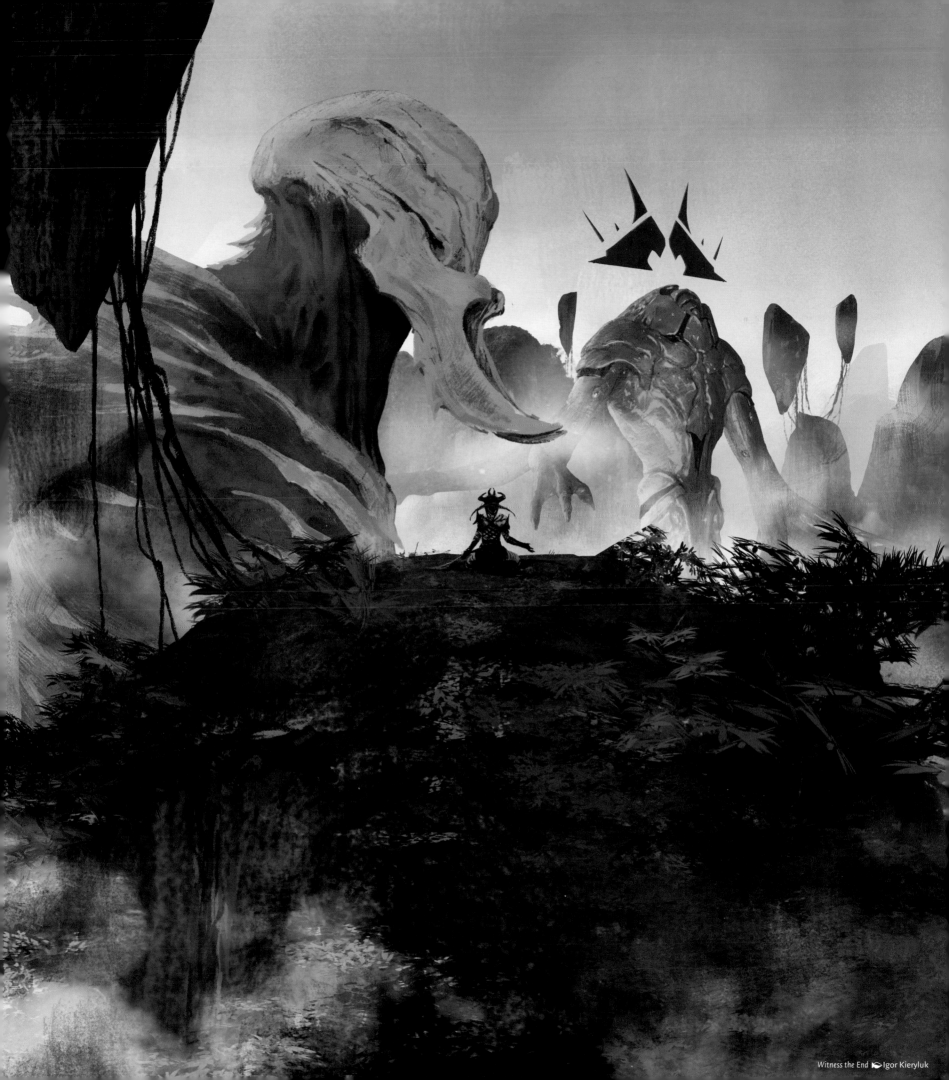

Witness the End ◖Igor Kieryluk

ULAMOG

Ulamog is the smallest and weakest of Zendikar's three Eldrazi titans but is still monstrously huge and powerful by any normal standard.

The Reeking Titan. Ulamog is a colossal horror, towering over treetops and dwarfing the largest natural animals. Though his form is vaguely humanoid, every feature is wrong, making his appearance particularly unsettling. His head resembles a bony helmet, giving an impression of a face though it lacks eyes and other features and betrays no hint of expression or emotion. Most of his body has the color and texture of exposed muscle and is covered in bony plates. Instead of legs, he has a writhing mass of sinewy tentacles studded with bony spikes. His arms, disturbingly human-like, split at the elbow and lead to four clawed hands. His arms and tentacles shift color from red near the body to blue to bright purple at the extremities. A stench like a combination of rotting meat, mushrooms, and sulfur surrounds Ulamog.

> "The least of gods shall tower over the mightiest of mortals, and death shall reign over all."
> —Inscription in the Crypt of Agadeem

Insatiable Hunger. All the Eldrazi seem driven by hunger, but Ulamog embodies infinite consumption. Sometimes called the Infinite Gyre, he is likened to a terrible sea maelstrom that sucks everything into the depths and leaves no trace. Indeed, a consuming aura surrounds him, draining life and mana from everything around him and drawing energy toward him in a darkly glowing spiral. Earth and stone break to pieces, sometimes hovering in the air as streams of white dust flow to the center of his monstrous vortex.

Unholy Creation. Ulamog's destructive hunger exists in a paradoxical balance with the creative force he derives from what he consumes. Through whatever process of metabolism occurs inside his alien form, the energy he takes in is released again in the form of wasting plagues, deadly parasites, incomprehensible magic, and endless teeming spawn. Thus he is both destroyer and creator, though his creation is monstrous, wretched, and inimical to life.

Dusty Wastelands. Where Ulamog passes, the land itself is transformed into broken wastes. Though landforms retain their general outline, at least for a time, they become elaborate, chalky-white husks. Walking across these blasted landscapes is perilous because the husks are fragile and often collapse under the weight of an incautious traveler. Water becomes white dust, and even the air around the titan becomes stale and dry.

Disaster Radius ▶ James Paick

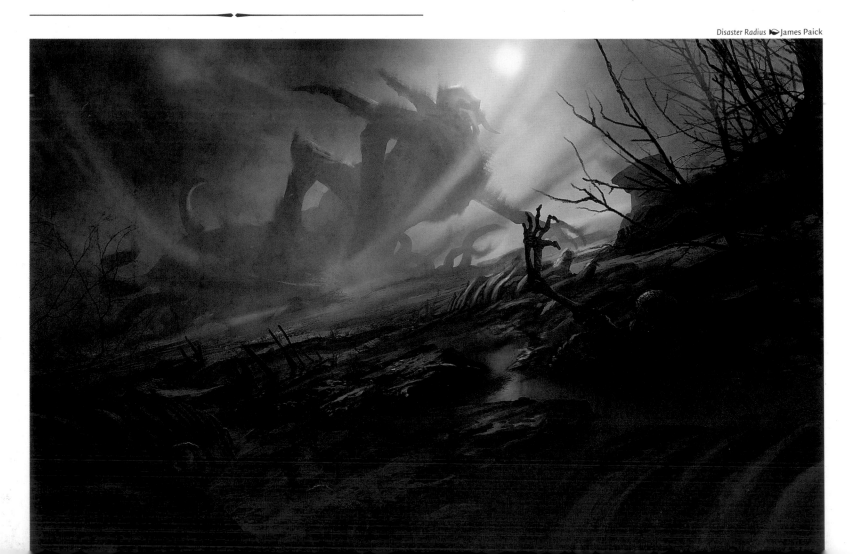

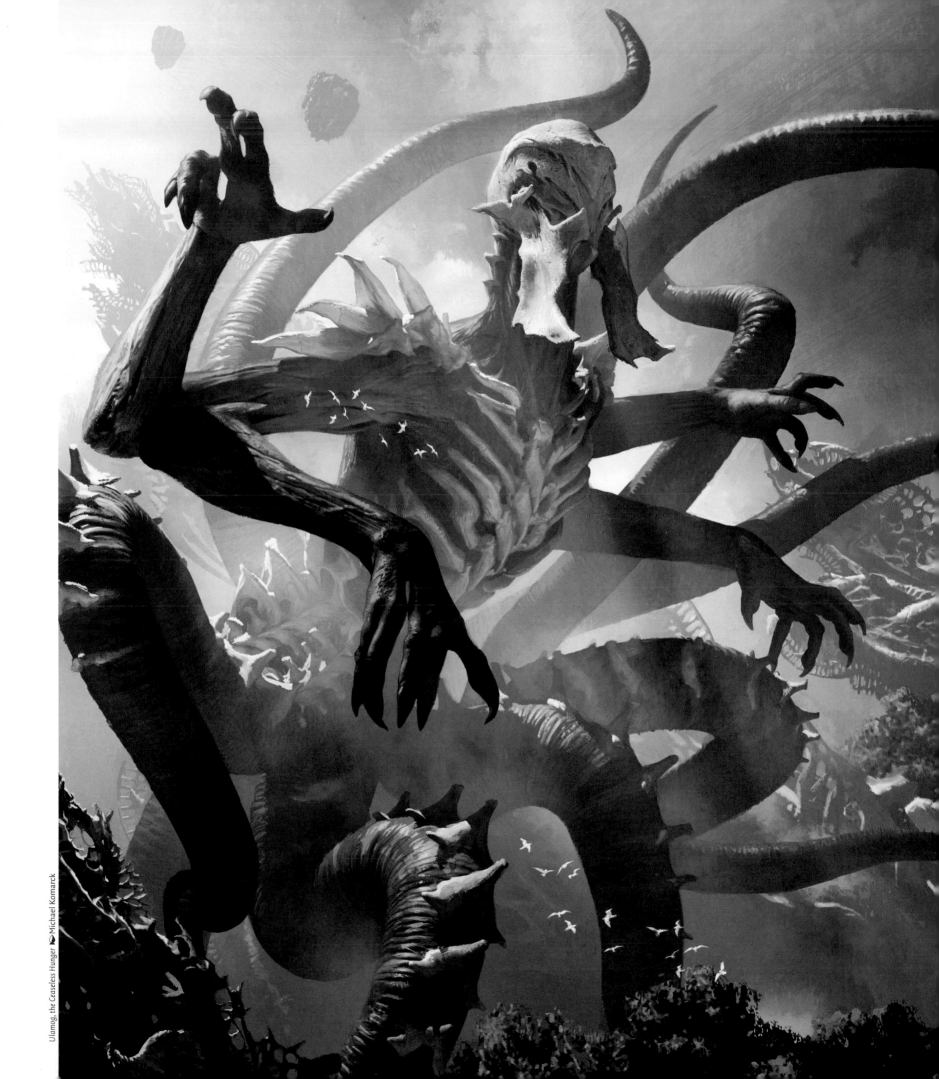

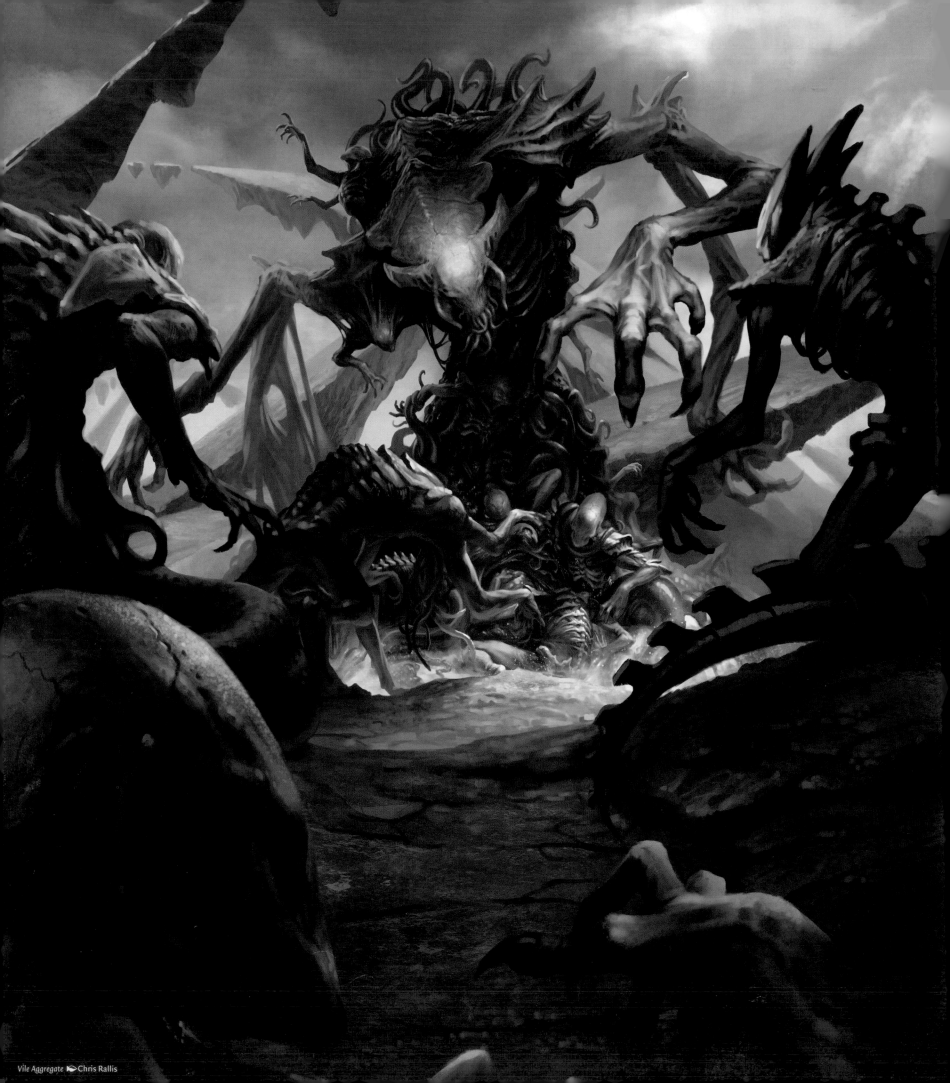

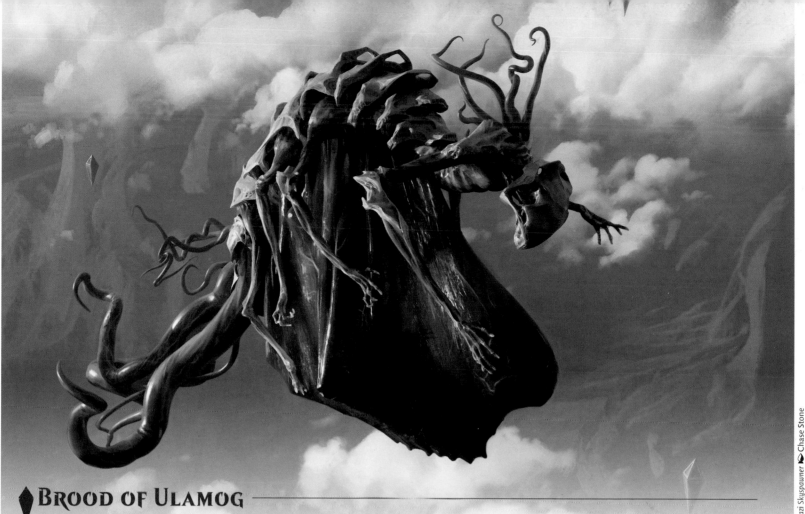

Brood of Ulamog

The ravenous and brutish Eldrazi of the Ulamog lineage lurch and shudder over the ground and writhe through the sea and sky. They leave corruption in their wake, spread disease, damage psyches, and drain the life energy of their victims.

The Ulamog brood lineage is characterized by dense masses of suckerless tentacles, multiple withered arms bifurcated at the elbow, and most unsettling, eyeless bony plates in inhuman but vaguely facial forms. Their coloration is similar to their sire's, with shades of scabby red, luminous purples, and deep blue predominating.

Ulamog's Spawn

The Eldrazi brood lineages appear to fall into three tiers below their respective titans. The smallest and weakest are the teeming hordes of nameless spawn. Ulamog's spawn are comparatively small, growing quickly from tiny larvae to their fully formed state, about the size of a wolf. Some skitter about on spiderlike legs, while others slither or swim using tentacles.

It's not clear whether these spawn mature further into other, higher forms—a careful study of the Eldrazi life cycle is impossible. Other Eldrazi treat spawn as disposable, readily harvesting their life energy as a resource for their own purposes.

Ulamog's Drones

Eldrazi drones are the next tier up from spawn. They vary in size from barely larger than spawn to perhaps ten feet long. They appear to fill specialized roles, like particular organs of Ulamog's body, and display little or no capacity for independent thought and action. They perform a limited range of tasks unless directed by a greater Eldrazi. Ulamog's drones can be grouped into two categories.

Broodkeepers. The broodkeepers are the drones that birth, tend, and sometimes feed on Ulamog's spawn. As far as any inhabitant of Zendikar can tell, the Eldrazi do not reproduce in any recognizable way. Some broodkeeper drones seem to spontaneously generate spawn inside their bodies—in membranous sacs, or like buds growing out of their flesh until they're ready to drop off and act independently. Others implant a larva or seed into a living host, where it matures until it erupts, fully formed, killing the host.

The Hunger. Another class of drones act as extensions of Ulamog's insatiable hunger, infesting the land, sea, and sky and transforming all they touch into chalky dust. For some of these drones, merely brushing past a physical surface is enough to drain its essence and mana, and they can even draw energy from fog or the air itself. Fighting these drones can be especially deadly since their corrupting effect happens so fast. But most of Ulamog's drones eat with intention, placing a hand or tentacle on the energy source and pausing to drain the energy slowly, like a mosquito drawing blood. As they feed, the chalky dust of their corruption spreads through the surface they are touching, rippling out to a distance of perhaps ten feet before the Eldrazi moves along to its next feeding site.

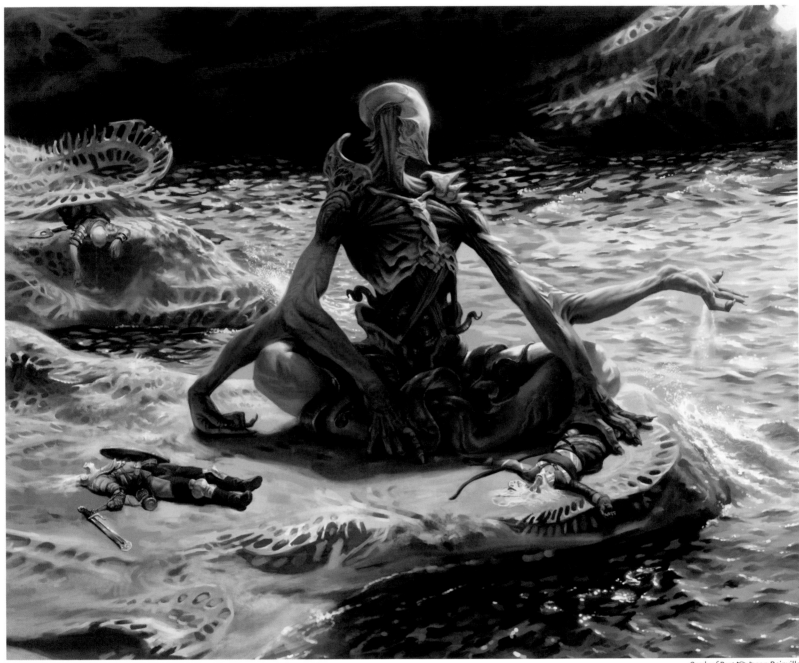

Oracle of Dust ✒ Jason Rainville

Ulamog's Eldrazi Lineage

The Eldrazi proper are the highest tier below the titans. They are generally large and powerful and display intelligence (alien as it may be) and adaptability, and they might even show unique, individual traits. One gargantuan monster, for example, is known for tearing large rocks from the terrain and hurling them at its enemies, while another of the same type seems particularly fond of wading into masses of humanoid foes and strangling them with its smaller tentacles.

The Plague. Some of these larger, deadlier Eldrazi use Ulamog's unbridled consumption to bring about a distorted creation, from wasting plagues to writhing spawn. Like their reproduction, the means by which these Eldrazi harvest and process energy that is

gathered by the hungering drones is a mystery. If the Eldrazi of Ulamog's lineage are the titan's digestive organs, perhaps the drones somehow feed energy directly to Ulamog, who can then distribute it to his Eldrazi of the plague.

The results of this horrible creation are as varied as the forms of the Eldrazi. Some of these Eldrazi birth new spawn, while others bolster or heal other Eldrazi. Some can inflict a debilitating illness that drains strength or saps memories. And some negate the effects of other magic.

The Desolation. These are the mightiest and most brutal Eldrazi of Ulamog's lineage. Most of them resemble their sire—towering behemoths, up to a hundred feet tall, large enough to crash through

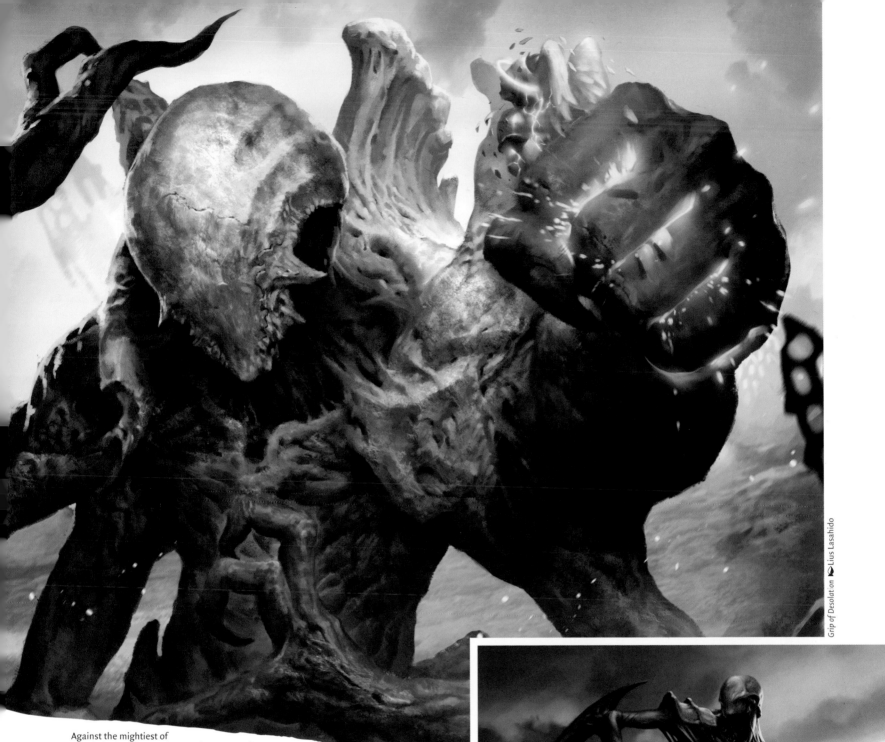

Against the mightiest of Emrakul's brood, even the angels are powerless.

Grip of Desolation ✒ Lius Lasahido

any defenses the natives of Zendikar might try to erect in their paths. They are living embodiments of Ulamog's own destructive power and direct extensions of his alien will. They are indiscriminate in their annihilation, crushing other Eldrazi as readily as they tear through Zendikar's defenders.

The mere presence of one of these horrors can reverse gravity, warp stone, and transform verdant land into a crumbling shell. Some drain the vitality from living creatures, and others can return from apparent death. Weird auras—utter stillness, twisting light, or distorted gravity—surround some of them. But as diverse as they are, all of them serve as Ulamog's many twisted limbs, extending his terrible reach.

Barrage Tyrant ✒ Chris Rallis

KOZILEK

If lack of understanding breeds fear, then Kozilek might be the most feared of the Eldrazi titans, though Emrakul's raw power might be greater.

Crowned with Impossibility. Kozilek is a titanic monstrosity, towering more than five hundred feet tall. His humanoid form suggests a bronze colossus more than it does a living person,

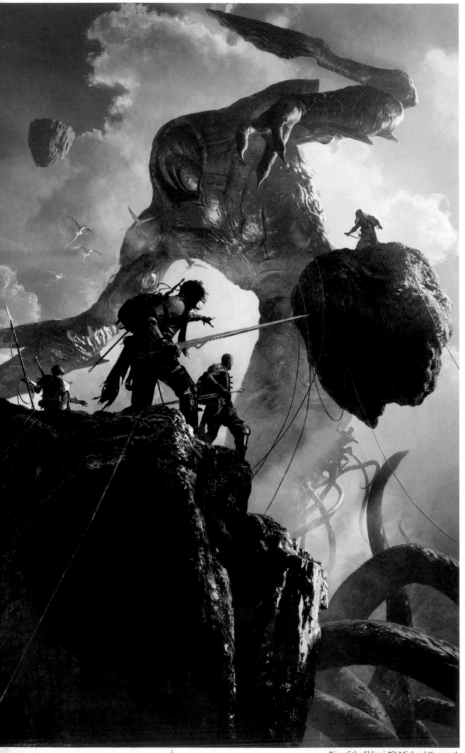

Rise of the Eldrazi ⟐ Michael Komarck

covered in greenish plating with an iridescent sheen like the carapace of a beetle. His body rises to a sort of hump where a human's head would be, which is crowned with an arrangement of geometric shapes resembling thin sheets of gleaming obsidian. He lacks any sort of facial features, but many eyes stare blankly out from his joints and other odd places on his arms and torso. From the greenish carapace over his torso, his coloration shades to mauve down his arms and the tight bunch of tentacles where his lower legs should be. His arms branch at the elbow: one pair ends in clawed hands resembling leathery gauntlets, while the other extends into weird, many-jointed appendages tipped with bony blades. The air around Kozilek is acrid, and vibrations that hover at the edge of hearing seem to emanate from him.

Distortions and Lies. Kozilek's presence warps reality and distorts perception. He is sometimes called the Butcher of Truth, since the actual nature of reality is nearly impossible to discern in his presence. Battle against Kozilek and his brood is unpredictably deadly: any creature might grow larger or smaller in an instant, transform into a different creature entirely, or gain capabilities it didn't have a moment before. Even mana, before Kozilek drains it away, is warped and twisted in violation of its own magical laws.

Sower of Discord. Besides warping physical reality and mental perception, Kozilek's presence has a distorting effect on sentient minds. He muddies thoughts and transforms emotions, banishing forethought and causing confusion, panic, and despair. He stirs aggression and inverts loyalties, so friends suddenly appear as enemies, and foes as trusted comrades. Those who stand against him lose themselves in circular traps of alien logic, question their own motivations, forget their purpose, or decide to stand with him in destroying life on Zendikar, even with no hope of being spared themselves.

Alien Landscapes. Kozilek's passage leaves devastation in his wake. Layers of reality are stripped away, and what remains is marred by a geometric, iridescent patterning. Landscapes and corpses alike are transformed into this new, alien reality, taking on an oily sheen in shades of red, green, gold, and brown. Rocks and trees are distorted into eerily regular shapes, utterly unnatural, as if following the twisting spirals of Kozilek's thoughts.

> "Have you ever killed insects nibbling at your crops? I think that's what the Eldrazi believe they're doing to us."
> — Sheyda, Ondu gamekeeper

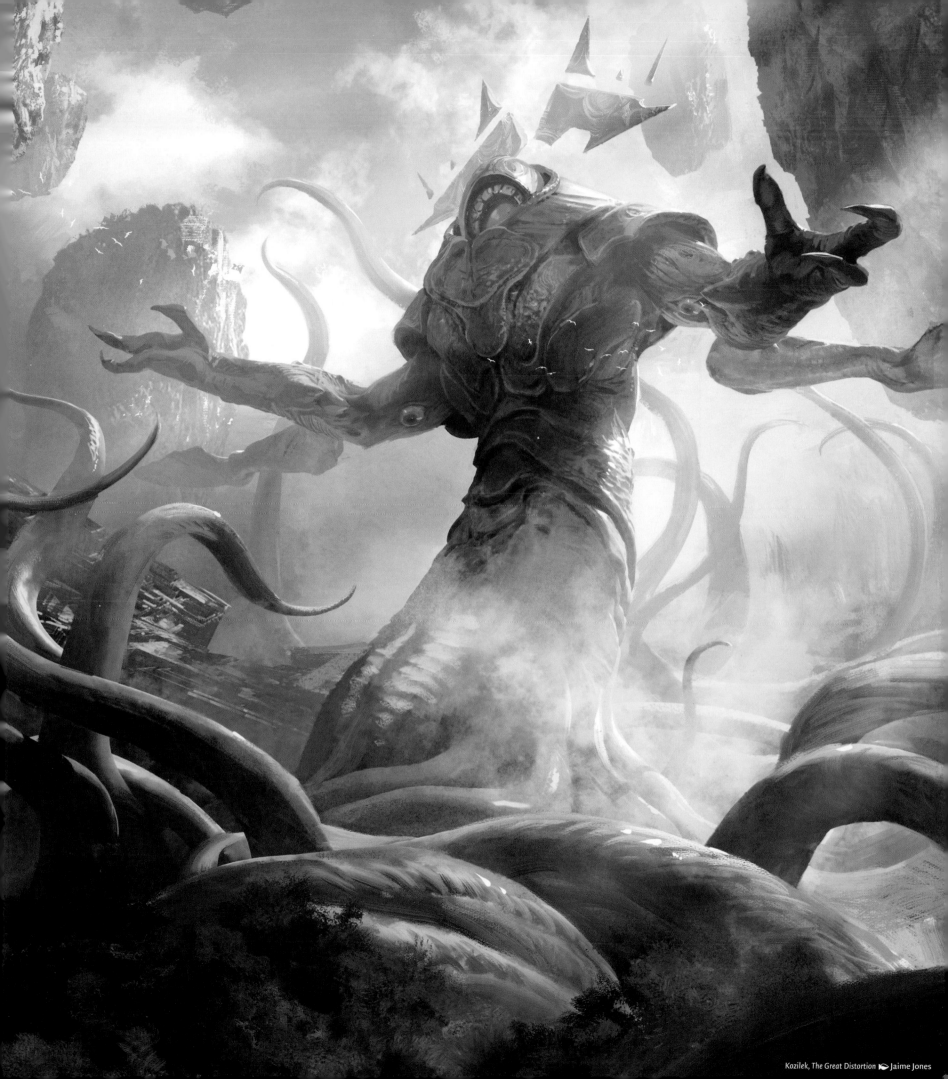

Kozilek, The Great Distortion ◈ Jaime Jones

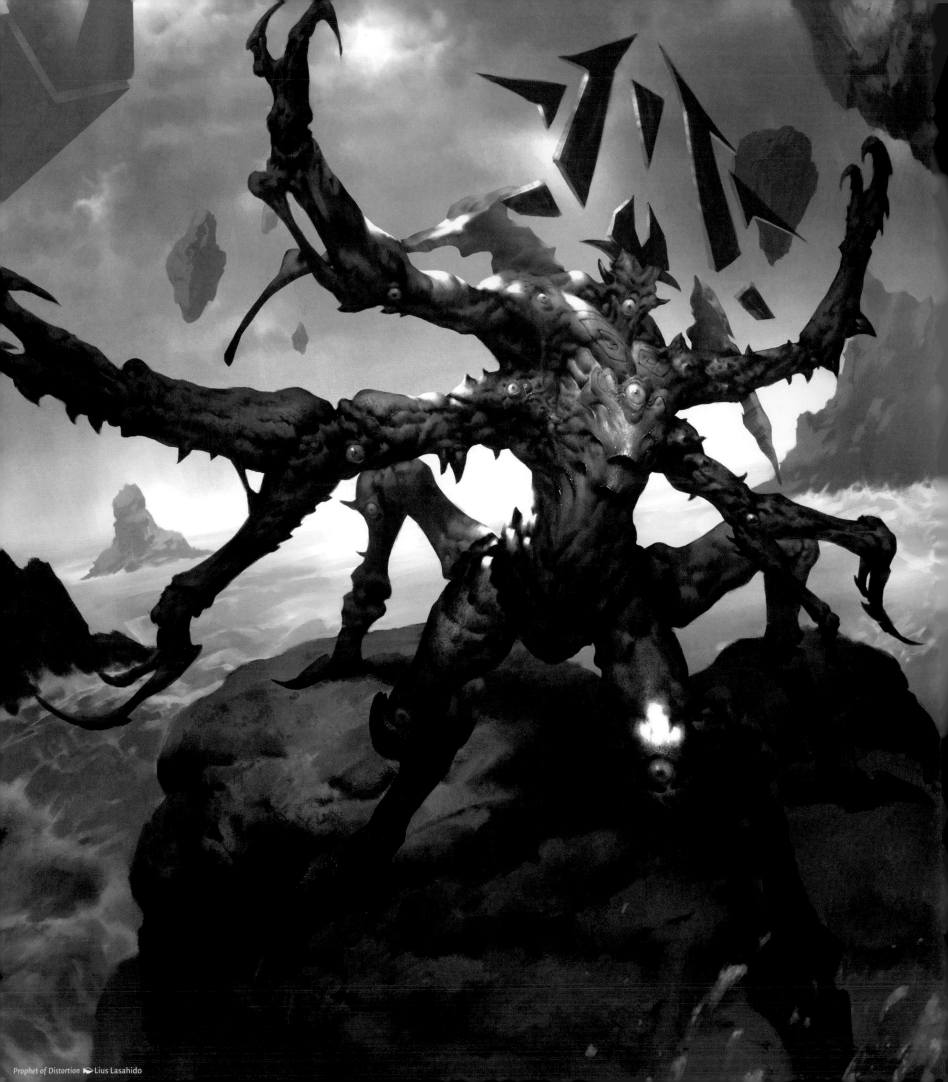

Prophet of Distortion ▶ Lius Lasahido

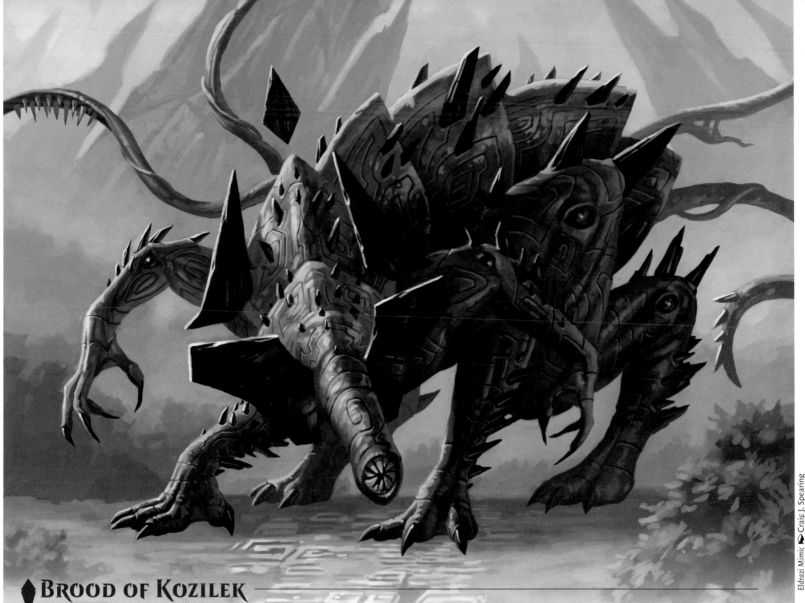

Eldrazi Mimic ◆ Craig J. Spearing

◆ BROOD OF KOZILEK

The Eldrazi of the Kozilek lineage are inscrutable and alien, scuttling across Zendikar with no clear purpose but destruction. They upend reality, turning everything on its head and transforming the landscape in their wake. They do not convey the same sense of insatiable hunger that surrounds the brood of Ulamog, but the devastation they wreak leaves the land stripped of life, growth, and mana. It is presumed that they funnel mana energy to Kozilek himself, but the process is even more inscrutable for this lineage than for the consuming Eldrazi of Ulamog.

The Eldrazi of this lineage superficially resemble beasts or enormous insects. They crawl on four, six, or eight legs across the land or the ocean floor, or occasionally drift eerily through the air, legs and tentacles dangling beneath them. They are typically covered with gleaming carapaces. Like their sire, Eldrazi of the Kozilek lineage often have eyes or eyelike protuberances in odd places, such as at limb joints or scattered seemingly randomly along the creatures' flanks. The appearance of such normal-seeming sensory organs on creatures such as the Eldrazi is deeply disturbing. The eyes occasionally seem to aim and focus, but usually only at empty space—or perhaps they focus only on ineffable things that exist beyond the normal spectrum of visual light.

These Eldrazi also have jagged plates or blades of lustrous black mineral that either jut out from or float around their bodies. These sharp projections tear effortlessly through physical substances, including both armor and flesh, but the Eldrazi seem not to use them intentionally as weapons. Their true function might involve communication, protection, or merely decoration, but no mortal being can be sure.

Kozilek's Spawn

The Eldrazi of Kozilek's lineage are hard to classify because few common features link them together—and even a single Eldrazi might change drastically over the course of hours or even minutes. Like Ulamog's brood, though, these Eldrazi seem to fall into three tiers.

Kozilek's spawn, the weakest, smallest, and most numerous of the lineage, are squat, insectile, multi-eyed creatures that skitter on crablike limbs. They swarm in great underground hives, their sheer numbers preventing any scholar of Zendikar from better understanding their life cycle. As with the Ulamog lineage, though, other Eldrazi treat Kozilek's spawn as dispensable.

Kozilek's Predator ▶ Steve Argyle

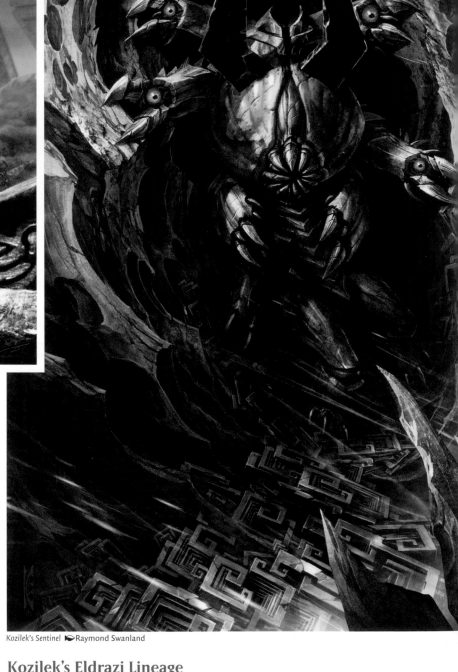

Kozilek's Drones

Somewhat larger and more dangerous than spawn are the drones. In contrast to Ulamog's drones, it is difficult to discern any specialized purpose of these Eldrazi, or even to determine whether they are acting independently or following some telepathic command. Many of these drones look much like natural animals in their basic outline, ranging widely from wolf-sized to about twelve feet tall, though they share the strange eyes and obsidian plates of all Kozilek's lineage.

Some of Kozilek's drones might serve functions relating to the production or care of spawn, but they don't seem to tend broods or birth them in any discernible way as Ulamog's broodkeepers do. Rather, the spawn seem to just appear—much the same way as other alterations of reality occur in the presence of Kozilek's lineage. Spawn have been seen bursting out of the corpse of a dead drone, tunneling up from the ground at a drone's feet, or apparently materializing from thin air beside another Eldrazi.

All of Kozilek's drones effectively extend the reality-warping aura of their sire around themselves, with fairly minor effects. The drones might change shape or alter the forms of other creatures around them. Some inspire fear or confuse loyalties. Sometimes they seem to wink in and out of existence, avoiding attacks or bypassing defenses.

As they move and fight, the devastation characteristic of Kozilek and his lineage spreads around them, apparently without any conscious effort on their part. It appears to be a result of their drawing mana from the land to fuel their strange magic, rather than a process of feeding like that of Ulamog's brood.

Kozilek's Sentinel ▶ Raymond Swanland

Kozilek's Eldrazi Lineage

Most Eldrazi of Kozilek's lineage are significantly larger than the spawn and drones, ranging from ten to fifty feet or more. Many of them have an almost humanoid appearance, but with many arms and inscrutable, insect-like faces. They have elaborate obsidian "crowns" like that of Kozilek, and larger crowns seem to indicate greater power and a closer connection to their sire. They clearly act with alien intelligence, reacting quickly to changing circumstances and anticipating the tactics of enemies.

Like the other creatures of Kozilek's brood, these Eldrazi are difficult to classify—and even the distinction between drone and Eldrazi proper is not easily drawn. Like the drones—but on a larger

scale these Eldrazi warp reality around them in much the same way that Kozilek does. Some defy death by drawing on the strength of other Eldrazi around them, and some seem to replace themselves by drawing another Eldrazi out of the Æther upon their death. Some turn spells back upon the mages who cast them or act as mana repositories to fuel the strange powers of other Eldrazi. Some grow from small creatures no larger than an Eldrazi spawn to equal the mightiest of their fellows when they fight as part of a horde, and many of them alter their form apparently at random. They warp the minds of those who dare to stand against them and bend allegiances as Kozilek himself does.

The mightiest of Kozilek's lineage are direct extensions of Kozilek's will and power, standing fifty to seventy feet tall. The land warps quickly into geometric desolation in their presence, and their reality-distorting auras extend to the very forces of life and death, returning the dead to life and wiping the living from existence.

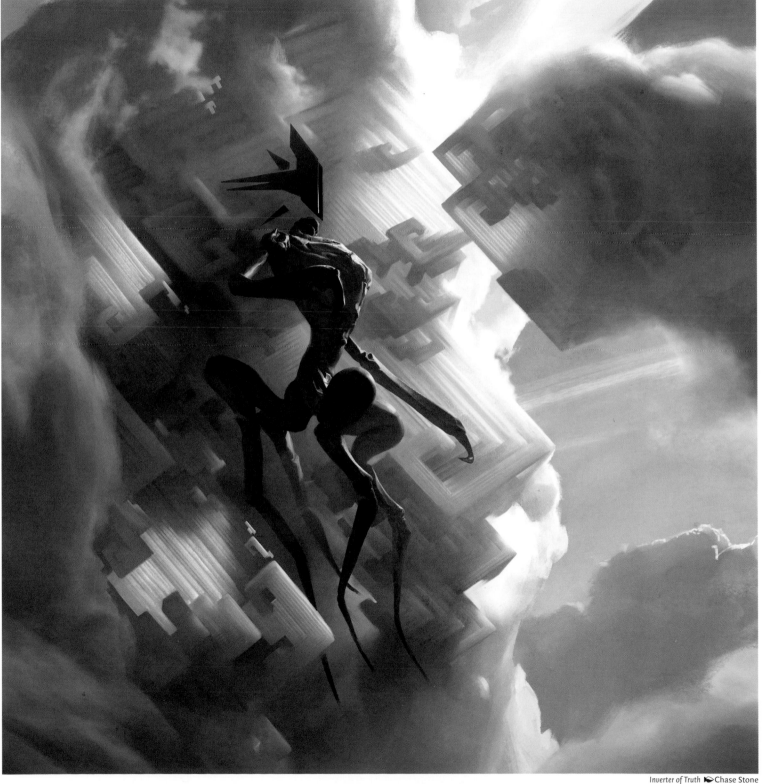

Inverter of Truth ☙ Chase Stone

EMRAKUL

Emrakul is the largest and undoubtedly the mightiest of the three known Eldrazi titans, drifting through the sky like a mountain unmoored from the bedrock. It appears that she recovered from her imprisonment more quickly than the other titans, and was the first to leave Zendikar in search of other planes to devour.

The Silent Horror. Emrakul is a grotesque monstrosity with a superficial resemblance to an alien jellyfish. The great dome of her body is about 600 feet wide and rises over 200 feet from the tangled mass of strangely jointed tentacles dangling below. The body is spongy, with a latticelike pattern of magenta flesh partially covered by a rocky crust that changes gradually from blue at the rim to gray at the top. A lavender light glows like a great eye in the center of her body. Her tentacles jut out in all directions, squirming and writhing in constant motion. They range from bright magenta near the underside of her body to various shades of blue and purple. Muffling sound and disorienting the minds of nearby enemies, she causes an unnatural quiet to fall upon the land wherever she moves.

Desolation of the Void. Emrakul's unnatural quiet creates a sense of utter desolation. She is sometimes called the Aeons Torn because looking at her is like gazing into an abyssal void, an overwhelming emptiness. Even soldiers massed in an army against her feel utterly alone, unable to function together and cut off from any

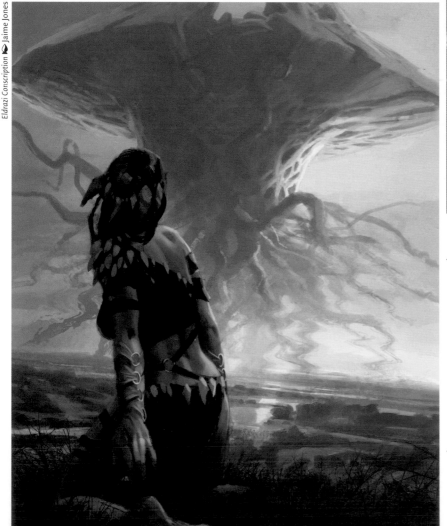

Eldrazi Conscription ◆ Jaime Jones

"No one spoke. There was no need. The threat of the Eldrazi presented a simple choice: lay down your weapons and die for nothing, or hold them fast and die for something."

—from *The Halimar Chronicle*

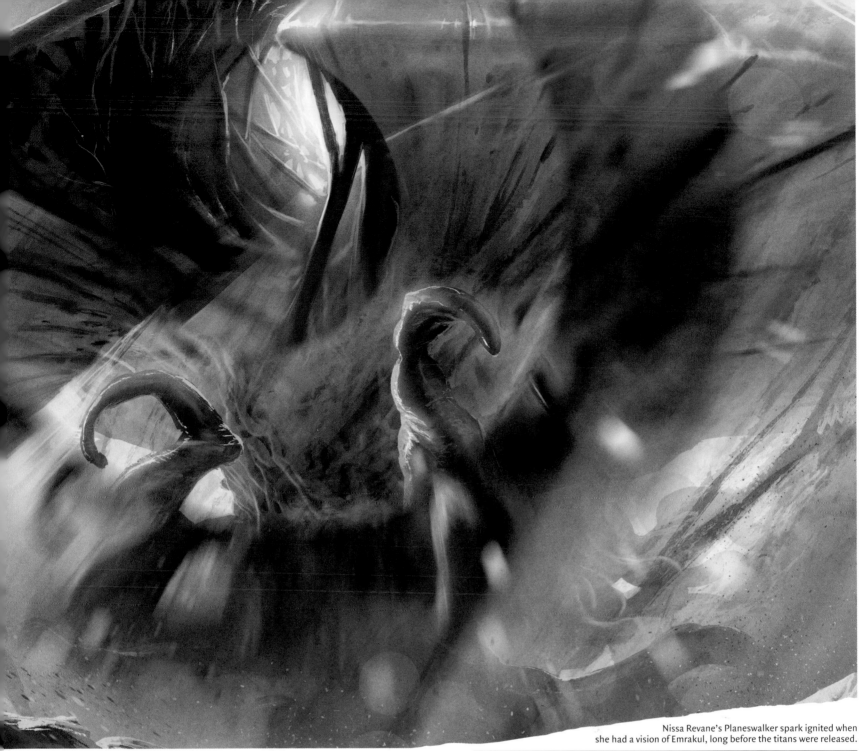

Nissa Revane's Planeswalker spark ignited when she had a vision of Emrakul, long before the titans were released.

Nissa's Revelation ▶Izzy

aid. Remaining in her presence long enough can lead to madness—the shattering of rational thought, the utter loss of purpose, and even the dissolution of identity.

Gravitational Distortion. Alone among the three titans, Emrakul does not move along the ground but drifts slowly and silently through the air. Around and beneath her, gravity's function is altered, allowing her to ignore its pull. Other flying creatures can move more easily in this narrow radius—if they can overcome the mind-numbing terror of Emrakul's presence—but creatures on the ground beneath her lose their footing and might even drift into the air toward her, flailing helplessly as they go.

Corruption of Life. Emrakul's proximity not only shatters minds, it also has a distorting effect on living flesh. In contrast to the utter desolation left in the wake of the other titans, Emrakul's passage is marked by the warping of living things, while rocks, water, and other inanimate substances remain unchanged. Trees and vines contort themselves into knobby, tentacle-like shapes. Animals and people, including survivors of battles where Emrakul was present, sometimes develop fleshy growths resembling the lattice structures of Emrakul's body. Perhaps this corruption represents Emrakul's feeding on mana in some way, or it might simply be the influence of her utterly alien nature.

BROOD OF EMRAKUL

Emrakul's brood lineage consists largely of strange bestial creatures, all soft flesh and tentacles. They do not appear in the same numbers as the broods of the other Eldrazi titans, perhaps exemplifying the terrible solitude that seems to surround Emrakul herself. And while they are perfectly capable of wreaking physical devastation, uprooting trees or carving chunks out of mountainsides, they do not lay waste to the land in the same way the other titans' lineages do. Their passage leaves madness and sometimes horrible distortions of living creatures.

The Eldrazi of Emrakul's brood resemble normal animals in their most basic outline. They're fleshier than Kozilek's lineage, and they all share the same spongy, fleshy latticework as Emrakul herself. This structure might be their means of respiration, a sensory organ, or perhaps a feature that facilitates their warping of gravity. Their coloration is also similar to Emrakul's, merging deep blues with crusty ochers and striking magentas. And they share thin, ropy, tentacular growths that often end in fingerlike or clawlike projections. These Eldrazi use their tentacles to snare or bind their prey before ingesting their living energies.

To their great horror, sages observing the effects of Emrakul's presence are speculating that some Eldrazi of Emrakul's lineage are actually transformed and corrupted native life-forms of Zendikar. This might account for their generally bestial shape and suggests the conclusion of the corrupting process that begins with the lattice growths visible on skin and hide. Whether or not this is true, the theory is spreading, and soldiers left with unnatural growths after facing Emrakul's brood sometimes beg for death for fear of becoming one of the enemy.

Hedron Matrix ▶ Jaime Jones

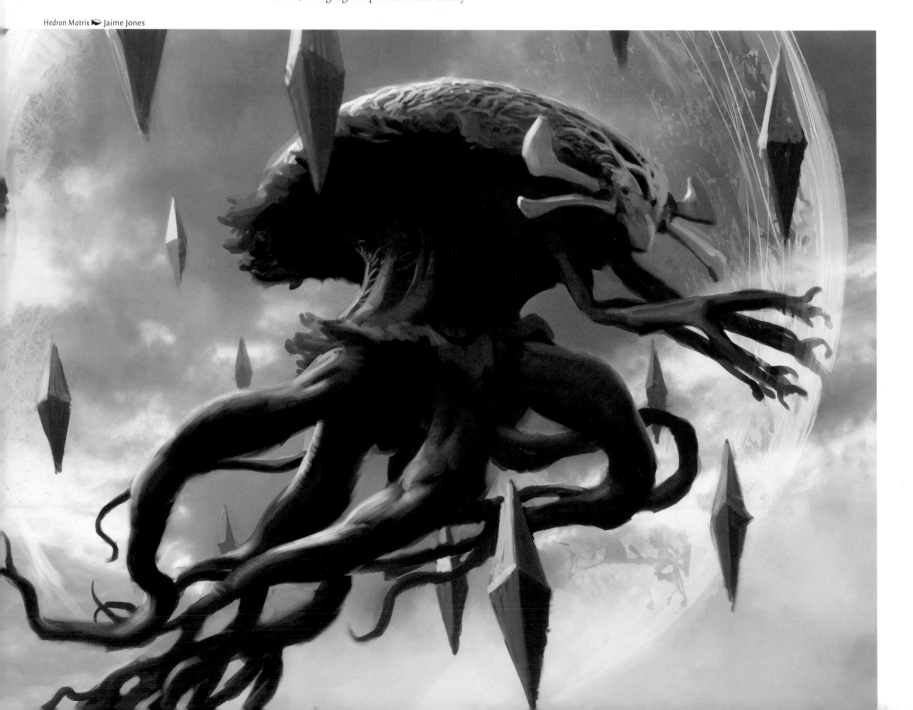

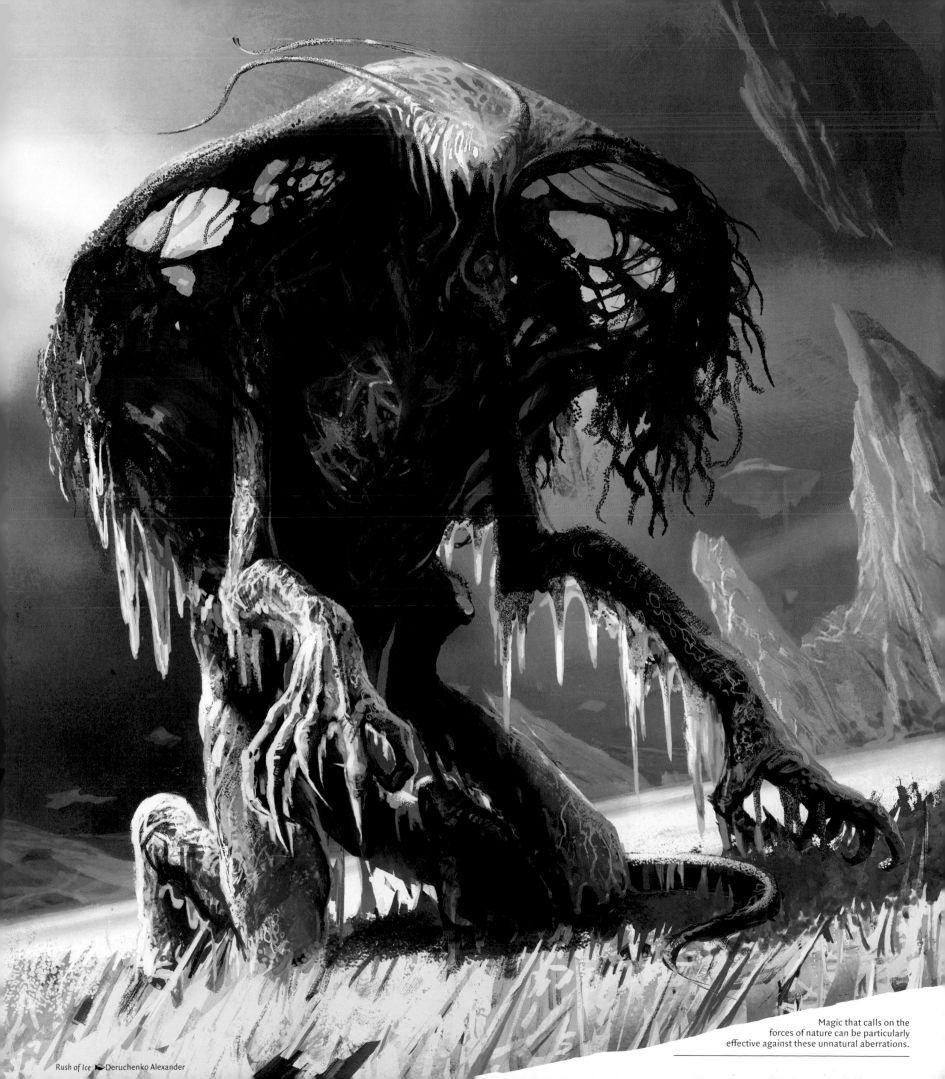

Magic that calls on the forces of nature can be particularly effective against these unnatural aberrations.

Rush of Ice ▶ Deruchenko Alexander

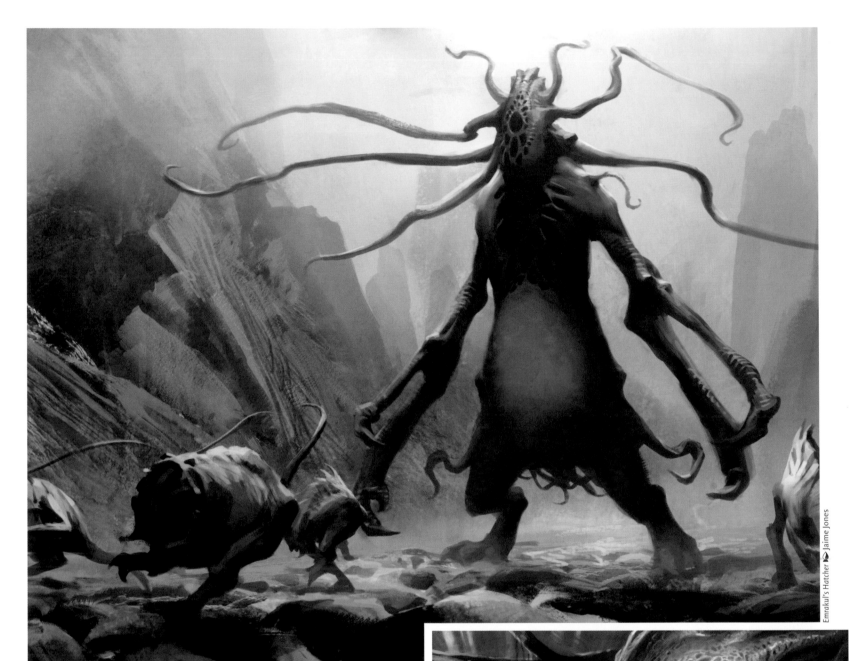

Emrakul's Hatcher ☙ Jaime Jones

Emrakul's Spawn

In contrast to the bewildering variety of Kozilek's lineage, only a few distinct kinds of Emrakul's brood have been seen. They are roughly grouped into three tiers like the other lineages, but the distinctions are much more open to question with so few examples of each type.

The weakest of Emrakul's brood are the squirmy spawn that totter and hop on two stumpy legs. They are the only Eldrazi of Emrakul's brood likely to be found in any numbers, whether because they are born in small broods of perhaps half a dozen or because they tend to congregate under the guidance of a drone. Even the drones that tend to them exhibit no real care or concern for them and sacrifice them readily in the face of any greater threat.

Nest Invader ☙ Trevor Claxton

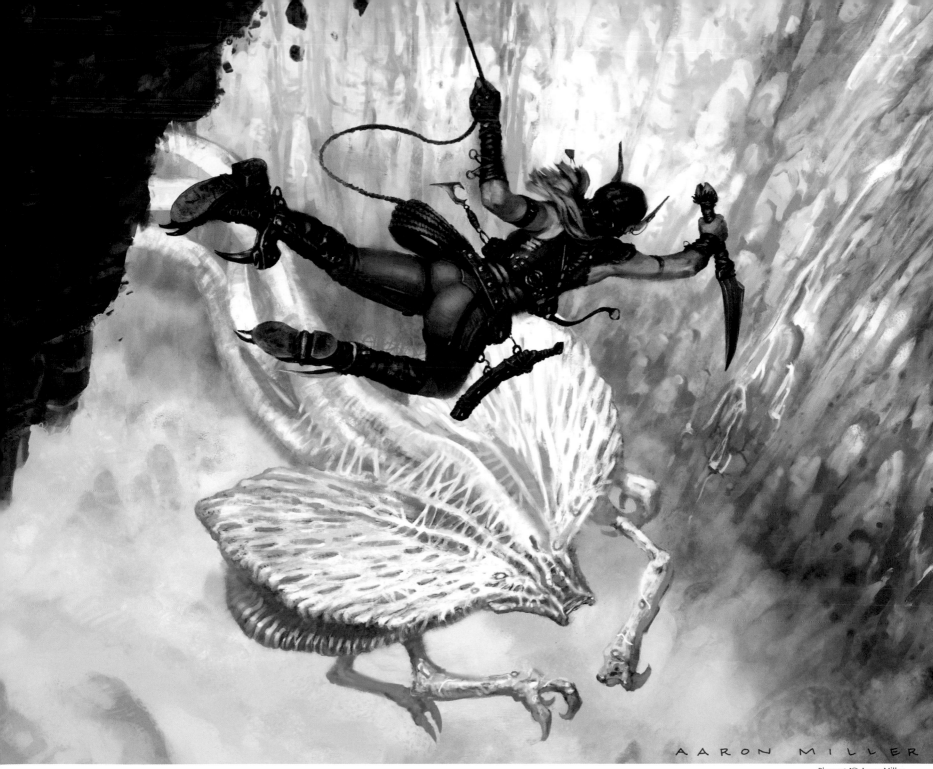

Plummet ▶ Aaron Miller

Emrakul's Drones

Most of the known drones of Emrakul's lineage serve functions related to the spawn, and only two varieties of these have been identified. Some (often called nest invaders) invade the burrows and lairs of natural animals. Perhaps they kill the animals and use their lairs to hatch their own brood, but the more horrific possibility is that they transform natural animals' young into Emrakul's twisted spawn. Different drones have an almost humanoid appearance. It is not clear whether they produce spawn by some means or simply tend them, teaching them by some alien communication how to carry out Emrakul's work.

Emrakul's Eldrazi Lineage

The mightiest Eldrazi of Emrakul's brood are huge, ranging from twenty to fifty feet tall. They are more likely than drones to have functional hands, and they give a greater appearance of sentience than the bestial drones and spawn. Still, they are far from humanoid, resembling great jellyfish, warped mushrooms, or strange flying rays. Among the largest are the great colossi called "hands of Emrakul," towering beasts with huge claws that dig into earth and stone and tear through defensive walls.

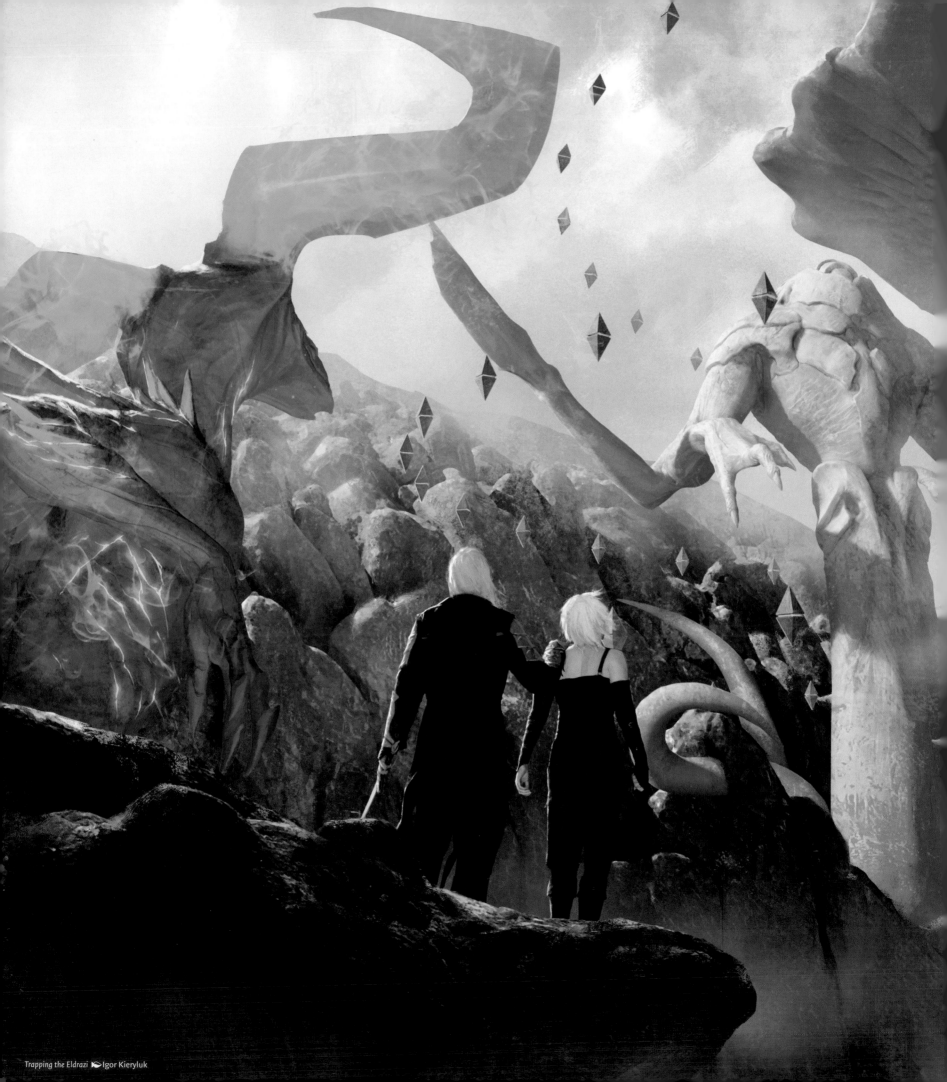

Trapping the Eldrazi ▶ Igor Kieryluk

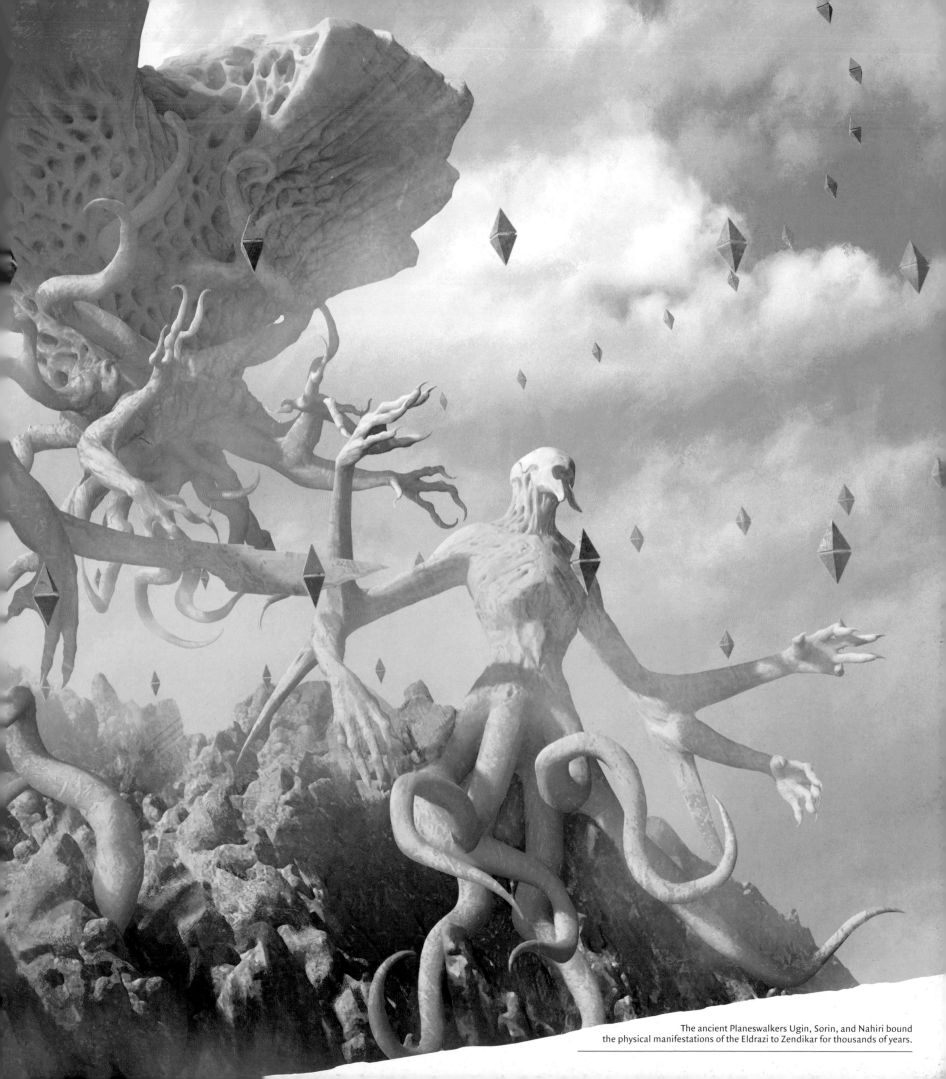

The ancient Planeswalkers Ugin, Sorin, and Nahiri bound
the physical manifestations of the Eldrazi to Zendikar for thousands of years.

THE BINDING OF THE ELDRAZI

Unbelievable as it might seem, Zendikar was once a tranquil world of rugged beauty. Vast, unspoiled tracts of magic-infused wilderness supported a vibrant ecology of gentle creatures and primitive humanoid cultures.

Thousands of years ago, all that was nearly wiped out forever. Three Planeswalkers decided to trap abominations from beyond the boundaries of the plane on Zendikar. In their desperation, they saved the Multiverse by sealing Zendikar's fate.

The Eldrazi at Large

In eons past, the Eldrazi wandered the Blind Eternities, the desolate spaces between planes. Their nature was an incomprehensible, ceaseless hunger. They devoured the mana and life energy of any plane they encountered, selecting their next target plane by some arcane, inscrutable intelligence. Roaming free in the Blind Eternities, the Eldrazi were a scourge on countless planes of the Multiverse.

Three Planeswalkers took action to try to destroy the Eldrazi. Ugin, the spirit dragon, fought the Eldrazi with his breath of invisible flame, using his knowledge of colorless magic to match the Eldrazi's colorless nature. The vampire Planeswalker Sorin Markov brought his familiarity with magic that leeches life energies. And Nahiri, a stone-shaping lithomancer, planned to force them into physical form and then destroy them utterly, ridding the Multiverse of the monstrosities.

But their plan failed. The Eldrazi were too immense, too alien, and too powerful to destroy, and the Planeswalkers were forced to consider a desperate course of action. Although they couldn't kill the Eldrazi, they could imprison the astral abominations on a single plane, cutting them off from the Blind Eternities and preserving the rest of the Multiverse. The world they chose would be in danger of utter destruction by the ravening Eldrazi, but the Planeswalkers decided that the risk would be worth the salvation of all other planes.

In order for their plan to work, they needed a world.

They found a plane with lush ecosystems and uniquely dynamic mana—a powerful lure for the Eldrazi's insatiable hunger. Over Nahiri's objections, they settled on her home plane, Zendikar.

The Prison Plane

The three Planeswalkers went to work to trap the Eldrazi monstrosities Emrakul, Ulamog, and Kozilek on Zendikar. Sorin Markov directed the Eldrazi's appetite toward the plane, luring them in with the promise of feeding on Zendikar's fierce energy. The invisible breath of the spirit dragon Ugin blunted the Eldrazi's counterattacks, and he used special colorless magic to bind them to the world. Nahiri constructed a massive network of stone diamonds called hedrons, whose power would form the bars of a worldwide prison, forever preventing the Eldrazi from leaving.

The Planeswalkers' trap worked. Emrakul, Ulamog, and Kozilek manifested in physical form on Zendikar, became confined by the magic of the network of hedrons, and thanks to the magic of the imprisonment spell, sank into harmless dormancy. Their mission complete, the Planeswalkers disbanded. Sorin and Ugin left the plane, while Nahiri remained on her home plane to keep watch over the prison.

The Eye of Ugin

The Planeswalkers concentrated the power of their imprisonment spell, the nexus point of the hedron network, in an underground chamber called the Eye of Ugin. Located beneath the mountains of Akoum, this cavernous vault held a great glowing hedron linked to all the others. Activating the hedrons required the efforts of all three Planeswalkers, including the invisible ghostfire breath of Ugin. Until three Planeswalkers and this ghostfire were present once more in the chamber, the prison could not be unsealed.

The Planeswalkers had a special connection to the Eye of Ugin that spanned the Blind Eternities. Any of the three of them could communicate with the others if one of them was in the vault, no matter what plane the other was visiting. This way, Nahiri could contact Sorin and Ugin if the Eldrazi ever broke free of their bonds—all she had to do was return to the Eye and send her call into the Æther.

Nahiri the Prophet

For centuries, Nahiri lived among her own people, the kor of Zendikar. She taught them the stoneforge arts, a form of lithomancy that allows its practitioners to craft stone or metal objects from unshaped rock. A cabal of so-called stoneforge mystics continues this tradition to the present day, even emulating Nahiri's clothing. The modern mystics attribute the tradition to a prophet of Talib, their god of the earth, although the rise of the Eldrazi has shaken that faith.

Nahiri also trained the kor to help her maintain the Eldrazi prison. She led bands of kor on long pilgrimages across the plane to visit specific sites that she knew were focal points of the hedron network's power. For lack of a better word, she told the kor that visiting these sites would prevent three "gods" from emerging to ruin the world.

After several centuries, though, Nahiri grew weary. She retreated from the world and withdrew to the Eye of Ugin. She wrapped herself in a cocoon of stone and meditated for thousands of years, emerging only occasionally, when a certain tremor in the ground alerted her to the arrival of another Planeswalker or a threat to the Eldrazi prison.

In Nahiri's absence, bands of kor continued their pilgrimages, but as the years went on, their understanding of the sacred sites' meaning changed. They still spoke of three gods, but they started to revere these gods instead of fearing them. Nahiri became an honored prophet in the kor's oral history, and the Eldrazi were forgotten.

Ugin's preparations had been thorough. He had worked out a way to trap the Eldrazi using a carefully shaped network of ley lines and magical nodes, channeling and focusing the flow of mana through the land. What he needed was someone to build it.

Nahiri was very good at building things.

It took forty years of near-constant work. One by one, she pulled carefully crafted stone shapes out of the earth—hedrons, Ugin had called them, and the name had stuck. She filled the skies of Zendikar with stone, and Ugin etched them with draconic runes that held them in the air and would bind the Eldrazi to this place.

The hedrons were lure as well as trap, sending out pulses of magical energy that drew the Eldrazi like the scent of blood draws sharks. Slowly, ponderously—and, Sorin reported, ignoring other worlds along the way—the Eldrazi approached Zendikar.

Nahiri spread word of what was coming to the merfolk, the kor, the humans, and the elves throughout the plane. The amphibian surrakar whispered to each other in the bubbling depths of the coming of monstrous gods, and the angels of Zendikar patrolled the skies with watchful eyes between the hedrons.

When the Eldrazi came, Zendikar was as ready as any world had ever been.

One Eldrazi titan in the distance had been monstrous, an abomination. Three together, seen up close, were an impossibility.

The one Sorin and Nahiri had seen before, the enormous thing that Ugin called Ulamog, was in fact the smallest of the three. The titan called Kozilek picked its way through the hedron fields, great black blades of senseless obsidian floating around what should have been its head. And above them loomed Emrakul, a hideous tower of latticed flesh and grasping tentacles floating lazily over the shattered earth.

Ugin breathed his ghostfire, searing the Eldrazi brood with invisible flame. Sorin countered their life-draining power with his own, leeching their strength before they could take too much of Zendikar's vitality. Zendikar's people fought the titans' brood lineages, but it was clear that if the onslaught continued, they too would be overrun.

The titans were heedless, mindless, making their inexorable way to the nexus of the hedron network, the source of the call that had pulled them there, the eye of the storm.

Nahiri was waiting for them, in the underground chamber that she and Sorin had named the Eye of Ugin. For Sorin, the name was likely mockery. For Ugin, the name might have come from pride, although it was difficult to tell. For her, it was a message: Remember, dragon. This was your idea.

There was a rush of mana, and then Sorin and Ugin were there with her. The earth shook, the crystalline walls of the Eye singing in sympathetic vibration.

"They are in position," said Ugin.

The three Planeswalkers focused their tremendous power on a single point, a nexus stone linked to every other hedron by invisible lines of force and mana.

Every single hedron on the plane glowed as they shifted into new positions. The network was taking its final shape. From icy Sejiri to the Silundi Sea, Zendikar quivered with effort.

Then it was done.

They sealed the chamber with a mystical lock, one that could only be opened by three Planeswalkers together, and made their way to the half-ruined surface.

Looming above the highlands of Akoum, the three Eldrazi stood petrified, surrounded by a web of floating hedrons. Nahiri knew the earth here. It was already reacting, growing around the great Eldrazi like a scab over a wound. The teeth of Akoum would swallow them, and the inhabitants of Zendikar would scour the plane of their brood. Zendikar had survived, ravaged but whole, and its people would learn to live in the shadows of the hedrons.

"Well done, Nahiri," said Sorin. "This was your work. Your sacrifice."

The three of them would test the strength of the lock to make sure the titans were secure. Perhaps Sorin and Ugin would help her scour the land of the Eldrazi broods. She hoped so. And then, sooner or later, the two elder Planeswalkers would depart, and Nahiri—and the Eldrazi—would remain.

She stared up at the silent, stony shapes. Ramparts of stone already crept up around them. Perhaps in a thousand years they would be forgotten, their destruction fading into legend. But Nahiri would not forget them, and neither would the land itself.

"This was our work," she said. "My work is just beginning."

—from "The Lithomancer" by Kelly Digges

SORIN MARKOV

The ancient vampire Sorin Markov was one of the three Planeswalkers who bound the Eldrazi on Zendikar thousands of years ago. He was born on the dark world of Innistrad, and though his family there no longer welcomes him, he still considers that plane home.

Birthed in Blood. Thousands of years ago, Edgar Markov was an alchemist and healer on Innistrad—a land that, at the time, was not quite so dark, a plane where vampires did not exist. As old age began to claim him, he despaired of finding an alchemical means to stave off death and turned to black magic. Not long after, the demon Shilgengar appeared to Markov and revealed a means by which Markov could achieve immortality: a dark ritual of blood magic that involved drinking an angel's blood. Thus were vampires born on Innistrad, and the first of Edgar's vampiric bloodline was his grandson, Sorin.

Blood Magic. Sorin's magic is intricately linked to his vampiric nature. He practices the magical art of sangromancy—blood magic. By draining the blood of another person, he can transfer life force and health to himself. He can prevent blood from clotting and wounds from healing, and inflict lasting curses that lead to wasting

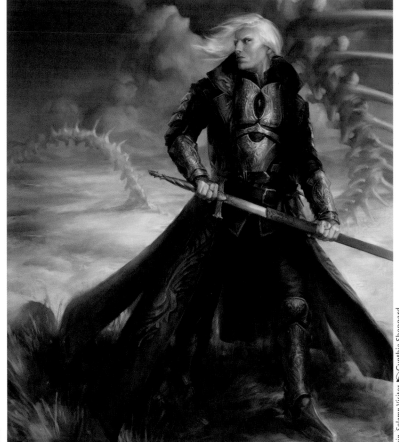

Sorin, Solemn Visitor ◆ Cynthia Sheppard

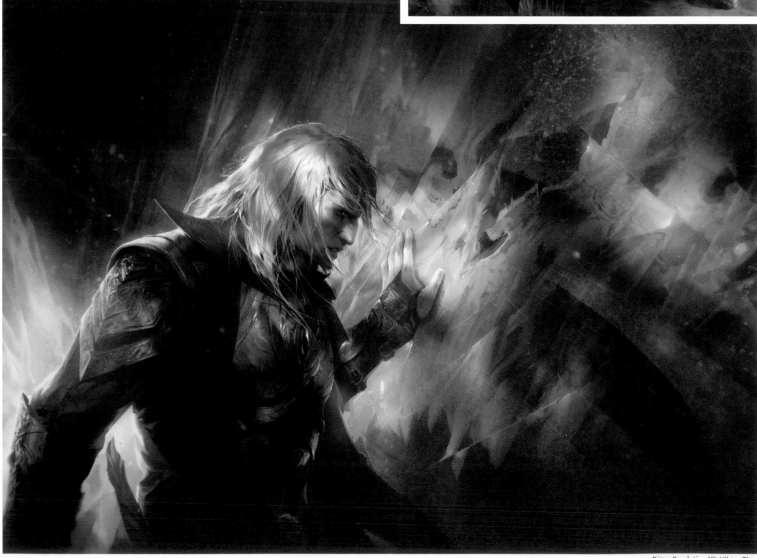

Bitter Revelation ◆ Viktor Titov

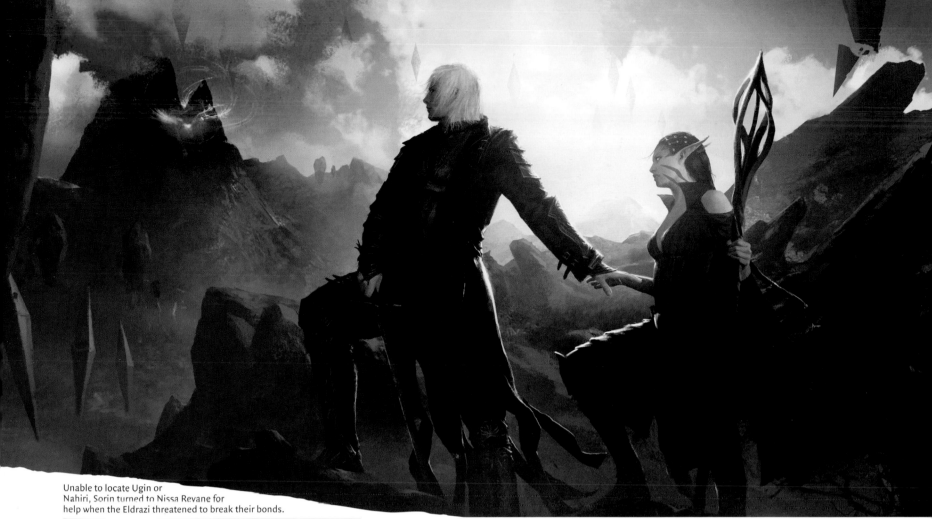

Unable to locate Ugin or Nahiri, Sorin turned to Nissa Revane for help when the Eldrazi threatened to break their bonds.

Sorin and Nissa ▶ Igor Kieryluk

and death. He can even control others' blood and thereby control their thoughts and actions.

Immortal Pleasures. As the grandson of the honored progenitor of the vampire race on Innistrad, Sorin is accustomed to living a comfortable life. Like many of Innistrad's vampires, he tries to ease the tedium of his ageless existence with the finest pleasures of life, but he is less inclined to decadence and overindulgence than many of his kin. His vast experience on countless planes has given him access to more delights than any vampire on Innistrad could ever imagine, but it has also shown him the vast potential of humans and other mortal races. Rather than looking down on humans as mere cattle—a food source—as most vampires on Innistrad do, he finds them endearing and also important.

Light in a Dark World. Over the centuries after the birth of their race, the vampires of Innistrad grew increasingly disdainful of humanity and hunted them ever more boldly. As Sorin watched through the years, he saw that as the vampires' power increased, human villages dwindled. If the trend continued, he realized, the defenseless humans would be hunted to extinction. That would be bad enough for the vampires, but Sorin found a surprising streak

> "I have seen planes leveled and all life rendered to dust. It brought no pleasure, even to a heart as dark as mine."
> —Sorin Markov

of compassion in his heart and established a protection for humanity on Innistrad. Borrowing from human superstition about the moon and the afterlife, Sorin created the archangel Avacyn and established a religion around her. Avacyn was a warrior who could hold back the vampires and other monstrous forces that pressed in on humanity, and the rituals of her church incorporated elements of magical wards that would give her followers additional protection.

Some vampires understood Sorin's act, but most reviled him as a traitor. Edgar Markov banished his grandson from his ancient manor, and Sorin is not welcome there to this day. Avacyn was Sorin's gift to Innistrad, but she also represented his betrayal of his own people.

Ancient Allies. Sorin and Nahiri first met when the young kor's Planeswalker spark first ignited, and they forged an unlikely friendship. Viewing her almost as a daughter, Sorin taught Nahiri about the Multiverse and introduced her to many new planes. Together, they discovered the Eldrazi, witnessing Ulamog's destruction of a long-forgotten plane. They met Ugin soon after, and the three Planeswalkers concocted the plan that bound the Eldrazi in Zendikar for millennia.

◆ NAHIRI, THE LITHOMANCER

The youngest of the three Planeswalkers who bound the Eldrazi, Nahiri is still incredibly ancient by the standards of other kor. The Planeswalkers of ancient times held a spark of immortality, which has sustained Nahiri long past her natural life span.

Vampire's Protégé. Nahiri was born among the kor of Zendikar, long before they adopted their nomadic ways. Her first, involuntary planeswalk brought her into the presence of Sorin Markov, who took her under his wing and introduced her to the vastness of the Multiverse. The two spent centuries together, and Nahiri grew to regard Sorin as a beloved teacher.

Mystic of Stone. Nahiri's magic, as her appellation suggests, is centered on lithomancy—the magical art of shaping and altering stone. She can create objects from stone and even transform stone into metal. Her work is exquisite—indistinguishable from an item crafted by a skilled artisan over the course of months at the forge. She often travels without a weapon because she can rely on being able to reach into nearby stone and draw out a stoneforged blade with a minimum of effort.

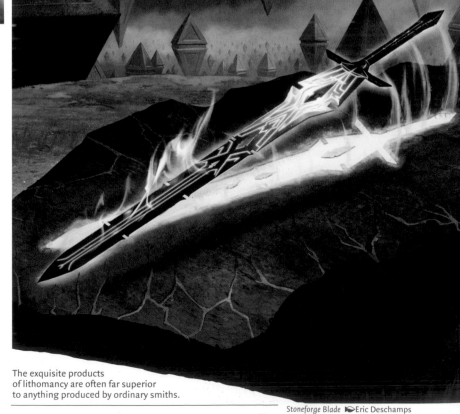

The exquisite products
of lithomancy are often far superior
to anything produced by ordinary smiths.

Stoneforge Blade ◆Eric Deschamps

> "Any hope is better than none. Always."
> —Nahiri

Nahiri's lithomancy extends beyond merely shaping stone, however. Her magic relies in part on being able to sense the flow of mana through earth and stone, and from Ugin she learned the power to shape that flow. When she crafted the hedrons to trap the Eldrazi on Zendikar, she relied on this ability in order to connect the hedrons together in a vast global network.

Zendikar's Guardian. Nahiri has felt protective of her home plane, and after she worked with Sorin and Ugin to trap the Eldrazi there, she remained on Zendikar as its guardian. Instantly aware of any Planeswalker's arrival, she greeted every planar visitor with a stern warning against doing anything that might rouse the Eldrazi. For centuries, she kept watch over the prison, trusting that if anything threatened to loose the Eldrazi's bonds, Sorin and Ugin would return to help her seal them away again.

Lost to the Ages. Nahiri's trust turned out to be misplaced. When the Eldrazi did stir and waves of their spawn spread over the plane, Sorin and Ugin did not come. With a tremendous and costly effort, Nahiri managed to seal the Eldrazi away again. Then she left the plane in search of her negligent allies—and has not been seen since.

Nahiri's Hedrons

For her part in the original binding of the Eldrazi, Nahiri created a vast network of diamond-shaped stones that Ugin called "hedrons." Together, she and Ugin inscribed the hedrons with arcane symbols and used them to bend the flow of mana throughout the plane to form the Eldrazi titans' prison. In Nahiri's absence, though, the hedrons have fallen out of alignment, settled (or plummeted) to the ground, broken to pieces, and become the focus of endless study and speculation.

Ancient Relics. The people of Zendikar have no doubt that the hedrons are ancient. The most commonly repeated legends suggest that they were created by the Eldrazi "civilization" which is supposed to have built many of the other ruins of the plane. However, once the Eldrazi awoke, some of Zendikar's defenders began to suspect that ancient enemies of the Eldrazi had created the hedrons, and they now study the hedrons in hopes of finding ways to defeat the alien hordes.

Warped Magic. In the presence of hedrons, magic becomes unpredictable. Sometimes the flow of mana seems dampened, and other times it is amplified. It might function differently than intended. What's more, sometimes the hedrons seem to repel Eldrazi spawn, and sometimes they seem to attract them. Often they are inert lumps of stone, but if they can be properly arranged and aligned, they spring to life, glowing and radiating magical power.

Hedron Alignment ▶ Craig J. Spearing

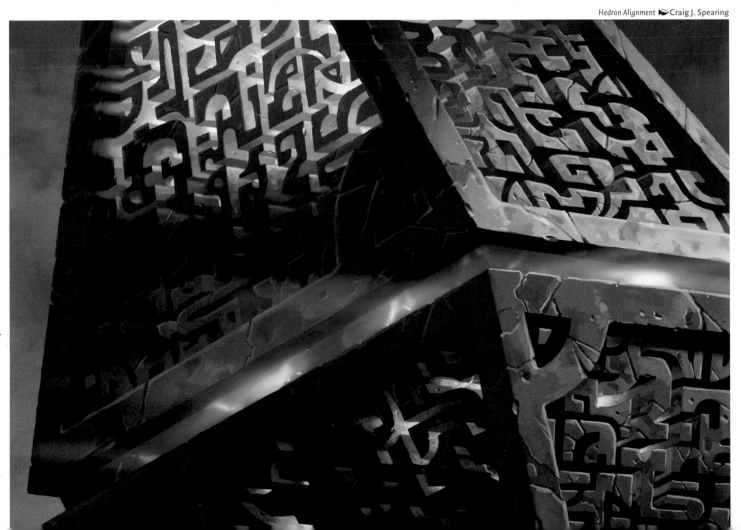

UGIN, THE SPIRIT DRAGON

Ugin is a dragon Planeswalker, ancient beyond measure, who is native to the plane of Tarkir. His long life has given him a unique perspective on the Multiverse; he sees it as an unbroken whole and seeks to understand its deepest mysteries.

Understanding the Unknowable. Ugin has dedicated centuries to understanding the Eldrazi. Even before working with Sorin and Nahiri to bind them on Zendikar, he tracked and documented the great titans, trying to comprehend their purpose and nature, and he frowns on any who seek to destroy them. Even now, as the titans rampage across Zendikar once more, Ugin plans to imprison them again so he can continue his study of them.

Ugin doesn't entirely understand the Eldrazi's role, but he has enough perspective to intuit their greater function in the Multiverse. He knows that the Eldrazi are ancient, perhaps as old as the Multiverse itself, and that they consume entire planes. Ugin reasons that either the Eldrazi are part of a larger system or the Multiverse creates new planes at roughly the same rate as the Eldrazi consume them—otherwise there wouldn't be any planes left. So he believes that imprisoning or killing the titans before their natural cycle is complete might have unforeseen consequences. Merely being kept from their task for a few thousand years by imprisonment might not create that much of a disruption, but their early destruction might have far-reaching effects.

Colorless Magic. Ugin has studied the energy patterns of entire planes—their creation, destruction, and renewal—and he has applied these universal principles to his own form of magic, which deals with the transmutation of matter into energy. On his home plane, the inhabitants have derived spells of concealment from Ugin's principles, but he views these spells as a brute-force application of his sophisticated concepts. He is far more intrigued by the Eldrazi's use of colorless mana, and he hopes that his study will further enhance his understanding of this alien magic.

Preserved Through the Ages. After sealing the Eldrazi on Zendikar, Ugin returned to his native Tarkir. There, a rivalry that spanned eons came to a violent head when Nicol Bolas—another ancient dragon Planeswalker—tracked down his enemy. The two dragons battled in the skies over Tarkir for hours, but in the end, Nicol Bolas proved too powerful. Ugin fell from the sky and crashed into the earth. Bolas left him for dead, but his life was preserved by another Planeswalker, Sarkhan Vol, who entombed him in a cocoon-like structure made from one of Nahiri's own hedrons. There he slumbered for over 1,200 years, and he has only recently awakened.

Rude Awakening. Sorin Markov was the one who finally freed Ugin from his cocoon on Tarkir. Sorin brought the news that the Eldrazi had broken free from their prison on Zendikar and promised to meet Ugin there after he located Nahiri. Ugin returned to the Eye of Ugin and began to rebuild it while he awaited the other Planeswalkers. To his dismay, Sorin and Nahiri failed to return. Instead, an upstart young Planeswalker named Jace Beleren appeared in his chamber, seeking advice on how to destroy the Eldrazi.

Crux of Fate ◆ Michael Komarck

> "We are all part of a vast tapestry. Break a thread, and that part of the Multiverse unravels. You can never know how small or how large the damage will be until after it is too late. That is why small minds should never be allowed to wield great power."
> —Ugin

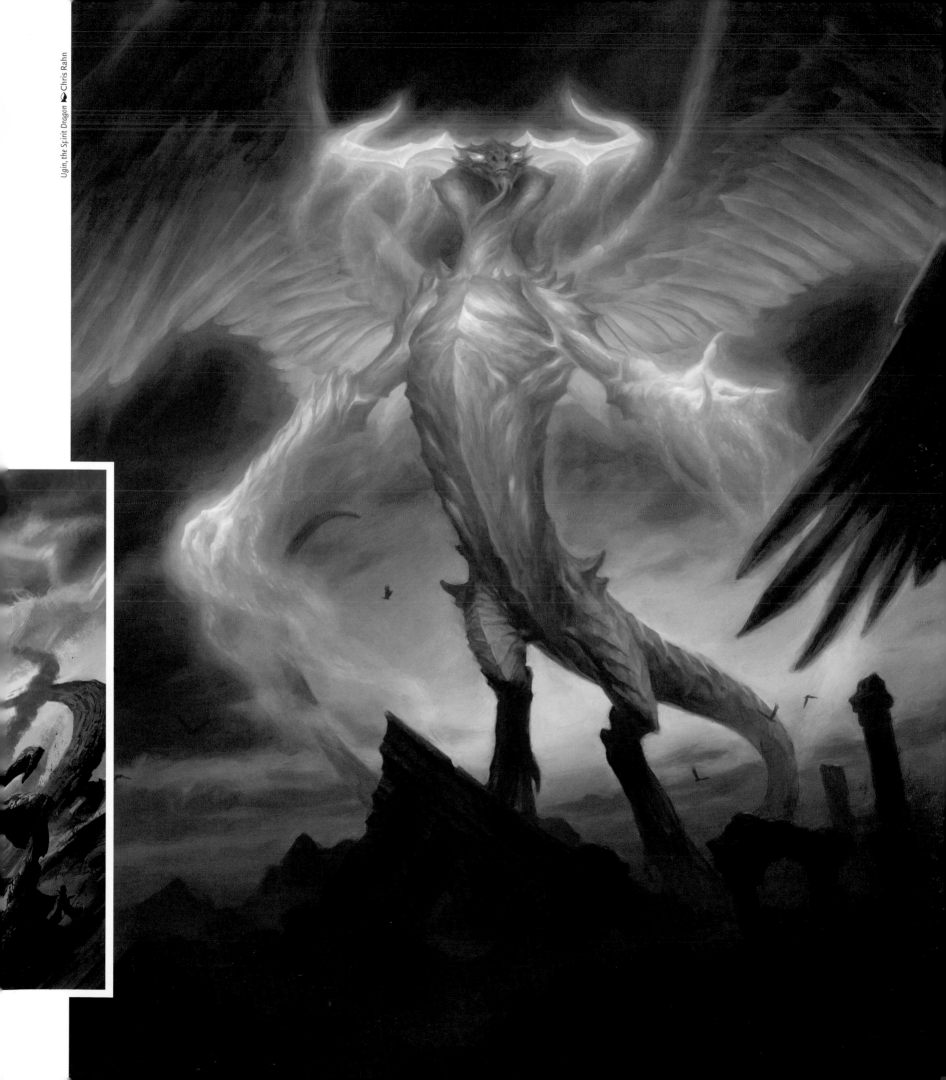

THE FIRST ESCAPE

The Eldrazi remained frozen in their prison for thousands of years. Their alien presence, however, had its effects on the world during this time. The mountains of Akoum grew up to entomb the petrified titans in an enormous subterranean cyst, and the first stirrings of what would eventually become the Roil began as the plane reacted to this infection. Earthquakes, sudden eruptions of rock, and volcanic activity became increasingly common on Akoum.

After a few thousand years, a more insidious poison seeped out from the Eldrazi's prison. The noxious creative force of Ulamog became an infection that took hold in the race of people who dared to live in Akoum's mountains despite the tectonic instability of the region. They became a sort of cult devoted to an imagined deity of the mountains, established a temple near the site of the prison, and began performing rituals inspired by their growing madness.

Those cultists avoided the notice of an increasingly reclusive Nahiri, and over time and multiple generations, their rituals actually proved effective in loosening the bonds of the Eldrazi prison. The titans stirred in their slumber and found their prison less than fully secure. Though they still could not escape, teeming hordes of their broods sprang into existence around them.

This swarming host devastated Zendikar. The greater Eldrazi of the brood lineages emanated a radius of destruction wherever they went, annihilating all life and mana in their path, absorbing the energies of the lush natural world. The lesser Eldrazi, the drones and spawn, tore through Zendikar's early civilizations, reducing them to ruins with terrible speed.

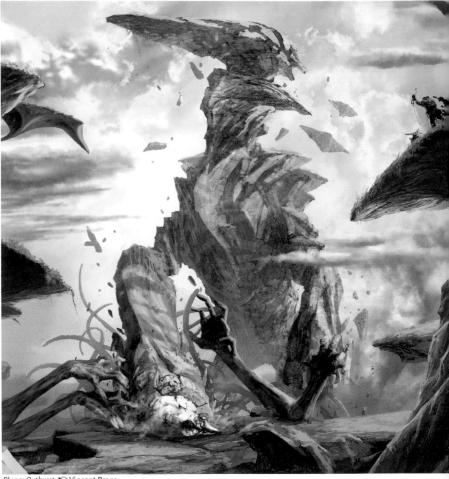

Planar Outburst ▶ Vincent Proce

During this rampage, the cultists who had helped secure this tiny measure of freedom underwent a transformation. Only twelve of them survived the initial wave of spawn emerging from the prison, but those twelve became the first vampire bloodchiefs, the progenitors of the vampire race. Whether they were originally human, kor, or a race of their own, they became something entirely new—and utterly enslaved to the will of Ulamog. Forced to conspire in this campaign of destruction against their home plane, the vampires' original identities and memories were lost.

The Eldrazi broods and their vampire slaves ravaged Zendikar, nearly reducing it to a lifeless wasteland. But the Planeswalkers' magic held the Eldrazi titans in place. Nahiri went to the Eye of Ugin and sent out the summons that should have called Sorin and Ugin to her aid, but no answer came. So through a heroic effort, Nahiri alone reinforced the bonds of the Eldrazi prison, ensuring that the titans remained firmly bound and could produce no more of their broods.

The Eldrazi brood lineages remained, but Nahiri trusted the people of Zendikar to deal with them. Though she was frustrated and angry at being left to deal with this catastrophe alone, her concern for Sorin overcame those other feelings. She left the Eye of Ugin to find Sorin, hoping to save him from whatever catastrophe had kept him from Zendikar, even as she had saved her home plane.

Nahiri was never seen on Zendikar again.

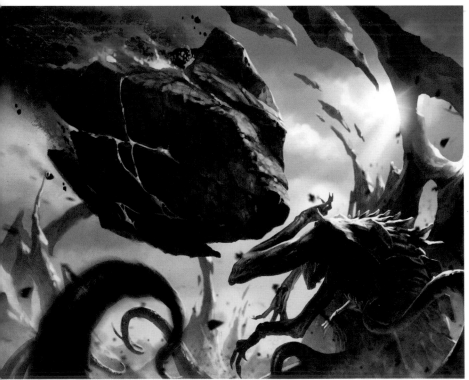

Stonefury ▶ Chris Rallis

Zendikar's Fierce Awakening

Zendikar itself reacted to the presence of the Eldrazi. As thousands of the plane's inhabitants perished, Zendikar fought back, stirring to life to fend off the Eldrazi menace. What had begun as localized tremors and shifts in gravity near the Eldrazi prison on Akoum developed into the deadly force of the Roil. The terrain grew slowly more treacherous and the creatures that lived there more ferocious. Zendikar sought to exterminate the Eldrazi.

Thwarted by Zendikar's instinctive backlash, the Eldrazi brood lineages eventually died off, leaving the three Eldrazi titans alone in their slumber. Life on Zendikar slowly recovered, and the destruction wrought by the Eldrazi passed into the fog of memory. The destructiveness and danger of Zendikar, however, was established forever.

Though the three Eldrazi titans remained imprisoned, some of the broods that emerged were large enough to obliterate armies.

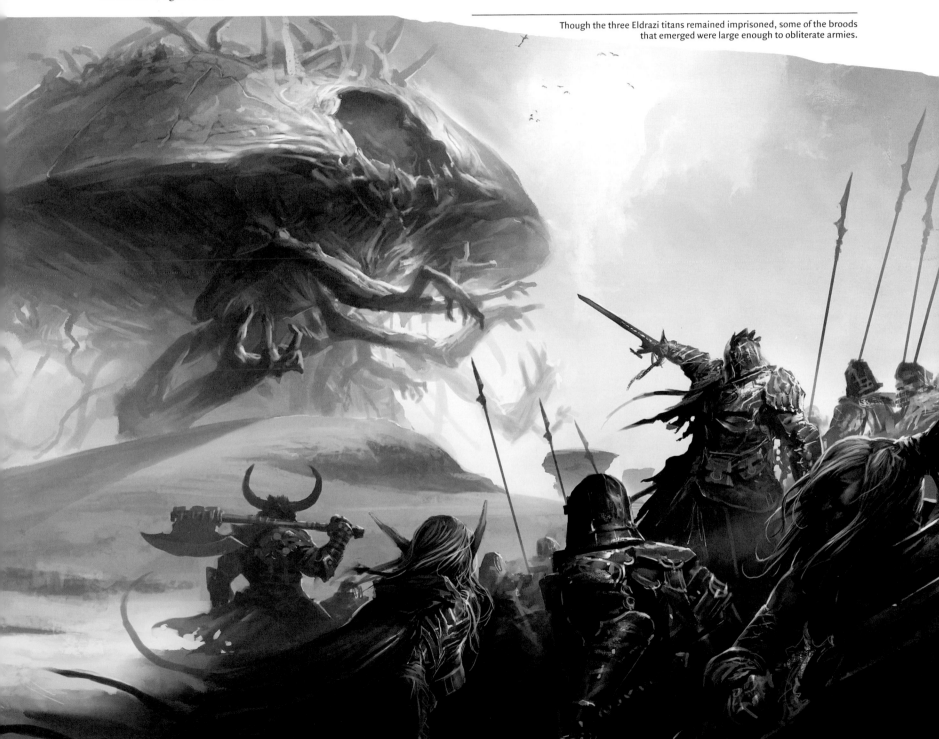

Time of Heroes ❧ Kekai Kotaki

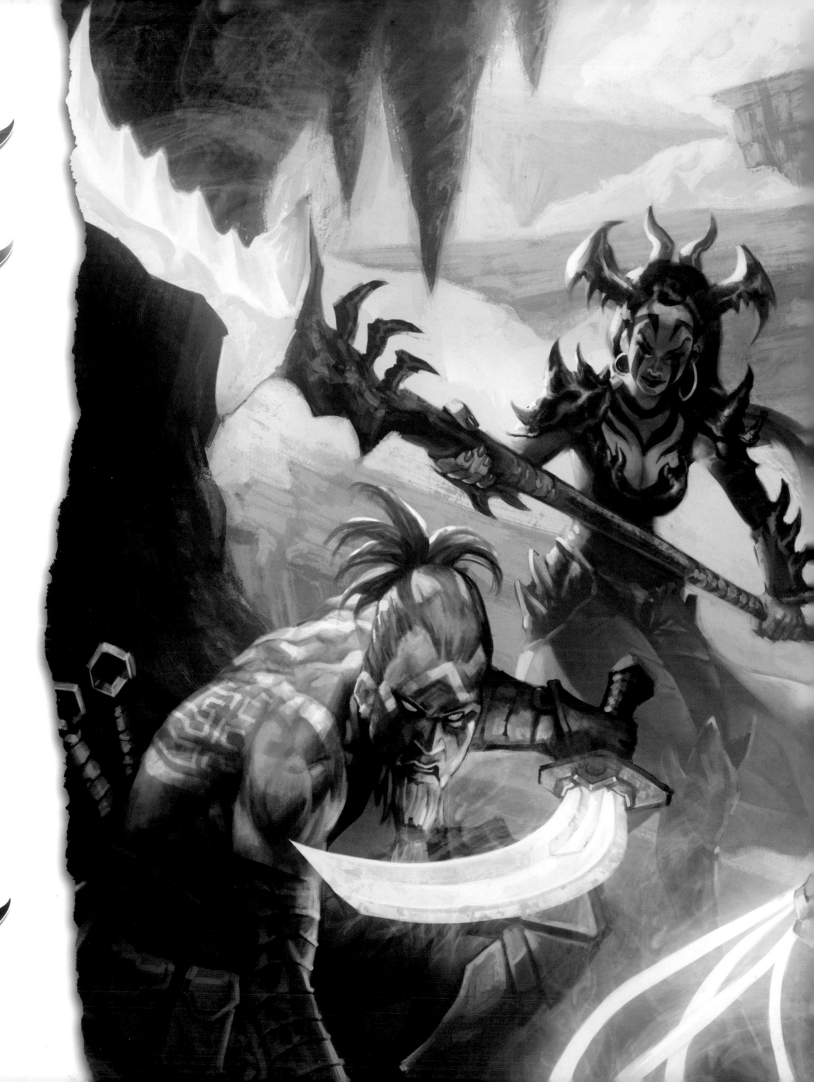

RACES OF ZENDIKAR

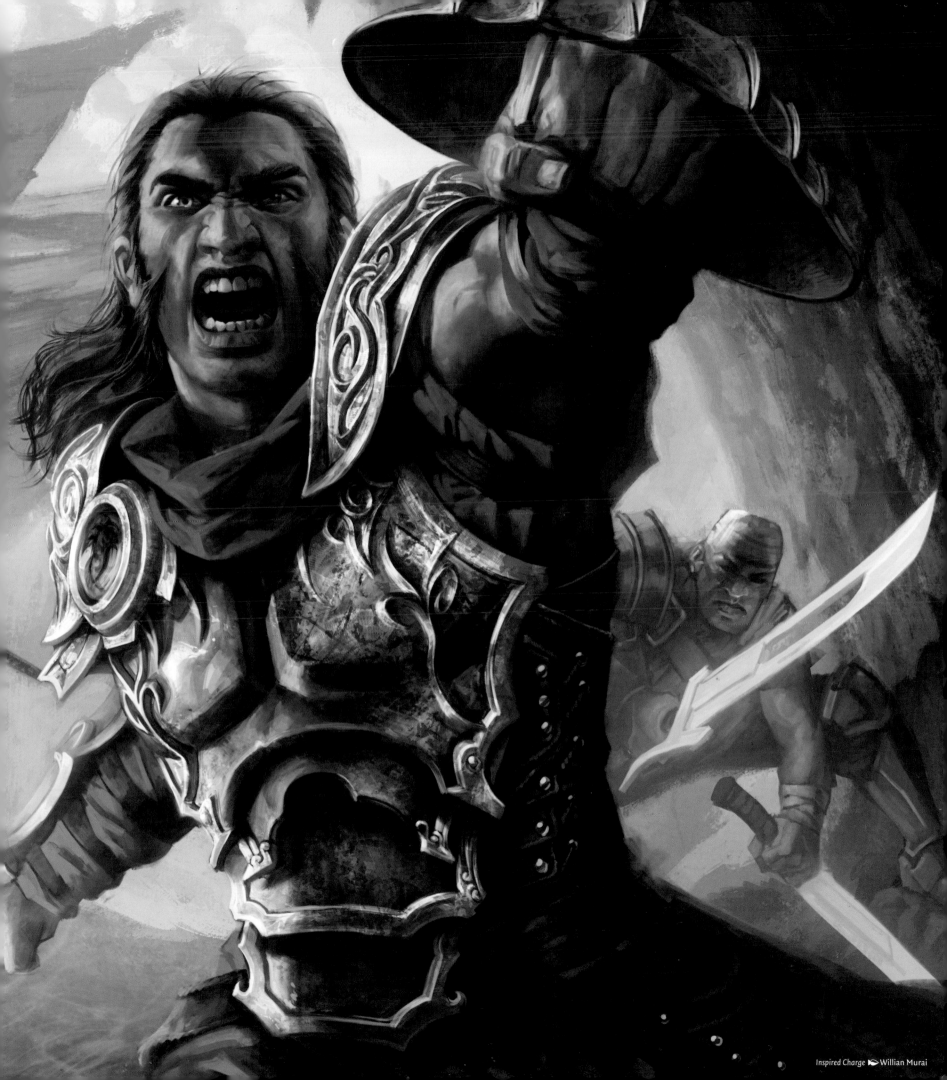

Inspired Charge ⟡ Willian Murai

HUMANS

Humans are the most numerous, diverse, and adaptable race of Zendikar, and they form the core of most exploratory and adventurous expeditions across the plane. Though many humans huddle behind stone walls and wooden ramparts, at least somewhat protected from the perils of Zendikar, a significant number of them venture out from the safety of these walls to explore and defend their world. As the Eldrazi spread, more and more humans are driven out of their refuges and forced to confront the harsh reality of the Eldrazi presence.

Life on the Frontiers

Most human communities on Zendikar are tiny villages, remote outposts, or temporary encampments. These settlements are found on every continent, from the tiny coastal villages of Guul Draz to the giant caravan of Goma Fada on Akoum. Without the safety of walls and ramparts, life here is all about the struggle for survival, leaving no time or energy for scholarly pursuits. The people of these communities rely on hunting, gathering, herding, and trading for the food and other goods they need. Some, though, survive by preying on the people of other communities and caravans.

The Kargan tribes of Akoum are fierce nomads who revere dragons. Each tribe is ruled by a Dragonlord who claims a dragon as a companion and mount. Few challengers would dare dispute a Dragonlord's authority in the face of a dragon's wrath, and taming a dragon is virtually impossible without the support of the whole tribe, so challenges to these leaders' authority are extremely rare. Some Kargan shamans can summon and control dragons, though others focus on the powerful elemental forces of earth and fire. The warriors of the Kargan tribes enter a berserk frenzy they call the dragonrage, which is usually induced by the chanting of a battlesinger.

Kazandu Blademaster ▸ Michael Komarck

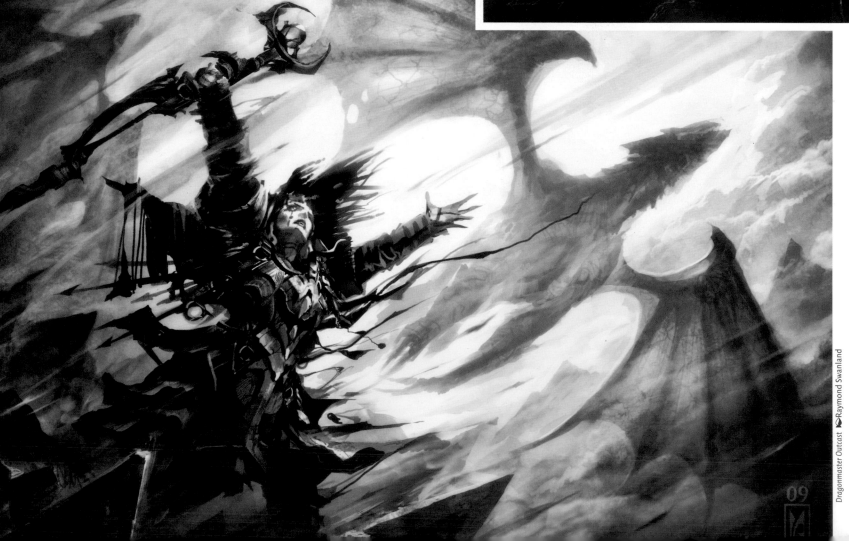

Dragonmaster Outcast ▸ Raymond Swanland

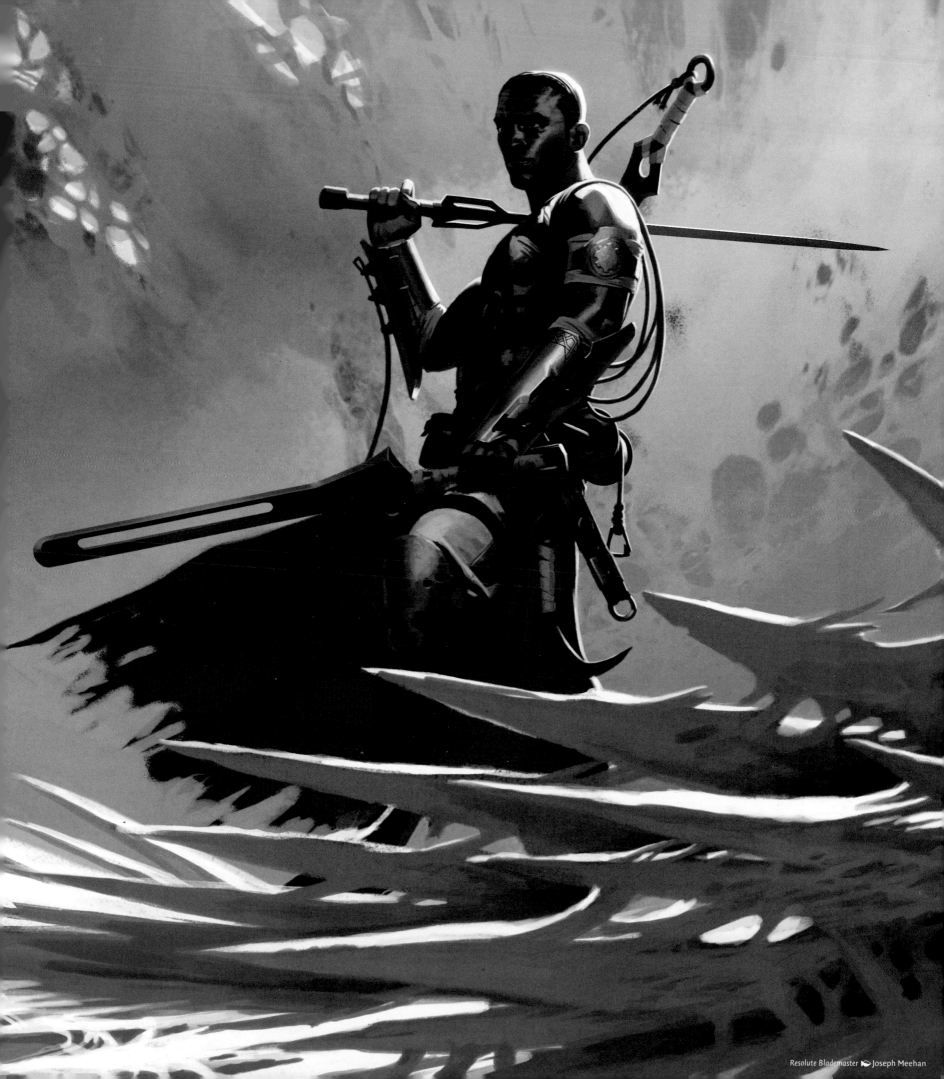

Resolute Blademaster ⚬ Joseph Meehan

Civilized Humanity

Despite the harshness of life on Zendikar, human civilization flour-ishes in a few scattered towns. Sea Gate (on the continent of Tazeem), Affa Town (on Akoum), and the so-called Free City of Nimana (in Guul Draz) are the most notable of these, boasting organized mili-tary forces, institutions of learning, established traditions of magic, houses of worship, and dark underbellies of crime and corruption. With populations measured in the thousands, they would barely qualify as towns on other planes, but they have no rivals on Zendikar except the vampire city of Malakir—which has been in ruins since the emergence of the Eldrazi.

Most organized efforts of exploration originate from these centers of civilization, particularly Sea Gate. Academic institutions sponsor explorers to draw accurate maps (which must be updated frequently, thanks to the Roil), collect ancient artifacts for study, and obtain general knowledge of the world beyond the city walls. Wealthy mer-chants also invest in expeditions, hoping to multiply their wealth and power with the discovery of valuable natural resources, the estab-lishment of new trade routes, and the acquisition of items that can be sold to academic institutions. Successful explorers often use the proceeds of their first expeditions to fund later ones, cherishing the freedom that comes from serving no master but the call of discovery.

Though humans often form the backbones of these expeditions, they typically incorporate adventurers of other races as well, drawing on the broad expertise of Zendikar's diverse peoples. Trail guides, porters, mountaineering experts, diviners, hunters, trappers, cartog-raphers, mages, missionaries, scholars, mercenaries, smiths, healers, and beasts of burden can turn an expedition into a large caravan that's practically a self-contained community.

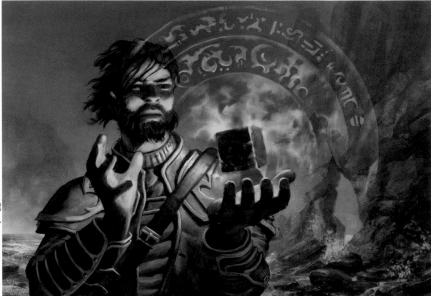

Sea Gate Oracle ♠ Daniel Ljunggren

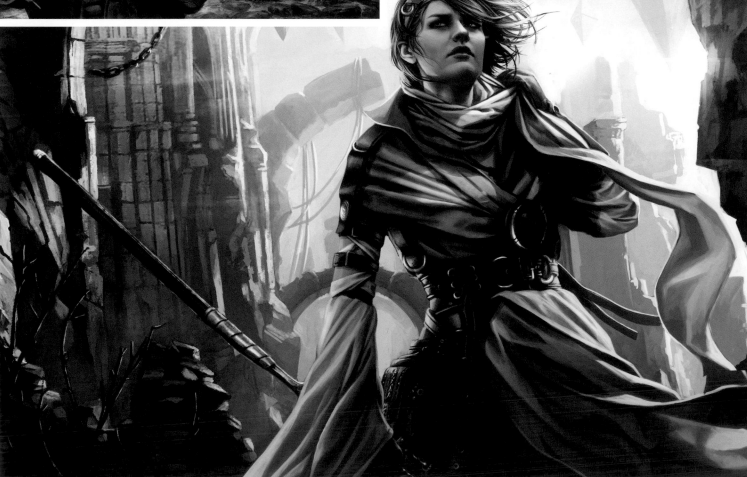

Serene Steward ♠ Magali Villeneuve

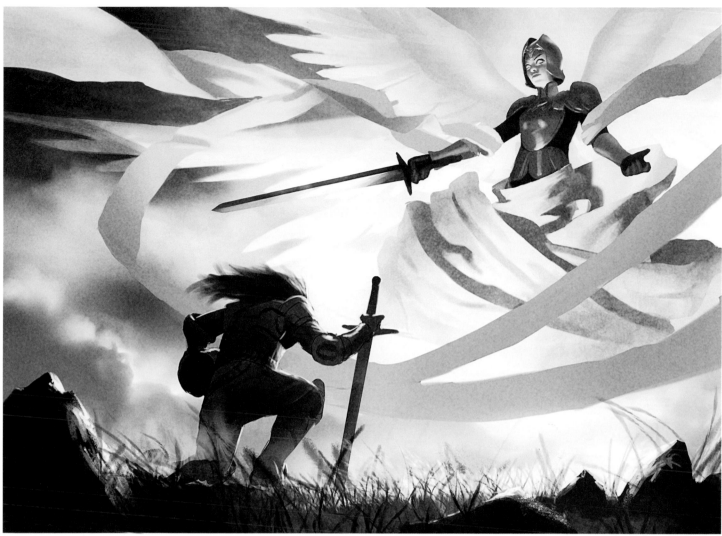

Iona's Judgment ✒ Mike Bierek

The Expeditionary Houses. In Sea Gate, five so-called expeditionary houses launch regular excursions into the wilds for various purposes. Named for the destinations of their first expeditions, they are the Valakut House, the Pelakka Foundation, and the Akoum, Murasa, and Bala Ged Expeditionary Houses. The rivalries among the houses are legendary, and they sometimes sabotage each other's expeditions. Each maintains hostels in various settlements, which serve as resources for adventurers and explorers who need to hire guides or purchase supplies.

> "Beneath the gaze of angels, only the righteous may stand without fear." —Ekar of Kabira

Human Religion

Zendikar's humans place their faith in the angels. They call out to the angels for protection, for justice, for peace and reassurance, and for healing, and human clerics dispense the angels' blessings among the faithful. Some devotees of the angels aspire to a state of transcendence attained through prayer, meditation, and acts of compassion. Those few who achieve this hallowed state are called luminarchs or transcendent masters, and they glow with their own light, becoming akin to the angels they revere.

The First among Angels, according to human belief, is Emeria—a name borrowed from the merfolk sky-goddess. The Sky Ruin above Tazeem, often called simply Emeria (or Emeria's Realm), is watched by angels, and Emeria herself is often depicted as a winged merfolk or angelic figure. The irony is that the merfolk goddess is based on a half-forgotten memory of the Eldrazi titan Emrakul rather than the angels who fought against the Eldrazi during their first emergence.

Unlike Emeria, who is said to be hidden far above the Sky Ruin, the archangels are concrete, physical objects of devotion for the human faithful. Iona, called Shield of Emeria, and Linvala, Keeper of Silence, are the two most revered of these lesser divinities. Both have been active in combating the Eldrazi since the titans awoke, with Iona abandoning her traditional post watching the passage to Emeria's true domain. The arrival of an angel is a blessing to beleaguered soldiers, but that breath of hope comes all too rarely in the ongoing battles.

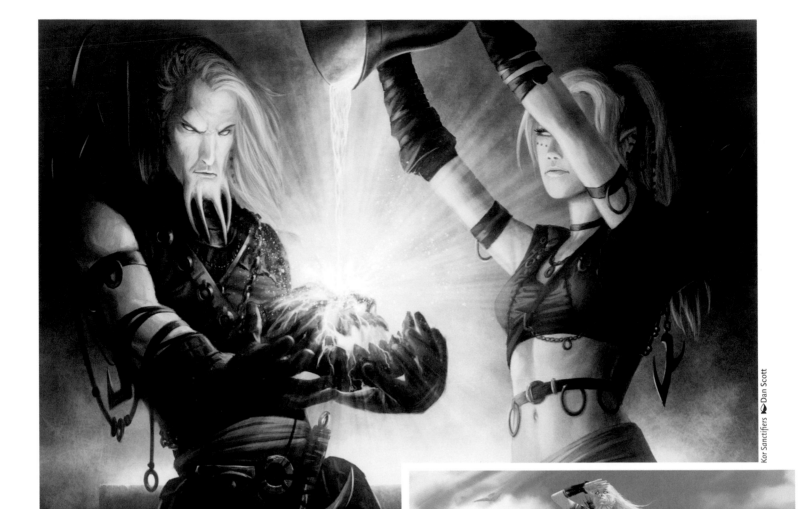

Kor Sanctifiers ◆ Dan Scott

Kitesail Apprentice ◆ Austin Hsu

◆ KOR

Deeply reverent of the land and its sacred sites, the nomadic kor live a spare existence defined by their constant travels. Masters of ropes and hooks, they scale sheer cliffs and cross yawning chasms with such skill and agility that they sometimes seem almost to take flight.

Kor are associated with white mana: their wizards and clerics employ spells of healing, of banishing the dark, and of protection. Their personalities and ideals also mesh with the characteristics of white mana in their emphasis on an ordered, harmonious community with strong traditions binding its members together.

Slender and Silent

Kor are tall, slender humanoids with light hair and gray, bluish-gray, or white skin. All kor have slightly pointed ears, and males have short, fleshy barbels on their chins. They paint softly glowing geometric patterns on their faces and bodies that suggest the shapes and design of the hedrons that appear across Zendikar. Their clothing tends to leave the arms and shoulders free to facilitate climbing, and they keep most of their gear in pouches and slings at their waists.

The kor have a nonverbal language of hand signs and gestures which allows communication despite significant distance (particularly when augmented with whirling ropes) or howling winds. They also use this sign language among themselves when they wish to avoid being overheard, giving rise to misguided rumors that they are incapable of speech. However, they do have their own languages—particularly important while all four limbs are occupied with climbing ropes—and readily learn others. When they speak, they tend to use as few words as possible to convey their meaning.

"We were not meant to put down roots. The heart is a moving organ." —Kor saying

Tied to the Land

Another common misconception about the kor is that, as perpetual nomads, they have no ties to specific locations. In fact, they revere dozens of sacred sites across Zendikar, and they spend their lives in constant pilgrimage along routes that can take decades to complete. Most of their sacred sites are natural features such as lakes, springs, waterfalls, promontories, pillars, caves, trees, or floating chunks of earth. A few are ancient ruins that the kor believe are connected either to their racial history or to the activity of their gods. In theory, the pilgrimage routes should be drastically altered by the movements of the Roil, but the sites display a remarkable stability that can leave them the only constant in an ever-shifting landscape. A few sacred sites are gone, but most have remained unchanged for centuries.

The kor travel in small bands of about a dozen on their ceaseless pilgrimages. When a band arrives at a sacred site, its members perform what they call the landbind ritual, taking up some of the soil or gravel from the site and rubbing it on their skin. They believe that this ritual reestablishes their spiritual connection with the site and connects them in turn with all the other kor who have visited that location in the past. Thus they strengthen and affirm their links to the past and to their racial community beyond their own bands. The oldest kor, who have survived long enough to visit the same site multiple times, believe that they are also reestablishing their ties to their past selves. These ties to the past can take concrete form in the manifestation of spirits, returned from death to aid their living kin or protect the sacred sites.

A Network of Lines

The kor are masters of ropes and hooks, which they use to travel and to hunt. They rarely use unreliable devices such as crossbows to propel their grappling hooks onto cliff faces or into flying game. They rely instead on simple, sturdy rope and the skill of the arm. Ropes and hooks are also incorporated into their spirituality. A hooked line is a social and sacred symbol for the kor that represents their connection to each other and to the world around them.

In addition to their ropes, some kor use small gliders called kite-sails for scouting or hunting. They are particularly effective in the trenches and canyons of Ondu, where fierce winds can keep them aloft for miles.

Kor Entanglers ▶ Jason Rainville

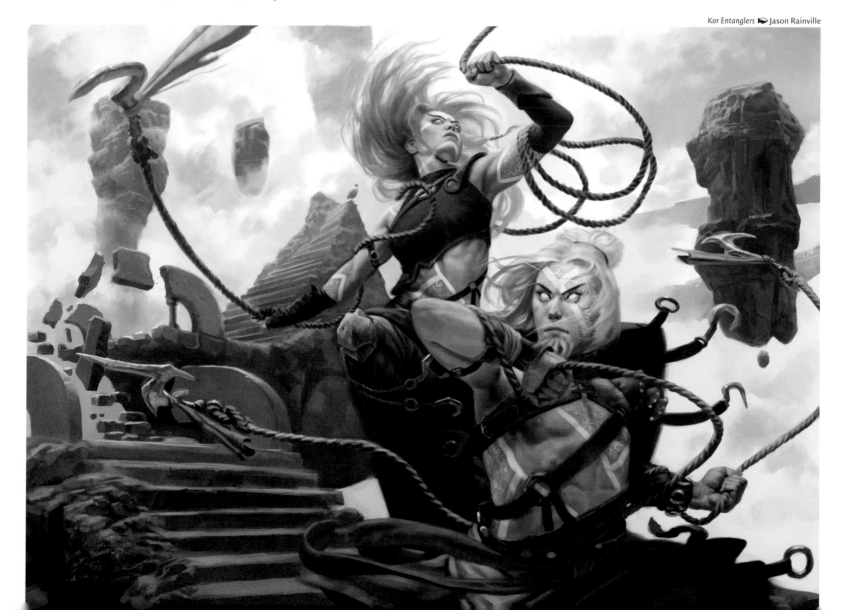

Body, Breath, and Blood

The kor traditionally worship a pantheon of deities who represent distinct aspects of nature. Talib, the Body of the World, is the harsh and unyielding god of the earth, who crushes the unworthy in rockslides and pits but also provides herbs and fungi to forage along the pilgrimage routes. Kamsa, the Breath of the World, is the benevolent goddess of wind, who fills the kitesails of the kor and provides them with game for the hunt, such as flying eels. Mangeni, the Blood of the World, is the unpredictable god of the sea, who fills the canyons and streams with rushing water and punishes the stagnation of kor—those who erect buildings in defiance of the traditional ways.

World-Gifts. As part of its religious observance, a kor family offers a child to the gods in hopes of appeasing the world's natural forces. This "world-gift" is typically the second-born child, who is left at one of the sacred sites as the kor move along their pilgrimage. Most of these children die quickly, but a surprising number are found and taken in by explorers. These kor adopt the language and culture of their new families, but as they grow they are often driven by wanderlust to venture back out into the wilds. They are never welcomed back among the kor, but many find gainful work on adventurous expeditions.

Shattered Faith. The emergence of the Eldrazi titans brought an end to the faith of most kor, but one remnant band still clings to the worship of these gods, which they now call by their Eldrazi names. These kor call themselves the Eternal Pilgrims and continue to walk the old pilgrimage routes. They attempt to appease their Eldrazi deities by raiding other survivor groups, capturing people, and binding their captives as sacrificial offerings in a distorted version of the world-gift practice.

Tactical Advantage

Through personal experience and received tradition, the nomadic kor are intimately familiar with the terrain and perils of Zendikar's lands, and they turn this familiarity into a solid advantage when battling the reawakened Eldrazi. They prefer to move in three dimensions whenever possible, using cliff faces and overhangs, which puts them on equal footing with flying Eldrazi and gives them a clear edge over those who are confined to the ground.

When facing hordes of lesser Eldrazi, they engage their foes at choke points or force them into treacherous terrain. If they can't use the

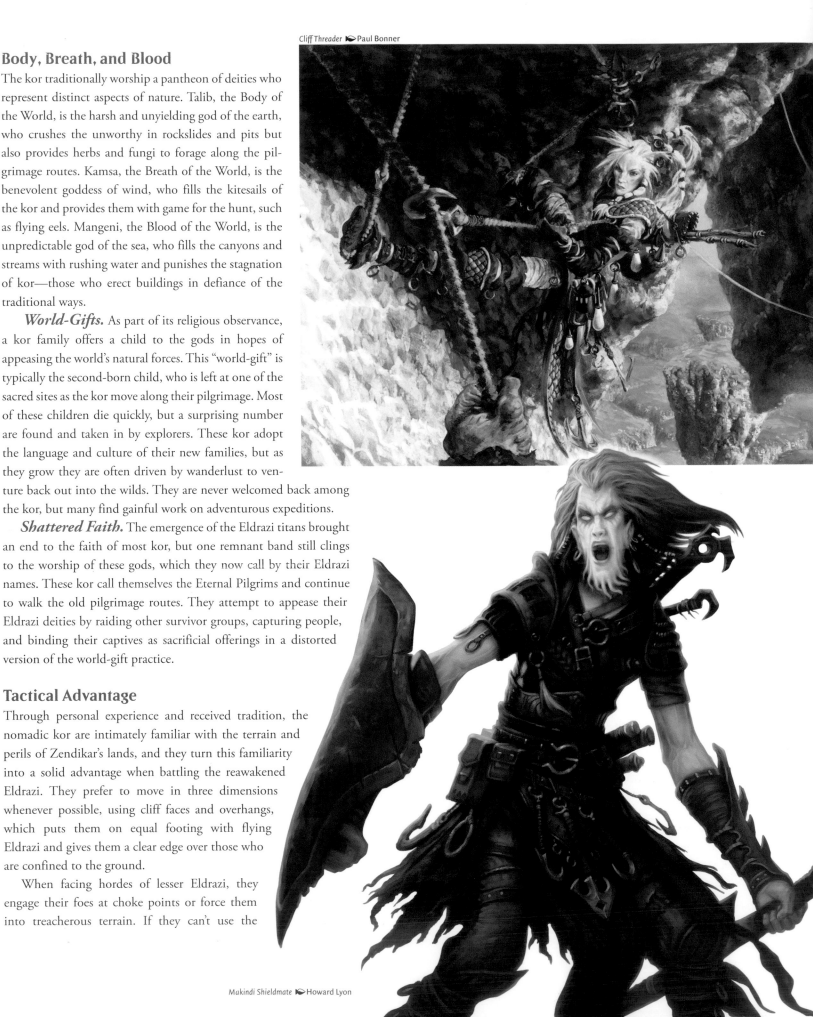

Cliff Threader ▸ Paul Bonner

Makindi Shieldmate ▸ Howard Lyon

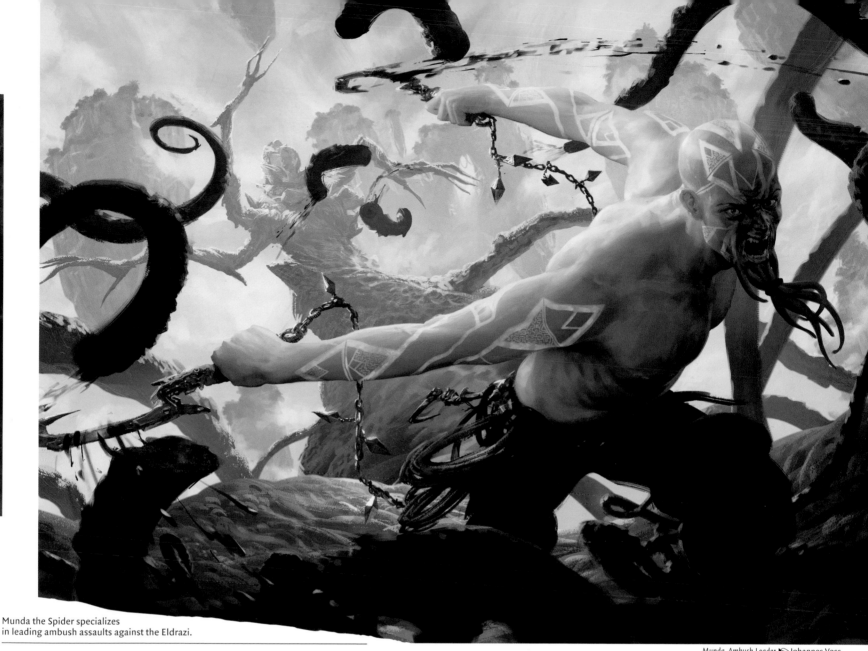

Munda the Spider specializes
in leading ambush assaults against the Eldrazi.

Munda, Ambush Leader ❧ Johannes Voss

natural landscape to their advantage, they create complex webs of ropes and lines that slow down or ensnare the enemy. When a larger Eldrazi is spotted, separate kor bands join forces and swarm it, using their climbing hooks to tear at the monstrosity and their ropes to restrain its movement.

The kor tradition of traveling in small bands has been both a benefit and a drawback in surviving the Eldrazi threat. Staying on the move helps them avoid the brunt of an Eldrazi incursion, and their small groups can scavenge supplies efficiently and travel without drawing attention. However, once discovered, a mere handful of kor can be quickly overwhelmed by larger swarms of foes.

Munda the Spider is a prominent leader among the kor. Spinning rope webs so complex that even other kor find them nearly impossible to navigate, Munda traverses his ropes as nimbly as his

epithet suggests. He wields a matched pair of hooks that he calls his "fangs" and weaves his lines in such a way as to keep his Eldrazi foes constantly off-balance.

Rediscovered Roots

The kor believe that their race had a very different way of life in the distant past, in which they built permanent towns with great citadels, palaces, and temples. As the Eldrazi move across the plane, the devastation they wreak has the unintended side effect of uncovering numerous ancient ruins long ago swallowed by the Roil, and some of these might in fact be evidence of this ancient kor civilization, particularly in Akoum. Some kor insist that their ancestors left the keys to destroying the Eldrazi hidden in these ruins, leading to a certain sense of responsibility for dealing with the Eldrazi. Surviving world-gifts, in particular, often act as guides for members of other races who venture into the newly exposed ruins in hopes of discovering knowledge that can be used to bind the Eldrazi once more.

MERFOLK

Curious, thoughtful, and analytical, the merfolk of Zendikar are natural scholars and explorers. In the past, merfolk society was organized around their belief in three deities. But in the wake of the Eldrazi, the merfolk have realized that their religion was a web of lies, built on a corrupted memory of the Eldrazi titans themselves and handed down from generation to generation. Now their society faces an identity crisis. In peaceful times, the merfolk would have

fought about the meaning of this revelation, but with the danger of the Eldrazi broods, the survivors have largely set aside their old creeds and joined together in a united force. Old grudges still linger, but the well-being of the race and world far outweigh the ancient conflicts between the creeds.

Merfolk are associated with blue mana, though the two traditional merfolk creeds express this connection in different ways.

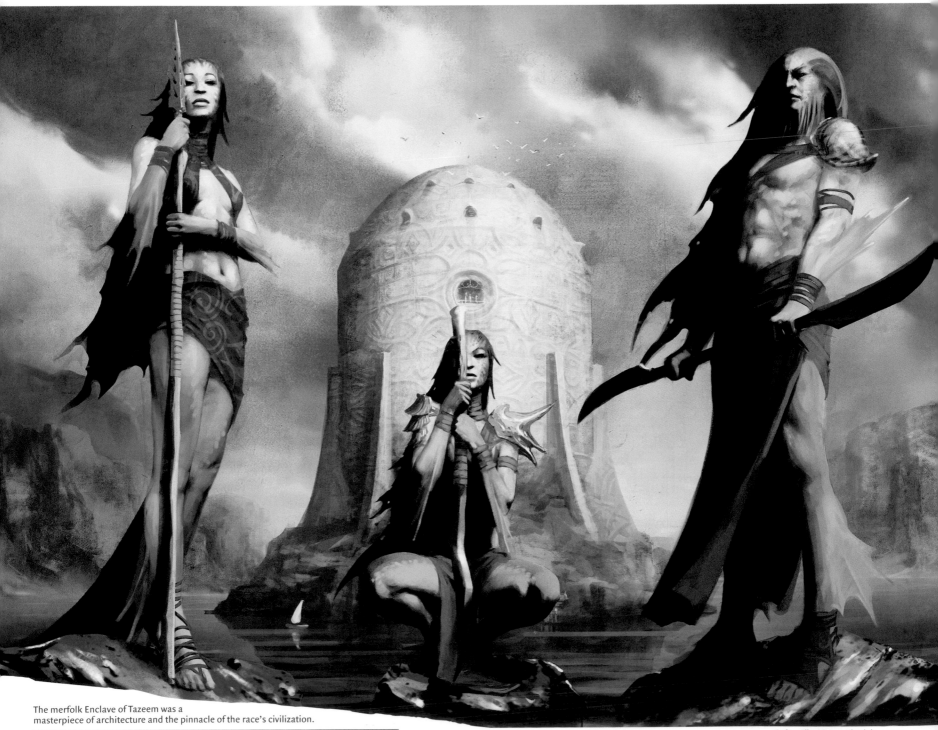

The merfolk Enclave of Tazeem was a masterpiece of architecture and the pinnacle of the race's civilization.

Enclave Elite ▶ Igor Kieryluk

Born of the Sea

Merfolk are an amphibious race, born and at home in the water but comfortable on dry land. Humanoid in form, they have skin tones of ivory, silver, russet, blue, or deep purple. Long fins extend from the backs of their forearms and calves, and their fingers and toes are webbed. Hairlike growths on their heads are either thick and bristly, like the needles of a sea urchin, or long and wavy, resembling fine seaweed. In either case, the hair typically ranges from red to warm brown to black. Male merfolk have fins extending down from their cheekbones.

Merfolk wear little clothing unless armored for battle. They drape themselves with nets and a minimum of cloth and use large, bleached seashells for armor, held together and augmented with leather.

Three Realms and Two Creeds

Merfolk beliefs divided the world into three realms of sky, sea, and land, each presided over by one deity. Before the rise of the Eldrazi, each individual merfolk would choose to follow the creed of one god or another, shaping his or her life around the teachings and ideals of that deity. With the emergence of the three Eldrazi titans, the horrible truth—that Emeria, Ula, and Cosi were nothing more than distorted memories of Emrakul, Ulamog, and Kozilek—has shattered these beliefs.

The goddess Emeria was thought to rule the Wind Realm, including the sky, the wind, and the clouds. She was seen as a goddess of magic and mysticism and was represented as an angel with dark hair and silver eyes. Those merfolk who followed her creed sought wisdom and truth in the Wind Realm, exploring mystical forces—rather than natural causes—behind historical events. They were evasive and intentionally enigmatic in their interactions with others and were often described as manipulative and deceptive. Part of the philosophy associated with blue mana is that a person's or thing's essence is as malleable as its surface appearance, so from that perspective this behavior was not deceptive as such, but

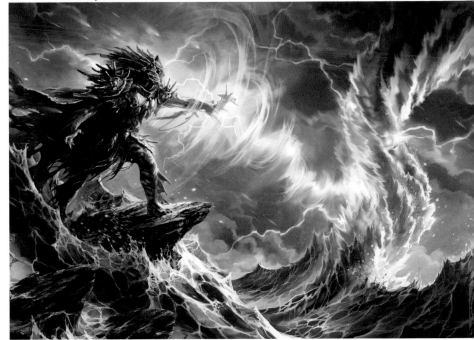

Scatter to the Winds ▶ Raymond Swanland

reflected the shifting and subjective nature of reality. Wizards of the Emeria creed focused their use of blue mana on spells of control, particularly magic of calming the land, its creatures, other people, or even magic itself. Practitioners of this magic, called lullmages, were highly sought after by explorers but rarely trusted because of their tendency toward manipulative scheming.

> "Some merfolk choose to rest their fins in the water. I believe wisdom exists not only where we were born but where we were told not to go." —Henn Aran, *galecaller*

The god Ula was said to rule the Water Realm, including the seas, rivers, and lakes. He was a god of practical knowledge and exploration and was depicted as a merfolk with the tail of a fish in place of legs. Ula-creed merfolk emphasized the intellectual aspects of blue-aligned philosophy, stressing hard evidence and reason over passion. They were analytical scholars, chroniclers, explorers, and navigators who prided themselves on being blunt and straightforward. Ula-creed "stonereaders" sought out and studied Eldrazi ruins in an effort to reconstruct a historical record.

The trickster-god Cosi ruled everything else—the dangerous and inhospitable land where chaos and misfortune reigned supreme. No merfolk would openly admit to following his creed, but the most ambitious and manipulative among them viewed Cosi as an ally who could grant them control over the chaotic forces of the world. Since the Eldrazi's rise, however, some of these merfolk have come forward and turned their skills as spies and infiltrators to the cause of their people.

A Refugee People

The Eldrazi have overrun the most prominent centers of merfolk habitation and learning, including the city of Sea Gate. The lighthouse at Sea Gate served as both library and home for merfolk scholars and explorers (particularly those of the Ula creed), and its destruction represents a terrible loss of both people and knowledge. As a result, merfolk across Zendikar have left their traditional homes and found shelter wherever possible.

The lullmage Noyan Dar, formerly an iconoclastic scholar at the Sea Gate lighthouse, has taken on the mantle of leadership for the merfolk refugees of Tazeem. He brought them inland to found Coralhelm Refuge, which has become a capital and shelter for merfolk from across the plane.

The Power of Observation

Even before the rise of the Eldrazi, Noyan Dar's studies led him to the conclusion that the merfolk deities were not actually gods but destroyers, but his research was dismissed by the Ula-creed merfolk, who rejected his intuitive leaps. He now guides the explorers and scholars among the merfolk in forming alliances with their counterparts among other races—coordinating their efforts to understand the ancient ruins, the power of the hedrons, and the anatomy of the Eldrazi in search of an upper hand against the monstrous invaders. Coralhelm is thus also a central repository for the results of these studies.

The brave merfolk who track Eldrazi and bring the information back to Coralhelm have a short life expectancy. The task

Coralhelm Commander ▶ Jaime Jones

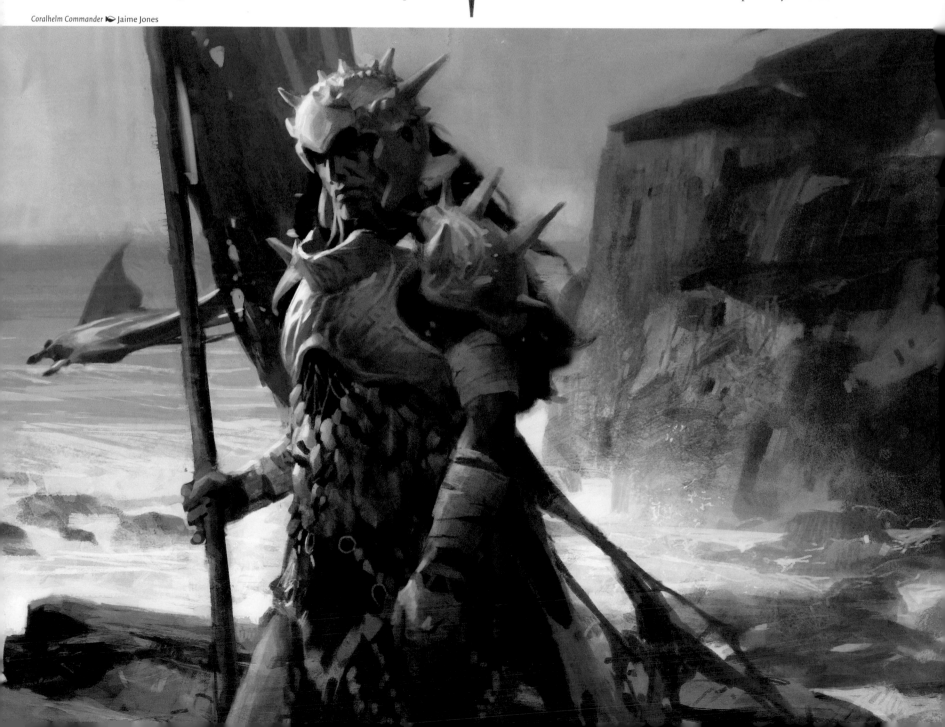

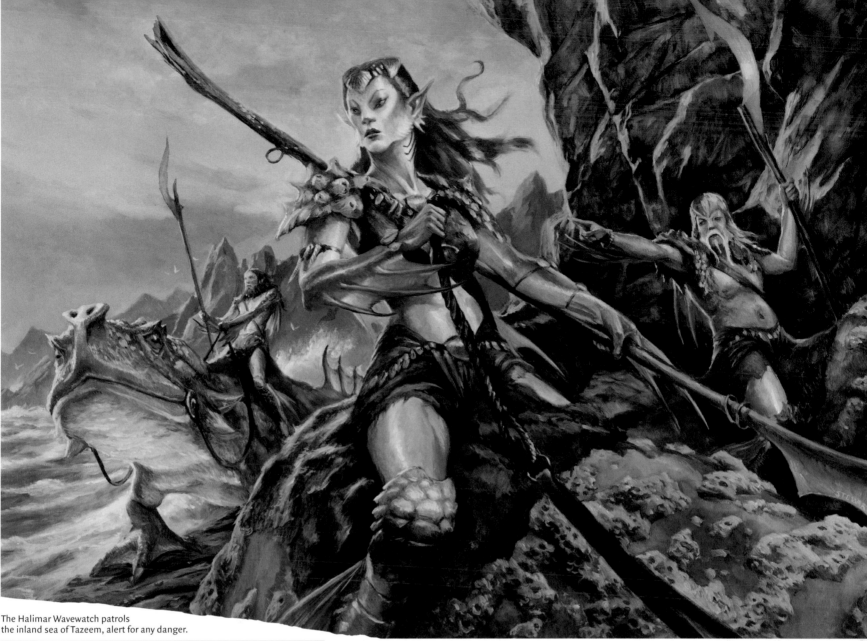

The Halimar Wavewatch patrols
the inland sea of Tazeem, alert for any danger.

Halimar Wavewatch ▷ Matt Stewart

necessarily involves getting closer to the Eldrazi than can reasonably be called safe. But these merfolk are united in the belief that they will find answers through observation and study. The merfolk who volunteer for this task are both intelligent and resilient, and they are increasingly joined by members of other races.

Elite merfolk soldiers called seastalkers are allocated from Coralhelm Refuge to protect expeditions that are believed to have a good chance of yielding valuable information. Occasionally, one or more seastalkers are assigned to accompany an expedition even against its leader's will to ensure that any knowledge gained on the expedition is put to proper use.

MERFOLK CHRONICLES

As a race, the merfolk place great value on scholarship and history. They consider writing to be the highest form of artistic expression, and the art of historical writing specifically—creating chronicles—is highly valued in merfolk society. Merfolk of different creeds have taken different approaches to their chronicles, but the heart of the practice was and remains consistent: analyzing current events in the context of history and making careful records that synthesize observations into a coherent narrative.

The sophisticated written language of the merfolk combines alphabetic script with pictographic symbols holding complicated layers of meaning. Merfolk record their chronicles on scrolls made from the tanned hides of gladeheart gazelles, embossing the script with specialized styluses.

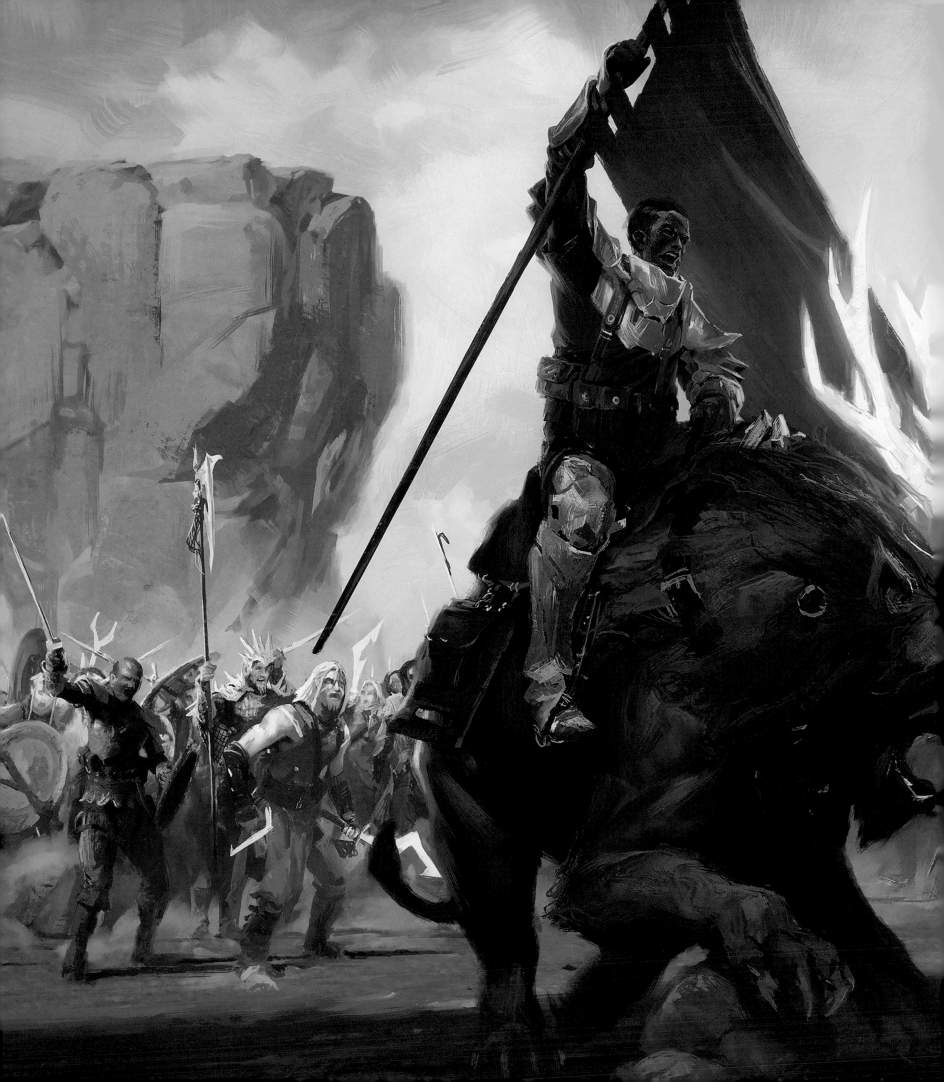

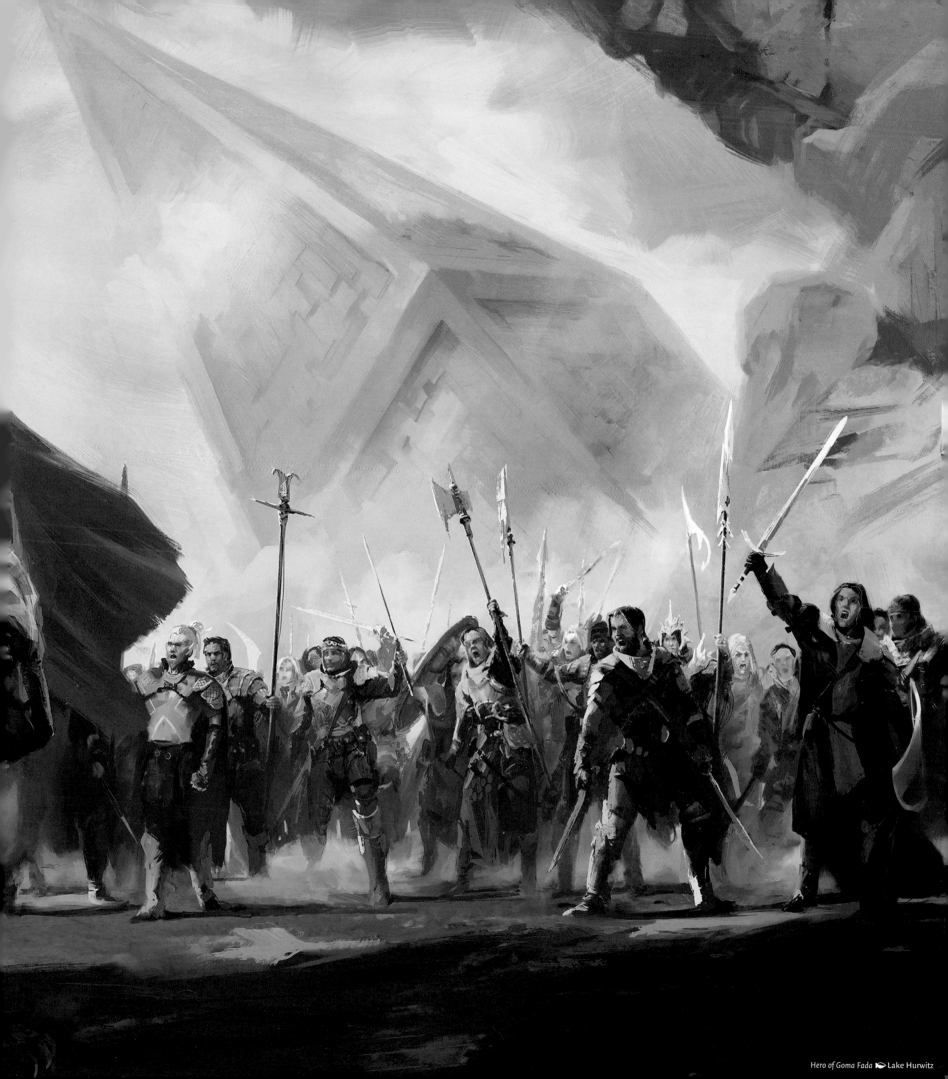

Hero of Goma Fada ☙ Lake Hurwitz

◆ VAMPIRES

Born in ancient servitude and bred to a life of decadent corruption, the vampires of Zendikar feed on the energies in the blood of living creatures—energies that are particularly strong in times of terror and pain. To members of other races, they are a fearsome mystery, the stuff of nightmares, hunting their prey like beasts through the jungle or reclining on thrones made of skulls in their moss-draped cities. But vampires are locked in a brutal civil war. On one side, desperately battling to remain free, are those who hold to their traditional ways. On the other side are those whose legacy reaches back into the deepest recesses of history. Bound once more to their ancient masters and creators, these vampires hunt their kin into the wild swamps in an effort to extinguish the very idea of freedom and rebellion.

Vampires are associated with black mana since their existence is predicated on draining the life from others to fuel their own existence, on putting their own lives ahead of everyone else's. Philosophically, they do not constrain themselves with artificial rules of morality but believe that the strong can and should take what they need from the weak.

Between the Living and the Dead

Vampires are not precisely undead. Their unique nature comes from an eldritch disease that turns their flesh cold, makes their skin—gray to purplish in hue—feel dead to the touch, and enables them to drain and concentrate magical energy from the blood of other living creatures. They are tall and slender, with long, elegant necks and

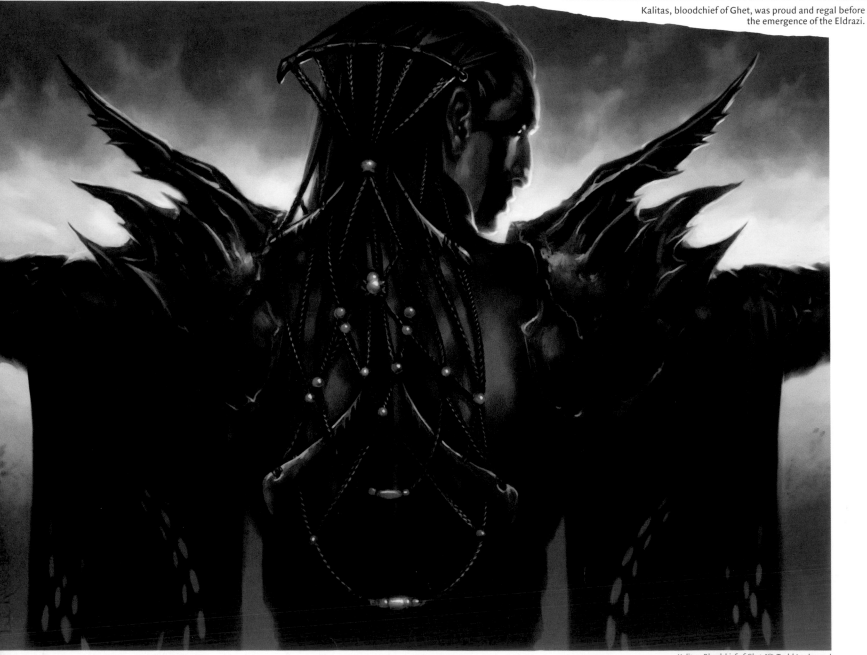

Kalitas, bloodchief of Ghet, was proud and regal before the emergence of the Eldrazi.

Kalitas, Bloodchief of Ghet ❧ Todd Lockwood

broad shoulders. Bony horns protrude from their shoulders and elbows, often augmented by the layered plates of their armor and clothing. Their canine teeth are slightly elongated but not enough to protrude between their closed lips.

Vampires dress in leather and the chitin carapaces of the gigantic insects that dwell in the swamps and jungles of their native Guul Draz, augmented with fine silk and gauzy fabric. They decorate their skin in elaborate, symmetrical patterns of red paint made from blood and mineral pigments. Their clothing is an odd mixture of complex layers and elaborate patterns combined with plenty of exposed skin, since their cold bodies are unaffected by outside temperatures.

A History of Servitude

Vampires were created many centuries ago by a magical infection that originated from the Eldrazi and enslaved them to Ulamog's will. Their unique diet was a means for the Eldrazi to drain the life and magical essence from the other sentient races, concentrating that energy in the vampires' blood for Ulamog to harvest at a later time. After the Eldrazi were sealed back into their prison, the vampires slowly built a dark civilization centered on the continent of Guul Draz. The memory of their ancient masters faded into fragmentary legend and became a distant notion that they are survivors of oppression and slavery.

"The vampires knew what was coming. I know it. And they did nothing. They deserve to feel the same agony they've caused all of us."
—Anitan, Ondu cleric

At its height, vampire civilization was perhaps the most refined and cultured among all the races of Zendikar. Vampire cities were places of decadent splendor, ornamented with grotesque art, macabre ornamentation, and the stately courts of the ruling bloodchiefs. The vampires lived comfortable lives of luxury, attended by legions of faceless undead thralls called nulls.

The bloodchiefs are the central figures of vampire society. The Eldrazi directly infected them, and they in turn created the masses of other vampires, each establishing a family that owes allegiance to its chief. The tastes and passions of an individual bloodchief tend to be imprinted on the vampires he or she creates, so each vampire family shares certain tendencies of behavior and personality. Unfortunately, most bloodchiefs tend toward violent insanity, though a handful are more benevolent than the rest. The bloodchiefs originally numbered in the hundreds, but centuries of brutal rivalry among the vampire families winnowed their number down to barely a dozen.

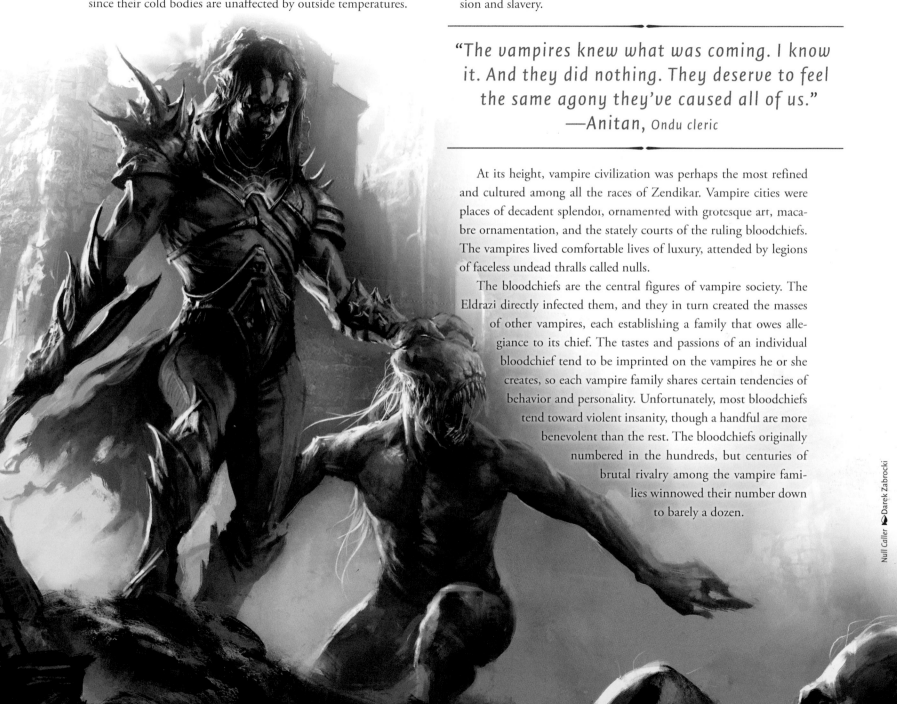

Null Caller ❦ Darek Zabrocki

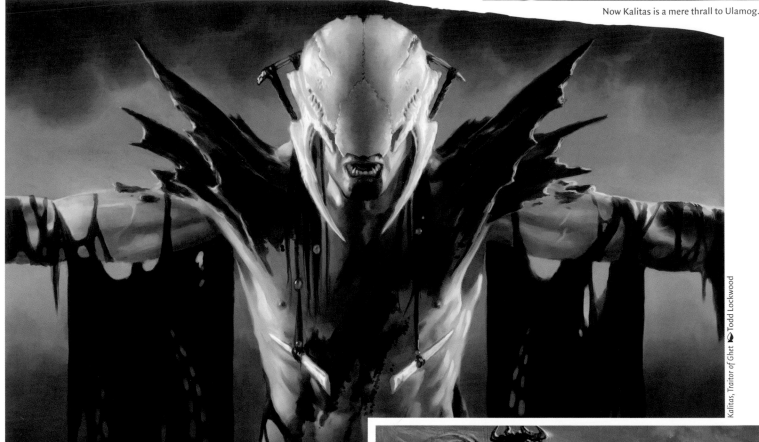

Now Kalitas is a mere thrall to Ulamog.

Kalitas, Traitor of Ghet ❧ Todd Lockwood

Drana's Emissary ❧ Karl Kopinski

Thralls and the Free

With the reemergence of the Eldrazi titans, however, all of vampire society has been thrown into chaos. The titan Ulamog's attention seemed centered on the vampires at first. A beacon of psychic and destructive energy summoned the vampires into the titan's awful presence at the heart of Bala Ged. Tens of thousands of vampires, including most of the bloodchiefs, found themselves magically bound to answer that call as Ulamog began the long-overdue harvest.

Driven by their distant memories of oppressive servitude, however, many vampires resisted the will of their alien creator. This led to a brutal and costly civil war, with the families who fell under the Eldrazi's thrall joining forces with the teeming mass of Ulamog's brood to annihilate most of those who resisted the titan's control. The Culling, as the surviving vampires came to call it, left only two bloodchiefs alive, and in the midst of the slaughter, much of the continent was leveled—swamps, forests, hills, and cities across Bala Ged were reduced to fine, powdery white sand.

Kalitas and the house of Ghet are now entirely in the service of the Eldrazi. These vampires have completely abandoned all aspects of their once-refined civilization. Their former elegance gone, they are now savage and wild. They wear featureless bony plates over their eyes that suggest the faceless skull of Ulamog, and the elegant patterns of their body paint have been replaced by random spatters from the brutality of the hunt.

Though he is no less savage than the vampires he leads, Kalitas seems to retain his considerable intellect. He is siring new vampires at a frantic pace never before seen in an attempt to make up for the losses suffered in the Culling. The vampires in his service are dedicated to hunting down and exterminating the few vampires that continue to resist the Eldrazi.

Drana and the house of Kalastria are the focal point of this resistance. Drana has gathered free vampires from every family to fight against the Eldrazi, though their main priority is staying alive. With most of the major settlements destroyed and swallowed back into the swamps of Guul Draz, the vampires live in settlements dragged on giant sledges by vampire nulls. Small and mobile, these sledge-camps

arc dangerous and predatory, often attacking the settlements of other races for food and new null servants. A typical sledge-camp consists of thirty or so vampires and as many nulls to serve them.

Drana herself is focused on acquiring the knowledge she needs to defeat the Eldrazi—by dredging it from her own memory. Ulamog's corruption created her in a long-forgotten time, and her inability to remember that time is maddening to her. She is exploring magical means to augment her own memory, with some success. Her unearthed memories have revealed secrets that have aided the vampires' efforts to fight the Eldrazi spawn. She is expanding her experiments to plumb the ancestral memories that linger in the blood of vampires sired by the bloodchiefs and has successfully dredged up memories of ancient ruin sites that might hold artifacts and weapons useful against the Eldrazi.

Forming Alliances

Working with other races is difficult for the vampires, much as a tiger working on a team with humans would be. There's no escaping the fact that no matter how closely their goals align, one member of the team sees another member as a potential meal. A vampire's blood hunger can be controlled but never truly suppressed. Still, some vampires have tried to integrate into the settlements and war bands of other races, with mixed results. Some settlements of kor and humans see the benefit in having a vampire working with them and are willing to give up some of their own blood in exchange for the assistance of a creature with superhuman strength, agility, and intelligence. When these arrangements fail, though, the outcome is predictably tragic for all involved.

Drana, Liberator of Malakir ▶ Mike Bierek

Drana, bloodchief of Kalastria, leads the free vampires into battle against the Eldrazi.

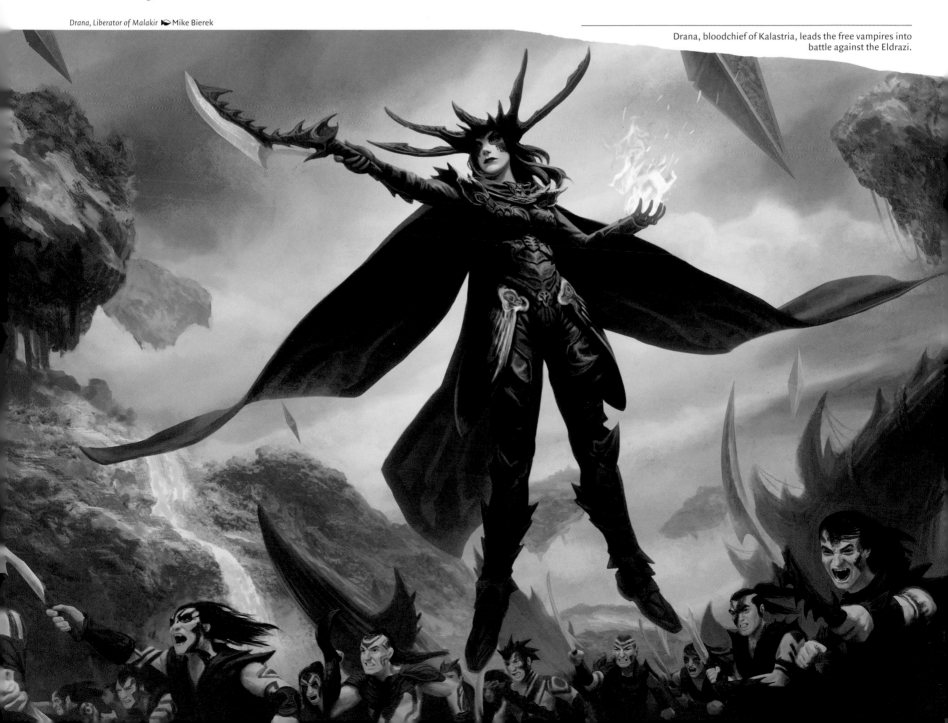

GOBLINS

Goblins are an inquisitive and adaptable race hampered by their small size, their natural cowardice, and a severe shortage of common sense. They eagerly explore areas that others hesitate to enter and obsessively fiddle with artifacts that more sensible folk would take careful precautions with. They prize ancient artifacts—not for their inherent value, but primarily as a mark of status, for a precious trophy proves that its owner survived a delve into a deep and dangerous ruin.

Goblins are associated with red mana. Their shamans are fond of spells that create or control fire and lightning to smite their foes, and they are quick to follow their impulses and passions into action without much forethought. Life to a goblin is an adventure full of new things to explore and experience.

Long Arms and Stony Skin

A typical goblin stands between three and a half and five feet tall, with a slender, elongated build. Goblins' arms are unusually long and spindly, making them adept at climbing cliffs and trees, and their skin has a stony texture, ranging from brownish red to moss green or gray. Their ears are large and swept back, their eyes are intensely red, and many sport heavy bone protrusions on their spines or elbows. Males have similar growths jutting from their chins, while females have heavier growths on their foreheads.

This distinctive appearance is a direct result of the goblins' unusual diet. Before the Eldrazi's rise, goblins supplemented their normal diet with a kind of rock they pounded into bits and called

Goblin Shortcutter ◆ Jesper Ejsing

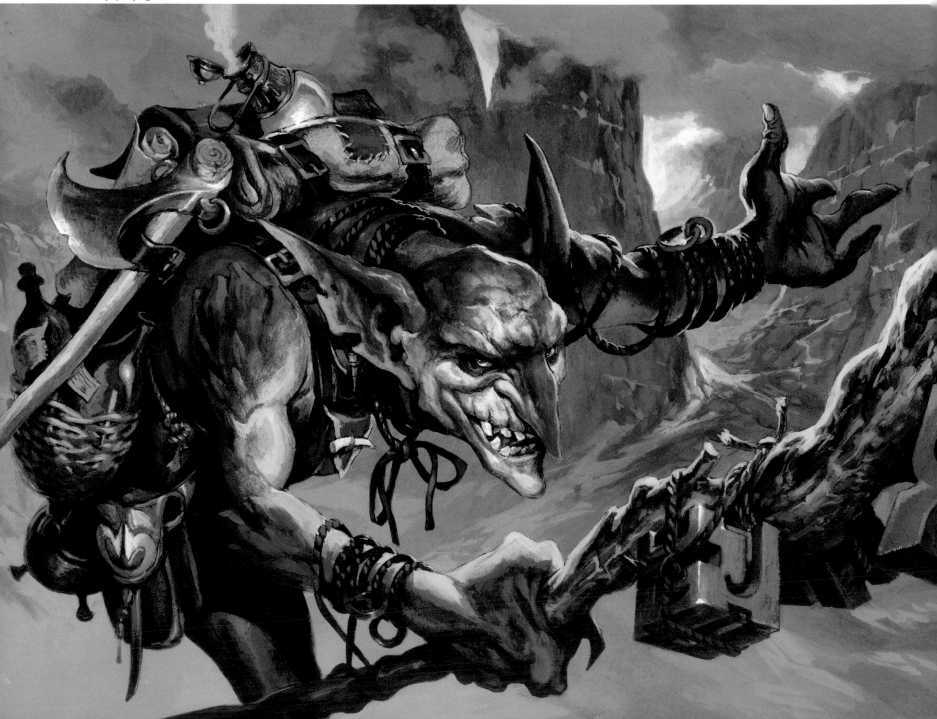

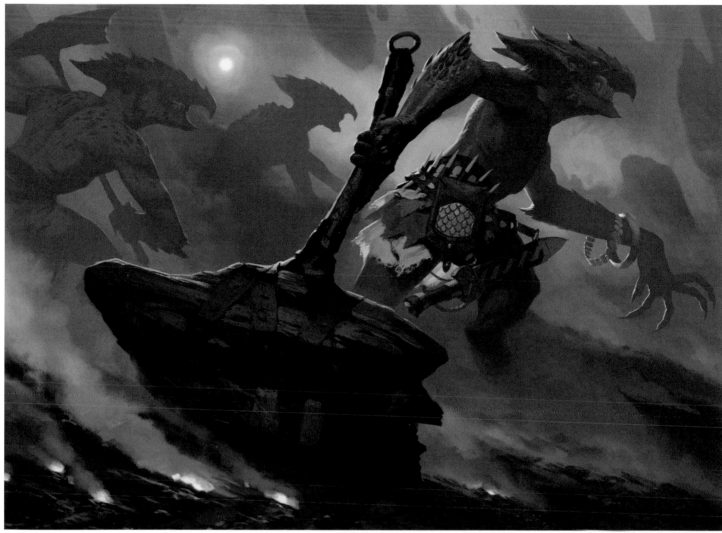

Slab Hammer ▷ Joseph Meehan

"grit." The Eldrazi presence has poisoned this rock, so the goblins have taken to eating powdered hedrons instead. Eating this magic-infused stone has given the goblins resistance to the maddening psychic emanations of the Eldrazi and some degree of invisibility to the Eldrazi's alien senses. As an added benefit, it toughens their skin, protecting them from the elements and from physical dangers.

"Goblin guides are cheap, but be careful. It's a lot easier to steal from a corpse than a customer." —Samila, Murasa Expeditionary House

The Authority of the Bold

To the goblin mind, the most useful trait in a leader is practical survival knowledge. Goblins used to measure this knowledge by venturing into ancient ruins to retrieve interesting or powerful objects, and goblins with more impressive artifacts held greater status in their tribes. Goblins would carry their most impressive prizes with them at all times, and a goblin who hadn't yet retrieved an object from a ruin was not considered a full member of the tribe. However, goblins would often accept a commonplace rock, shell, or chunk of metal as an artifact since goblins' fearful nature steered many of them away from any actual ruins. Ambitious goblins, though, would strive constantly to outdo each other, delving deeper and deeper in search of the most impressive prizes. Thus, few ambitious goblins lived to an old age, so most goblin leaders were comparatively young.

These practices have changed somewhat since the emergence of the Eldrazi. Instead of cherishing the artifacts they find, goblins have turned to eating them—at least the ones constructed of hedrons. Goblins now gain status by measuring how many hedrons they have ingested, considering it a point of pride to have consumed as many as possible. Instead of displaying whole trophies, a goblin leaves a small corner or fragment of the original relic intact and carries it as part of a collection, which is often strung together on a bit of rope, a belt, or a shoulder strap. They still compete frantically to locate new finds.

Zada's cleverness led to the fall of Tuktuk and her rise to lead the largest remaining goblin tribe.

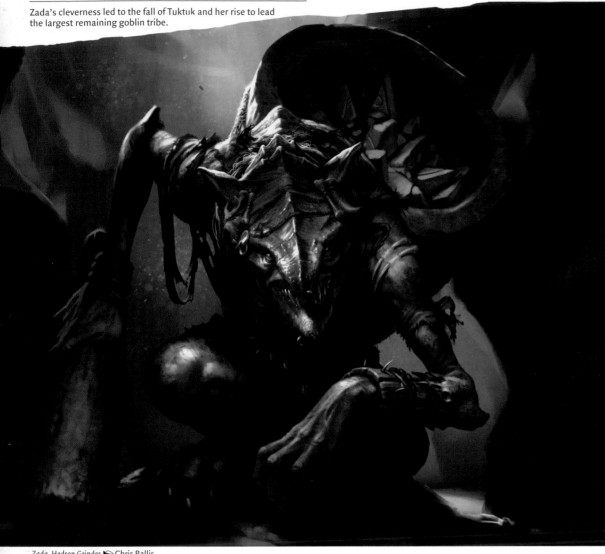

Zada, Hedron Grinder ▶ Chris Rallis

Trials of the Tuktuk

Of the three major tribes of goblins, only one has endured the rise of the Eldrazi mostly intact. The Tuktuk tribe is named for its late leader, a brave explorer who triggered a magical trap in an ancient ruin and emerged as something else. Tuktuk was remade by strange magic–his living body was destroyed, but some remnant of him was imbued into a stone body that was goblin-like in its general outline. Clinging to fragmented memories of his past life, this duplicate Tuktuk returned to the tribe and was made chief. Though he was unable to speak, it was obvious that he had brought something truly amazing back from the ruins, and his physical strength was amplified fivefold. And so he led the tribe for fifty years, communicating with his followers by means of a weird psychic network, a result of the magic that created him.

Tuktuk's leadership was brought to an end by a clever goblin named Zada. Struck by the insight that the most rare and powerful artifact was Tuktuk himself, Zada convinced the other goblins that Tuktuk was contaminated by contact with the Eldrazi and was a dangerously unreliable leader. She assured them that destroying the construct and consuming its essence would make them virtually immune to the Eldrazi and perhaps confer other benefits as well. The goblins rose up and overthrew Tuktuk, shattering him into many pieces, which they then devoured.

Zada now leads the tribe, directing them to prepare for survival in a world being rapidly consumed by the Eldrazi. She reasons that places already drained of their power will not be bothered again by the monstrous broods, so the goblins are establishing settlements in lands that have been desiccated by Ulamog's horrible presence. Looking for ways to build secure shelter amid the brittle white residue of Akoum's rocky ground, the goblins have developed domes that hang from stone spires or cling to the sides of cliffs, and they are experimenting with building on a solid slab constructed in the midst of the chalky waste.

Driven Underground

The Lavasteps used to be the most industrious and warlike goblin tribe, using the geothermal activity of Akoum to make alchemical weapons and to forge strong metal gear. They believed that the fires deep beneath the ground were sentient, and their shamans inhaled sulfurous fumes in hopes of receiving communications from their fiery deities. Ritual burning and scarification, part of their religious rituals, left most Lavasteps extremely tolerant of heat and flame and highly desensitized to pain.

The Lavasteps were hit hard by the emergence of the Eldrazi titans, however, without the supernatural leadership that helped to shield their Tuktuk kin. Seeking shelter in the deepest parts of Akoum, the scattered remnants of the tribe have colonized the volcanic caves left behind by previous eruptions and deep chasms opened by the Roil. They live as far underground as possible, following strange magical emanations called the "stonesong," which they believe comes from the fire gods of the depths—but which are actually the result of the alien energies of the Eldrazi. Perhaps warped by these energies, the subterranean goblins have adapted quickly to the lightless conditions of their new home and have become sightless and pale, with enlarged ears for echolocation.

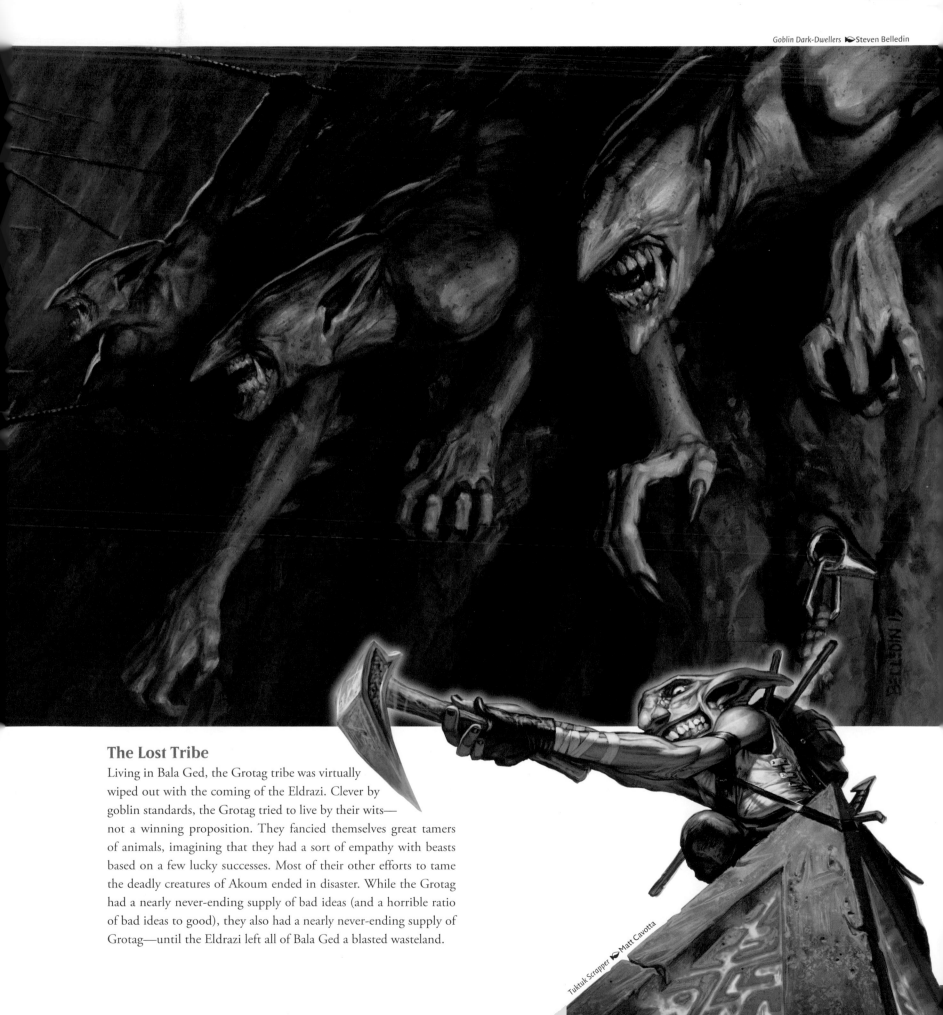

Goblin Dark-Dwellers ◗ Steven Belledin

The Lost Tribe

Living in Bala Ged, the Grotag tribe was virtually wiped out with the coming of the Eldrazi. Clever by goblin standards, the Grotag tried to live by their wits— not a winning proposition. They fancied themselves great tamers of animals, imagining that they had a sort of empathy with beasts based on a few lucky successes. Most of their other efforts to tame the deadly creatures of Akoum ended in disaster. While the Grotag had a nearly never-ending supply of bad ideas (and a horrible ratio of bad ideas to good), they also had a nearly never-ending supply of Grotag—until the Eldrazi left all of Bala Ged a blasted wasteland.

Tuktuk Scrapper ◗ Matt Cavotta

ELVES

Elves are a fearless and adaptable race that have fared better than most others in the tumultuous terrain of Zendikar and have even reacted to the appearance of the Eldrazi with resilience and courage. They remain the most prevalent race on Murasa and have a strong presence in other regions as well. Even their villages, suspended from the treetops in the tangled jungles of the hilly interior, seem to regrow almost as soon as they are destroyed—much like the Murasan jungles themselves.

Elves are strongly associated with green mana, the magic that flows through their forest homes. Their shamans and druids use magic of life and growth, communing with the land or the spirits of the departed. Striving to live in harmony with nature, they celebrate the ties of their small communities and their connection with the broader world around them.

Wildly Elegant

Elves are about as tall as humans but more slender. Their legs are long, and their pointed ears sweep back from their heads. They move gracefully and hold themselves with elegant poise, but they are people of the woodlands, and their life in the wilds is manifested in the practical simplicity of their clothes and equipment. Never ones to waste anything that can be reused, they stitch fabric from torn garments together into new ones and transform broken sword blades into climbing gear. They prefer leather for protection rather than metal, but they use metal for swords, spears, arrowheads, and climbing hooks.

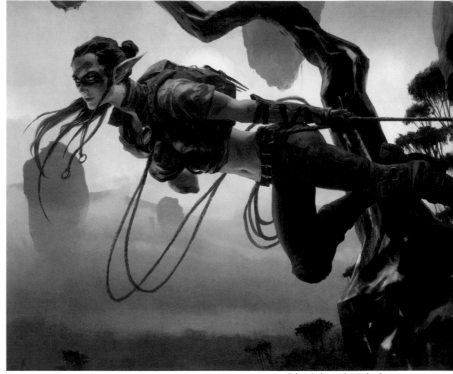

Tajuru Stalwart ▸ Wesley Burt

Fearless and Prepared

For the elves, surviving and thriving are deeply interdependent, and this is apparent throughout their daily lives. An elf rarely lacks the equipment for any task that might arise during the day. On the rare occasions when preparation fails, they make up for it with improvisation and quick thinking. Using zip lines and expert climbing techniques, the elves fearlessly span the gaps between branches or cliff faces. Indeed, some of the branch paths elves take are impassable

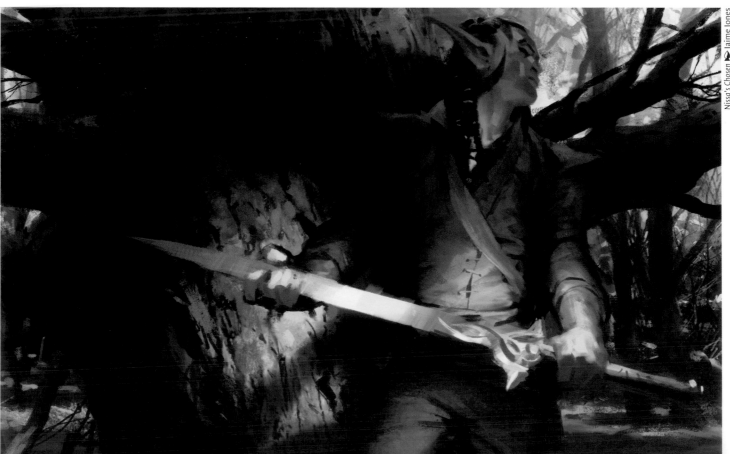

Nissa's Chosen ▸ Jaime Jones

without their guidance and skills, as they often leap breaches and climb hidden trails.

Confident that they can handle any threat or obstacle, Zendikar's elves are risk takers by nature, and they believe that nothing can be gained without some venture of risk. They're not usually foolhardy, but they stand in the face of danger with courageous calm.

Perspective of Long Life

Elves live much longer than humans, sometimes surpassing 200 years of age. Perhaps as a result, they have a very different experience of time than humans do. From their perspective, it is perfectly natural that past generations should persist among the living in spirit form, blending past and present in an eternal instant. Similarly, there's nothing exceptional about the land changing, whether it takes place over centuries or in moments as a result of the Roil. To humans, this

sense of time dilation can seem like a spiritual experience, but the elves ascribe no special significance to it. They generally do not see mystical truths, transcendental weight, or a divine hand in events, however extraordinary they may be.

> "Wonders hide where the trees grow thickest."
> —Mul Daya proverb

For better or worse, elves are inclined to see the coming of the Eldrazi in a similar light—as another passing phenomenon that must be endured. The deaths of thousands of elves and the destruction of a continent are a terrible loss, of course, but the elves do not wallow in sadness. If the past is always present, then the fallen elf nations remain a part of elf experience.

Turntimber Ranger ▸ Wayne Reynolds

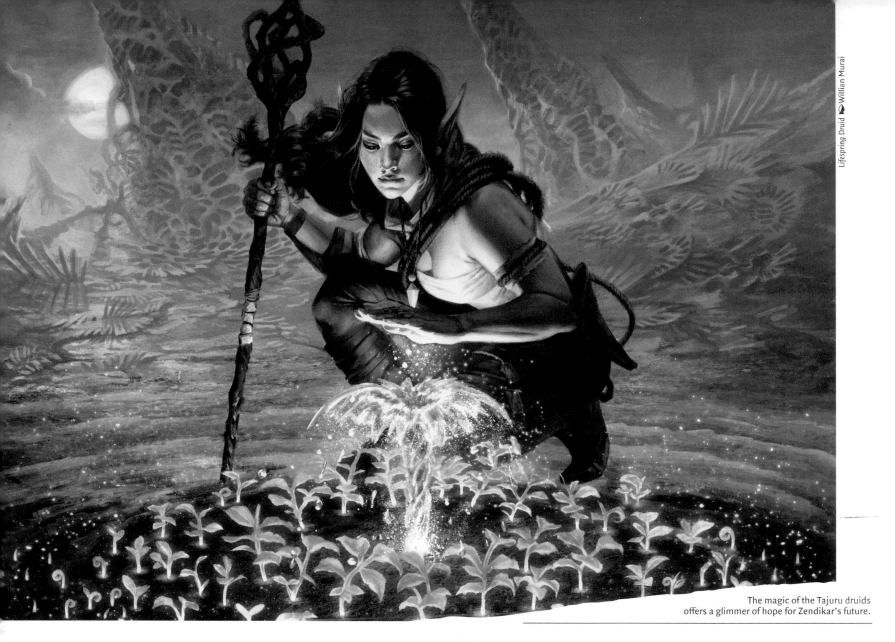

Lifespring Druid ◆ Willian Murai

The magic of the Tajuru druids
offers a glimmer of hope for Zendikar's future.

Three Nations, Many Clans

Elves live in small village clans. Leadership is decentralized and communal, although those with a combination of age and the particular skills relevant to a given decision tend to take the lead. Elvish social organization reflects their high degree of self-sufficiency. Individuals are expected to look after their own needs first and foremost, then those of their families, and finally those of the clan at large.

Elvish Mystic ◆ Wesley Burt

Most clans were part of one of the three major elvish "nations," which were regional populations more than coherent states. With the coming of the Eldrazi, however, two of the nations were virtually exterminated when the titans destroyed the continent of Bala Ged.

The Tajuru nation, concentrated in Murasa but counting among its number hundreds of far-flung clans in other parts of Zendikar, was the largest of the three main nations and is the only one that survives more or less intact. The Tajuru elves were always the most open to people of other races, seeing their skills and perspectives as valuable new tools for survival, and that openness has made it easier for the remnant clans from Bala Ged to join the Tajuru nation.

In the past, the Tajuru nation was always led by a shaman who carried the title of Speaker, but the death of Speaker Sutina opened the way to change. A young elf and master tracker named Nisede has been selected as the new leader of the nation. She is humble, resourceful, and not entirely comfortable with her new role, but her pragmatic nature reflects the elves' new reality amid the horrors of the Eldrazi.

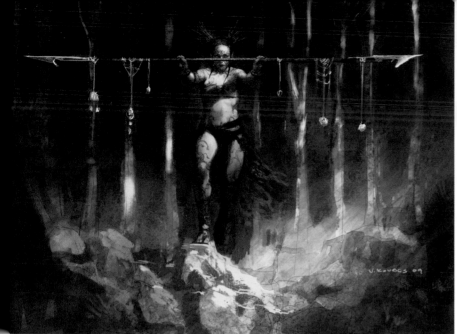

Oracle of Mul Daya ✎Vance Kovacs

identical, aside from their tangibility. Death and the spirits of the dead were as much a part of their lives as the natural world. This was not macabre to the elves at all—they considered it the truest view of the natural system. Like the Joraga, many of the survivors of the Mul Daya have joined the Tajuru, while others continue to follow their eccentric leader, Speaker Hazzan, who in turn heeds the instructions and advice of a centuries-old elf ghost called Obuun.

Preparing for the Unthinkable

Though there was no preparing for the waking of the Eldrazi, the elves continue to stress preparation as the key to survival. The Tajuru have been working to rebuild their hidden paths in an effort to facilitate quick movement away from an Eldrazi incursion. Bands of rangers and naturalists have assembled to study Eldrazi movements, with the intent of discerning their behavior patterns. Tajuru elves have become the stewards of the roads, often escorting caravans of refugees that are fleeing Eldrazi devastation, no matter what their race. Meanwhile, elf druids experiment with harvesting the resources that Zendikar itself provides and using them as weapons against the Eldrazi. They sometimes coax trees into weaving bows, staffs, and weapon handles, which make light weaponry that they believe to be particularly effective against the Eldrazi. They also create arrowheads from hedron shards, which can have effective if unpredictable effects when loosed at Eldrazi.

The elves of the imperious Joraga nation of Bala Ged had little respect for any other race of Zendikar, or even for other elves. They saw the survival of their nation as most important, and they jealously guarded their traditions, viewing the influence of other cultures as a weakness. With the destruction of Bala Ged, many Joraga have joined the Tajuru and given up their xenophobic beliefs, but other remnants of the nation have instead taken up a nomadic lifestyle as raiders who prey upon both elves and non-elves.

The Mul Daya nation of Bala Ged had a relationship with the spirits of their elvish ancestors that set it apart from the other nations. The Mul Daya saw the spirit world and mortal realm as

Skyrider Elf ✎Dan Scott

Some elf druids have also marshaled the creatures of the land and sky to aid them against the Eldrazi.

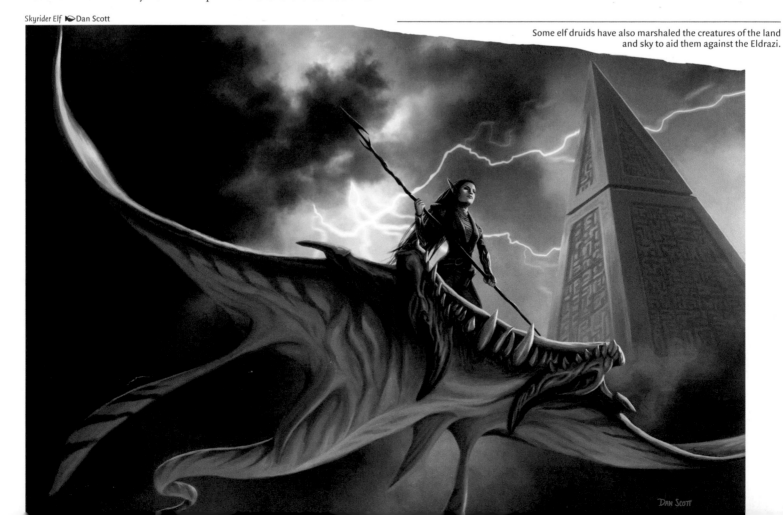

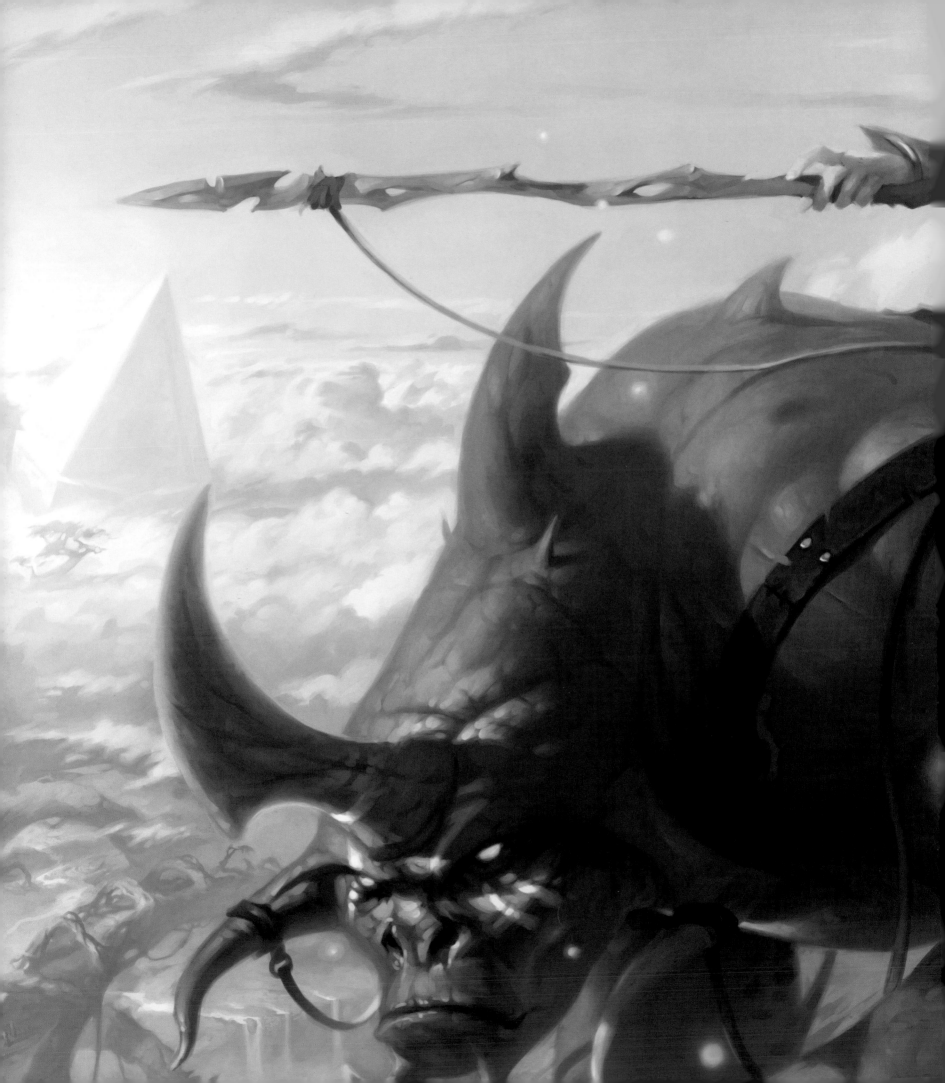

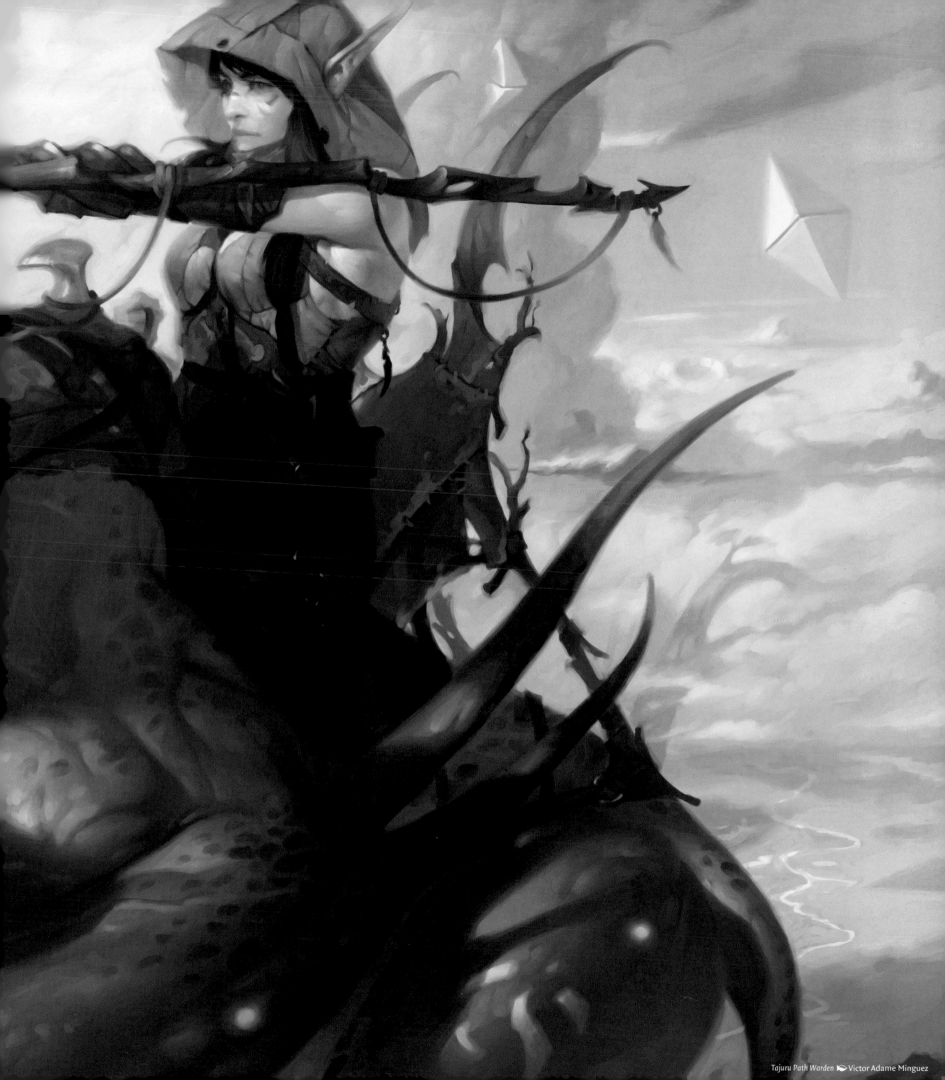

Tajuru Path Warden ❧ Victor Adame Minguez

◆ ANCESTRAL MEMORY: GODS AND ELDRAZI

When Sorin, Nahiri, and Ugin first brought the Eldrazi titans to Zendikar, the alien horrors were greeted as monstrous gods, and all the races of Zendikar fought the hordes of the titans' brood. This battle persisted long after the titans were imprisoned, until at last all the lesser Eldrazi were wiped out and no new ones could be made. And then, for generations, the peoples of Zendikar passed down their tales of the dark gods' coming.

As the centuries passed and the tales were retold again and again, though, they changed ever so slightly—but in terribly important ways. Angels had been among the first creatures to mount a resistance

to the Eldrazi, and they fought on the forefront of every great battle. To the people of Zendikar, the defiance of the angels seemed like concrete proof that a benevolent divine force stood between them and the horrors of the Eldrazi. The kor and the merfolk remembered stories of three gods who were present as their ancestors fought hordes of monsters. But in time, they forgot that those gods birthed the monsters.

Mighty Ulamog, who swam through the seas as easily as he walked across the land, became an ocean deity. The merfolk worshiped him as Ula, god of the ocean depths, while the kor called him

Harmless Assault ▷ Chippy

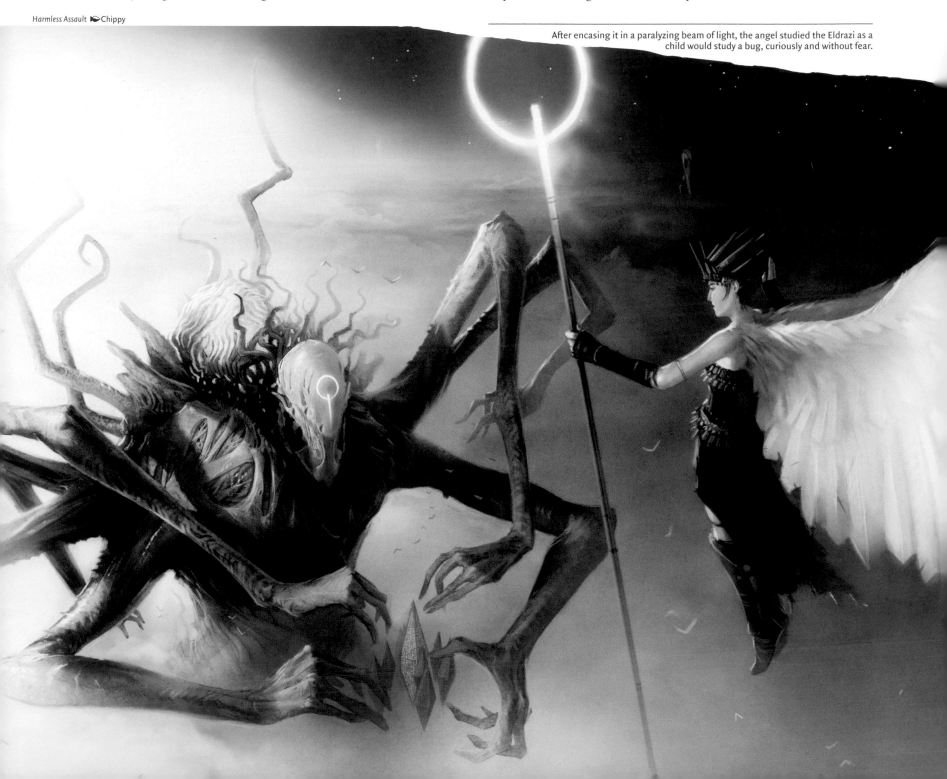

After encasing it in a paralyzing beam of light, the angel studied the Eldrazi as a child would study a bug, curiously and without fear.

Shrine of the Forsaken Gods ▶ Daniel Ljunggren

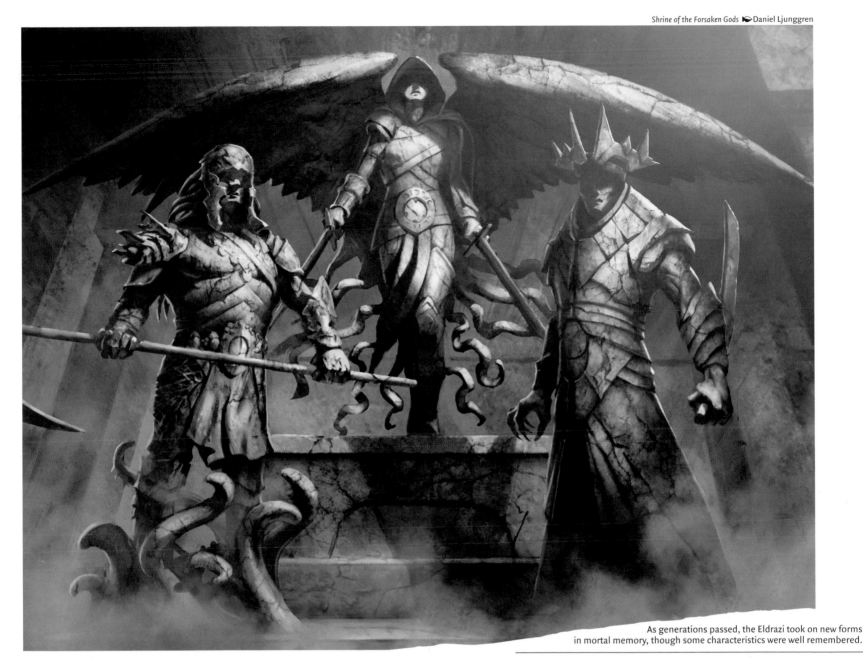

As generations passed, the Eldrazi took on new forms
in mortal memory, though some characteristics were well remembered.

Mangeni, "blood of the world," god of the waters and of movement and change.

Dread Kozilek, whose presence warped the nature of reality, became a god of chaos—not a friend to mortals, but not their implacable foe. To the merfolk, he was Cosi, the malevolent trickster-god of chaos and misfortune, not so much worshipped as appeased or avoided. Cosi's realm was thought to be the solid ground between sea and sky. To the kor, Kozilek was Talib, god of the earth and "body of the world," who created rockslides and aberrations in gravity while also providing herbs and fungi to feed the kor as they wandered their pilgrimage routes.

And maddening Emrakul, whose presence in the sky blotted out the sun, became the goddess of the air. The merfolk called her Emeria, goddess of the wind realm, while the kor called her Kamsa, the "breath of the world." As the one most easily associated with the angels, she was always depicted as kind and benevolent. Remembering the kindness of the angels above all, the humans of Zendikar adopted Emeria as the First among Angels, the center of their own faith.

Passed down from generation to generation, the legends of these races told of Emeria/Kamsa sending angels to fight the invading monsters and of Ula/Mangeni providing knowledge and resources to help their followers endure the conflict. Some legends identified the trickster Cosi/Talib as the source of the monsters, as he attempted to scour the earth of the annoying pestilence of mortal life. Others claimed the trickster didn't send the monsters but didn't help in the battle against them either. A few stories even told of how the trickster helped clever and resourceful mortals overcome the dangers they faced.

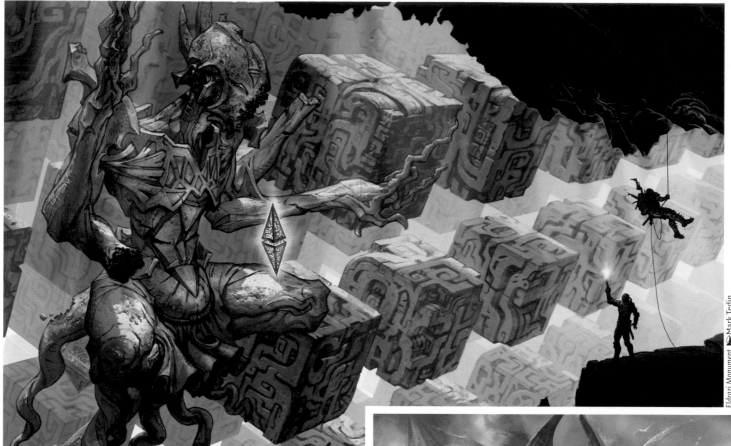

Eldrazi Monument ▶ Mark Tedin

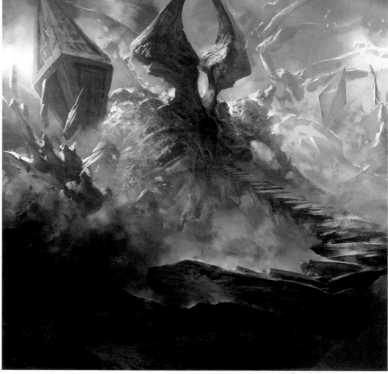

Godless Shrine ▶ Noah Bradley

Monuments to a Lie

The myths of benevolent gods are not the only distortion of ancient memories. Even the word "Eldrazi" came to mean something entirely different during the time of their long absence. The people of Zendikar believed that the Eldrazi were an ancient civilization, a race not too different from humans or merfolk, who created the hedrons, erected great buildings and monuments from stone, and left behind a legacy of great magical power.

In truth, the Eldrazi were not builders. The hedrons were shaped by Nahiri, inscribed by Ugin, and empowered by Sorin Markov. The ancient ruins scattered across the plane are indeed the remnants of ancient civilizations, but those civilizations belonged to humans, kor, merfolk, and the other races that still inhabit Zendikar. In ancient times, these races built on a scale that their descendants can barely imagine—because the world was more stable before the Eldrazi came. They mastered magic that has since been forgotten and crafted artifacts of tremendous power. And they warred against the Eldrazi, only to be forgotten and called by their enemies' name.

Images of the Eldrazi titans—the three monstrous gods who threatened to destroy their civilizations—appear often in these ancient sites, contributing to the misconception that they were constructed by an alien race. As later generations of explorers ventured into the ruins, they believed that these images represented the builders, not the gods they feared. And so the idea of an ancient Eldrazi civilization has become a common assumption among explorers and scholars alike.

Summoning Trap ▶Kieran Yanner

Monster-Infested Death Traps. Zendikar's ancient ruins are no safer than its wilderness. Dangerous predators are almost as common in underground ruins as they are in the Teeth of Akoum or the great forest of Turntimber. Burrowing creatures favor underground ruins as an alternative to digging lairs of their own, and ruins aboveground can still offer some shelter from the elements for everything from giant scorpions to terrible dragons. Still worse, the original creators of these ancient structures often included deadly traps in their design to ward off Eldrazi intruders, and those traps are no less dangerous to ordinary explorers. Whether magical or mechanical, traps might loose a volley of arrows, expel a blast of fire or toxic fumes, drop an intruder into a pit filled with poisoned spikes, cause magic to backfire or writing to explode in flame, animate a stone statue to attack, or other similar effects. As a result, skilled trapfinders are highly valued members of any expedition that dares to enter an ancient ruin—and unskilled trapfinders rarely undertake a second journey.

"A good explorer has to be as slippery as a gomazoa, as tough as a scute bug, and luckier than a ten-fingered trapfinder."
—Arhana, Kazandu trapfinder

Even in the wake of the Eldrazi's rise, the truth behind this myth is only gradually becoming clear. Some kor have come to a better understanding of their race's settled past, and other explorers have realized that magic contained within these ruins can be useful for fighting against the Eldrazi, suggesting that they were first built by the Eldrazi's foes. For the merfolk, retrieving such magic from ancient ruins has become a high priority, providing a glimmer of hope that their race, and the other peoples of Zendikar, might somehow survive the Eldrazi walking their world.

83

REGIONS OF THE WORLD

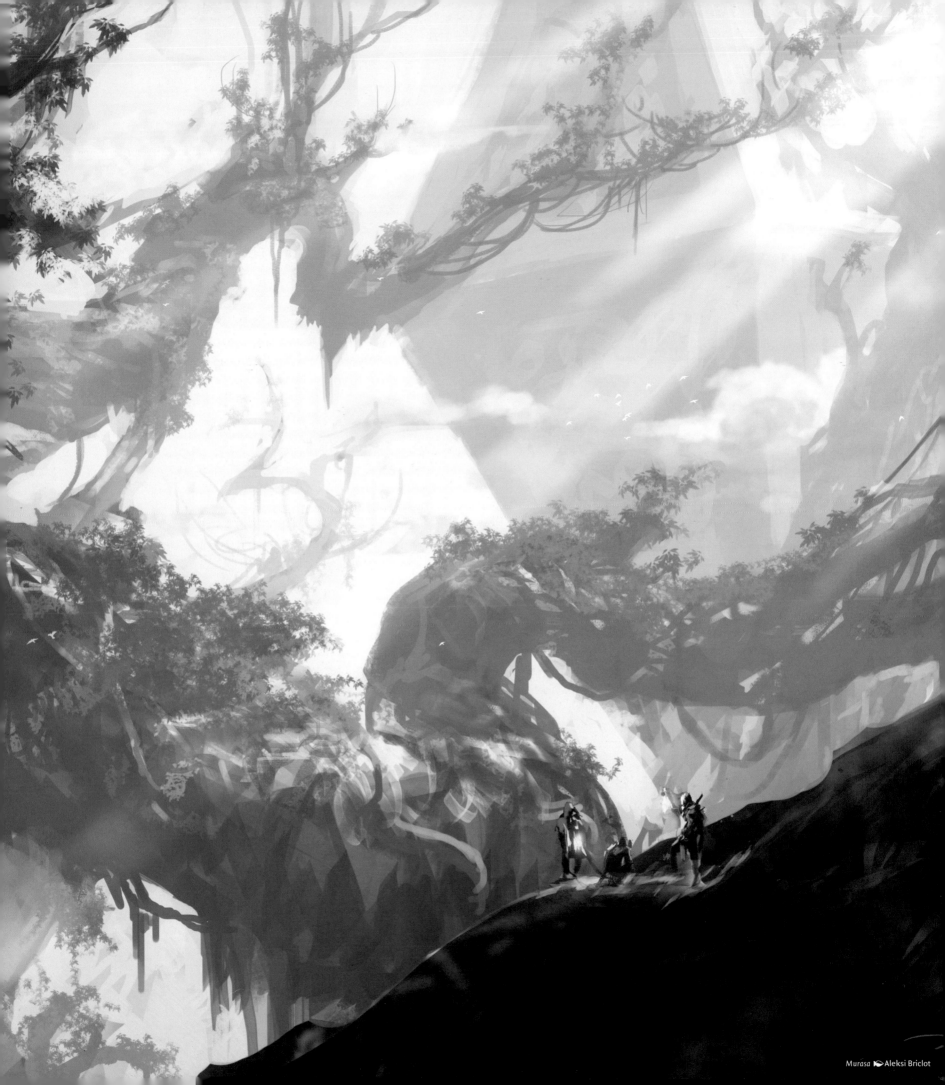

Murasa 🜂 Aleksi Briclot

AKOUM

Jagged mountain peaks rise high into the air, topped by gravity-defying arches and spires. Titanic structures of crystalline rock formations, abyssal crevasses where magma bubbles and flows, desolate badlands of eroded volcanic rock, geysers of sulfurous water and vents of toxic gases—all these features define the harsh landscape of Akoum. Floating mountains, unmoored from the earth, hover in defiance of gravity, extending the uneven landscape upward as far as the eye can see. From the jagged obsidian cliffs at the coast to the soaring mountains called the Teeth of Akoum in the north, the region is bristling with angular spikes as if the land itself is trying to ward off any encroachment.

Mountain ◆ John Avon

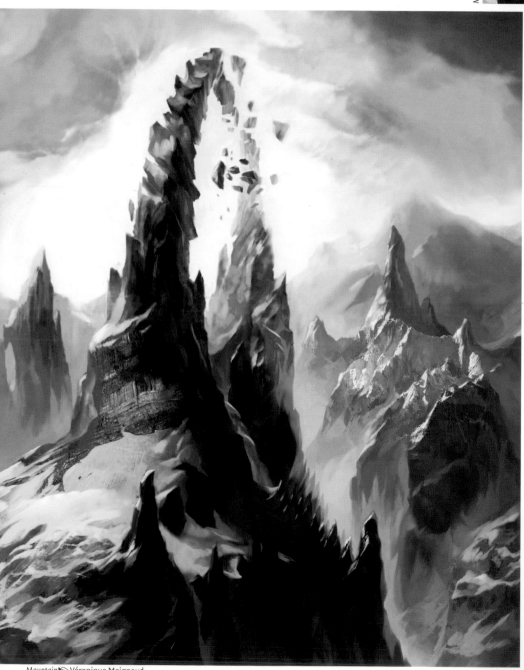

Mountain ◆ Véronique Meignaud

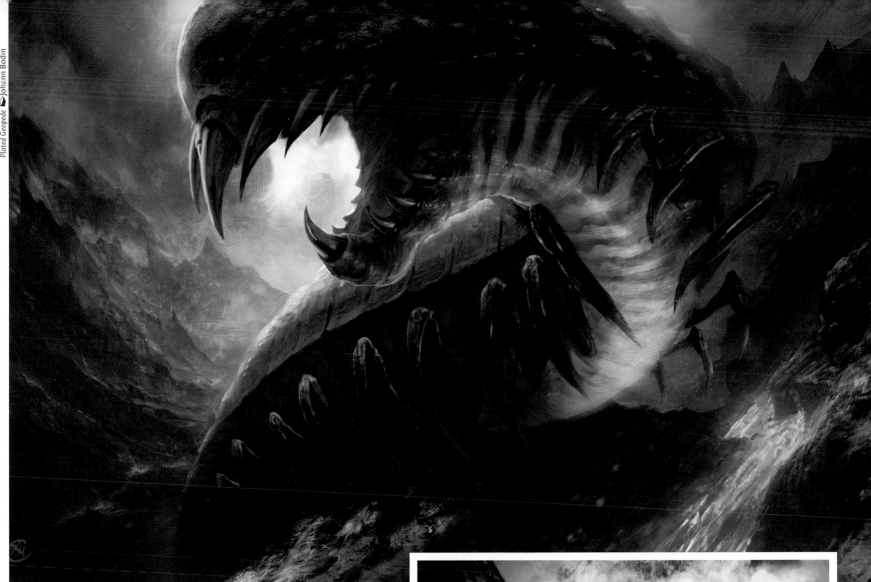

Plated Geopede ● Johann Bodin

Life in Akoum is harsh, perhaps more so than anywhere else on tumultuous Zendikar. Its largest settlement, Affa, was a tiny cluster of stone and brick buildings nestled in what pass for foothills at the base of the Teeth of Akoum—before disaster drove its scant population underground. Akoum's greatest concentration of people is not a settlement at all but the giant caravan of Goma Fada.

"We move because the earth does." —Bruse Tarl, Goma Fada nomad

Most of the land is cracked and dry, but hardy plants and animals find a way to thrive in unlikely places. Trees and shrubs cluster around volcanic gas vents, defining environments unlike anything else on Zendikar. Aggressive silver and blue grasses take root in volcanic stone and spread rapidly, providing meager fare for the larger fauna of the region. From time to time a volcanic burst brings fertile earth to the surface, and Akoum springs into beautiful flora in an event the elves call a "life bloom."

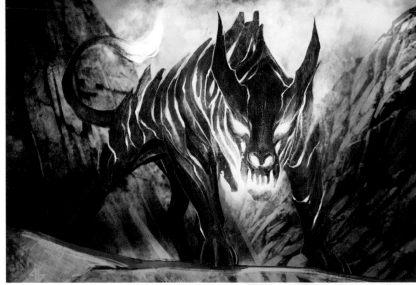

Kiln Fiend ➤ Adi Granov

Creatures that can survive this rugged land are as tough and dangerous as their environment. Even the mammals have some form of hard carapace or shell, and many forms of insect life, from tiny beetles to enormous burrowing geopedes, thrive in the ground. Various kinds of elementals—living embodiments of earth, fire, and magma—are the most common predators.

87

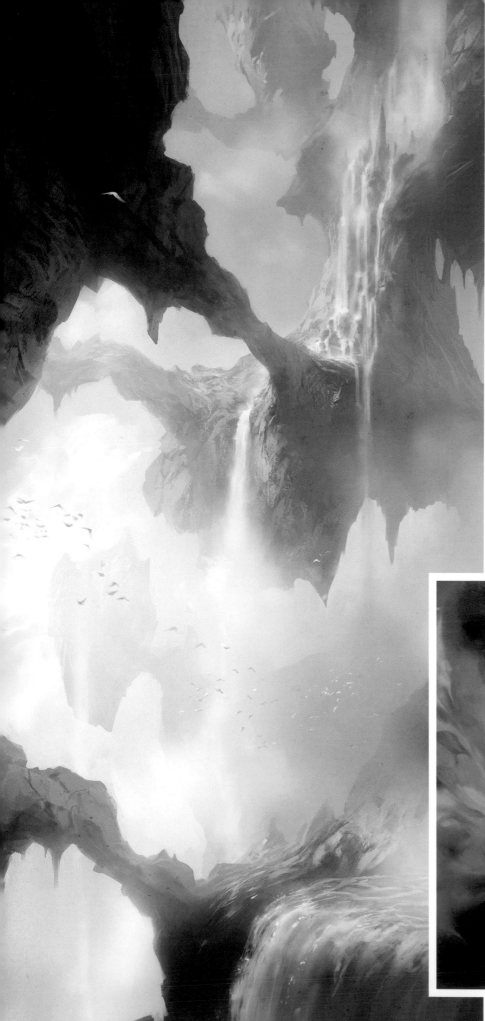

Island ◆ Sam Burley

The Coastal Cliffs

The coasts of Akoum are a deathtrap to travelers. Spires of volcanic glass jut from the sea, lava flows cascade from the cliffs, and seaquakes send high tidal waves crashing in, so few harbors allow ships access to the shore. After braving a journey filled with krakens and storms, it is not uncommon for a ship to meet its end within sight of the Akoum shores, the hull torn apart on jagged underwater rocks essentially invisible to a lookout's eye.

Akoum has no permanent ports. The coastline changes significantly every year because of volcanic eruptions, above and below the water, and seismic activity that sends coastal shelves into the ocean depths. Still, upon sighting a ship, any people sheltering on the coast make every effort to help bring it in, since a ship might carry valuable supplies that simply can't be found elsewhere on Akoum.

The Spike Fields

Akoum's crystalline fields shimmer in a rainbow of colors beneath the harsh sun. This awe-inspiring beauty hides a deadly reality. The smallest stone carries sharp edges that can slice through leather and flesh when an unwary traveler slips and falls. What's more, the surface can reach extremes of temperature—during the day, the sun's glare on the gleaming crystals creates blistering heat, but the stone cools quickly, and the cloudless sky can make for bitterly cold nights.

Lavaclaw Reaches ◆ Véronique Meignaud

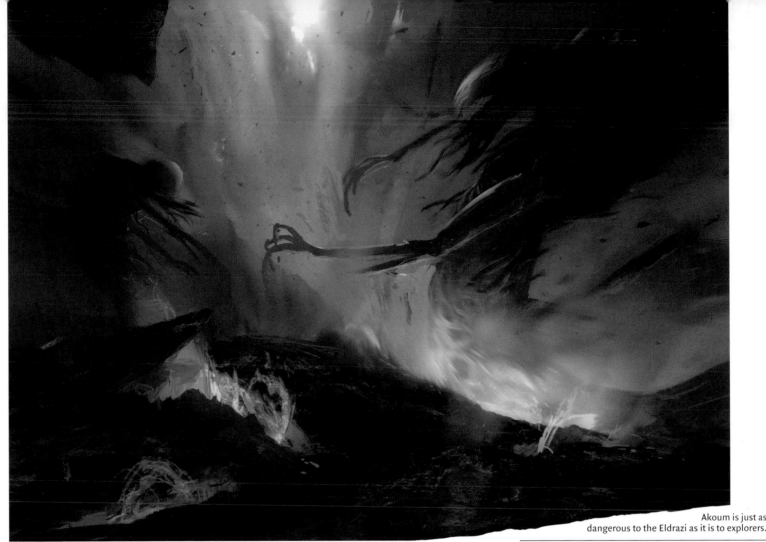

Akoum is just as dangerous to the Eldrazi as it is to explorers.

Boiling Earth ▶ Titus Lunter

The Teeth of Akoum

Much of Akoum is covered with jagged mountains. The so-called Teeth of Akoum are a series of broken mountain ranges that are extremely difficult to navigate. Riding griffins carry travelers from Affa to the handful of camps nestled among the peaks, but only a very clever explorer can forge a path through the gullies and gorges to find an uncharted ruin or a hidden mine.

The land itself is dangerous enough, but the mountains are also home to fierce dragons and the savage human barbarians who revere them, the Kargan tribes. Hellions—enormous wurm-like creatures that swim through lava—occasionally burst to the surface here as well, devouring anything that moves.

The Roil on Akoum

Akoum is essentially one enormous volcano, though it is not prone to major eruptions. Instead, because of the Roil, the whole region is constantly shaken by more minor activity. The Roil's activity is primarily felt from below—not in air or water, but in the earth and the fiery magma that is never too far from the surface. Lava flows alternately flood and clear tunnels, sometimes causing gases from deep within the earth to vent explosively to the surface, and the shuddering earth can bring down a rain of crystalline shards as deadly as a volley of arrows.

> "My boots are in ribbons. The steeds' hooves bleed. We carry too much tinder and not enough water. We would have no motivation to continue to the ruins except that it's just as far back to the coast again." —Journal of Prina Wey

The Glasspool

Rainfall comes to Akoum in violent torrents during the winter, and the surface undergoes a brief but glorious transformation in spring. Lakes form overnight in the crystal fields, and water cascades across the rock spires. This beauty is as fleeting as anything else on Akoum—after days or weeks, another tremor drains the water away beneath the surface.

The one fixed body of water of any notable size in the region is the Glasspool, a huge lake with cool, clean water. Its name comes from the complete stillness of its surface at nearly all times. Tremors and eruptions somehow leave the water unmoved.

Khalni Garden ➤ Ryan Pancoast

Ora Ondar, the Khalni Garden

Most life blooms last only a year or two. A notable exception is Ora Ondar, sometimes called the Impossible Garden. This oasis of growth in the harsh, angular setting of Akoum has remained a fixture of the land for almost a hundred years, and calling this lush tangle of magical, and occasionally deadly, plants a "garden" is the height of irony.

A small clan of elves (technically part of the Tajuru nation) lives among the stone crannies of a large outcropping in the midst of the forest. These elves call themselves "nourishers" and consider it their mission to help sustain the forest. A few human druids and merfolk lullmages have joined the elves here to nurture the Khalni Garden and try to shield it from the tumult of the land.

The Khalni Garden of Ora Ondar is marvelously diverse. Thick clusters of ferns cover the ground, with gigantic flowers rising above them to catch the sun. Thorny vines twist up the stems of the taller plants, and giant pitcher plants and flytraps catch and devour the smaller animals that venture into the wood. The small kolya trees, their slender trunks topped with narrow leaves hung with glowing green fruit, are the tallest plants here.

The succulent fruit of the kolya tree has magical properties, thanks to the trees' property of absorbing mana from the land. The sweet, tangy fruit has unpredictable effects on those who eat it, ranging from supernatural enhancement of strength or intellect to the creation of phosphorescence in the blood that makes the eater's veins glow through the skin. Certain elf druids, believing that the gifts of the ancestors are contained in the fruit, eat it as part of their spiritual practice. They claim that the fruit grants them wisdom and visionary insight, but eventually the fruit's magical properties corrupt their bodies, leading to death.

The Khalni Heart. Although the nourishers of Ora Ondar consider it to be an exceptionally durable life bloom, the true source of the forest's vitality is an enormous flower, bursting with magical energy, called the Khalni Heart. This lotus-like bloom grows in the midst of a waterfall in the exact center of the forest, and the vibrant life of the Impossible Garden comes from the intense green mana flowing out from it.

As the Eldrazi demolish the plane and leave lifeless ruin in their wake, some druids and elves believe—or desperately hope—that the Khalni Heart can be removed from Ora Ondar and transplanted to Bala Ged, Sejiri, or some other land laid waste by the Eldrazi. It is also possible that Zendikar itself might produce another Khalni Heart in such a place, as the plane seems determined to endure and regrow.

Ulamog's Devastation

Large sections of Akoum have been destroyed by the rampage of Ulamog. The Eldrazi titan's passage left behind delicate latticeworks of ash and stone that crumble at the slightest touch or tremor. Having been drained of all vitality, these areas are safe from further encroachment by the Eldrazi, but they are hazardous to inhabit—though the Tuktuk goblins are trying anyway.

Lotus Cobra ▶ Chippy

Khalni Heart Expedition ▶ Jason Chan

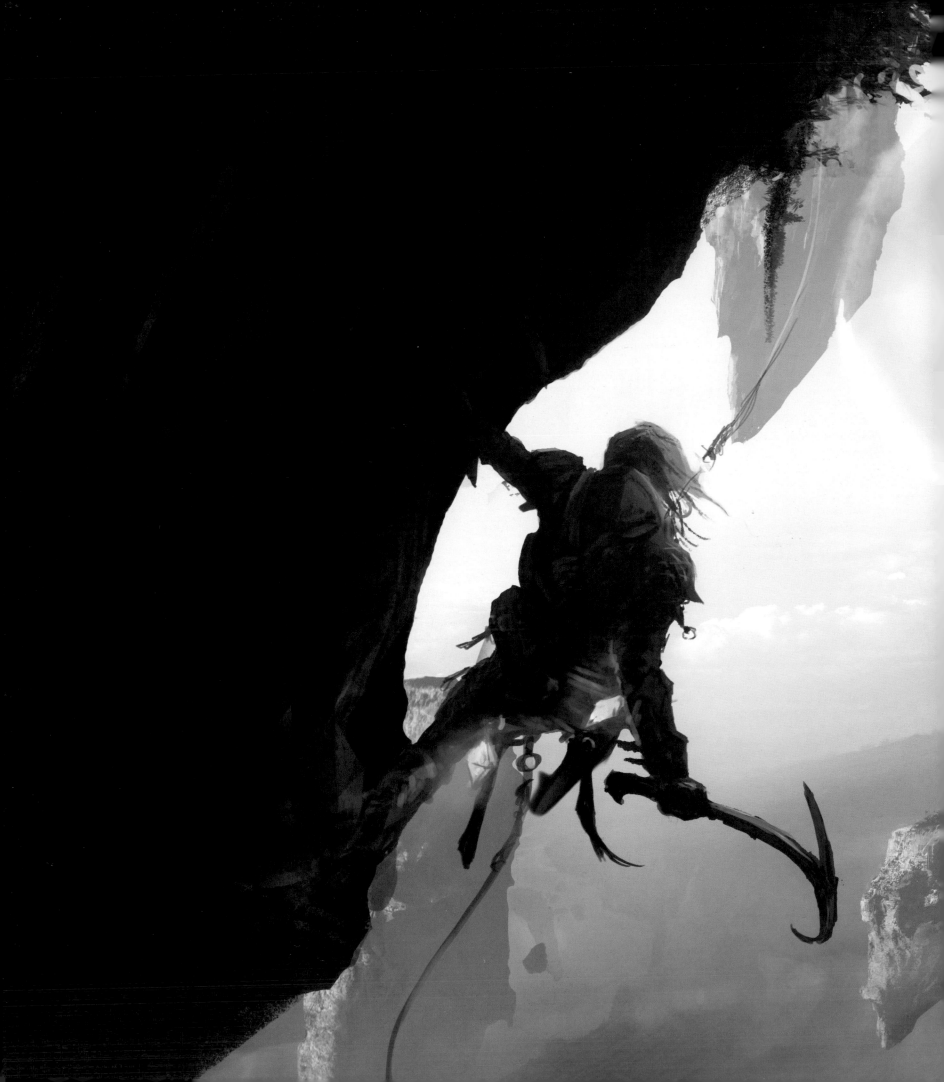

Tazeem 🔷 Aleksi Briclot

LIFE IN AKOUM

Civilization clings tenaciously to the crags and slopes of Akoum, as much as the ground shakes and despite the rampaging of the Eldrazi. All the races of Zendikar are represented here, though humans and goblins predominate.

Affa

Before the rise of the Eldrazi, Affa was a little clump of buildings at the base of the Teeth of Akoum. A river flowing down from the Teeth provided the town with one of the few safe, reliable sources of water in all of Akoum. Its population was mostly human, though elves, kor, and even the occasional vampire would call it home for

Affa ▸ Nic Klein

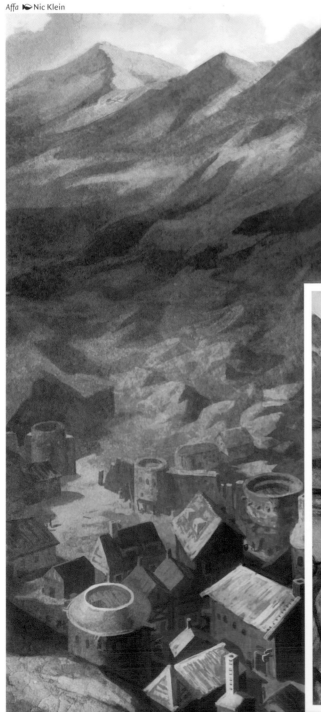

a time. It was the major trading hub in the region, with goblins bringing minerals and other materials to the bazaar for trade, and it served as a launching point for expeditions searching for ruins in the mountains. The Akoum Expeditionary House, based in Sea Gate, maintained a hostel in Affa run by a cheerful, heavily scarred human named Sachir.

With the coming of the Eldrazi, Affa has managed to survive only by moving its entire population into a cavernous underground ruin. Lining the cavern walls, ancient hedrons stand sentinel against the Eldrazi broods that threaten the survivors. The hedrons provide a false sense of security, though, for they protect only two sides of the cavern. If a horde were to come from the wrong direction, the hedrons would do little to hold them back, and the people of Affa are unprepared for such a catastrophe.

Goma Fada, the City that Walks

Perhaps the strangest population center in all of Zendikar is not technically a settlement at all. Goma Fada, literally "The City that Walks," is an enormous caravan constantly on the move across Akoum. It consists of several thousand people—mostly humans and kor, with a few elves and merfolk—along with hundreds of huge, sturdy carts pulled by horses, oxen, and the strange, giantlike beasts called hurdas. The carts comprise homes, shops, eateries, and even farms of sorts—fig trees and similar hardy plants are grown in the dirt-filled backs of wagons. Cisterns full of water and granaries laden with food are drawn along by the enormous beasts of burden.

Caravan Hurda ▸ Dave Kendall

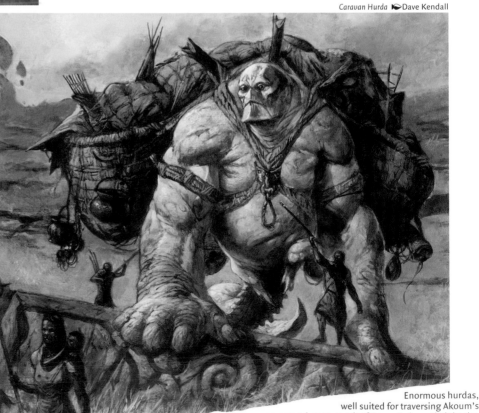

Enormous hurdas, well suited for traversing Akoum's uneven ground, carry much of Goma Fada on their backs.

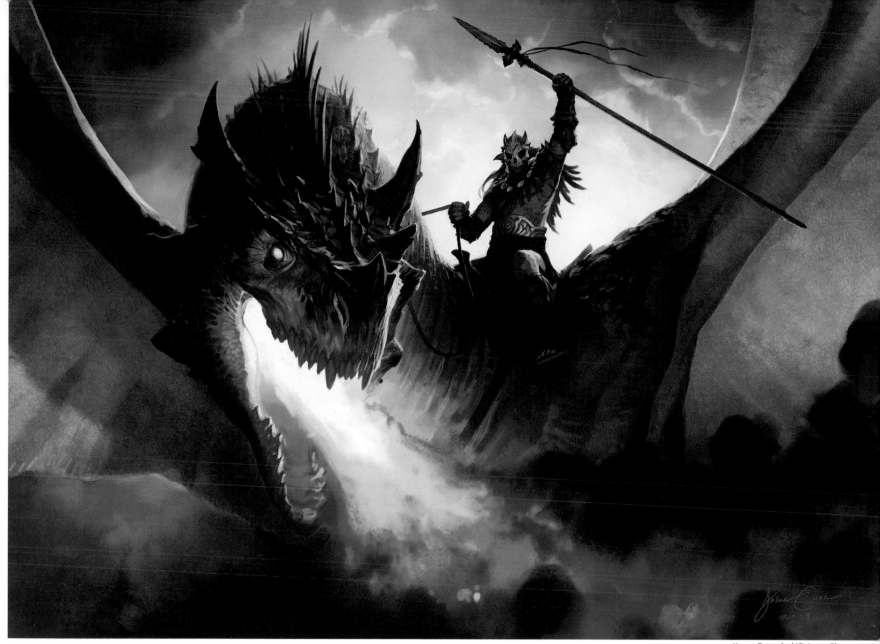

Kargan Dragonlord ► Jason Chan

"All the major routes of the region—the Rogah Throughway, Akoum's Belt, the Pass of Woe—were carved by the wagon wheels of Goma Fada. The greatest explorer of Akoum isn't Sachir or Kala the Bold—it's the Walking City itself." —*Chronicle of Vurundi*

Goma Fada faces all the challenges of life on Akoum by never sitting still for long. Since resources can appear and disappear at a moment's notice, the caravan hauls supplies of food and drink to last for months and sends roving waterscouts—part explorer and part engineer—to find the ephemeral streams that appear after rainfall and channel the flow into the caravan's cisterns. Of course, the dangers of Akoum often move faster than the caravan, but the tenacious folk of Goma Fada have survived so far, even enduring the coming of the Eldrazi.

Because of the destruction wrought by Ulamog and his brood, the ground is not always strong enough to support the massive carts and wagons of the caravan. Light outriders now travel before the main body of the caravan, testing the ground before the great wagons arrive. The rolling city avoids most of the crystalline Spike Fields because of this weakening, though it sometimes sends smaller wagon trains across the fields to trade with the goblin warren called the Slab.

The Kargan Lands

The fierce, nomadic humans of the Kargan tribes live high in the Teeth of Akoum and compete for territory with the dragons that hunt in the mountains. The tribes can hold their own in this competition only by stealing dragon eggs or capturing their whelps and raising the creatures themselves. When they are grown, these dragons serve as mounts and companions for the tribes' leaders so that other dragons view the tribal lands as dragon territory.

Stone Havens

The passage of the Eldrazi, while devastating to the land, sometimes leads to important revelations. Layers of volcanic rock crumble away at the Eldrazi's touch, occasionally revealing ancient ruins long buried underneath. In the midst of the Spike Fields, a string of ruined fortresses have been unearthed in what is now a chasm stretching for miles across the desiccated land. Word of these ruins has drawn many kor to Akoum, including a group of stoneforge mystics—heirs of Nahiri's lithomantic tradition—who are turning these ruins into shelters for people fleeing the swarms of Eldrazi broods. The stoneforge mystics bind the walls of the ruined fortresses to hedrons, marshaling the hedrons' protective powers to ward the havens. More humans live in these Stone Havens than kor, since most kor continue on their pilgrimage routes, but all the races of Zendikar are represented in these refuges.

A remnant of Mul Daya elves have come to reside in one of the havens, where they are working with kor clerics to add another layer of protection to the refuge. Together, they have invoked kor revenants and elf ghosts to bolster the haven's defenses. The residents now call their home Ghostwatch and respect the shamans and clerics to the point of reverence.

Elves and kor stand together at Ghostwatch . . .

Joraga Auxiliary ◖David Gaillet

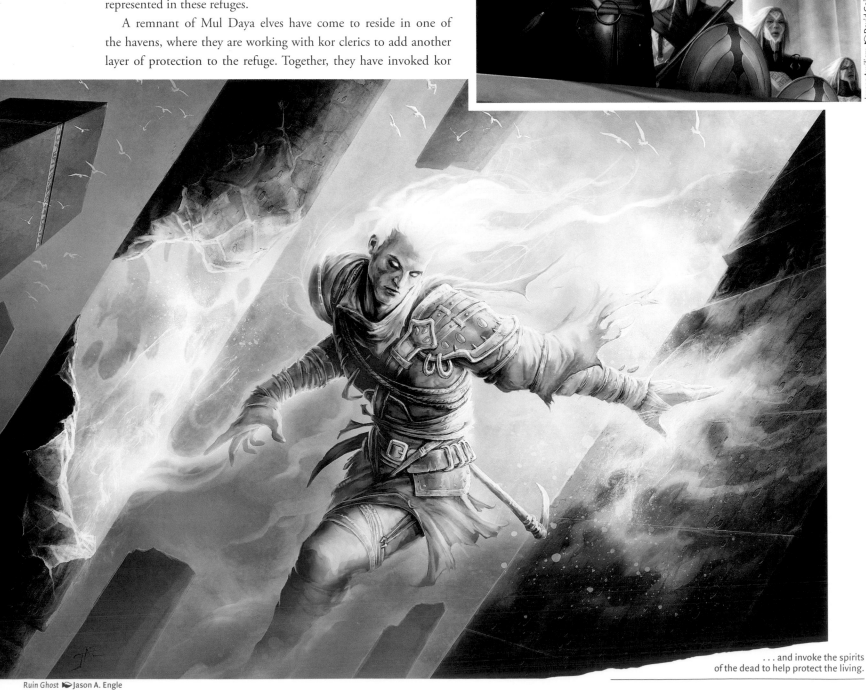

Ruin Ghost ◖Jason A. Engle

. . . and invoke the spirits
of the dead to help protect the living.

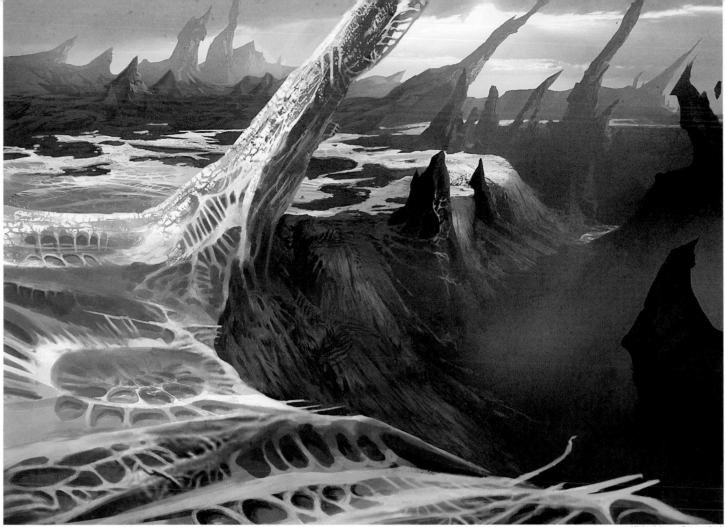

Blighted Gorge ▷ Jung Park

Goblin Havens

The goblins of the Tuktuk tribe have struggled to survive in a world being rapidly consumed by the Eldrazi. Possessing neither great strength nor magical power, they have little to rely on but their occasionally inspired imaginations. Their leader, Zada, reasoned that the lands already drained of their power by the Eldrazi would be the safest places to live, just as a predator is unlikely to return to a carcass already stripped of flesh. So she led her tribe into the calcified areas left in Ulamog's wake and challenged the goblins to find a way to make the devastation habitable.

The goblins initially found that the brittle, powdery rock was too weak to support dwellings. They tried scraping away the crumbling deposits to reach more solid ground beneath, but the Eldrazi had drained away so much mana that the underlying stone was weakened as well. Then a clever goblin called Lako the Builder invented a method of constructing spherical or dome-shaped dwellings from the silk of enormous spiders called ventcrawlers. Two goblin settlements reflect two different implementations of his ideas.

The rest of the tribe moves around in the higher Teeth to stay out of the way of the Eldrazi, but all too often they fall prey to dragons or Kargan ambushes instead, making Zada eager to get more settlements constructed as quickly as possible.

Grip Haven. The buildings of Grip Haven resemble drops of dew clinging to a handful of solid rock spires that jut up from the surrounding white devastation. The droplets are formed from ventcrawler silk that gives them a frothy appearance from outside, and the interior divisions are formed from rocks mortared together with the same substance. Flaps of hide or the thick carapaces of scute bugs cover small openings on the tops or sides.

The spaces between the domes are spanned by simple rope bridges consisting of two ropes strung a few feet apart, one for feet and one for hands. Members of races taller than goblins have trouble using these bridges, which the goblins consider an advantage.

Slab Haven. The other Tuktuk settlement is built on a large stone slab, about five feet thick, which is anchored to standing stones that jut above the chalky waste. Dome huts made of ventcrawler silk, resembling pustules on the dusty surface, are spread across the slab. The slab took some time to settle to a stable point on the desiccated ground, but it seems to have found a steady position, and now goblins can walk across the slab in relative safety. However, the community is very exposed to attack, whether at ground level or from above. The goblins are building a concrete wall around the edge of the slab, and each hut has a sort of defensive station on top, accessed by way of a hatch from below, where spear-carrying goblins can attempt to drive away dragons and giant birds of prey that come to harass the settlement.

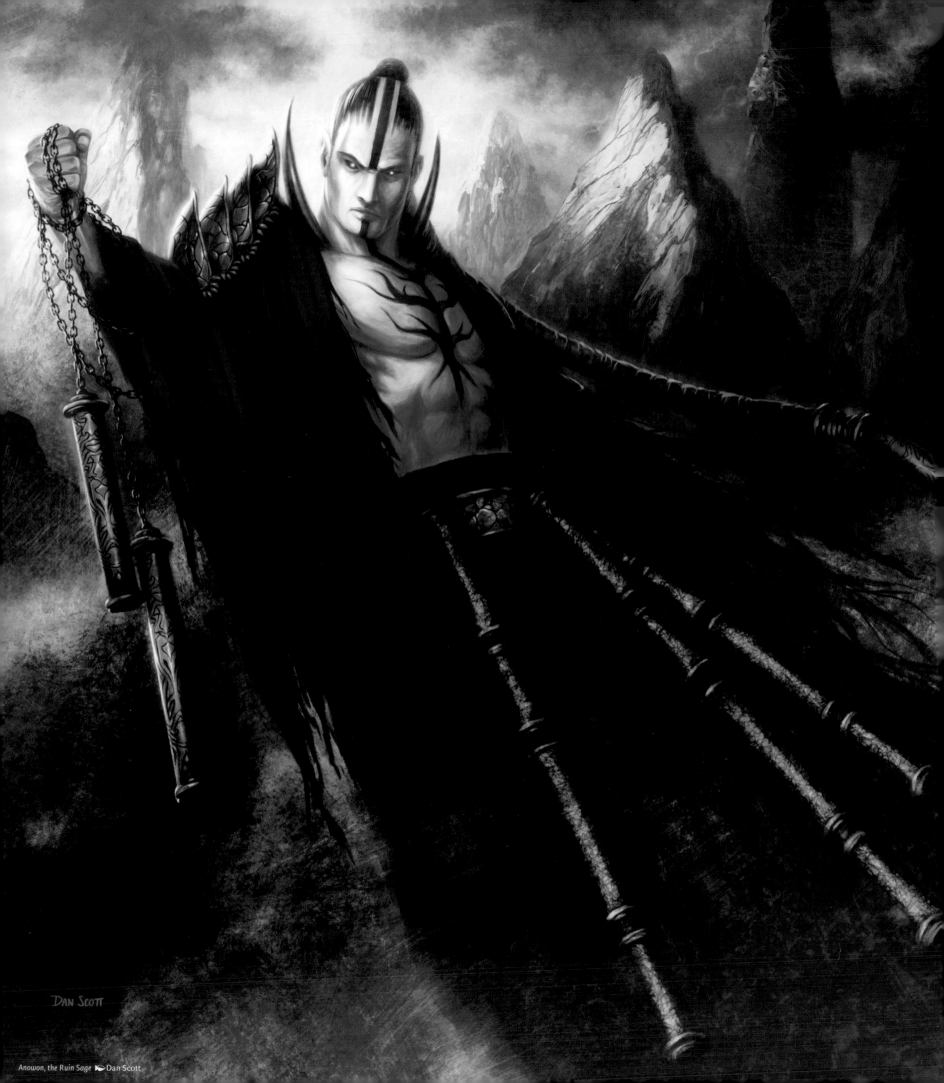

Anowon, the Ruin Sage ▶ Dan Scott

ANOWON THE RUIN SAGE

Anowon is the scion of a powerful vampire family in Malakir and an expert on ruins, runes, and ancient languages. In his relentless search for answers, he has left a trail of corpses from Tazeem to Akoum. Clever and callous, Anowon is a threat that requires serious attention.

In settlements around Zendikar, Anowon is considered a renowned mage and benevolent scholar who leads expeditions from his base camp in the mountains of Akoum. With the help of his followers, he's cultivated an image of himself as a knowledgeable scholar—the man to go to with strange relics and hard questions.

But there are others who speak of Anowon's treachery. Many call him a thief and a murderer. His fellow vampires believe that Anowon is a ruthless power seeker, yet they view him with grudging respect. The dark mysteries of his past paint a picture of him as a sinister figure who is anything but an innocuous scholar.

A Murderous Mercenary

During his early years, Anowon was "first son" of the House Ghet, under the tutelage of bloodchief Tenihas. The exact method of his "birth" is not recorded, but Anowon viewed Tenihas as a father figure, and the bloodchief seemed to hold his young heir in high regard.

By all accounts, Anowon was fascinated with Tenihas's extensive library, particularly ancient texts that alluded to the enslavement of vampires by "famished gods." Before the rise of the Eldrazi and the subsequent Culling, this ancient servitude was merely a vaguely remembered but poorly understood aspect of the vampires' history. According to witnesses, it was this mystery that created animosity between Anowon and Tenihas, who didn't want his young protégé to unearth things better left buried in the past.

One night, Tenihas was brutally murdered in his own bedroom, his retinue slaughtered and his treasure stores plundered. The only surviving witness swore that Anowon had killed his bloodchief in a fit of rage and then vanished. Anowon didn't return to his homeland for many decades, and in the intervening years, the legend of the killing of Tenihas grew to almost mythic proportions.

Anowon spent the next decades as a sell-sword, honing his skills as a mage and warrior during dangerous expeditions. The most reliable information from this period comes from the Bala Ged Expeditionary House, where Anowon pledged his loyalty for a brief period. While hiring himself out to expeditions, he deciphered archaic dialects, inked hundreds of rune-scrolls, and amassed a great collection of relics. Although the circumstances are lost to memory, it was during one of these expeditions that Anowon acquired a powerful scroll now known as the Dragon's Fire. Almost immediately afterward, Anowon renounced his loyalty to the expeditionary house and disappeared from Bala Ged, launching a quest to find the legendary Eye of Ugin.

The League of Anowon

Anowon eventually established a base camp in Akoum, gathering a group of ragtag explorers, adventurers, and mages to help his search. His widespread reputation as a ruin sage proved especially useful, drawing adventurers to seek him out for aid and information. He used their relics and knowledge to further his quest for the Eye of Ugin.

Anowon's students learned techniques for navigating hazardous ruins, retrieving ancient artifacts, and protecting themselves from the many dangers that lurk in such places. Those who left his tutelage could readily find work with other expeditions across Zendikar. When an injury, such as a lost limb or eye or a crippling curse, brought an end to an explorer's career in the field, that person usually remained as a tutor in the league's camp.

Reaching the base camp was no small task, usually involving taking a griffin from the town of Affa below. Prominent explorers often came to the camp looking for student volunteers to help on their next mission. It is believed that Anowon strongly encouraged students he considered expendable to volunteer for such efforts.

Anowon and the Eldrazi

Anowon's many expeditions had a hidden purpose. The Dragon's Fire scroll he acquired during his years as a sell-sword led him to devote many years to searching for the Eye of Ugin, though he had little understanding of its true nature. He ended up playing a small and unwilling role in the release of the Eldrazi when he followed Chandra Nalaar to the Eye of Ugin and then led Jace Beleren there. When the Eldrazi titans awoke and emerged, Anowon was initially drawn to Bala Ged by Ulamog's monstrous call, but he managed to remain free of the Eldrazi's enslavement and has returned to Akoum to rebuild his scattered league.

◆ ANCIENT SITES OF AKOUM

Akoum is rich in ancient ruins and magical sites, which draw explorers despite all the dangers of earthquakes, lava eruptions, dragons, and Eldrazi. Most of the ruins here are thought to be the remains of an ancient kor civilization. Strongly influenced by the presence of Nahiri within the Eye of Ugin, these kor were the first to learn her techniques of lithomancy and to begin the tradition of the stoneforge mystics, and many of the items found in the ruins were shaped from living stone using these methods.

The Eye of Ugin

The three Planeswalkers who originally imprisoned the Eldrazi crafted this site, shaping intricate tunnels and chambers inside the roots of a great mountain. The Eye of Ugin held the key to keeping the Eldrazi in stasis. When the key was destroyed, the three imprisoned titans arose from beneath the mountain, smashing it—and the Eye—into rubble as they emerged. The surrounding lands were completely drained of life and even cohesion: the stone became powder, and the sky was polluted. At the surface, the site of the Eye is now a pit surrounded by heaps of rubble and fallen hedrons. Crazed goblins perch at the edges, gabbling their twisted insights. But deep inside, much of the Eye of Ugin remains intact.

Eye of Ugin ▸ James Paick

Ior Ruin

The still waters of the Glasspool enfold an ancient ruin called Ior. From a high enough vantage point, the bottom of the Glasspool is visible. Circular buildings linked by long arcades stand half-crumbled beneath the surface of the water, their bases sunken in the sand. The site has not been extensively explored, but it was once an ancient center of learning, home to a repository of the kor's magical knowledge.

Ior Ruin Expedition ▸ Chris Rahn

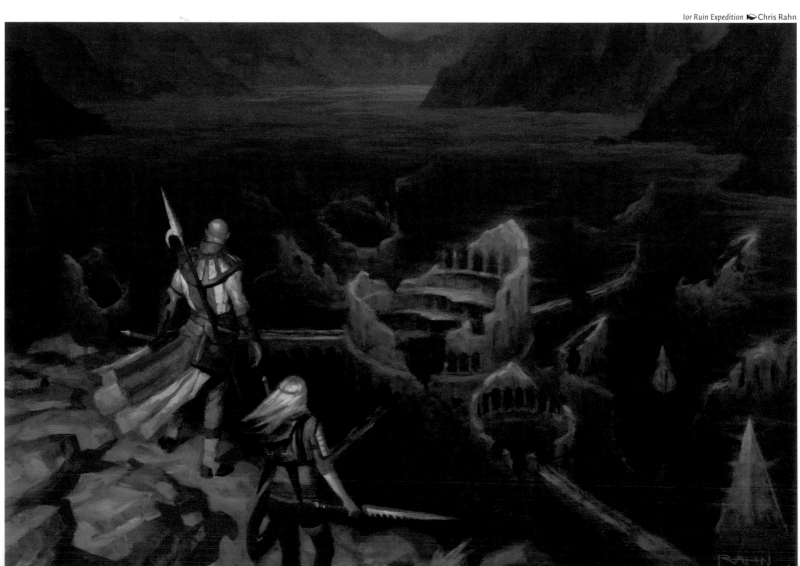

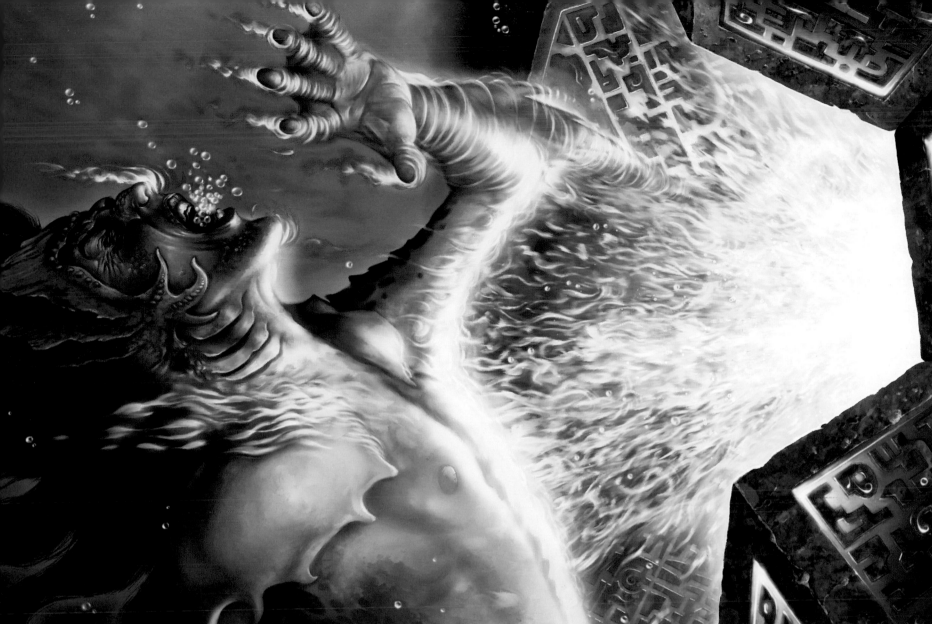

Runeflare Trap ◥ Franz Vohwinkel

Tal Terig

Rising hundreds of feet high out of the Spike Fields is an ancient structure known as Tal Terig, or "The Puzzle Tower." One of the most famous sites on Akoum, the ruin's exterior is a pillar of seemingly randomly assembled geometric shapes of all sizes—ranging from tiny decorative cubes jutting from the surface to enormous tetrahedrons, 20 feet on a side, that make up a significant portion of the structure. The angles and lines of the tower appear to defy the bounds of logic. Some have reported headaches and nosebleeds after looking at its surface for short spans of time.

Reportedly, the portion of Tal Terig that juts above the surface of the ground is just a small portion of the tower's enormous size. Every time an explorer claims to have reached the lowest level, another one discovers some new shaft or stairway leading still farther down. Within the labyrinthine halls and chambers, delvers have found great riches and powerful items of magic, though reports of curses and misfortune seem to trail in the wake of items recovered from Tal Terig.

As expected, the site is as deadly as it is valuable. Kor spirits haunt the halls, and many constructs of animated stone guard against

> "Life is a maze. This is one of its dead ends."
> —Noyan Dar, *Tazeem lullmage*

intruders. Magical traps line each and every hall, and the halls of the spire rotate and cycle, ensuring that no trap learned by explorers stays exactly the same for long. The sound of grinding stone carries for miles from the tower, and it's a sound that tells the few creatures brave enough to serve as guides that all their hard-earned information about the layout of the ruin has just become obsolete.

Tal Terig was actually constructed by the ancient people who eventually became the vampire race. As the Eldrazi infection took root in them, many of them were driven mad, their minds touched by the alien intelligence of the Eldrazi, and the madness of Tal Terig is the result. It was theoretically a temple to the "mountain god" they revered, but its construction far exceeds the extent of its actual use.

◆ GUUL DRAZ

Guul Draz is a humid region of twisted, dark-leafed trees, fetid lagoons, and vast, tangled swamps. A sense of decay pervades the place, from the reek of moldering vegetation to the crumbling ruins jutting up from the black waters like broken bones. Venomous spiders and scorpions crawl among the trees, and deadly snakes slither on branches or swim in the stagnant waters. This dismal place was the vampires' homeland, but the rise of the Eldrazi hit Guul Draz hard, and the vampires were changed by their presence. Ulamog ravaged the continent, and now the land bears a massive scar of barren, chalky rock where no vegetation will grow and dust-filled riverbeds where water refuses to run.

The festering decay and noxious growth that define most of Guul Draz extend from the depths of the earth and high into the air. As on the rest of Zendikar, islands of rock, vegetation, and mud float in the air overhead, often spilling cascades of water from some impossible source. Tangles of roots and raw elemental water are suspended above the swamplands. And gaping sinkholes open into deep caverns with their own stagnant swamps far below.

Death comes in many forms on Guul Draz, most of them slow, subtle, and agonizing. Vampires embody the ever-present danger, stalking and feeding on members of other races that are foolish enough to come in search of ancient ruins or actually build settlements in the vast swamp. Venomous animals of all kinds lurk in the swamps and gullies, from tiny spiders to enormous six-legged basilisks. Even the terrain—quicksand, hidden sinkholes, carnivorous plants, and toxic pools—can kill as surely here as in the volcanic reaches of Akoum. The sodden land and murky waters alike are treacherous, concealing deadly hazards and hungry predators. At least a monstrous crocodile offers a swift death, in contrast to the lingering torment of a wasting sickness or a giant scorpion's agonizing sting.

> *"Is there anything in Guul Draz that doesn't suck the life out of you?"*
> —Tarsa, Sea Gate sell-sword

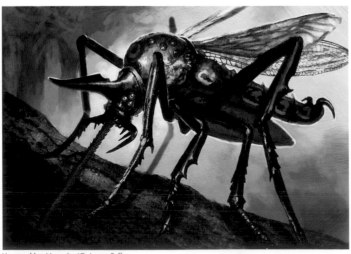

Heartstabber Mosquito ☙ Jason Felix

Swamp ☙ Sam Burley

Hagra Swamp

Much of Guul Draz is covered in an enormous mire of murky water called the Hagra Swamp, dotted with clumps of rotting organic matter and the occasional rocky outcropping. Low trees draped with hanging moss jut up from the sodden ground to hide the sky, and rising mist shrouds the surface of the water. Standing pools of water often have a sickly green tint, exposing the foulness they contain. Gloom hangs over the swamp like a dark canopy, which perfectly suits the vampires and other creatures that reside in it.

The abundant flora in the Hagra Swamp includes a wide array of deadly plants that derive nutrients from large prey rather than the waterlogged soil. Tendrils from giant carnivorous lilies and algae eagerly latch on to passing creatures, dragging them down into the fetid depths to be consumed. Giant underground caverns have filled with strange fungal organisms with toxic spores. Interestingly, some of these growths have spores that specifically disorient and weaken the broods of the Eldrazi, while leaving other creatures mostly unharmed.

Snap fens are low rises that appear to be solid ground surrounded by reeds. But when a creature or vessel pushes into a snap fen, the strong, sharp reeds whip out to their full length, spearing nearby creatures—and boats—and then slowly retract into the water, dragging their prey along. Creatures that survive the initial attack often

Hagra Crocodile ▶Daren Bader

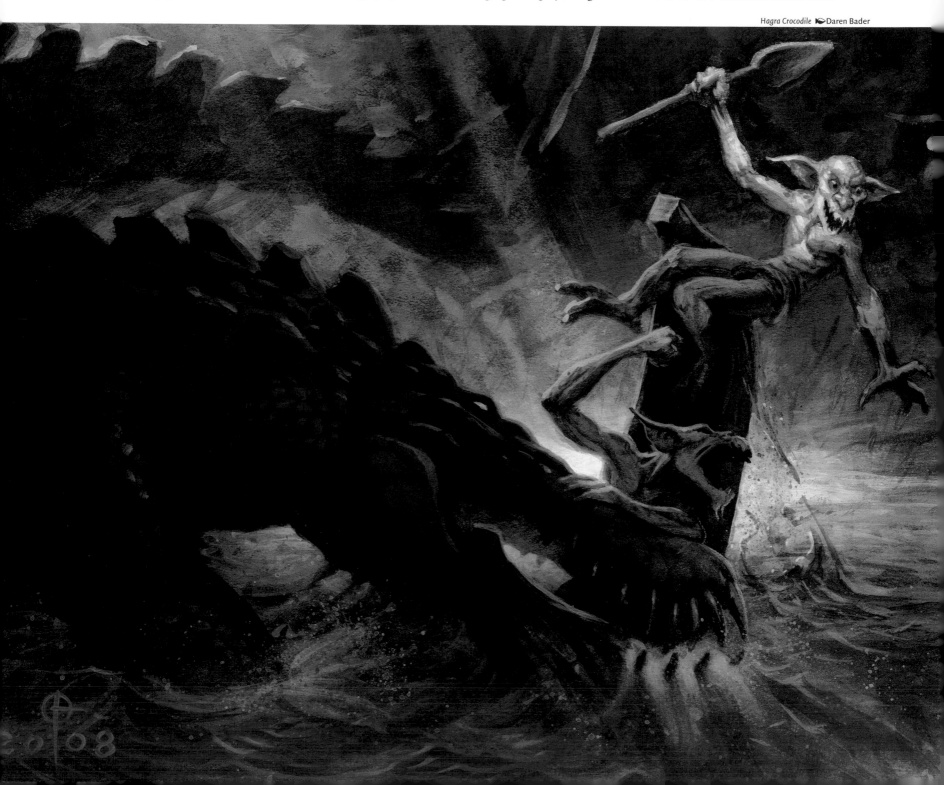

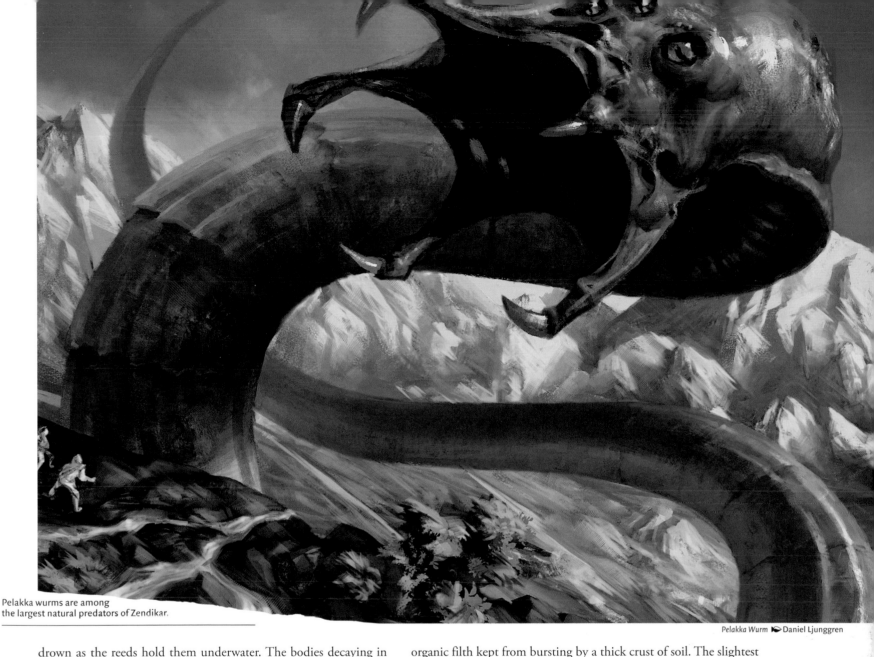

Pelakka wurms are among
the largest natural predators of Zendikar.

Pelakka Wurm ⏵Daniel Ljunggren

drown as the reeds hold them underwater. The bodies decaying in the water serve as food for the horrible reeds. Merfolk bandits often lurk around the snap fens, since the reeds are easily avoided below the surface of the water. These bandits lure small barges into range of a snap fen and then scoop up the cargo after the barge is shattered and dragged under.

Giant water lilies grow in many areas of the swamp, completely covering the water surface with leaves so large, and so densely packed, that travelers can march across them without sinking more than ankle deep. However, lilies of a carnivorous variety—called greed lilies—grow among stands of their harmless cousins. When a creature stands or walks on a greed lily's pad, the leaf rapidly curls inward, wrapping around its hapless prey. While the thick, waxy leaf holds the creature fast, corrosive fluid seeps out to dissolve its flesh and extract the nutrients that the plant feeds on. Some opportunistic scavengers make a living by gathering metal equipment, unharmed by the corrosive fluid, that accumulates in the muck below a greed lily.

Filth Bursts. Scattered around the Hagra Swamp are patches of ground that appear solid but are actually bubbles of noxious gas and organic filth kept from bursting by a thick crust of soil. The slightest damage to this crust, though, releases a massive eruption of oily black sludge called a filth burst. The toxic sludge is usually fatal to whatever creature triggered the burst, but occasionally the corrupted magic it holds actually transforms the creature into a bestial horror.

Pelakka Karst

A vast region of limestone gullies, sinkholes, rises, and caves surrounds the Hagra Swamp, crossed by fast-flowing rivers churning through narrow canyons and tunnels. This Pelakka Karst is treacherous to navigate, and the predators lurking in the waterways—some of the largest river predators in all of Zendikar—add to the danger. In addition, much of the Karst shifts regularly, and some of the caves are actually monstrous mouths. Those who travel down the wrong channel can find themselves ground to a paste by the rapidly moving walls or swallowed by enormous wurms. Even so, groups of vampires and other refugees have set up camps in the Karst, preferring to take their chances with the natural dangers of the place rather than face the unnatural horrors of the Eldrazi.

Hanging Swamp ▶Vincent Proce

Zof Marsh

The northwest coast of Guul Draz is covered in a huge mangrove swamp called Zof Marsh. The red mangrove trees that grow here are valued for their flowers, which are a source of a powerfully intoxicating pollen that is used to make perfumes, potions, and in high concentration, a deadly poison favored by vampire assassins. Stalking swampcats, a small clan of Tajuru-nation elves, and enormous saltwater crocodiles are prominent denizens of the marsh. An ancient ruin, the Helix of Zof, lies in the midst of the swamp, spiraling up among the mangroves from an unknown source buried in the silt at their roots.

Lake Jeft

Rivers that flow southward out of the Pelakka Karst wind their way to Lake Jeft, a large freshwater lake to the southwest. Its dark waters are thick with weeds and algae, but merfolk swim near the shores and up the rivers that feed the lake.

The Lake of Dust

The northernmost part of Guul Draz is connected to Bala Ged and shared in that region's utter destruction. The people who live nearby, including refugees who fled the area, now refer to the desolated swampland as the Lake of Dust. It is a massive scar of barren, chalky rock where no vegetation will grow and dust-filled riverbeds where water refuses to flow.

The Hanging Swamp

The Hanging Swamp, in the north of Guul Draz, is a maze of floating water globules, clots of mud and reeds, and tangled vegetation. This bizarre swamp network hangs in the air above and inside an enormous sinkhole, with roots and creepers anchoring the whole soggy mass to the sinkhole's sides. The entire thing is in constant motion: water flows from one location to another, clumps of earth drift to new positions, and vines twist and coil around whatever solid mass happens to be nearby. Only the most expert guides can navigate the swamp with any certainty since the pathways are constantly changing, and many unprepared explorers have entered it and simply never emerged again.

The Hanging Swamp is filled with predators that use the terrain to mask their own presence and trap prey. Giant amphibians and insects abound, concealed in the vines and reeds. The deadly Guul Draz python is large enough to swallow a human, and a few small tribes of humans live in crude reed huts on some of the larger clumps of sodden ground.

Blighted Fen ▶Jonas De Ro

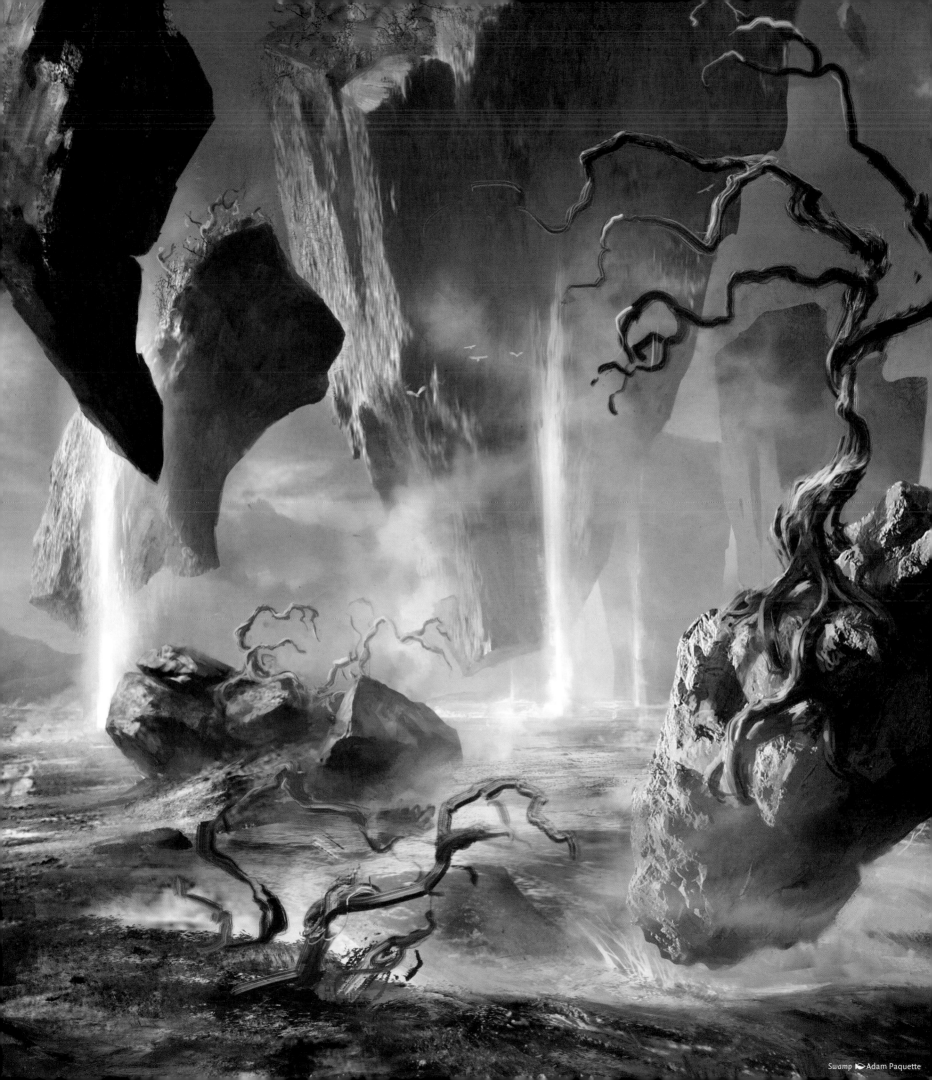

Swamp ◈ Adam Paquette

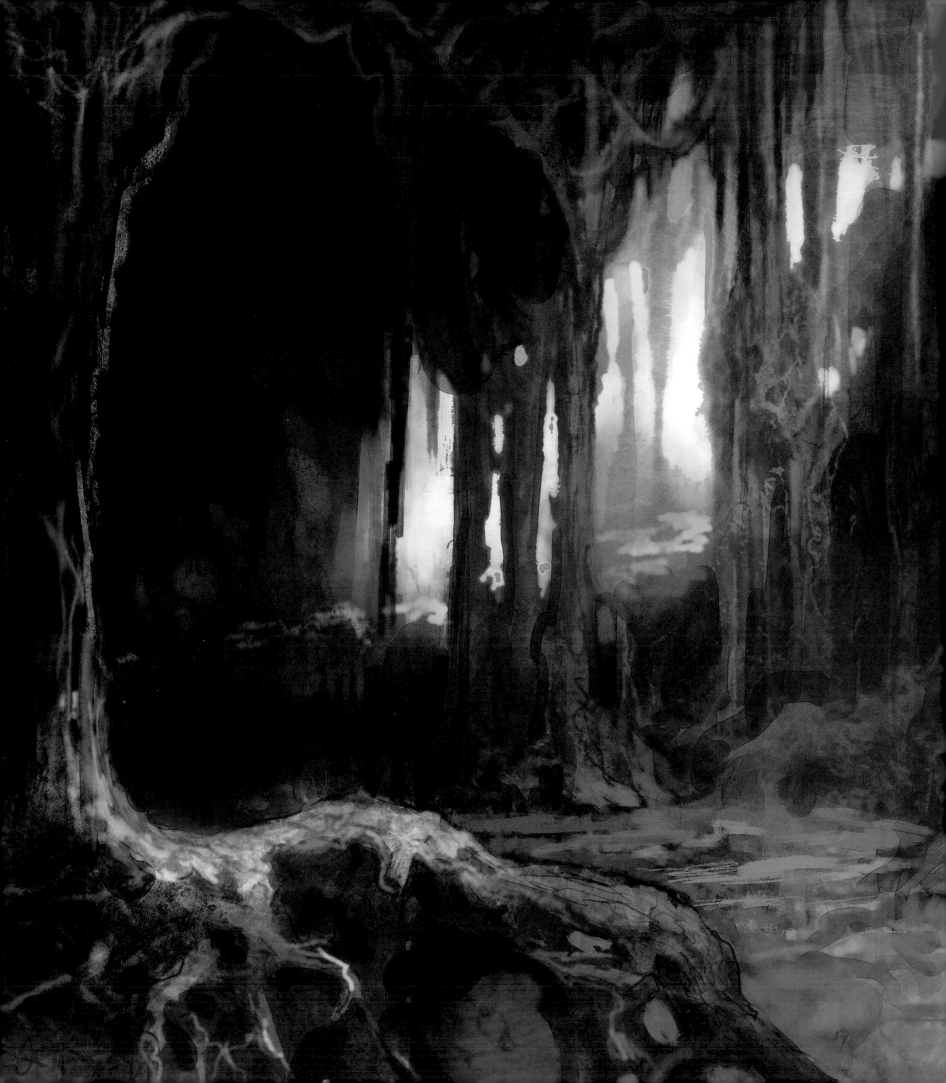

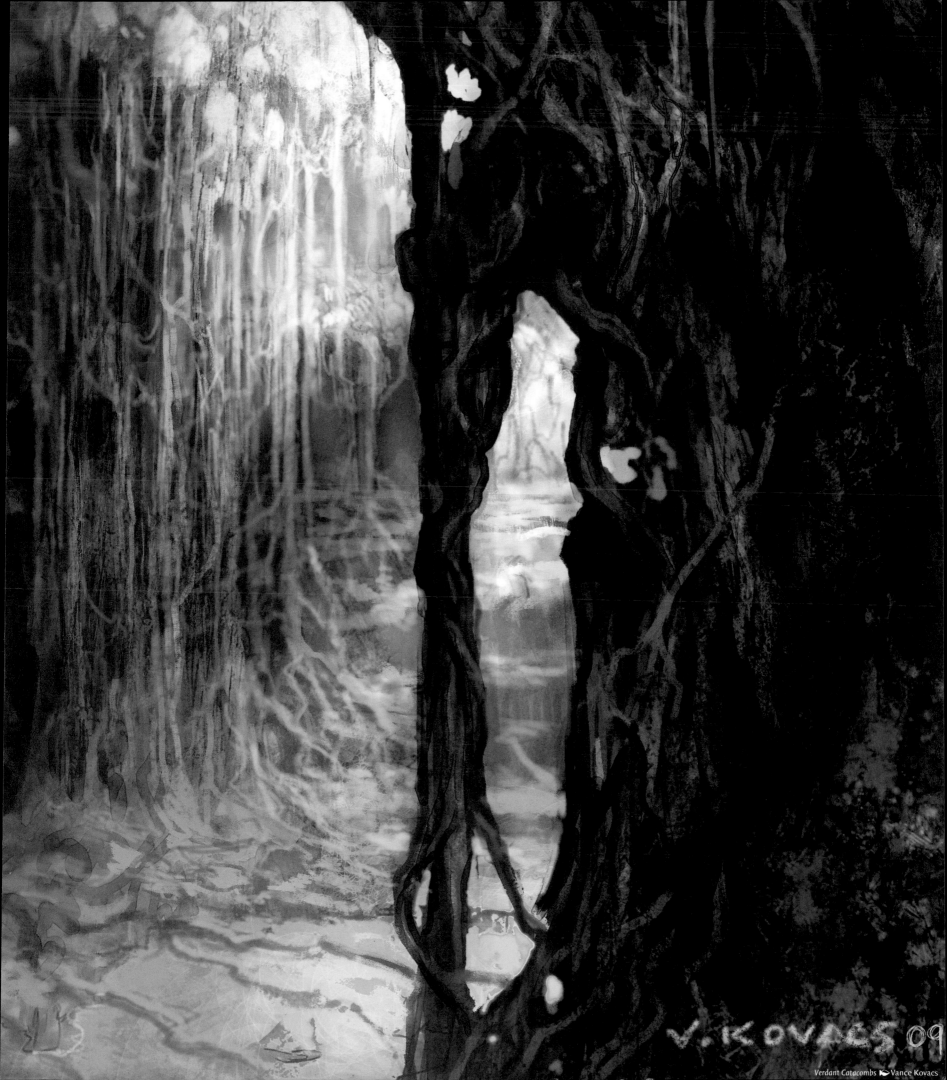

◆ LIFE IN GUUL DRAZ

Guul Draz is the vampires' homeland. On other continents, vampires usually live in hiding, blending in among the other races as best they can, but in Guul Draz they live openly. They are dangerous, sometimes turning on the merfolk and humans who are bold enough to live in the vampire cities, and sometimes infiltrating and feeding on the scattered villages and tribes of elves, humans, and merfolk that exist across Guul Draz. Despite this, Guul Draz has a significant number of visitors. Although walking among the vampires is extremely risky, the dark swamps also offer the prospect of dark power and great wealth.

Besides the vampires, merfolk live along the waters of Guul Draz and are an important part of the flow of trade and commerce through the land. An unusually high number of merfolk who secretly follow Cosi's creed dwell here, though some of them have now renounced their creed and put their skills to use against the Eldrazi. Humans have also carved out several settlements along the edges of Guul Draz and along its major waterways. Both humans and merfolk make their livings on the rivers that are the most reliable highways throughout the region, despite the risks of predators.

In addition, small tribes of elves and humans live in the Zof Marsh and the Hanging Swamp, respectively. These tribes are extremely insular and suspicious of visitors, as they believe that all outsiders are deadly bloodsuckers like the vampires that occasionally raid their territory.

Retreat to Hagra ▶ Kieran Yanner

Even the ruins of the vampires' mobile sledge-camps, made from the chitin of giant insects, are useful shelter from the hostile environment of Guul Draz.

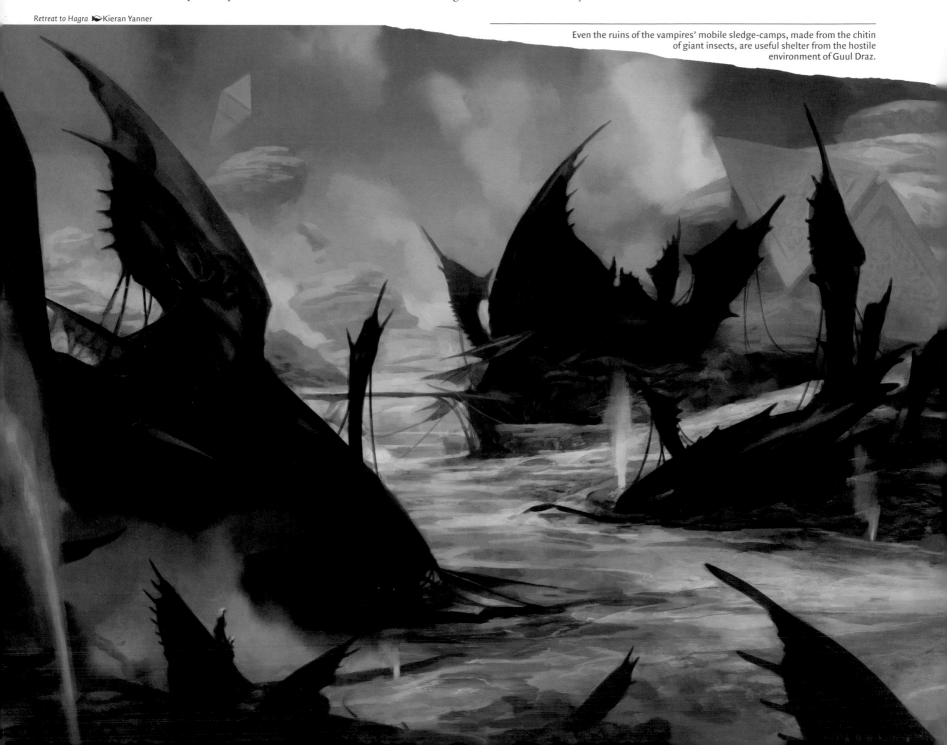

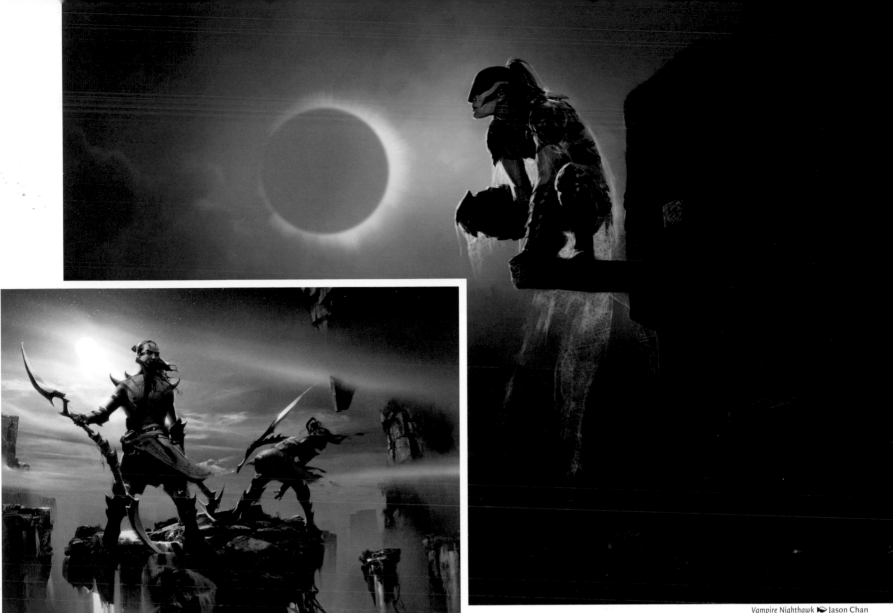

Kalastria Nightwatch ◗ Jama Jurabaev

Vampire Nighthawk ◗ Jason Chan

Malakir, the Dark City

Built on a low rise amid the Hagra Swamp, the former vampire capital of Malakir was once the largest city on all of Zendikar. When Ulamog awoke, however, half of its vampire population immediately fell under the Eldrazi titan's control and turned on the other half, launching a devastating civil war that left Malakir in ruins. Drana, the bloodchief of the Kalastria family, escaped the initial fighting and has now returned with other surviving vampires who are free from Ulamog's control and retaken the city. Once a place of dark excesses and dubious pleasure-seeking pursuits, Malakir has been repurposed as a grim fortress, the last true refuge of the free vampires.

Before the rise of the Eldrazi, Malakir had a reputation for debauchery and decadence, befitting the hedonistic ways of the vampires. The city was divided into five districts, each named after the vampire family that controlled it. These districts survive, though not all of them are still inhabited.

Nirkana District is built on the water and can only be traversed using the rancid canals that wind through the decrepit buildings.

Kalastria District is located on the highest ground in the city and doesn't depend on the dikes and levees to keep it dry. It is the oldest, wealthiest part of the city and also the most defensible, so it remains Drana's base of operations.

Emevera District is positioned at a low point in the city. Giant stone dikes once kept the swamp waters out, but with the fall of the city the dikes were broken, and this district has become part of the swamp. Its vampire inhabitants have given way to crocodiles and pythons, which are nevertheless effective at protecting the district from Eldrazi invaders.

Urnaav District is a mix of stone-paved roads and narrow canals, lying between the low point of Emevera District and the high ground of Kalastria District.

Ghet District is a flooded and barren ruin. Even before the rise of the Eldrazi, House Ghet had suffered a major political setback that left it impoverished and outcast. House Emevera diverted water around its dikes to flood Ghet District, and now house Ghet has gone completely over to the service of the Eldrazi under the leadership of Kalitas.

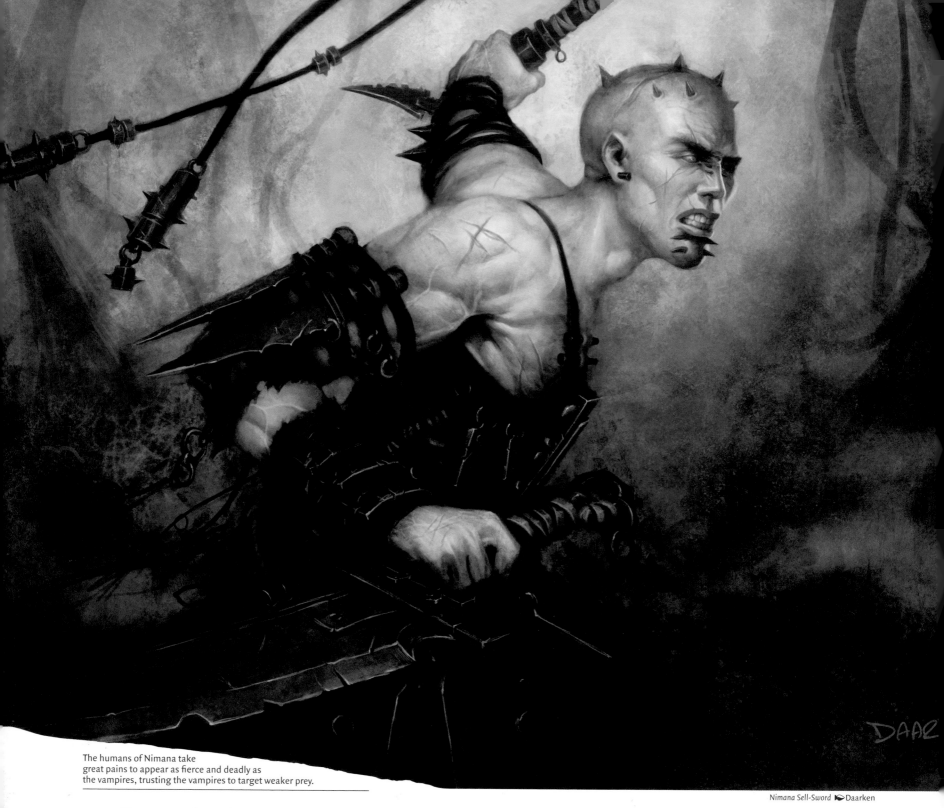

The humans of Nimana take
great pains to appear as fierce and deadly as
the vampires, trusting the vampires to target weaker prey.

Nimana Sell-Sword ▶Daarken

The Free City of Nimana

A coastal city built by humans, the Free City is ironically named because it is the major port where slavers buy and sell their wares. The most hardened denizens of Guul Draz, mostly vampires but also lowlifes of other races, purchase slaves in huge lots to work in their industries, and in the case of the vampires, to provide new food and sport. Likewise, Nimana is the major export center for the mercantile products of Guul Draz that are sent to other lands for trade. As such, nearly every vampire who is heading out to infiltrate the rest of the world passes through Nimana.

A shadowy council known as the Septumvirate rules Nimana and represents the major interests of the city. The members of the council carry bizarre and evocative titles: the Keeper of Keys (representing the city's slavers), the Prismatic Seer (representing the Chromatic Council of mages), the Carrier of Coins (representing the merchant houses), the Scaled One (representing trappers, whose prey is largely reptilian), the Forger of Chains (representing smiths), the Dock Keeper (representing the wharf laborers), and the Sentinel (representing the city guard).

Before the coming of the Eldrazi, the Septumvirate was infiltrating Malakir and other settlements in and around Guul Draz, trying to take control of the "Dark Trades," as they euphemistically refer to their criminal endeavors. A secret alliance with house Ghet in Malakir gave them access and a safe base of operation in vampire territory. For its part, House Ghet used this alliance to gain access to the inner decision-making apparatus of Nimana and began actively converting influential members of the town to their cause—and sometimes to their race—in hopes of adding the city to their holdings and raising their own prestige and power. With the coming of Ulamog and the enslavement of Kalitas and House Ghet, of course, all these plans have come to nothing, and Nimana is in chaos.

The Chromatic Council. The Chromatic Council is a pretentious order of mages specializing in the pure colors of mana. Although it enjoys some modest fame as a school for mages, the council's more important work is the sponsorship of various expeditions to explore the ruins of Guul Draz. The Chromatic Council has always been particularly interested in magical treasures and lore, and all the more so now that the Eldrazi have become such a threat. Persistent rumors before the Eldrazi's rise said that the council had

secret lore foretelling some terrible apocalypse, but that lore has not proven particularly useful in combatting the Eldrazi now that they have brought ruin to the world.

Lulea

A merfolk settlement called Lulea is located on the dark shore of Lake Jeft. The merfolk are mostly concerned with the river and lake trade, policing the major waterways and demanding tolls from anyone who travels over or under the waters. The settled merfolk actively oppose most of their kind who act as river bandits, but a few such bands are recognized as official privateers, chartered to take down the other groups and bring their plunder to Lulea.

The merfolk of Lulea had largely rejected the traditional creeds even before the Eldrazi's arrival. Many of them follow Cosi, including their leader, a sage named Ennesh. Ennesh has ruled for the last decade, and she is widely regarded as a just, if stern, ruler. The vampires count her as a good neighbor, figuring that the predation of her privateers is substantially less costly than the river and swamp bandits they hunt.

Cosi's Trickster ◄ Igor Kieryluk

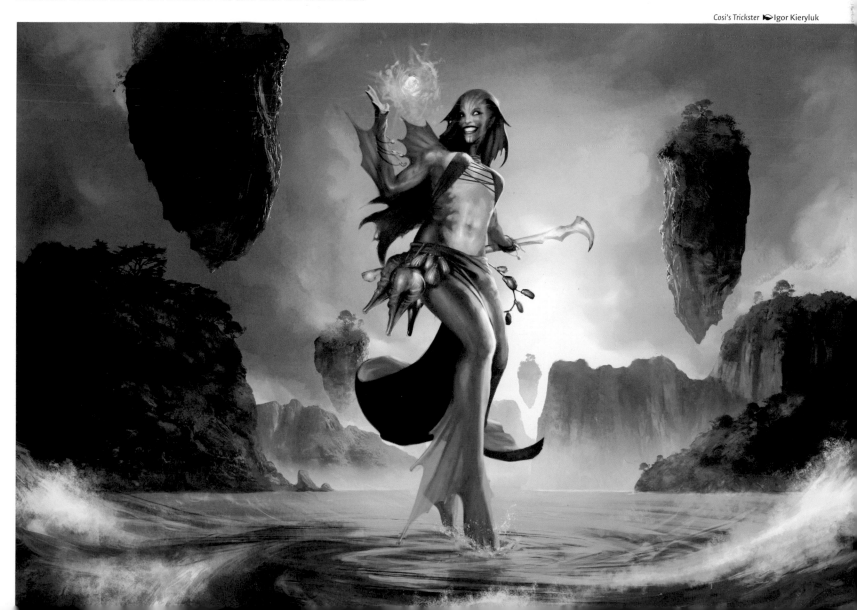

◆ BLOODCHIEFS OF MALAKIR

The bloodchiefs who rule vampire society are incredibly ancient beings, infected long ago by a disease of Eldrazi origin. Any given bloodchief has literally forgotten more than most other living beings will ever know, carrying no recollection of his or her own creation or the first escape of the Eldrazi. Drana of House Kalastria, though, has begun experimenting with magic to dredge her memories for information that might be useful in combating the Eldrazi, with some limited success.

The bloodchiefs are the parents of the entire vampire race. Only a bloodchief can pass on the infection that animates their nearly dead bodies. Over the centuries, the number of bloodchiefs has been reduced from hundreds to barely a dozen as the houses warred among themselves, and in the wake of the Culling, only two bloodchiefs survive. Survivors from a slain bloodchief's house have been incorporated into other houses, so it is not necessarily accurate to say that all members of House Ghet, for example, were transformed by Kalitas, the Ghet bloodchief. Nevertheless, they all owe Kalitas their allegiance and follow his lead in everything, even now that he serves the Eldrazi.

A vampire house consists of the bloodchief, a number of lesser vampires, and each vampire's retinue of nulls—the zombielike creatures created when a lesser vampire drains the blood of another thinking being. A major house, like the five that used to rule Malakir, might contain about a thousand vampires, each with a contingent of three to five nulls. Lesser houses might have as few as a hundred vampires.

The five major vampire houses formerly dominated the city of Malakir, each in its own district of the city. Two houses have risen to prominence in the wake of the Eldrazi's arrival—Kalastria and Ghet.

House Kalastria is led by Drana, who is the leader of the resistance to the Eldrazi devastation. Most of the lesser houses have banded together under her leadership, and many members of the other major houses follow her lead even if they won't publicly swear their loyalty. House Kalastria has long been the wealthiest vampire family, and members considered themselves the aristocracy of Malakir even before Drana's new position of leadership. They often call themselves the Highborn, and they still think of themselves as superior to the other vampires who have united under Drana's banner.

House Ghet, led by Kalitas, has gone completely over to the service of the Eldrazi. Kalitas is perhaps the only member of the house who retains his intellect and reason, and many of his subjects aren't really capable of thinking of themselves as a house anymore. But Kalitas fills the role expected of a bloodchief, siring new vampires at an unprecedented rate to make new slaves for the Eldrazi.

House Nirkana's bloodchief, Tanali, was killed in the Culling that resulted from Ulamog's awakening. Now the house is split, with many of its members following Kalitas and others joining house

Vampire Lacerator ◆ Steve Argyle

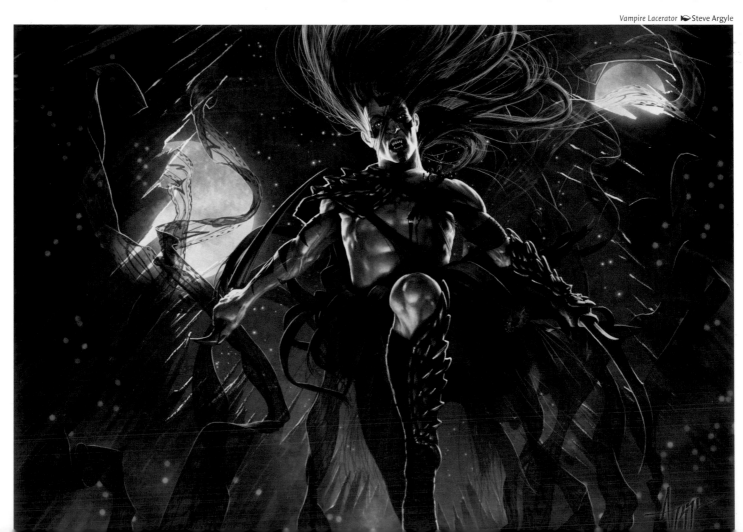

Defiant Bloodlord ▶ Craig J Spearing

"The Nirkana are cutthroats who run about the swamps like drooling animals. The Ghet are no better than gutter rats. The Emevera are so common they couldn't appreciate a fine meal if it died on their doorstep. The Urnaav are obsequious idiots who think we are too stupid to see their machinations. They would all be Kalastria if they could, and who could blame them?" —Lyandis, *family Kalastria*

Kalastria. Nirkana assassins, called Lacerators, have always been notorious for their stealth and skill, and now these assassins fight on both sides of the plane's conflict.

House Emevera was a wealthy family but not an aristocratic one. Its access to resources enabled it to build the strong stone dikes that kept its district of Malakir from flooding before the city's fall, but the Highborn of House Kalastria never admitted their Emevera cousins as social equals. Most of House Emevera has returned to the service of the Eldrazi, and even those who escaped Ulamog's thrall prefer to make their own way in the world rather than follow Drana.

House Urnaav claimed the distinction of being the largest of the major houses, though it lacked the wealth and prestige to hold much influence in Malakir's politics. Like house Nirkana, its members are now split between Drana's and Kalitas's leadership.

115

Watery Grave ▶ Min Yum

◆ ANCIENT SITES OF GUUL DRAZ ─

No doubt Guul Draz holds as many ancient ruins as any other region of Zendikar, but its vast marshes have swallowed many sites that might otherwise lie accessible to explorers.

Hagra Diabolist ▶ Karl Kopinski

Ḥagra Cistern

This ancient structure, vast and mysterious in purpose to all current knowledge, sits at the edge of the great Hagra Swamp—no one can say for sure which gave its name to the other. It was built by merfolk shortly after the Eldrazi's first escape in an effort to reclaim land that had been corrupted by the teeming broods of the Eldrazi titans. These ancient merfolk used powerful spells—distantly remembered as the magic of lullmages that soothes the churning land—to reshape the terrain, channeling water to flood the desolation and wash away the corruption the Eldrazi left behind. The great cistern was constructed at the center of the flood to drain the water away and purify it.

The effort was only partially successful. The land shifted, creating the Pelakka Karst, and the rivers diverted. The magic of the cistern itself was not up to the task of cleansing the Eldrazi pollution from the water. The pipes and drains clogged, the filtering spells failed, and the fresh river water pooled into an enormous mire of foulness and corruption. The waters of the Hagra Swamp still flow, very slowly, toward the cistern, but instead of being purified there, they carry corruption back out under the swamp. The filth bursts that occur in the swamp are the result of this water making its way back to the surface.

The origin and intended function of the Hagra Cistern are not widely known, and careful study of the cistern has proven difficult thanks to the corrupt and evil forces that seem drawn to it. Ogres haunt the area, led by shamans who view the cistern as a portal to the underworld, supported by the frequent sighting of demons in the area.

Helix of Zof

At the heart of the Zof Marsh, a mysterious structure lies mostly submerged beneath the mangrove roots. Floating above this structure, though, is a giant spiraling monument of ancient origin called the Helix of Zof. It is covered in clinging vines, which makes it almost disappear among the leaves and branches of the trees. This strange monument was constructed by the vampires when they first came to Guul Draz from Akoum, while the Eldrazi broods still swarmed over all of Zendikar. The helix was an effort to channel the energy that the vampires siphoned from other living creatures and direct it toward the imprisoned Eldrazi in hopes of loosing their bonds and freeing them upon the plane. Nahiri managed to seal the titans' prison before the helix could be put to use, but now that the Eldrazi titans have been freed, the helix has begun to turn, tearing the clinging vines free from the ground and nearby trees.

The Helix of Zof is haunted by shades—dark spirits that bear little resemblance to whatever form they had in life. The animals and elves of the marsh give the ruin a wide berth.

"Tribes of ogres make their home in the Hagra ruins. Cruel as vampires, they place no value on life. It's like their lungs are filled with the foul breath of the underworld. I always hire one, though, because they can slaughter undead better than anyone else."
—Ferth, Nimana expedition leader

Zof Shade ▶ Jason A. Engle

MURASA

A thick mat of leaves, flowers, ferns, vines, and shrubs covers most of verdant Murasa. Dense jungles blanket the land, from the edges of the towering cliffs along its coasts to the inland heart of the continent. Leafy plants cling to the rocky ridges, fill damp crevasses to bursting, and reach high up into the sky where they clutch at floating rocks and worn hedron stones. Clinging vines wind through deep valleys, up cliff walls, and down into caverns in the earth, where they hang in midair. The growth is irrepressible—though the Eldrazi titans have passed over the land several times, Murasa has regrown its jungles time after time. Above the dense forest canopy, Murasa seems healthy and alive, untouched by the Eldrazi cancer. But under the trees, new types of Eldrazi broods grow with the same vibrant fervor as the jungle foliage, multiplying and learning to navigate the perils of Zendikar.

Murasa is an island—a vast, steep-walled plateau that rises sharply from the sea. Sheer, stony cliffs form an almost impenetrable wall around its perimeter, which drops off sharply to the interior.

Only four reliable routes pass through Murasa's Wall, and most of them require the assistance of guides—or the payment of heavy tolls.

Isolated from the rest of Zendikar, Murasa boasts many unique varieties of flora and fauna. Harabaz, jaddi, and jurworrel trees form distinctive environments in different parts of the island. The aerial jellyfish called gomazoa, enormous four-legged predators called terra stompers, and gigantic jagwasps are examples of the peculiar animals native to Murasa's jungles.

> "Now I know why they call it Shatterskull Pass. Rocks fell all night like hammers smashing an anvil. It's no wonder the giants are angry all the time." —Mitra, Bala Ged missionary

Skyfang Mountains

The high, steep-sided Skyfang Mountains are covered in forests. They extend from the western side of Murasa and wind deep into its interior, dividing the western half of the continent in two. Those who wish to get over the mountains must brave the dangers of its beasts and the perils of its "fangs"—huge stalactite-like shards of rock that float above the mountains when the sun shines on them but plummet down to stab the mountainsides when the sun sets or when a passing cloud blocks the light.

Shatterskull Pass. Flying is the safest way to go through the Skyfang Mountains, but the next best option is traveling by way of the aptly named Shatterskull Pass. A wide trail passes through on a relatively shallow incline, but dozens of rock fangs hang above the pass, their bottoms blunted into flat surfaces by countless ground-shuddering impacts into the earth. Travelers through Shatterskull must beware not only the fall of the fangs but also raiding bands of giants and minotaurs.

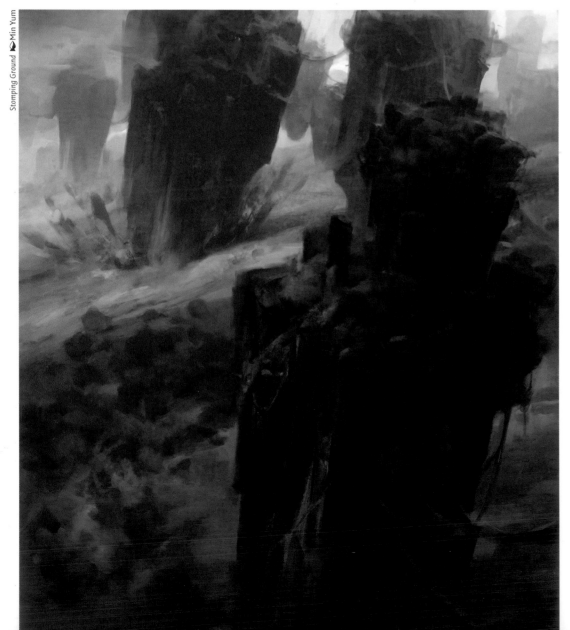

Stomping Ground ◆ Min Yum

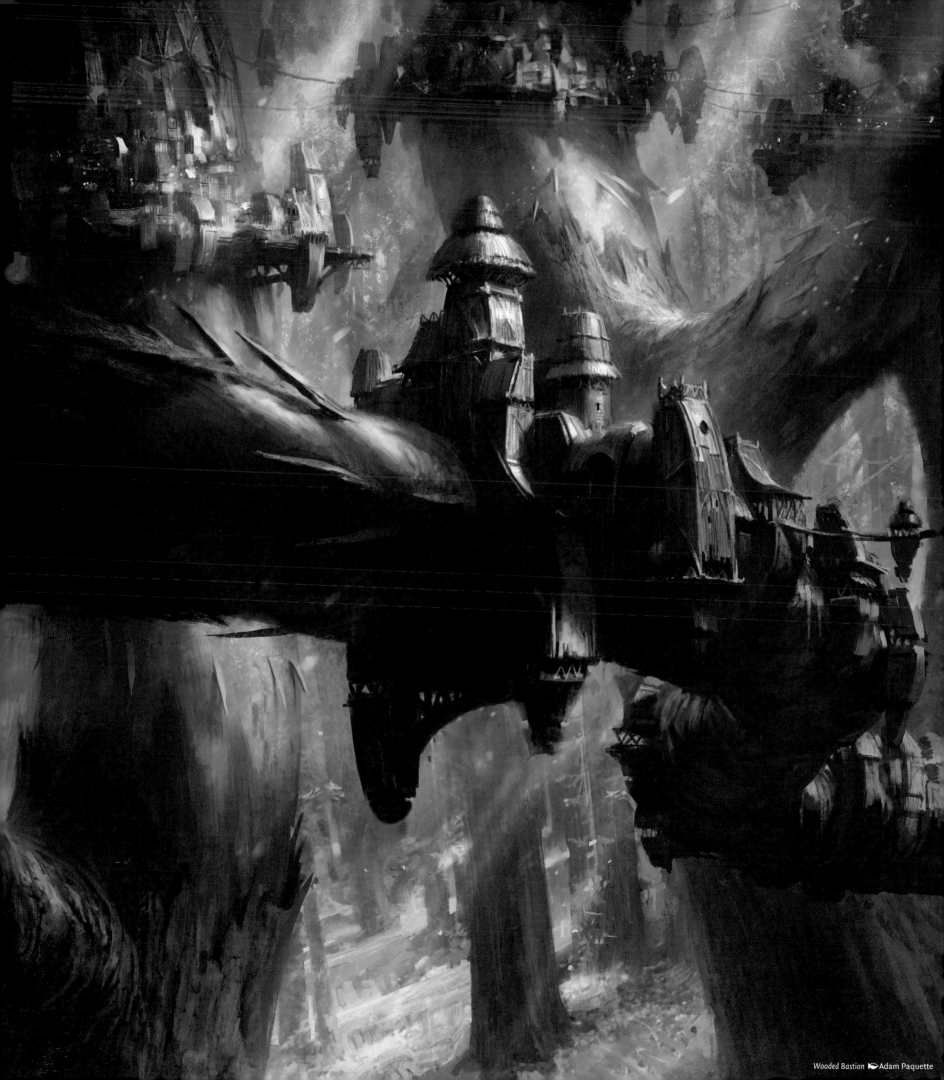

Wooded Bastion ✎ Adam Paquette

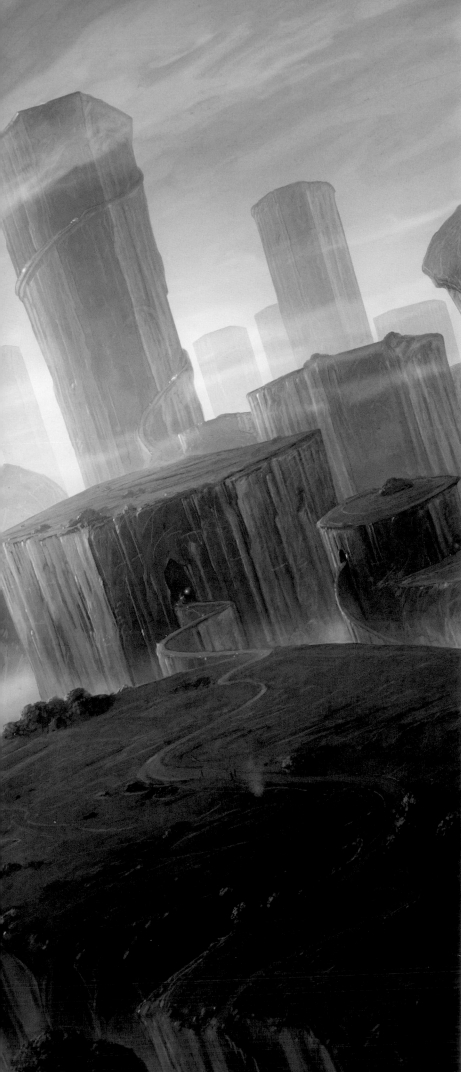

Kazandu

In a cataclysm lost to memory, the region that is now Kazandu collapsed into the earth as though a bubble had burst beneath the skin of the world. This collapse left a broken landscape of irregular canyons, twisting valleys, and high broken steppes, all dotted here and there by plateaus that tower above the landscape, marking the previous ground level. Most of the lower areas are dominated by the towering jaddi trees, many growing nearly as tall as the plateaus.

Jaddi Trees. The jaddi trees form an enormous web of branches, capable of supporting whole villages of elves. Countless plants grow on their branches, and whole species of creatures live and die in their canopy, many never even seeing the ground. The trees are so tall and their branches so wide that the ground beneath them is draped in eternal shadow. Jaddi trees grow slowly but dauntlessly. The wood of a jaddi tree is as hard as stone and grows over cuts. No one knows how long a jaddi tree can live—none have ever died.

Root Caves. Deep beneath the canopy of Kazandu, in the valleys created by the roots of the jaddis, three great crevasses open into the earth. One is the Doom Maw, dominion of demons and bone-hoarding dragons. The second, Silent Gap, is plumbed by a group of vampires that seeks some secret beneath the earth. The third is the migratory home of deadly species—caustic crawlers, giant bats, and shadow scorpions—each inhabiting the crevasse at a different time.

Na Plateau

The Na Plateau rises from the land just east of the center of Murasa. Roughly a quarter mile high, its forested top is about as high as Murasa's Wall. Giant wurms dwell in the cracked cliffs of the plateau, hunting the surrounding lands for miles around for beasts large enough to make a meal. The plateau is also home to several small goblin tribes that battle over the scraps they can retrieve from peril seekers and explorers who come to plumb its secrets.

Raimunza River

This rushing flow of water winds from the base of the Na Plateau to the edge of Kazandu. There it falls onto the wide branch of a jaddi tree that grew under the water's flow. Now the river flows along jaddi branches for miles. While some stretches are relatively level and quiet, others dive like waterslides or fall from a great height only to be caught by another channel in a different branch. Eventually, the river plunges into the marshy Blackbloom Lake in the center of Kazandu.

Pillar Plains

A section of Murasa's Wall on the eastern side of the island is cracked and broken into thousands of massive pillars, the tops of which are grassy plains buffeted by sea winds. For generations a clan of kor dwelt atop the pillars, living a simple herders' lifestyle, a strange

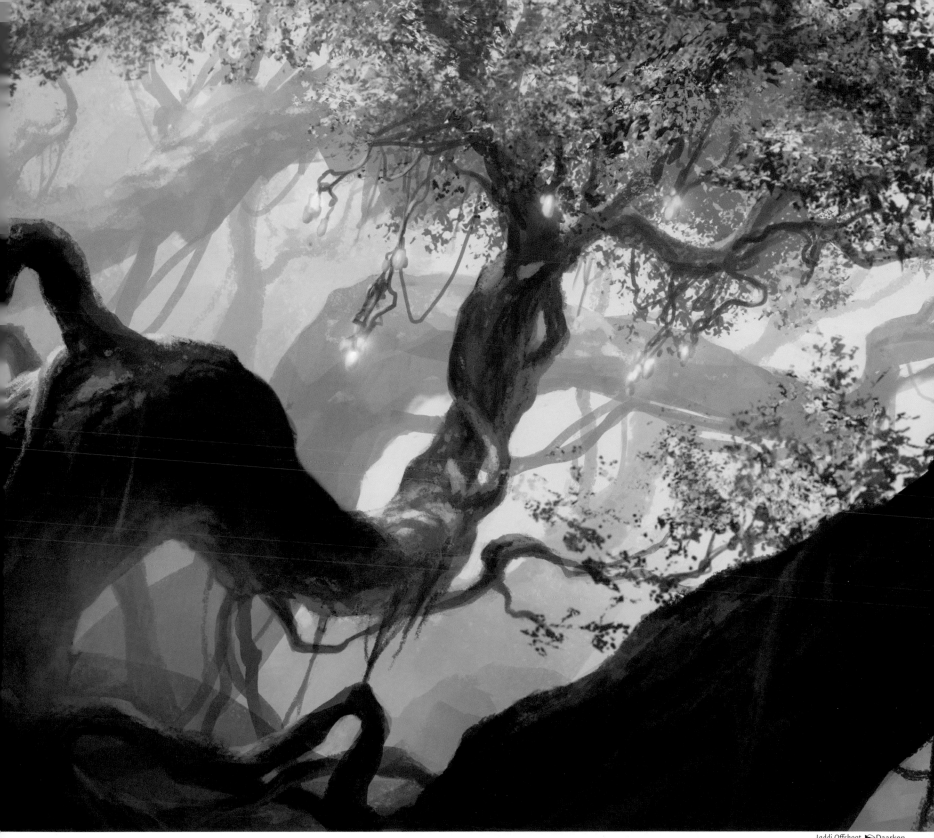

Jaddi Offshoot ☞ Daarken

Vazi River

blend of the pastoral and perilous. They crossed between the pillars on bridges they crafted of rope and bone, or they swung from leaning monoliths to cross the gaps that their oxen could simply leap. Living in simple tents and herding the hardy pillarfield oxen, they received all else they needed through trade with travelers through Thunder Gap. Now the campsites are abandoned, the oxen run feral across the pillarfields, and only a memory of the kor haunts the Pillar Plains.

The Vazi River rushes down a sloping and twisting canyon to crash into the sea. The river splits many times as it passes through the Pillar Plains, but these side channels typically rejoin with the river in crashing waterfalls. Its waters are difficult but navigable for a few miles inland from the ocean, but after that most of its length consists of thundering rapids supplemented by roaring waterfalls from the top of the wall and from higher side channels.

Sunder Bay

This huge bay is filled with a maze of the multitrunked harabaz trees. Gripping the seabed with their entwined roots, these towering plants join together to form one giant organism. The harabaz trees grow blade-shaped prows on their seaward sides that cut the giant waves that smash into the bay—particularly during the worst of the tides or after the rising of a kraken or the great sea monster Lorthos. Ships attempting to make passage through the harabaz forest must remain vigilant against submerged tree trunks and maintain tight control of their vessels to avoid being smashed. Making passage during the changing of the tides, a storm, or a manifestation of the unpredictable Roil spells certain doom.

Elves of the Tajuru tribe and their merfolk allies often attempt to mark the safest route through the bay, but new hazards arise all too often. If the elves spot a sundered ship, they quickly try to save the crew, but no elf risks travel through the harabaz forest at night or when the water is rough.

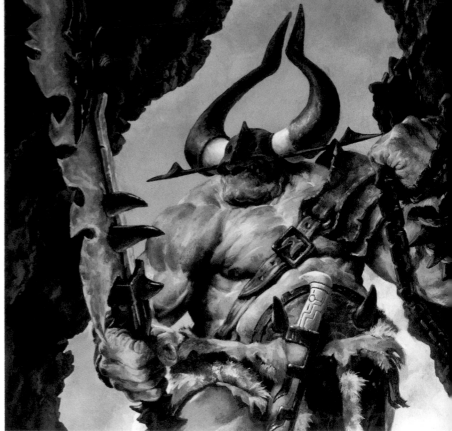

Kazuul, Sadistic Slaver ❧ Paul Bonner

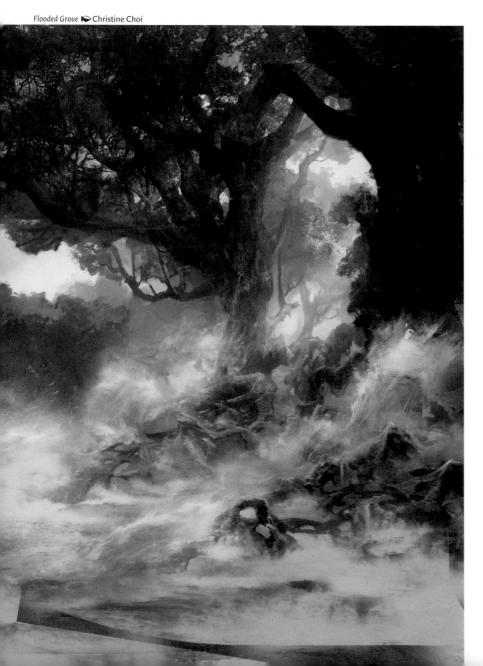

Flooded Grove ❧ Christine Choi

Cliffs of Kazuul

In one spot on Murasa's towering cliffs, the Tajuru elves created a passable route over the wall. The route, consisting of steep, winding switchbacks and a few rickety wooden lifts, is now maintained by humans and guarded by ogres, all in the service of an ogre named Kazuul. Upon reaching the top, travelers must pay tribute to Kazuul, and if the Tyrant of the Cliffs is not satisfied, he hurls them right back down the way they came as punishment for their impudence.

Thunder Gap

This passage follows the route of the rushing Vazi River as it heads out to sea. Boats can navigate the rough waters for a few miles inland through the canyon of Thunder Gap, but travelers must then disembark and take the precarious trails and rope bridges that run along the canyon walls, across the thundering water, and beneath or above the many waterfalls that burst from side canyons or the plains above. Some trails lead up and out of the canyon, while others follow the river for its length, eventually leading to the ground beyond Murasa's Wall.

Thunder Gap used to be known as the safest means into the interior, for it was well maintained by Tajuru elves and a clan of kor that lived along the Pillar Plains above Thunder Gap. But two decades ago, something happened to the kor. Travelers found kor bodies all along the path of Thunder Gap, their corpses hung like butcher's meat from their own hooked lines. The trail hasn't been maintained since, and the most shadowed sections of the pass are said to be haunted by tortured kor ghosts.

Glint Pass

A huge sea cave leads under the east side of the Wall, and at its rear lies a cavern opening accessible when the tide is low. If a traveler can follow this cave far enough before the tide rises to fill it again, the way through Glint Pass lies open. Although miles of the pass lie in utter darkness, the caverns of the Glint Pass gained their name from the light given off by flame-quartz, clusters of crystals that jut from the rock throughout much of the underground passage. These faceted stones shine with the light of internal fire, like lanterns lit by fires in the earth. In some places along the trail, the fire of the earth is obvious as the path wends its way over rivers of magma. Glint Pass is a bewildering labyrinth, but vampire guides from Visimal, the Hidden City, are often available to steer travelers on their way.

Gnawing at the Roots

Since the Eldrazi arose, Murasa has resisted them and their corrupting influence. Its verdant jungles were able to regrow quickly after the initial waves of Eldrazi attack, but recently the corruption has taken deeper root. Flying Eldrazi have crossed Murasa's Wall, and some have come in through Glint Pass, where the vampires have been unable to hold them back. Now Ulamog's chalky dust spreads through the Pillar Plains and the jaddi trees, and Kozilek's weird devastation is seen in Kazandu and the Skyfang Mountains.

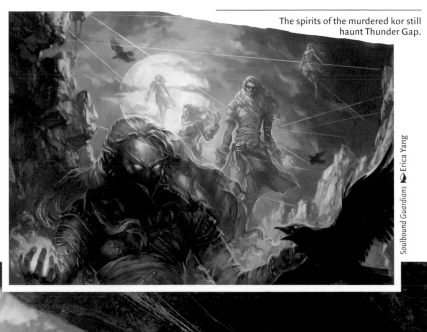

The spirits of the murdered kor still haunt Thunder Gap.

Soulbound Guardians ▶ Erica Yang

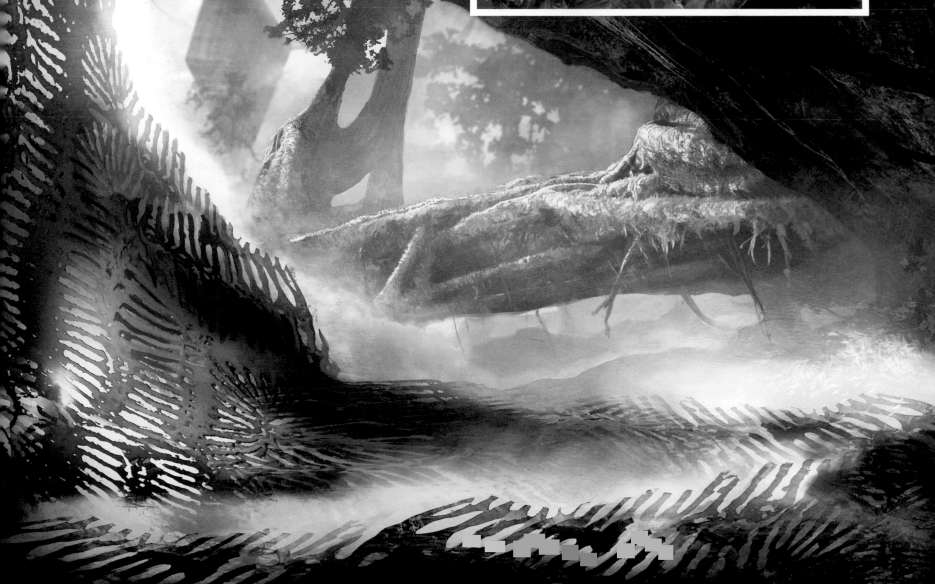

Blighted Woodland ▶ Jason Felix

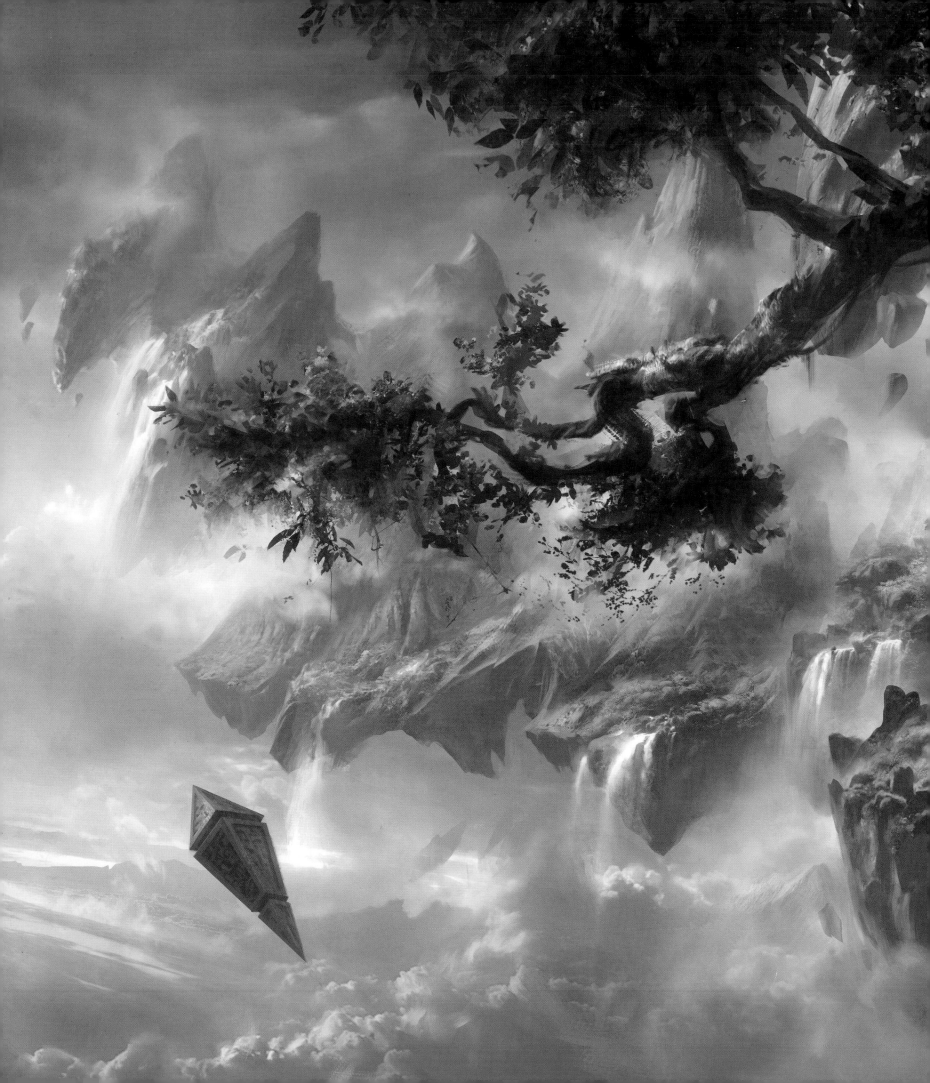

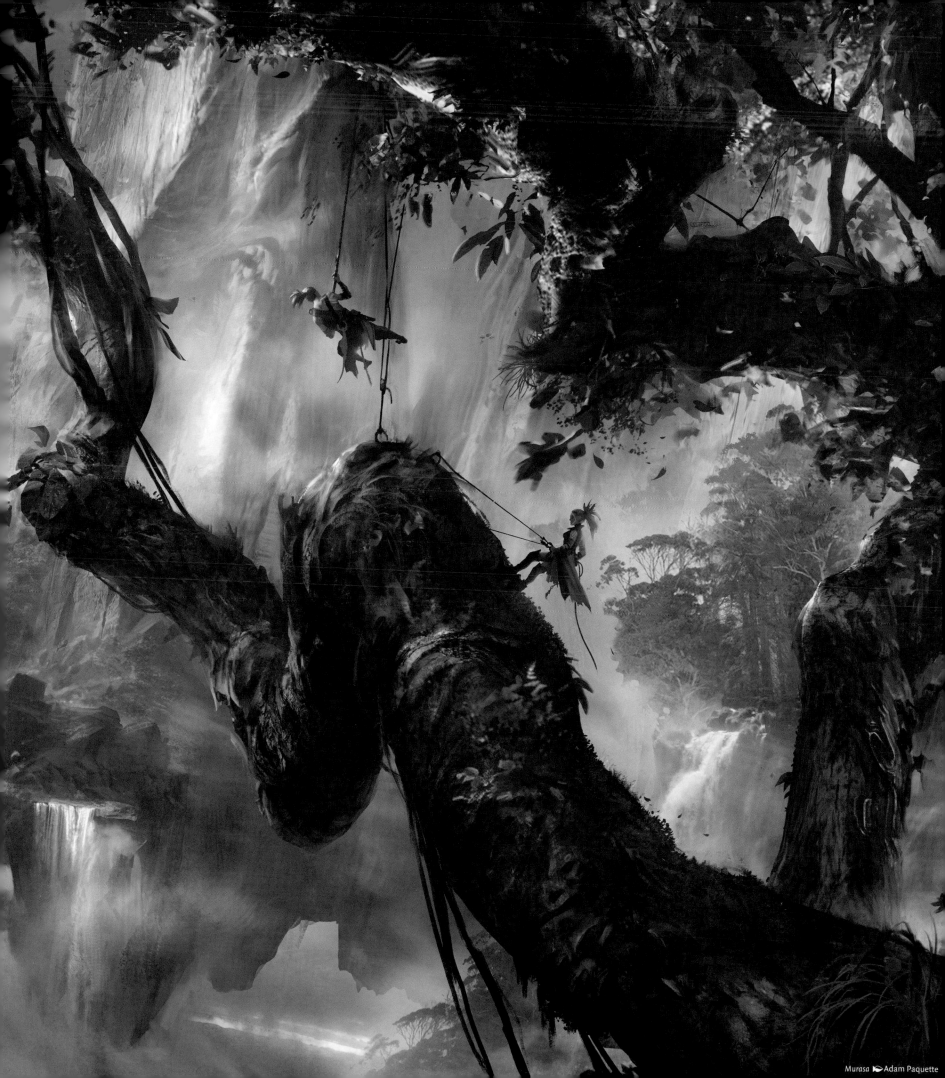

Murasa ◆ Adam Paquette

LIFE IN MURASA

The inhabitants of Murasa are as wild and tenacious as the great island itself. Murasa is the homeland of the elf race and the refuge where the largest surviving tribes remain in the wake of the Eldrazi scourge. Humans are scarcer here than in other regions, but some members of every race live within the bounds of Murasa's Wall.

> "Those who think the trees shall remain bystanders throughout this conflict shall be sorely mistaken."
> —**Sutina,** former Speaker of the Tajuru

The Tumbled Palace

The elf nation of the Tajuru is the largest of the three elf nations and accounts for most of the elf population on Murasa. The individual clans that make up the nation are scattered across Zendikar, including several different clans on Murasa alone, but they all acknowledge the leadership of a young tracker named Nisede.

The shamans who used to lead the Tajuru nation took up residence in the Tumbled Palace, a crumbling edifice on the cliffs of Sunder Bay. The ancient palace is clutched in the boughs of a huge jurworrel tree that has lifted it up from the cliffs and holds it suspended in the air. Although the perch seems precarious, as though the palace might fall into the bay at any moment, it has hung suspended in this manner for as long as even the elves can remember.

For her part, Nisede does not like spending time in the Tumbled Palace—not because she fears the drop, but because she prefers living in the wilds, in constant motion. The palace seems like a target for the Eldrazi, while living on the move lets the Tajuru leadership respond quickly to Eldrazi threats. Her skills as a tracker have allowed her to lead her people away from the chaotic movements of the Eldrazi broods and helped her to direct attack forces toward them. Her followers believe that the land speaks to her directly.

Jurworrel Trees. Jurworrel trees grow on cliffsides and rock outcroppings across Murasa. Their dark, twisting branches bristle with thorns, which leak a thick green sap that can knock creatures unconscious. Jurworrels possess some measure of intelligence but have no ability to move except by changing the direction of their slow growth. The jurworrel beneath the Tumbled Palace has been trying to push that edifice into the sea for centuries, for reasons that are unknown to the elves. In fact, the palace holds remnants of Eldrazi corruption, which might have affected past speakers and probably accounts for Nisede's mistrust of the place. The jurworrel, like most of Zendikar, is simply trying to purge the Eldrazi influence, but the magic of the palace has prevented it.

Elf Habitations. The elves of Murasa live on the enormous branches of jaddi trees, and they build villages and roadways along the branch surfaces. They construct elegant, almost hedron-like structures surrounding smaller branches, linking them together with graceful rope bridges. Some structures are even built on the sides of the great trunks and branches.

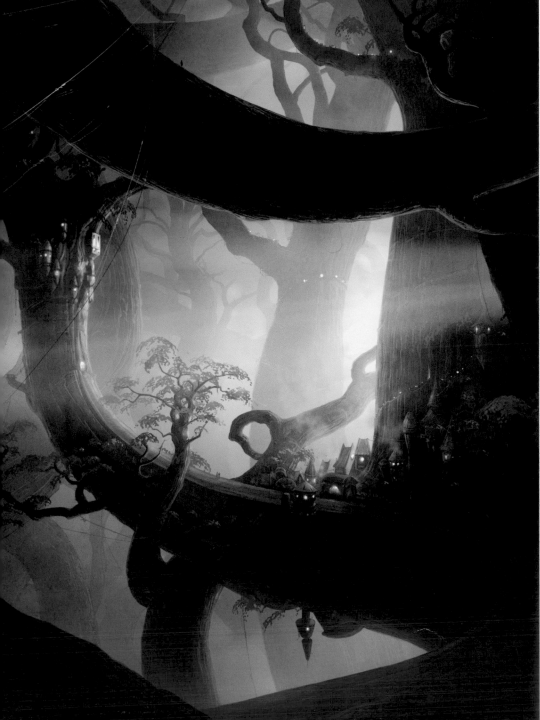

Forest ◆ John Avon

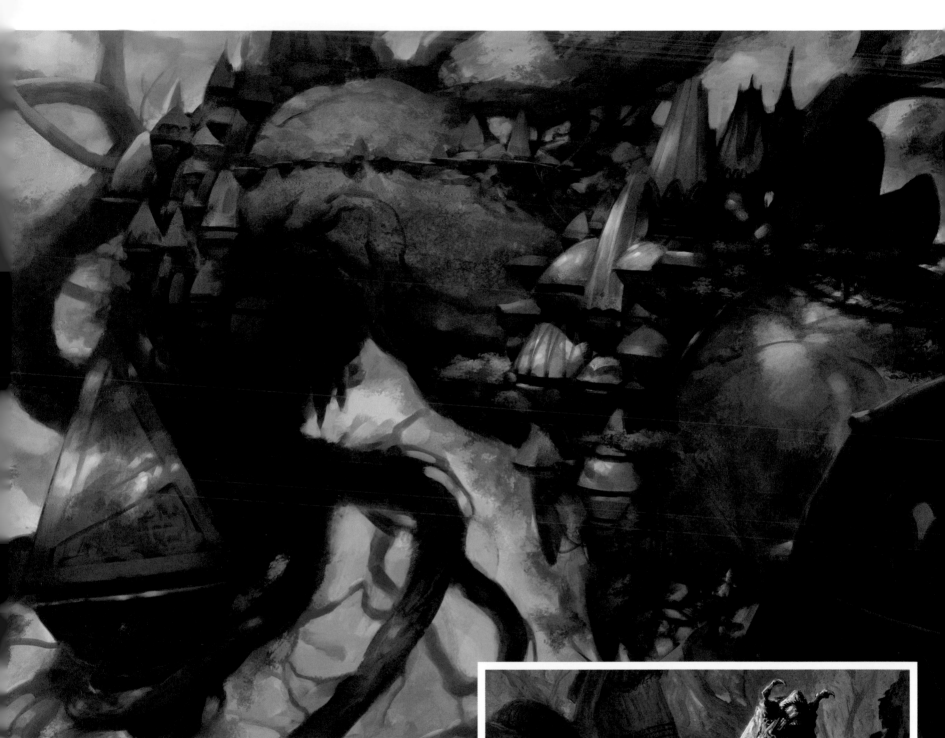

Retreat to Kazandu ▸Kieran Yanner

The Kazandu Splinter

One large clan of Tajuru elves has a strained relationship with the nation's leadership. Dwelling in the badlands of Kazandu, these elves were always uneasy under past speakers, and they rejected Speaker Sutina's authority entirely. Since Nisede's selection as the new leader, she has made overtures to the Kazandu and begun a slow process of reconciliation. The fact that Nisede is not a shaman like her predecessors might be the defining factor.

Canopy Gorger ▸Lake Hurwitz

The giant trees of Murasa house enormous wurms that pose a significant threat to the elves that live on the branches.

Soaring Seacliff ▶ Izzy

Kazuul's Mines

The enormous ogre called the Tyrant of the Cliffs is in nominal control of the entire passage up the Cliffs of Kazuul. Kazuul is smarter than other ogres, and no less cruel. He enjoys throwing his weight around and maintains his hold on the cliffs by being stronger than any challenger so far.

In addition to the passage up the cliffs, Kazuul claims ownership of a network of mines inside Murasa's Wall, dug from the inland side of the mountains. His agents bring slaves of all races, purchased from North Hada or Zulaport, to toil in the mines and carry ore to sell in Sea Gate and Kabira.

Raimunza Falls

Raimunza Falls is a raging torrent of water that cascades off the southern side of the Na Plateau. At the top of the falls is a scattering of brick shops and dwellings—a mining town inhabited mostly by humans and a few Tajuru elves. The mines themselves are crude, shallow caves dug into the cliff face to extract iron ore from the rock. The fast-flowing water turns gigantic wheels along the length of the falls, which operate great winches to lift miners and their extracted ore to and from the mines. Unable to compete with Kazuul in larger markets across Zendikar, the people of Raimunza process and work the metal themselves, selling finished goods to the elves or traders from other lands.

Each summer, giant jagwasps come to the cliff and use abandoned mines for nests. As they protect their nests, the aggressive adult wasps can be a serious hazard to the miners, but the larvae actually help the mining operations. The larvae secrete a viscous, highly acidic substance that eats into the rock and can expose seams of ore that were previously undiscovered. Once the larvae mature and leave the area, new mines are often begun in the caves they abandon.

Visimal, the Hidden City

Glint Pass opens into an ancient structure of flooded, diamond-shaped passages on the interior side of Murasa's Wall. Beyond this waterlogged maze lies Visimal, a vampire settlement carefully concealed by its inhabitants. The vampires keep to themselves and protect their city from any intruders, but they hire themselves out as guides to travelers trying to get through the pass, steering their clients well clear of the Hidden City.

"They build their camps around hedrons, as though the lifeless stone can protect them. Sometimes it even seems to work, for a while."
—General Tazri

Refugees in Murasa

For the first months of the Eldrazi rampage, Murasa remained relatively free of their influence. Its wall proved a difficult barrier for the Eldrazi to cross, and its jungles resisted their corruption. As a result, many refugees from the devastated regions of Sejiri, Bala Ged, and other besieged areas have found their way to Murasa. A handful of scattered encampments have been established among the towering jaddi trees and on the Pillar Plains, often gathered around hedrons that lie on or near the ground. These are often no more than tents or crude huts surrounded by makeshift wooden palisades or walls of unmortared stone. Members of all races come together in these shelters for mutual protection. Every once in a while, a would-be general appears in an encampment and mobilizes the population to launch an assault on the Eldrazi, usually without much success. As a result, deserted encampments are also found here and there in the jungles.

Ally Encampment ▶ Jonas De Ro

◆ LORTHOS THE TIDEMAKER

Murasa is home to many large creatures, including summit apes, jagwasps, terra stompers, baloths, thunder eels, and gomazoa, not to mention the enormous jaddi trees. But dwelling outside Sunder Bay is a creature so large that his movements affect the tides—Lorthos the Tidemaker. In the past, Speaker Sutina of the Tajuru elf nation was suspected of having some connection to the Tidemaker, since she was often seen on the cliffs of Sunder Bay when Lorthos's great tides surged through the harabaz trees. Sutina's death, though, has not altered the frequency of the great creature's appearances. If anything, the presence of the Eldrazi has brought Lorthos to the surface more often.

> "When Lorthos emerges from his deepwater realm, the tides bow to his will, and the coastline cowers in his presence." —Ayli, *Kamsa cleric*

So the big-shot explorer got that huge stone head aboard his ship, and the whole fleet pulled anchor and got underway. It was easy as you please, and he and his bunch had only been on the island for a couple of hours. Smooth sailing, right? I couldn't figure out why he'd brought nine ships for an easy run like this.

Then things started turning sour. A storm blew up. The sea got choppy, and the skies grew dark and foggy. Then, through the mist, we heard one of the other ships sound the alarm, and sounds of yelling and fighting from that direction. Then another ship started ringing its bell, and another, and then the water next to our ship started to froth, and something reared up—something big.

Well, we'd fought sea serpents before. The bosun sounded the alarm, and the quartermaster started handing out pikes. But it just kept rising, going up and up, and then all at once, it crashed down onto the deck and wrapped clean around the boat. We saw the head come around the other side again—only it wasn't a head. This wasn't any serpent—it was a tentacle.

A tentacle! Yeah, I know how it sounds. But that's what it was. The sails billowed, the boat creaked—we were held fast. We stabbed it and stabbed it, but nothing happened. Then the storm died down. The sails went limp, the fog started to lift. Everything was still. We saw the other boats, all held like we were. Except for one—the flagship, with the big explorer and his precious cargo still aboard, adrift on its own in the middle of the fleet.

The leader of the hunters he'd brought with him watched it all unfold. "I told him this would happen," she said. "There were warning glyphs all around that thing, old merfolk words for *big*, and *ocean*, and *angry*. But he wouldn't listen. Just had to have his prize."

Then the ocean . . . moved, like there was something huge coming up, pushing all that water out of the way. A great mountain of water rose up amongst the fleet, right under the flagship. I saw the ship silhouetted against the sky, that damned explorer leaning off the bow like a maniac, looking down to see whatever was swallowing him whole. There was a flash of light, the sun behind him, and then down went the ship, into the belly of the beast.

The mountain of water fell, and all those tentacles unwound and slipped back into the depths. Just like that, the thing was gone. The boats were all half-crushed, taking on water, but we managed to limp back to port.

That was my last voyage. Never set foot on so much as a raft after that.

—from "Legends of the Deep" by Kelly Digges

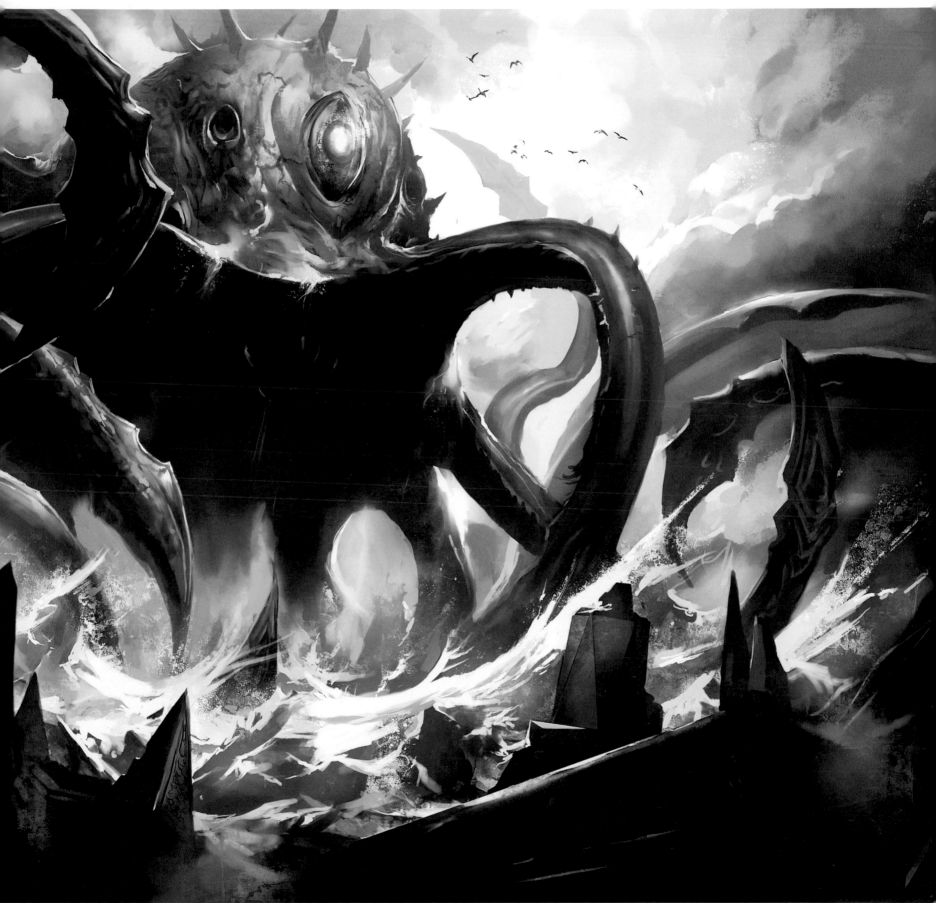

Lorthos, the Tidemaker ▶Kekai Kotaki

◆ ANCIENT SITES OF MURASA

Murasa's ruins are mysterious and steeped in powerful magic, presenting the promise of world-shaking power alongside the risk of utter annihilation.

The Singing City

The Singing City is a cyclopean maze of strange structures and tumbled towers hidden somewhere near the center of the enormous Na Plateau. Known by legend throughout Zendikar, the Singing City is named for the eerie, almost musical sounds that come from underground chambers below the ruined buildings. The sounds have driven many explorers mad, causing them to turn on companions or hurl themselves from great heights, but enough have survived with proof of great treasures and powerful magic to draw others to grim fates. Goblin tribes dwell around the ruin, offering aid to those who would enter the Singing City and then hovering like vultures in the surrounding trees, waiting for their chance to pick up the pieces.

Song-Mad Goblins. Goblins that go too deep and too often into the Singing City inevitably go "song-mad." These poor wretches are banished from their tribes to stumble drunkenly about the ruins, absently crooning in tuneless imitation of their song. Left alone, they are harmless and eventually waste away, but removing one beyond range of hearing the city's singing drives a song-mad goblin into a frenzy. Goblin tribes at war with one another often sweep the city to gather as many of the song-mad as they can. They then strap blades to them and tie weapons into their fists. These song-mad goblins are prodded into battle by other goblins and

"I believe the influence of the Eldrazi is strong here. The notes that play in my skull spell out what feels like a message, the words of which I feel I can just barely translate in my dreams. When I wake, though, the morning shreds my revelations like damp paper. No matter. I can feel a breakthrough coming. Tomorrow we journey into the ruin's heart, and I will finally know what they wish to tell me." —Journal of Aida Lunda (final entry)

Ancient Tomb ◆ Howard Lyon

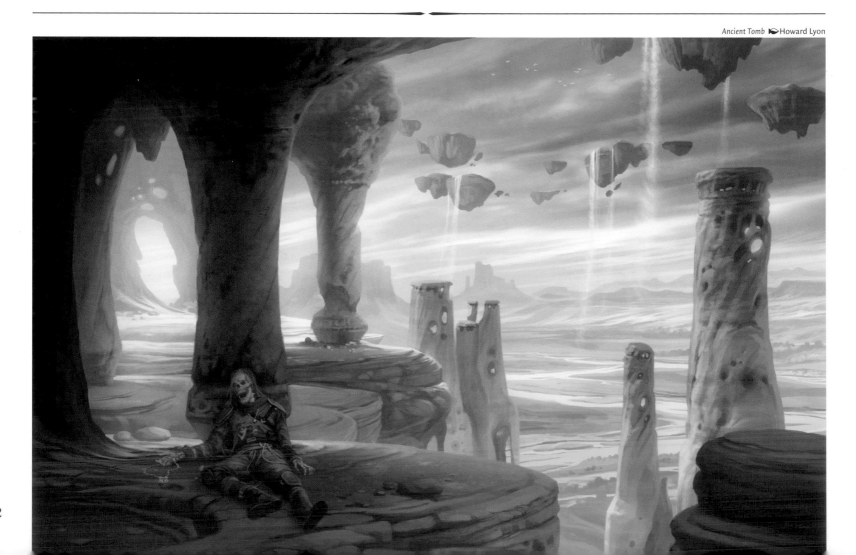

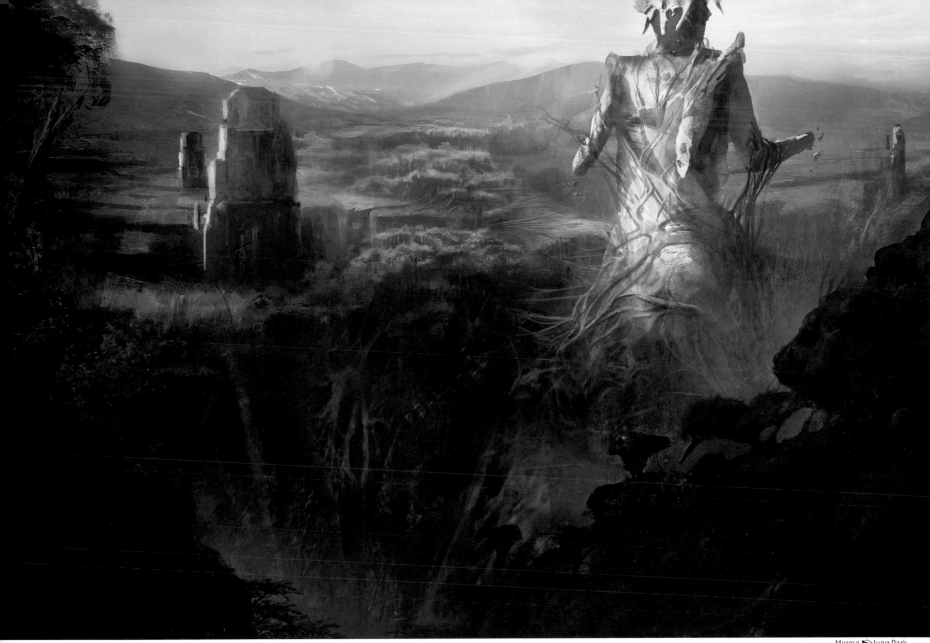

Murasa ❧ Jung Park

then released among the foe. The screeching creatures thrash wildly about, causing havoc and casualties—often on both sides of the conflict—until they are killed.

The Cipher in Flames

The Glint Pass hides the fabled Cipher in Flames, an ever-burning and complex glyph set in the heart of the rock. It is said that those who can survive the journey and decipher its magical instructions can perform a ritual that transports them anywhere in the world. Whether or not this is true or what other effects the cipher might have are unknown—none have returned from seeking it except a bedraggled few who found the search too perilous or who failed to read its magic.

The Living Spire and the Grindstone Crucible

The Living Spire—also called the Howling Spire—is a natural rock pillar in Kazandu, honeycombed with caverns that are not all of natural origin. Strong winds cause the spire to whistle and moan as

they sweep past and through these caves, lending an eerie aura to the place that befits the strange statue at the top of the pillar. The statue depicts Talib, the kor god of the earth, who glares balefully down from on high at the jungles below. Jurworrel trees and bloodbriars clutch at the statue as if intent on tearing it down, but despite the wear of the ages, the statue still stands mostly intact.

Titanic hovering vines also spiral through the caverns to a great chamber at the pillar's heart. There, a thundering mass of huge, rune-covered boulders and shards of rock grind together in a constant rumble, encompassed in a spherical latticework of vines. Called the Grindstone Crucible, this strange place is a font of wild mana, but to draw on its strength one must stand on the vine lattice or between it and the Crucible. But when winds howl into the chamber, they are drawn into the Grindstone Crucible with hurricane force, taking pieces of the latticework with them and potentially drawing a nearby creature into the grinding stone to certain death. When the winds are still, the vines grow, thrash, and writhe, struggling to encompass the Crucible before its next great inhalation.

◆ ONDU

Ondu is a vast plateau formed of jagged cliffs rising sharply from tumultuous seas. Wide mesas and plateaus top the high cliff walls, rivers rage through narrow-walled canyons, and cave mouths open into cathedral-like caverns with high, vaulted ceilings. Fierce winds sweep across this high ground and roar through the canyons.

> "The crossing demands singular focus. Your life consists of these ropes, these hooks, and these rocky crags. Your past is miles below."
> —Javad Nasrin, *Ondu relic hunter*

Travel in Ondu often seems a matter of going up or down as much as moving east or west. The precarious Makindi Trenches, the sky-raking trees of Turntimber, and the abyssal Soul-Mad Stair define the dizzying heights and depths of Ondu. Great bergs of striated rock drift in the sky above even its most level plains, offering whole new worlds of exploration for the kor and their kitesails or explorers who have tamed drakes or griffins as mounts. The land is wild and sparsely settled, with its most populated areas located off the mainland. Three major islands stand off the coast of Ondu: the large, southernmost island of Agadeem; the smaller, temperate Beyeen; and tiny, sea-swept Jwar.

Since the rise of the Eldrazi titans, the canyons and forests of Ondu have teemed with their broods. Fortunately for the inhabitants of the region, the land here seems to react particularly strongly to their presence. Huge crystalline shards jut up from the ground to impale the Eldrazi or block their movements, great canyons open up at their feet, or motionless mesas suddenly develop legs and tromp on the Eldrazi. The defenders of Zendikar have a staunch—if unpredictable—ally in Ondu itself.

Needle Spires ◆ Jonas De Ro

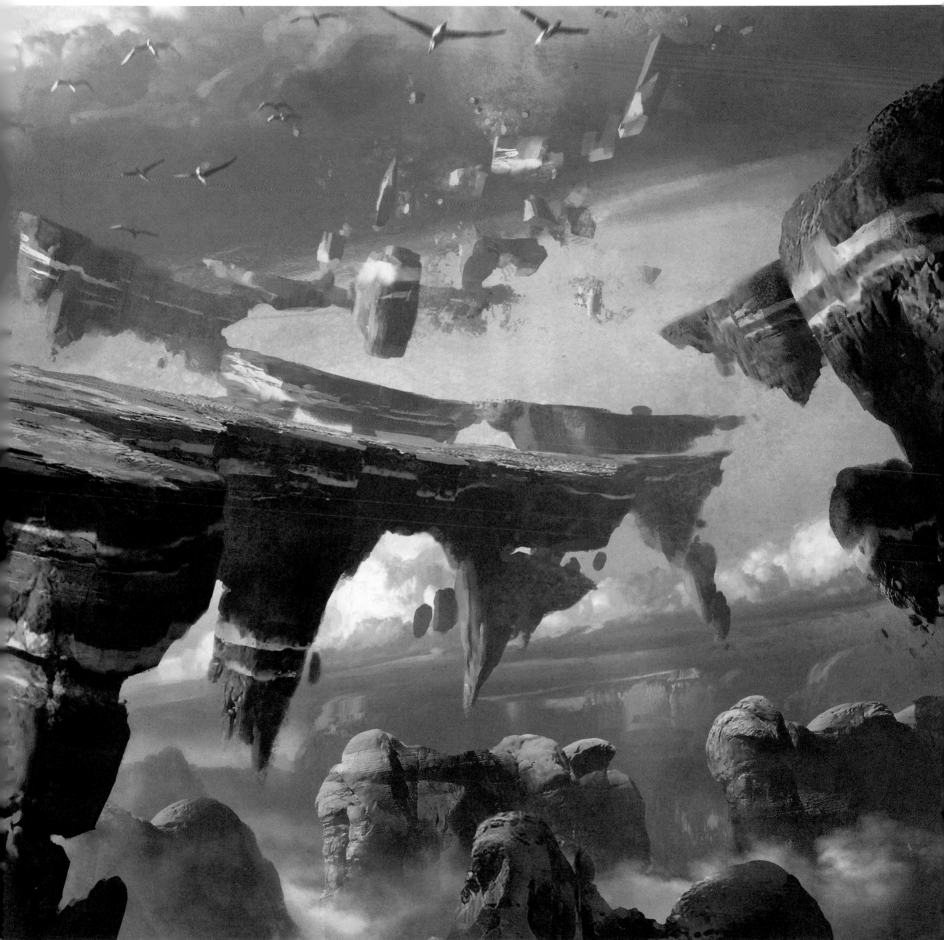

Sandstone Bridge ✒ Cliff Childs

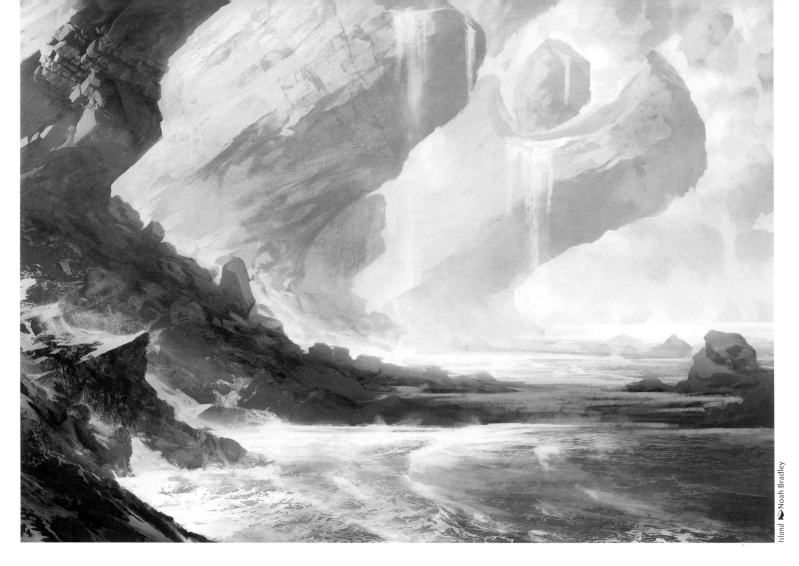

Island ♦ Noah Bradley

Makindi Trenches

The Ondu mainland is crisscrossed by a maze of high-walled canyons called the Makindi Trenches. The canyon walls tower hundreds of feet over white-water rivers or bare rock channels. Mana-fueled winds howl through the canyons at odd intervals, making it essential for climbers and builders to attach their instruments carefully to the cliff walls. Travelers usually make their way along the cliffs' edges on wagon trails, but those who are willing to accept great risk in exchange for great speed opt to ride the fast-moving rivers.

The walls of the canyons support a surprising range of life. Birds, reptiles, and insects of all sorts nest on the trenches' sheer surfaces. Goblins and kor build into, on, or between canyon walls. Deformed trench giants scale the walls looking for crunchy animals to eat, and enormous spiders spin their webs in the overhangs to snare fliers and climbers.

Teetering Peaks. Throughout the canyons and plateaus of Makindi, huge boulders perch in precarious, gravity-defying positions atop slender rock spires. Though they have not been seen to move, these formations are called the Teetering Peaks. Historical changes in Zendikar's fickle gravity may have caused these rocks to shift into their current positions, but some believe that they are deliberate traps set to lure—and then crush—curious passersby. Some mages study the areas around the Teetering Peaks, speculating that their locations form a pattern or map that could have deeper significance to the region.

"We count the cliff strata as we soar, their layers marking time like the rings of trees, history laid out by altitude. Ondu's journey has been like our own, stretching high beyond its lowly beginnings, striving to kiss the clouds. When we need guidance we aim our kitesails straight down, plunging into the shadowed Trenches, the years dashing by the tips of our canvas wings—and we pull up just before the bottom, surrounded by the oldest of times, whose stony memories enrich our perception." —Wamata, *kor skyfisher*

Turntimber, the Serpentine Forest

Only wild and brave creatures reside in Turntimber, a vast temperate forest on the Ondu mainland. Turntimber's famous corkscrew-like trees twist into staggering heights, tracing lazy circles in the sky and inspiring the woodland's name. Over decades and centuries, the trees bend and twist around invisible spikes of mana like a climbing vine around a pole. The mana feeds and strengthens the trees, pushing them to ever-greater heights. However, the mana spikes provide no physical support, so the trees' overburdened root structures creak constantly as the trunks sway in the wind. This creaking has inspired stories of a secret language known only to the trees. Many human shamans and druids have ventured into Turntimber in hopes of deciphering this sacred language, believing it to hold the key to the deep wisdom and lore of the forest.

Turntimber supports a menagerie of dangerous creatures. The apex predator here is the baloth, a muscular, omnivorous hunter with claws that allow it to climb the spiraling trunks. Territorial baloths in search of prey have been known to leap from one tree to another with surprising nimbleness, and their jaws can slice through bone.

However, the dominant fauna in Turntimber is the snake, which fills predator roles at all levels. From tiny tree snakes to giant cobras, from the harmless to the lethally venomous, from the mundane to the mana-infused, serpents writhe and hunt throughout the woodland. Some elves believe the snake's shape to be a symbol of mana itself and track their movements to detect patterns in mana flow.

Turntimber Grove ☛ Rob Alexander

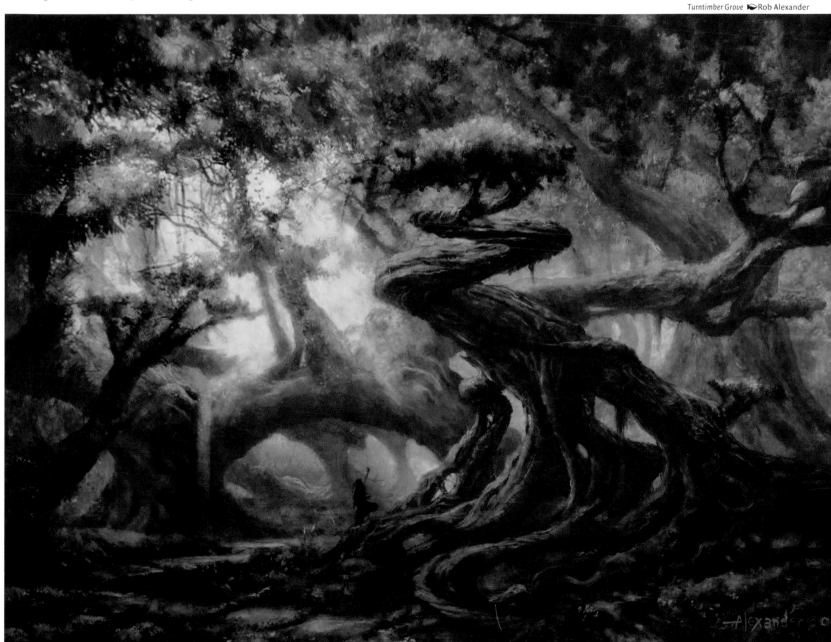

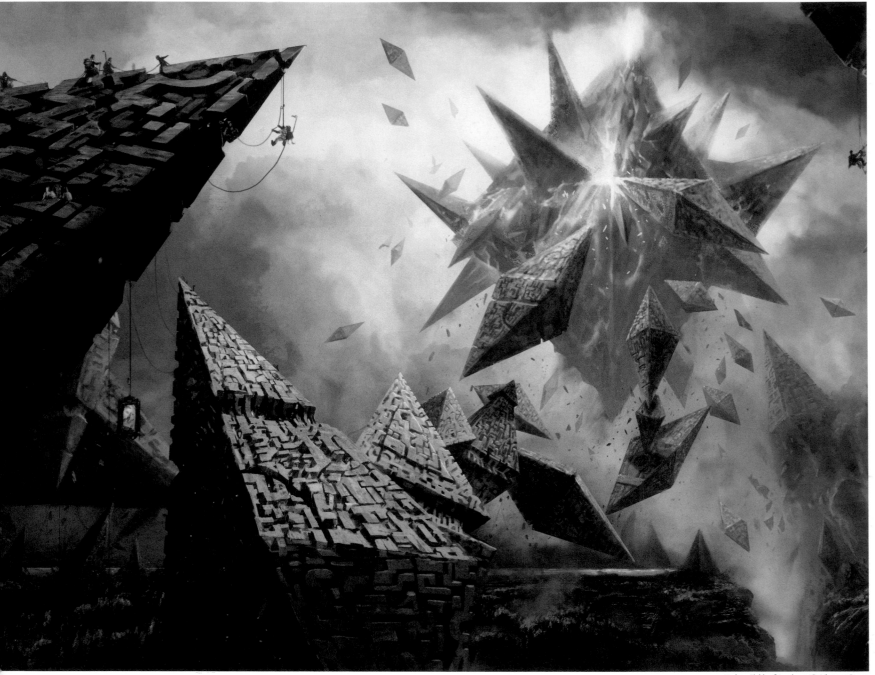

Hedron Fields of Agadeem ⮞ Vincent Proce

Agadeem, the Hedron Fields

The largest of Ondu's three coastal islands is Agadeem, which seems like an extension of the mainland. Savanna covers the island surface, broken up by canyons that are similar to the Makindi Trenches, though not as deep or as numerous. The land is littered with ancient stone hedrons, ranging in size from a few inches to a dozen yards or more. Many of them are partially or entirely buried in the sodden earth, but since the rise of the Eldrazi, a number have risen from the ground and started spinning in unpredictable formations. Sometimes they drift together and form into starlike configurations before drifting apart again.

So many hedrons gathered in one place have a marked effect. The laws of nature warp strangely around the Agadeem hedron fields, causing bizarre and unpredictable magical and gravitational phenomena. In a distortion of the Roil, huge discs of earth thrust up from the ground, rotate in place, and settle down again at odd angles. Humid winds gather in knotted eddies, forming spheres of elemental air that encase groups of floating hedrons and trap flying creatures. Scholars speculate that the power of the hedron fields, if properly harnessed, could be great enough to accomplish almost unimaginable feats of spellcraft, but the erratic conduct of the hedrons makes it too dangerous for large-scale experimentation.

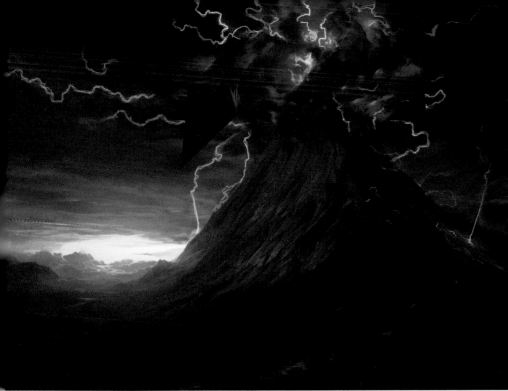

Tears of Valakut ◗Noah Bradley

A combination of ancient geomancy and fierce mana coursing through the land has severed the peaks from the top of several mountains in the God's Crown. At unpredictable intervals, a peak can lift up off the craggy mesa below, only to smash down again some time later. Brave—or foolhardy—explorers sometimes venture beneath the floating peaks in search of valuable relics or to tap into the primal mana in the earth, but many have died in the effort.

The Boilbasin. Near the western coast of the isle of Beyeen is a group of enormous tide pools that stair-step down the mountainous slope toward the sea. The pools mingle seawater with hot springs from below, creating basins that seethe with steam. The Boilbasin is said to be a favorite location of dragons, which use the boiling water to cleanse their scales.

Beyeen, the Crown of Talib

The island of Beyeen is actually several small volcanic landmasses connected by bridges of clinging vegetation. A ring of jagged, volcanic peaks rises from the center of the island, resembling a monarch's crown. The kor call the small range the Crown of Talib, after their god of the earth, which gave rise to its more common name: the God's Crown range.

A number of the volcanoes are still active. Among these is Valakut, called the Crown Ruby or the Molten Pinnacle. The largest and most dangerous volcano in the range, Valakut has been erupting almost constantly since the first appearance of the Eldrazi, shooting an enormous column of lava into the sky, where it coalesces into floating islands of volcanic glass that drift away, sometimes colliding and raining down razor-sharp shards on the terrain below.

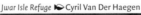

> "Day Nineteen. Climbed among the springs of Boilbasin. Most of us could only tolerate the second or third pool up from the sea, where the water was merely skin-flayingly hot—but Bikbi scrambled even higher up the rocks to a hazy, sulfurous lagoon that must have been the springs' source. I've never seen a goblin's skin so cherry red, but he had a smile on his face; I think he boiled his brains."
> —Ruta Legala, Ondu Expeditionary House

Jwar, Isle of Secrets

Jwar Isle lies near the southern coast of the Onduan mainland. Jwar has largely been written off by explorers due to the swirling ocean currents and territorial sea serpents that encircle it, but mage-explorers contend that magic of great value and power lurks there. Sphinxes are known to live on the island, and some visitors come to Jwar in the hope of prying secrets from the mysterious creatures.

On some cool nights, a streak of bluish light radiates skyward from the center of Jwar. The phenomenon originates from a deep, seawater-filled pit on the island and attracts flying creatures such as drakes and even dragons. Some kor tribes called it the Strand, hypothesizing that it was the spiritual thread that connected Zendikar to the afterlife, but some merfolk reviled its magic and considered it bad luck, even prohibiting their race from looking upon the light. The merfolk were probably closer to the truth. With the rise of the Eldrazi, some of the larger minions of Ulamog boiled up from the watery pit at the base of the Strand.

Jwar Isle Refuge ◗Cyril Van Der Haegen

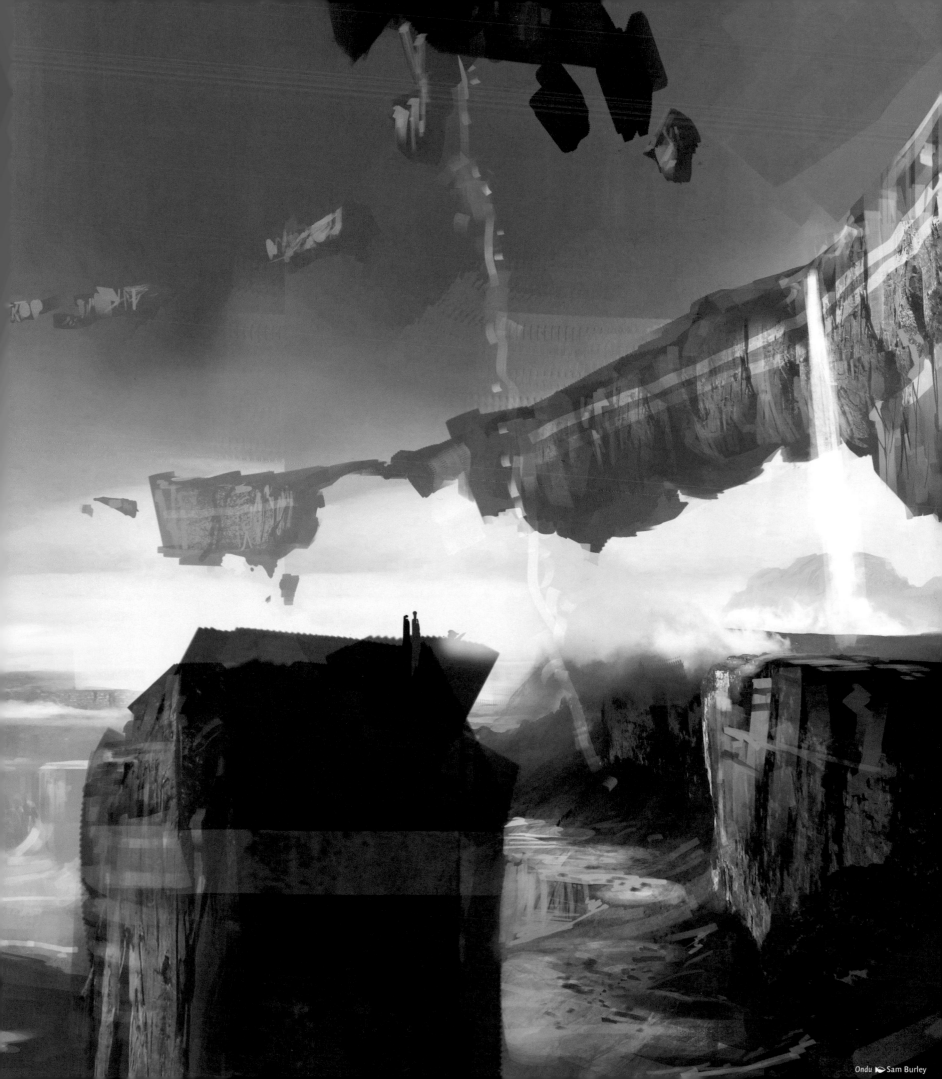

Ondu ⏴ Sam Burley

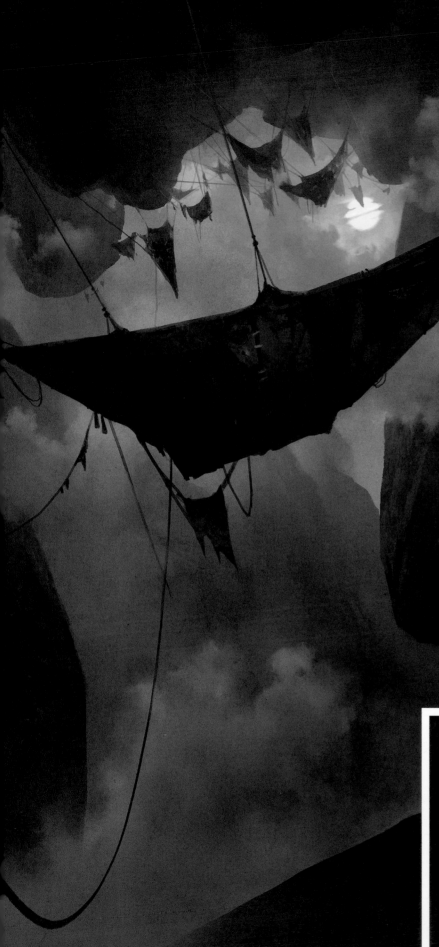

◆ LIFE IN ONDU

Ondu is more hospitable than many parts of Zendikar and supports a number of small communities of every race. The kor and goblins are particularly adapted to life in the Makindi Trenches, the Turntimber offers an abundance of game and edible flora, and the islands of Agadeem and Beyeen provide relatively stable locations for habitation.

Kor Cliffhavens

Using their lines and hooks as extensions of their limbs, the kor are as comfortable in the vertiginous verticals of Ondu as other races are on flat land. Large numbers of kor live on the mesas and canyon walls in temporary shelters that cling to the cliff faces and hang between the canyon walls on a network of anchor lines and pulley devices. Since the Eldrazi awakening, the kor have started to use their hooks and ropes to trap the spawn as well as to anchor their shelters.

The kor use the name "Cliffhaven" to refer to any shelter in the Makindi Trenches, which has led to the mistaken belief among members of other races that there is a single place by that name. Of course, the kor are constantly on the move, hanging temporary structures as they go. These havens serve as base camps for many explorers of all races.

Graypelt

Graypelt is a small settlement of druids, hunters, and trailblazers on the outer edges of Turntimber. Its name comes from the tents made from the woolly grey hide of Turntimber warthogs, although many different materials are used in the encampment. Explorers venture out from Graypelt into Turntimber to seek nodes of mana to harvest from the ancient, creaking trees, for they have developed a way to temporarily "tame" and store small, stable quantities of primal mana. These parcels of mana are very valuable and are attracting the interest of powerful expeditionary outfits.

Kor Haven ▶ Jonas De Ro

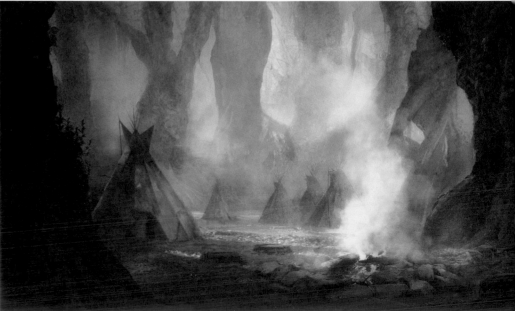

Graypelt Refuge ▶ Philip Straub

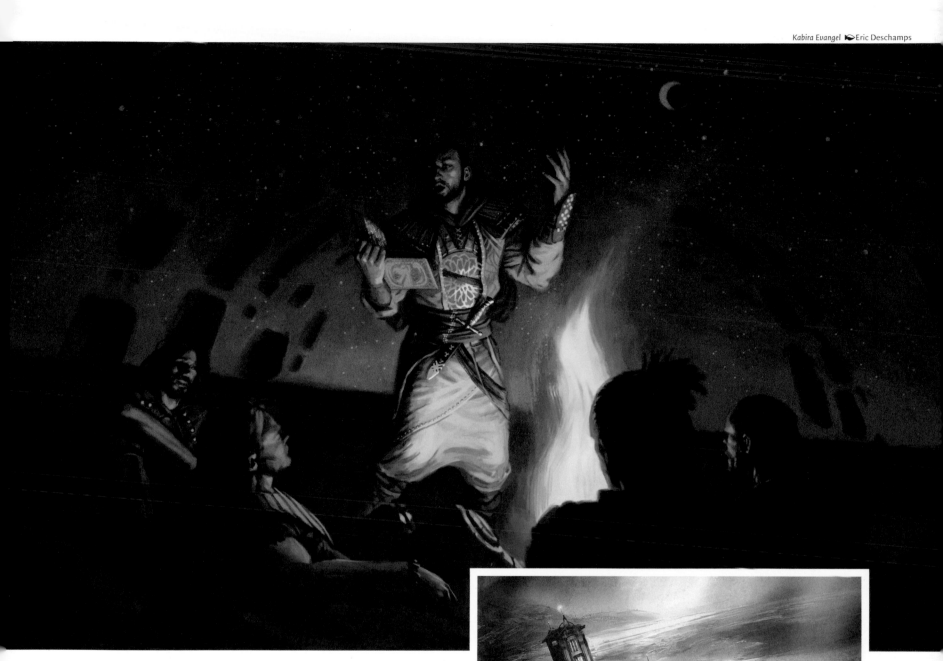

Kabira Evangel ☞Eric Deschamps

Kabira Crossroads ☞James Paick

Kabira

A community of humans and other races has encamped near the Agadeem hedron fields, some to study the hedrons, some to loot them, and some to worship them. The influence of the hedrons is clear in the architecture of the settlement, which mimics and incorporates their shapes and the glyphs that cover them.

A merfolk cleric-scholar named Viniva runs the Kabira Conservatory, a small academy which sponsors research of the hedron fields and passes on what it learns to the Lighthouse at Sea Gate. Some of the Conservatory's recent research concerns the way that certain types of magic—particularly healing, protection, and some types of illusion—respond best near the hedron fields.

A human religious sect has risen to great prominence in Kabira since the coming of the Eldrazi. The sect's evangels, as they call themselves, preach that the Eldrazi are the angels' punishment for the sins of the mortal races. Thus, they offer some dark form of hope by promising that true repentance can bring deliverance from the Eldrazi scourge. The repentance they demand involves utter self-abasement, as well as refraining from any trespass into ancient ruins, which they believe are sacred to the angels. They utterly reject the heretical notion that Emeria is nothing more than another name for Emrakul.

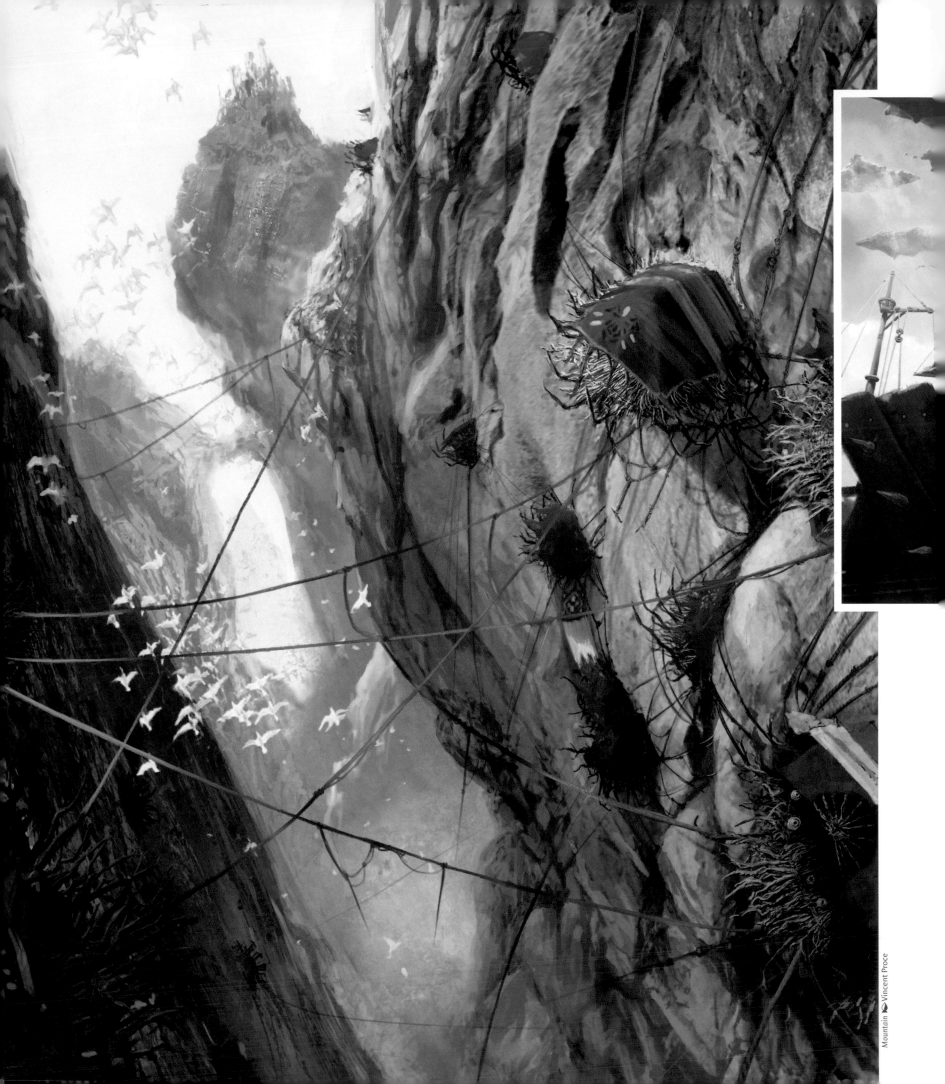

Zulaport Cutthroat ✒ Jason Rainville

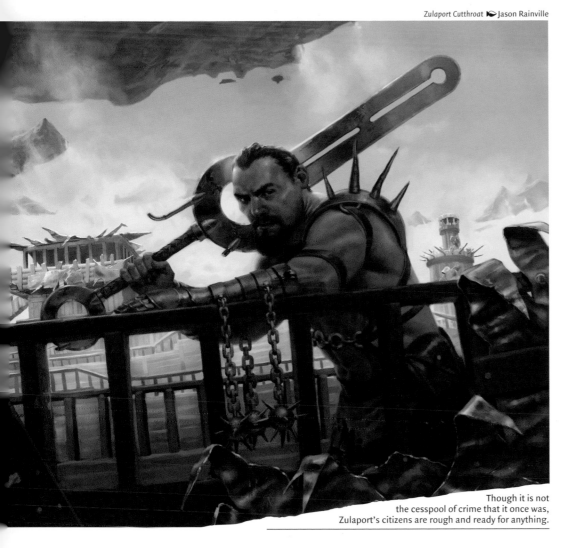

Though it is not the cesspool of crime that it once was, Zulaport's citizens are rough and ready for anything.

Zulaport

Before the rise of the Eldrazi, Zulaport was a small city on the coast of Beyeen, a transient community of mages, explorers, and artisans of all races and origins. It had a thriving economy controlled by a powerful vampire named Indorel, who used a network of goblin, human, and ogre thugs to ensure herself a cut of all the trade that happened around Beyeen.

The devastation wreaked by the Eldrazi swallowed Zulaport beneath a great tsunami. Merfolk came to the city's aid, and Zulaport was reestablished as a floating community that serves as a base of operations for traders and a resupply stop for expeditions across the sea. Indorel still lurks around the community, but her stranglehold on its trade has been broken.

Elves of Turntimber

A small clan of Tajuru elves lives within the Turntimber, tapping into the powerful mana spikes at the centers of the spiraling trees. Mostly peaceful druids before the Eldrazi resurgence, their leaders were capable of calming a rampaging baloth. Now they are armed for war and staunch in defending the forest from the Eldrazi. Hostility

has erupted between the Turntimber elves and the people of Graypelt, as the elves resist any incursion into what they consider their territory, whether by Eldrazi or humans.

Goblins in Ondu

Scattered throughout the Makindi Trenches, small goblin warrens are dug into exposed rock faces and offer little protection against flying or climbing intruders. Theoretically, the individual families living in these caves are united into a single tribe, but in practice they compete with each other for food and other resources more than they cooperate. They unite only when threatened by a common enemy—often the kor, but increasingly they band together even with the kor against the Eldrazi.

Fissure Goblins. Some goblin communities in Makindi gravitate toward small, tight fissures between boulders and converging crags—spaces that offer better protection against the dangers of the trenches. These "fissure goblins" have an uncanny affinity for the geology of the region; some of their warriors are hired as climbing guides, and some of their shamans are consulted as oracles of earthquakes and gravity shifts.

Goblin Dynasties of Beyeen. The goblins on the island of Beyeen move from peak to peak within the mountain chain and are experts at locating ore, obsidian, and gems. They attempt to appease the volcanic forces of the island with regular sacrifices of fruit and gemstones, but they are highly vulnerable to the vagaries of the islands' volcanic activity—as well as the elemental and natural predators of that environment. Though their culture appears simple to outsiders, the Beyeen goblins actually have a deep dynastic history tracing back generations. Their genealogical history is painted in swirling colors along miles of cavern wall, called the Beyeen Vein, deep under the mountain Valakut.

Nomads of the Silundi Sea

A motley band of humans and merfolk lives on and in the water along the Ondu coasts. Their wooden boats serve as both transport and shelter, though the merfolk spend as much time under the water as on their boats. They subsist on fish and seaweeds gathered by divers, crabs trapped and hunted on the shores, and whatever they can trade in Kabira or Zulaport. The appearance of an increasingly large number of aquatic Eldrazi has added to the existing dangers of shoal serpents, drakes, and krakens to drive these nomads to the brink of extinction.

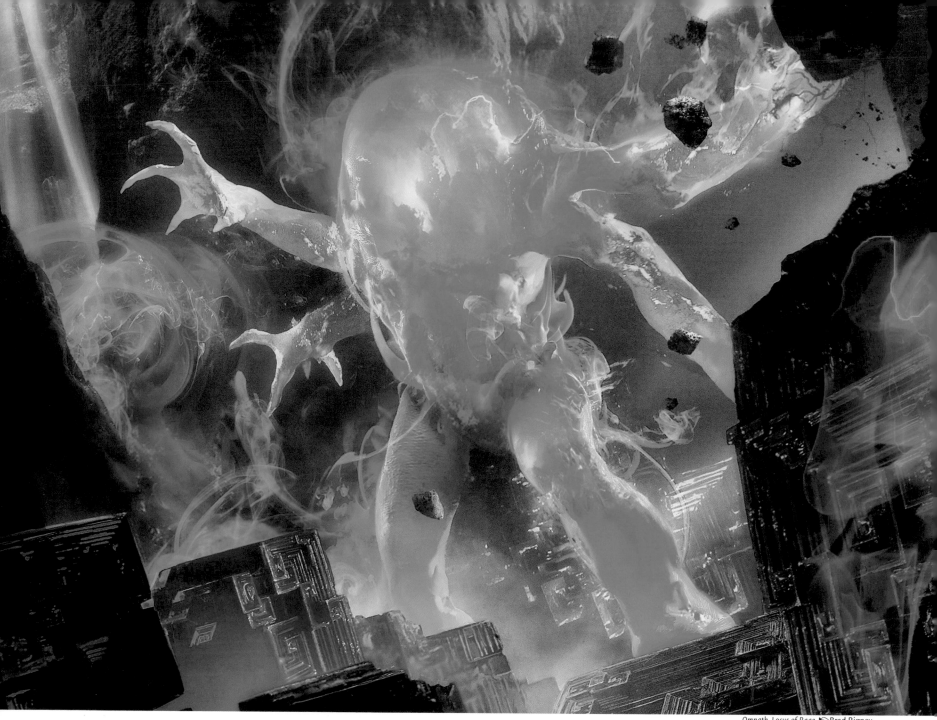

Omnath, Locus of Rage ▶ Brad Rigney

◆ OMNATH, LOCUS OF MANA

Of the legendary places of Ondu, none is surrounded by more controversy than the Prison of Omnath. Omnath is believed to be a divine manifestation of Zendikar's chaotic, primeval mana. Some scholars point to old creation myths suggesting that the gods themselves—the merfolk or kor triads, or Emeria as worshiped by the humans—were created by another being, which could be identified as Omnath. Some call Omnath the "flickering heart," the origin of the primal mana that pulses throughout Zendikar. Despite the uncertainty of Omnath's nature and even existence, a real site in Ondu has been dubbed the Prison of Omnath.

At the top of a soaring mesa, through the dense forest that crowns it, and into a murky mire at the grove's heart where shadows move and twist, a binding circle once surrounded the entrance to Omnath's

prison. A complex arrangement of strange globular swamp growths, stone hedrons, floating elemental flames, and animal bones, the

"For centuries, mana flowed into the Locus in his prison. Now he is free, and his rage flows as freely outward." —Anitan, *Ondu cleric*

circle created an uneasy sensation in those who approached it. The effect deterred most living beings from approaching the circle's center, where an unfathomable pit gaped in the ground. Destructive

146

surges of power lashed out from the circle from time to time, often striking dead those who came too close.

Despite the danger, pilgrims used to travel from across Zendikar to visit the Prison of Omnath. Twice a year, they gathered to perform the Ritual of Lights, which they believed would keep Omnath contained in the prison. In their view, Omnath was a malevolent force, and its release would bring about the destruction of most forms of life. In their rites, they would encircle the site with seventy-seven candles and chant prayers and songs, believing that they were strengthening the magical bonds that made up the prison.

But as the Eldrazi stirred and Zendikar came to life, the binding circle in Omnath's prison broke. Omnath surged out into the world in fury, simultaneously showing the Ritual of Lights to be a sham and proving that the legends of Omnath's existence were true. The being's destructive force wreaked havoc over the land for a time, but when the Eldrazi emerged, Omnath's rage found its proper target.

No mere mortal can call Omnath an ally, for Omnath does not fight for any cause or alongside any comrades. But Omnath and the people of Zendikar do share a common goal—the destruction of the Eldrazi. The difference is that Omnath does not hesitate to destroy anything that gets in the way.

The Soul Stair. The pit in the center of Omnath's prison is ringed by the Soul Stair, a spiral staircase leading down into the bowels of the world. It connects the relatively rational surface world with the seething, surreal void below, where Omnath was bound in incomprehensible chains. Explorers still visit the site in order to plumb the depths of the Soul Stair and to try to uncover the mystery behind Omnath's imprisonment in the desperate hope of finding some new weapon to unleash upon the Eldrazi.

Soul Stair Expedition ❧ Anthony Francisco

◆ ANCIENT SITES OF ONDU

The Ondu mainland is littered with nameless ruins worn to gravel by the raging winds and churning rivers of the Makindi Trenches or overgrown with the flora of the Turntimber. Most of these ruins date to ancient civilizations of kor and elves. The Onduan islands, though, hold more significant sites.

Faduun of Jwar Isle

Dozens of huge granite sculptures depicting alien-looking heads loom on and around Jwar Isle. Called "faduun," they are tall and thin and generally resemble human faces except for their mouths, which gape open and glow with bluish light. Many lie half-buried in the ground or in the coastal sand, tilting at odd angles. Rumbling voices in forbidding tones sometimes issue from their mouths, speaking dire warnings in the forgotten language of their creators.

The faduun were created by an ancient cabal of human mages, scholars of ancient secrets and esoteric magic. These mages shaped the faduun as guardians of their secret stronghold. The magic of the faduun lets them speak their warnings to those who approach the island or tread on its shores and also instills a heavy sense of dread in any who come too close to the entrances that lead into the stronghold. Only the sphinxes are immune to this effect, and the magic of the ancient wizards is one secret they never reveal.

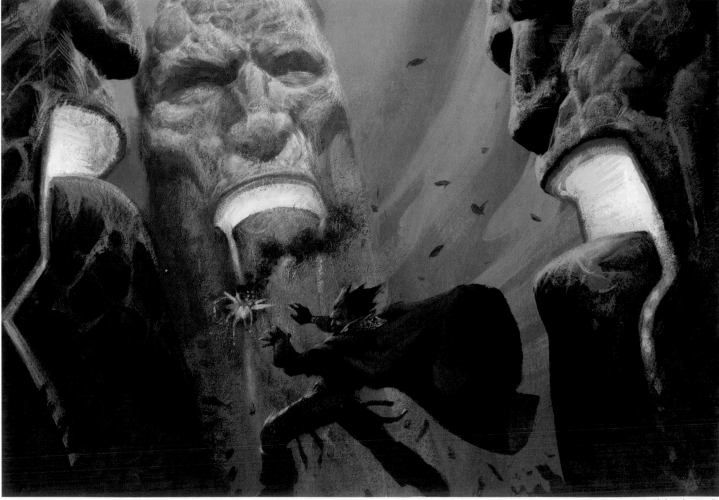

Mindbreak Trap ▱ Christopher Moeller

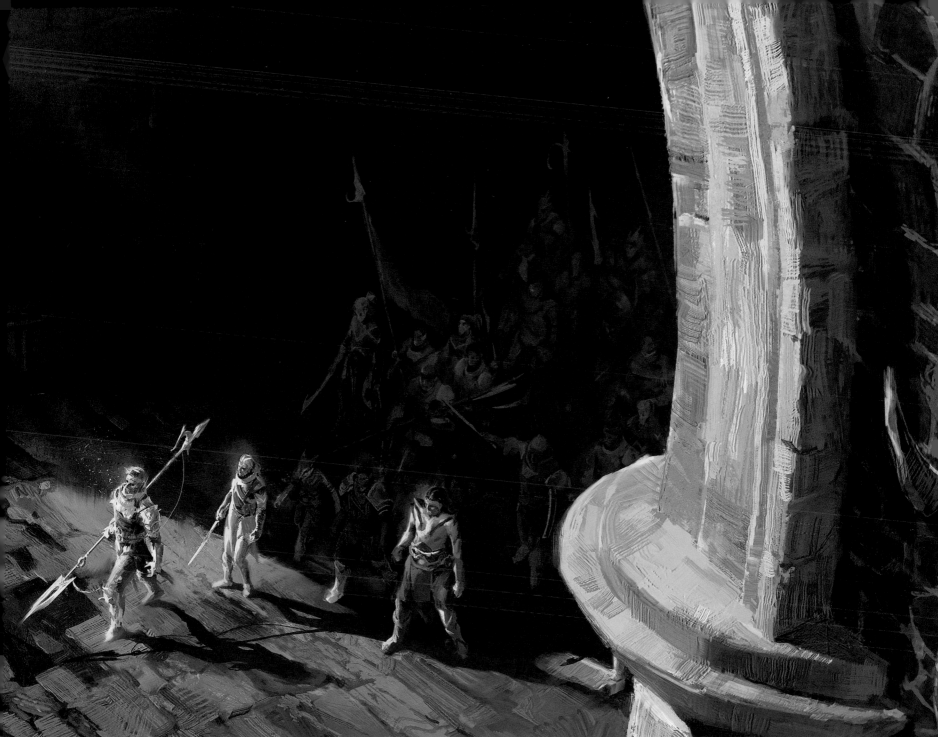

The Crypt of Agadeem

Nestled into the canyons on Ondu's southernmost island is the Crypt of Agadeem, a natural cavern that was used as a burial site by an ancient human civilization. The crypt's entrance stands on a shelf deep in a canyon where no sunlight penetrates. Elaborate carved pillars flank the enormous archway, and huge spikes jut from the canyon wall as if warning intruders away. Beyond the arch is the Crypt Maw, a huge cavern the size of a cathedral, lit with pale purplish light. Thousands of bats and an unknown number of malevolent spirits reside in the cavern.

On the rear wall of the Crypt Maw stands a massive stone sculpture that functions as a mystic lock, the so-called Cryptlock, barring travelers from exploring the rest of the crypt. Archaeologists have concluded that the lock opens only on rare occasions during the death-hour just before dawn, and only when certain incantations are spoken. However, certain mad human, goblin, and vampire mages, calling themselves "witch vessels," have bypassed the lock and traveled down through the miles and miles of shelf-lined crypt tunnels behind it. These tunnels are filled with deadly traps, which have added countless explorers' corpses to the ones originally interred in the crypt. There, the mages have spoken in a lost "ghost tongue" with the thousands of dead bodies or the spirits that once inhabited them. These mages claim that their communion has granted them knowledge of events to come—and indeed, with the benefit of hindsight, many of their apparent ravings do seem to have predicted the release of the Eldrazi.

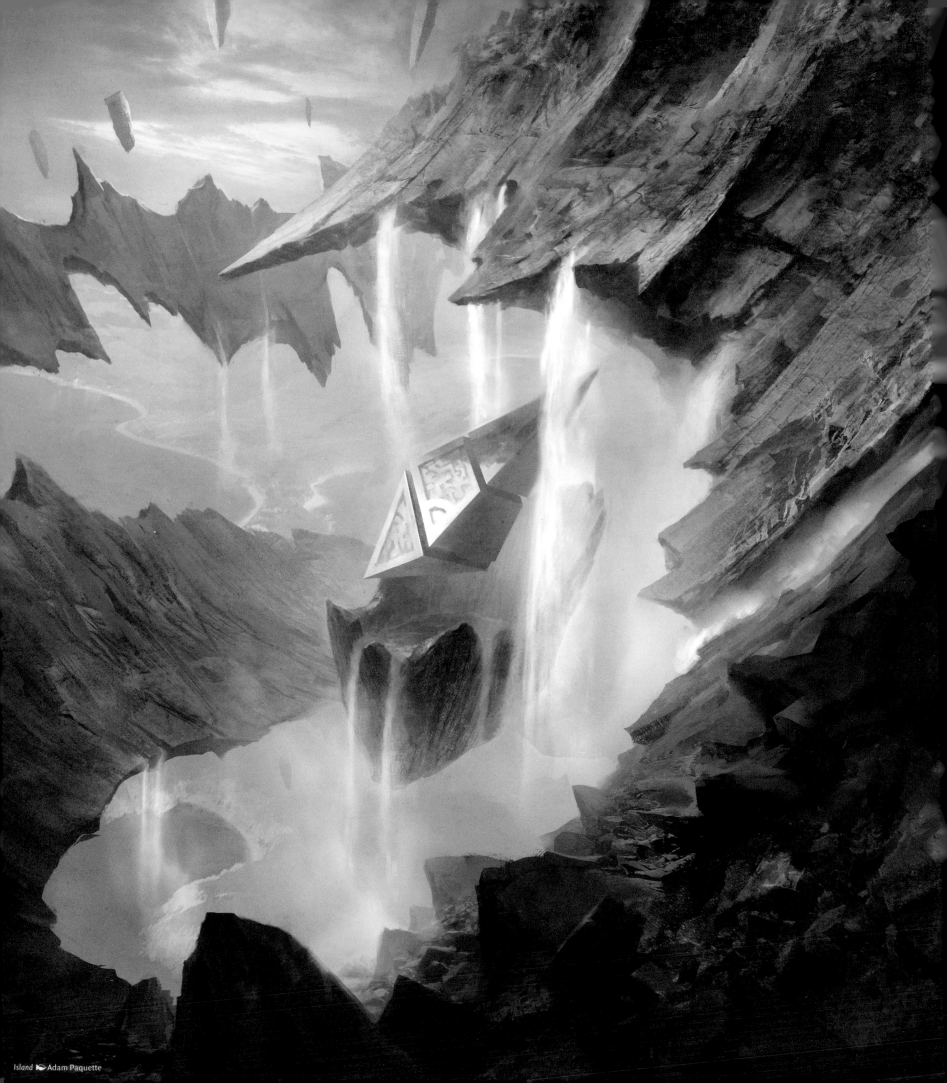

Island | Adam Paquette

TAZEEM

Wide rivers originating from bubbling springs and huge, mist-cloaked lakes meander through Tazeem's verdant plains and teeming forests. Rushing waters plunge through narrow canyons and cascade down towering cliffs into the sea. Dismal swamps trap the waters that can't find their way to the sea. Peninsulas jut out into the sea, and narrow land bridges arc over rivers and bisect great lakes. And the largest city on the continent, Sea Gate, is built not on the dry land, but on an ancient dam that divides the inland sea of Halimar from the ocean beyond.

Halimar, the Inland Sea

Tazeem is an island shaped like a crescent moon, with a large inner sea at its heart, called Halimar. Originally a bay, Halimar is surrounded on three sides by the rocky cliffs of the island. But the mouth of the bay is closed off by an ancient dam of incredible width and strength. The dam towers high above the level of the ocean on its outer side, while the Halimar laps at the top edge of the dam's inner side. The dam and the town built on its surface are collectively known as Sea Gate.

The dam is incredibly ancient, the product of ancient kor engineering reinforced by powerful magic. Halimar has been separate from the outer sea long enough that it has its own unique species of brightly colored fish, tusked seals, and massive leviathans that dwell in the depths.

When Halimar is placid, the water is a sparkling cerulean. But the Roil moving across the water creates white-capped waves and treacherous whirlpools. Tidal waves crash against Sea Gate and the cliffs. Despite the tumultuous seas and plethora of carnivorous sea creatures, sailing the Halimar is the safest way from Sea Gate to the mouth of the Umara River Gorge, so maritime trade thrives on Halimar, and ships carry explorers and other travelers across the Inland Sea on a regular basis.

Forest ◄ Adam Paquette

Halimar Depths ◄ Volkan Baga

"Never look too deep,
where the waters turn dark.
What the sea has hidden there
may not stay down forever."
— Thada Adel, merfolk acquisitor

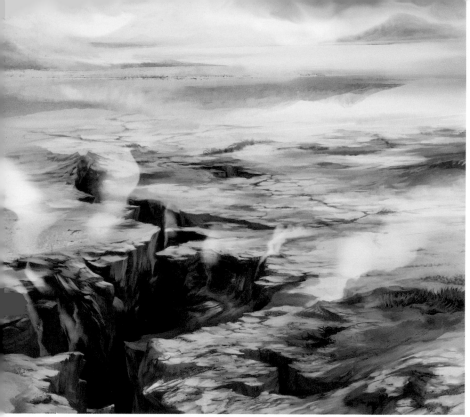

Plains ☙ Véronique Meignaud

Calcite Flats

The beaches around the perimeter of Tazeem consist of crunchy, white sand made of calcite crystals. They are stable enough in some places, but in others the calcite is a thin layer over soft mud or water-saturated sand that quickly swallows any creature that breaks through the outer crust. The calcite spreads in wide flats between the churning waves and the rise of the Bulwark just inland.

Scattered throughout the flats, like foothills before the sharp rise of the Bulwark, are looming rock formations shaped by the ocean tides. These outcroppings are large enough to provide solid campsites for groups of nomads moving across the treacherous beaches, and the abundant crevices and pockets in their surfaces provide an environment where life can flourish. Trees sink their roots into the rock, giving shelter to small animals such as turtles, small primates, large sloths, and numerous flying species—drakes, herons, owls, and giant falcons. Thus, the rocks are islands of green vegetation and life in the otherwise barren sandy flats.

The hedrons that drift in the sky above most of Tazeem do not extend past the Bulwark onto the Calcite Flats, and the flats are unaffected by the Roil. Once in a while, though, a hedron tumbles past the edge of the Bulwark and plummets to the ground, lodging in the sand. The nomads of the flats break these hedrons into small pieces and sell them as pathway stones to guide explorers—or as material to use in making weapons to wield against the Eldrazi.

The Bulwark

Just inside the ring of the Calcite Flats, the land rises sharply into a ring of high rock. This is called the Bulwark due to its resemblance to a fortified wall. In fact, an artificial wall used to follow the entire perimeter of the ridge, but most of it has eroded away. Watchtowers spread out along the wall have mostly crumbled to ruin as well, but empty shells still stand in places, and a few remain more or less intact. Vying for control of the various towers and ruins, different factions of nomads and raiders skirmish with each other and occasionally make raids on Sea Gate.

Umara River

The Bulwark is highest at the north end of the island, and the Umara River has its source in the surrounding highlands. Hundreds of tributaries in the northern hills and the Oran-Rief forest feed into the stream until it becomes a fast-flowing river cutting a deep gorge down the length of Tazeem. It spills down a number of waterfalls and churns through many areas of rapids before tumbling into Halimar. The river and its gorge are relatively stable, resisting the effects of the Roil, so many settlements of humans, merfolk, and elves cluster in the relative safety of the rocky canyon.

Winds matching the speed of the river sweep along the gorge, and the merfolk use gliders to drift down the gorge. These gliders aren't fast and can't carry cargo, but they are an easier way to travel downstream than taking a boat over the river and across the many portages around waterfalls.

Magosi Waterfall. Plunging almost 300 feet over a sheer cliff, Magosi is the tallest waterfall along the river. The portage near the top of waterfall is a popular resting point for travelers, including both nomads and adventurers. Some number of traders and other explorers are always camped at the portage. This is the best place outside of Sea Gate to trade for pathway stones, supplies, and minor magic. That said, it is hardly a safe refuge. Since the fall of Sea Gate, Eldrazi surge up the gorge all too frequently. Sphinxes seem drawn to the falls, and a huge kraken dwells in a deep, water-filled cave behind the cascade.

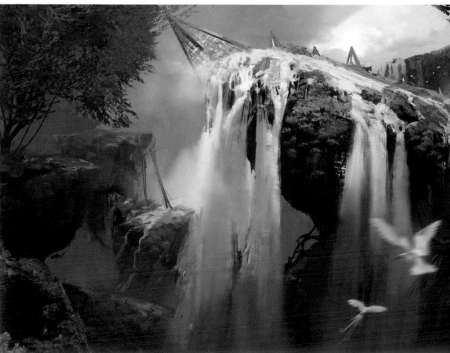

Part the Waterveil ☙ Titus Lunter

Oran-Rief, the Vastwood

Much of the interior of Tazeem is covered in a thick network of giant trees, with wild branches forming an enormous lattice across the island. Shrubs, vines, honeysuckle, ferns, grasses, and tangles of blackberry thrive beneath the tree branches. Because the dense canopy blocks much of the sunlight, the ground vegetation grows explosively fast in places where the sun does manage to shine through. Known as Emeria's Blessing, this explosive growth is both beautiful and dangerous—vines and brambles can grow so quickly that animals and explorers can become caught and suffocated in the growth.

In part because of the danger of this "blessing," many of the creatures that live in the Oran-Rief are enormous, contributing to the forest's nickname, the Vastwood. Hydras, wurms, and oversized spiders and antelopes are among the animals that crash through the heavy growth, sometimes clearing away the ground cover and sometimes breaking away canopy branches and letting sunlight reach the ground.

Pit Caves

In many places across Tazeem, deep vertical shafts gape open, leading down into swampy caves below. Birds make their homes in the walls of these caves, and some elves carve deep indentations into the walls to make sheltering places that are relatively safe from the Roil. Some of these pit caves have reservoirs of fresh water at the bottom, so resourceful travelers have installed pulley systems to bring the water to the surface. Others are filled with a choking mist that leaks into the air above, poisoning anything that ventures too close to the mouth of the shaft. The most dangerous pit caves look totally innocuous, but geysers at the bottom occasionally blast boiling water into the air.

Sunken Hollow ▶ Adam Paquette

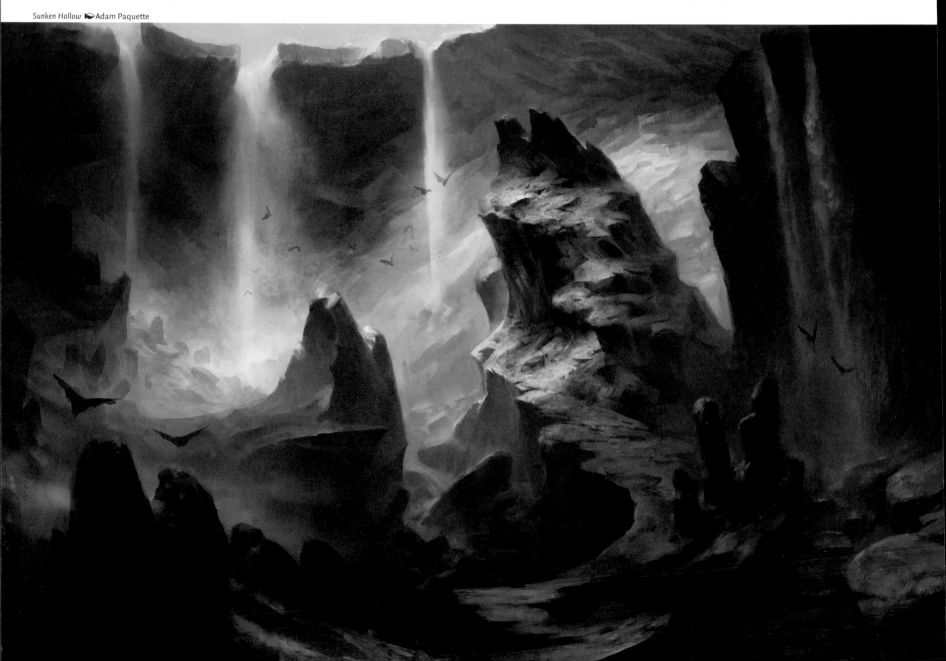

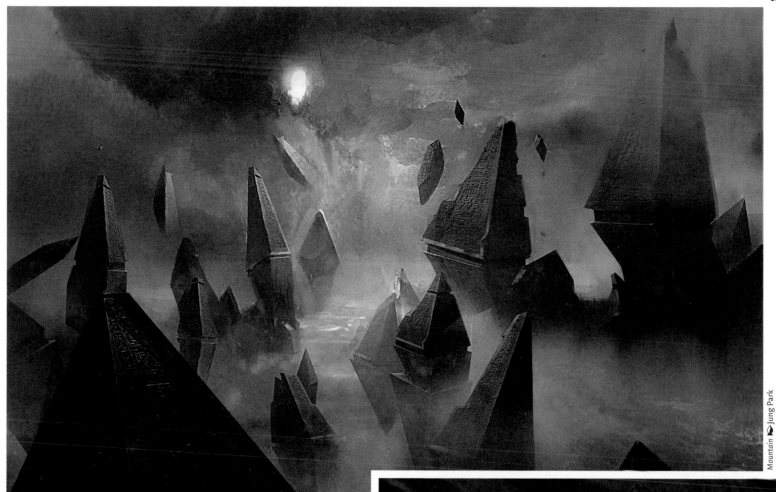

Mountain ◗ Jung Park

Lantern Scout ◗ Steven Belledin

Emeria, the Sky Realm

The sky above Tazeem is covered in a blanket of hedrons floating high overhead. Before the rise of the Eldrazi, the merfolk placed great religious significance on this hedron field, calling it Emeria after their goddess of the sky. Emeria's floating castle, they said, was shattered in a great cataclysm, but they believed that parts of it remained intact above the lower levels of hedrons and drifting rubble.

It has now become clear that Emeria is actually a fractured memory of Emrakul, and the Sky Realm has lost its religious significance. But some expeditions still come here to discover the true power of the hedrons and their connection to the Eldrazi, where previously they merely sought treasure.

Pathway Stones. The massive hedrons are covered in runes and retain magical properties even when they fall from the sky or are broken into shards. Pathway stones always point to the direct center of the hedron field, no matter where in Tazeem they are taken. Those who understand how to orient themselves according to the hedron field can use the pathway stones for navigation.

These pathway stones are usually sold in palm-sized chunks, which are painstakingly chipped off the hedrons by cutter-traders.

Most of these merchants are merfolk who scour the surface of Tazeem for fallen stones, but they cannot meet the high demand for pathway stones. Thus, brave adventurers risk falling, being crushed by colliding hedron pieces, or succumbing to other, more mysterious hazards by climbing into the heights of Emeria's Realm to scavenge pathway stones from hedrons that still float in the sky.

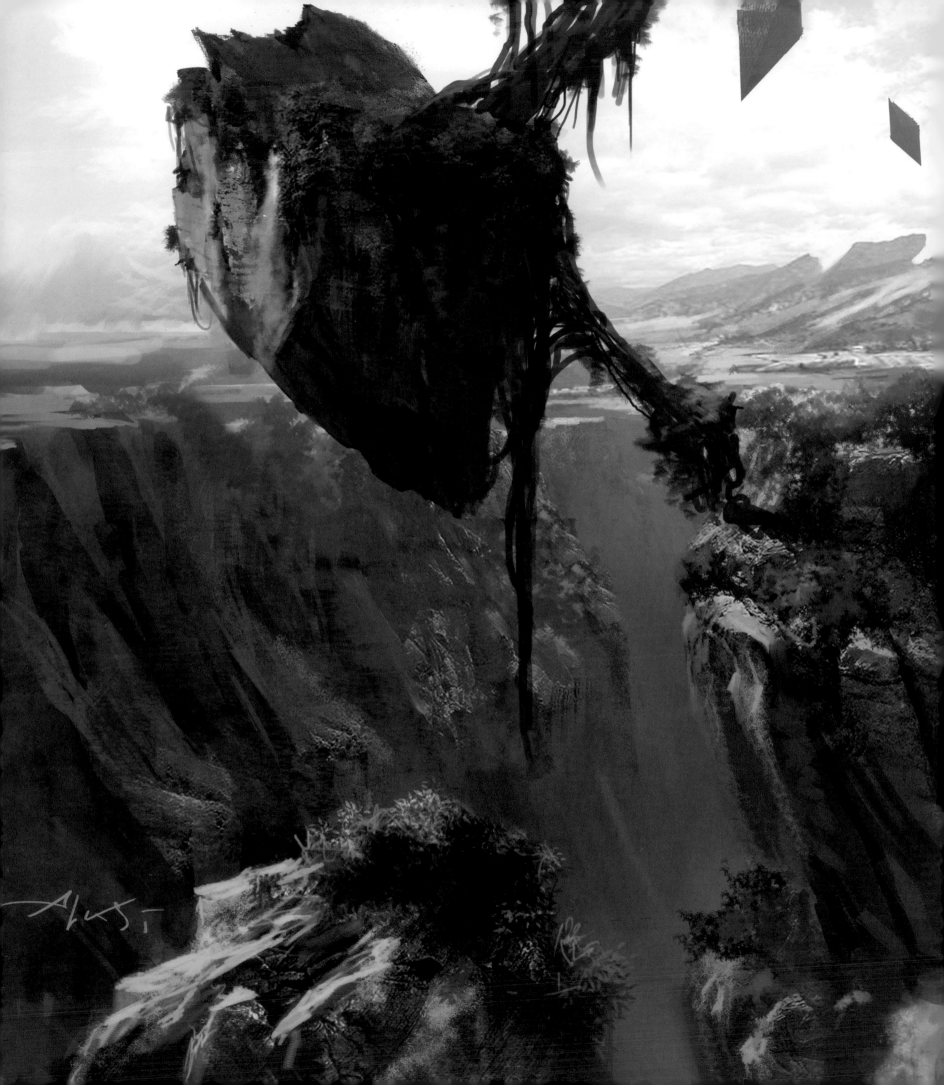

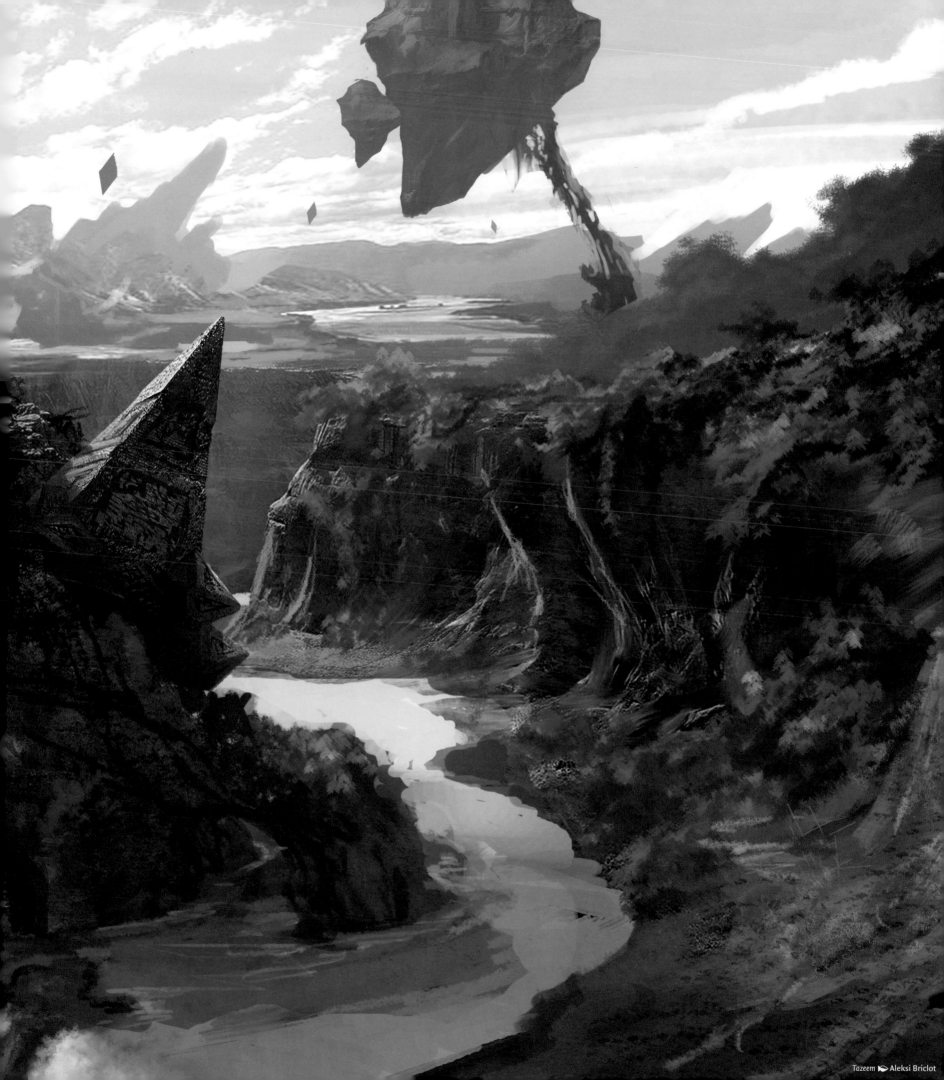

Tazeem ◆ Aleksi Briclot

LIFE IN TAZEEM

Tazeem offers a few bastions of stability that provide relatively secure shelter for its people: the immovable wall of Sea Gate and the Umara River Gorge. Thanks to this stability, these places have always been the centers of civilization and habitation for the people—primarily humans and merfolk—of the island.

Sea Gate

The town of Sea Gate is built atop the great stone dam that forms Halimar, Tazeem's inland sea. A cylindrical tower of white stone—the Lighthouse—rises high above the dam, and buildings of stone, brick, and wood are built all across its wide, flat surface.

The largest settlement on Tazeem, Sea Gate, had a strong, well-trained militia organized to protect the town against raiders and aerial attacks (from drakes, thunder eels, and so on), as well as to maintain law and order. The militia presented the most organized fight against the Eldrazi during the recent upheavals. However, even this army was unable to protect Sea Gate from the endless waves of Eldrazi that overran it.

More than just a beacon, the Lighthouse used to be the center of all learning in Tazeem. It was a nexus for merfolk explorers and chroniclers, boasting thousands of leather scrolls filled with maps, spells, descriptions of archeological finds, lists of plant and animal classifications, and theoretical discussions of the Roil. The Lighthouse, tended by merfolk mages, had always kept a blue flame lit to guide ships into port, but the flame has gone dark since the settlement was overrun by the Eldrazi.

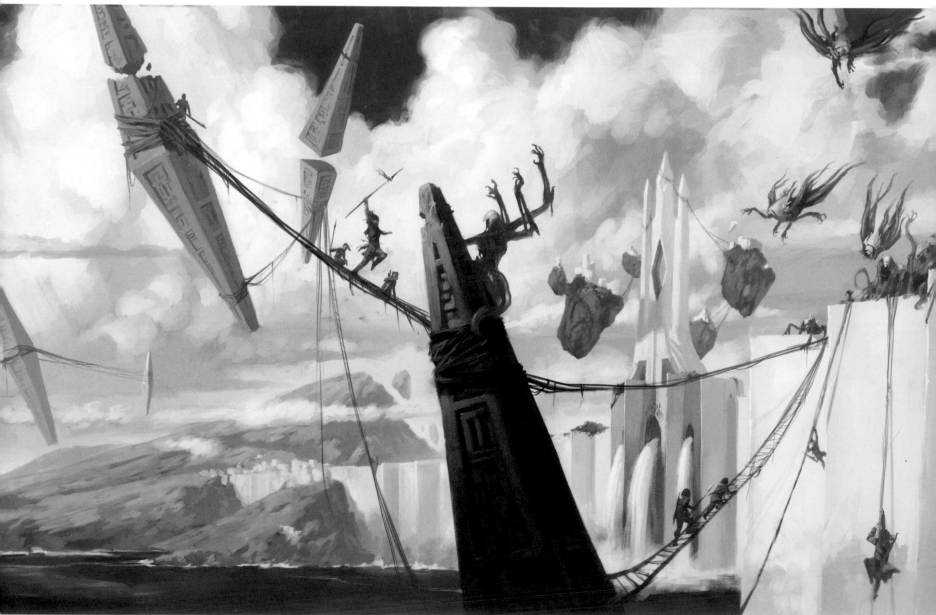

The Liberation of Sea Gate ❧ Tyler Jacobson

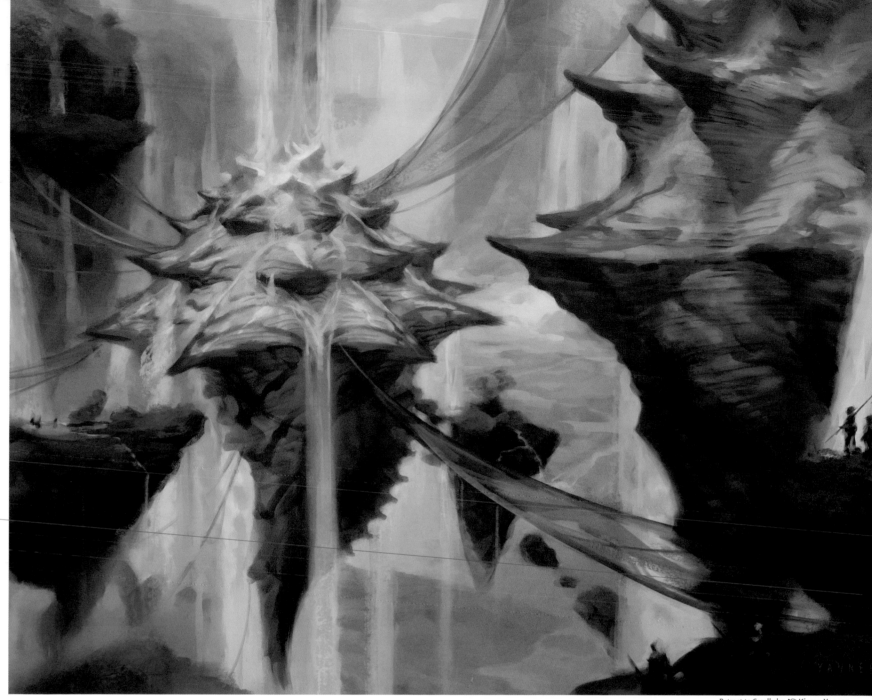

Coralhelm Refuge

The original merfolk Enclave, situated on an island in the middle of a wide section of the Umara River, was an elaborate structure of pale stone flecked with sparkling crystals, a masterpiece of architecture and the pinnacle of merfolk civilization. Like Sea Gate, it was overrun by the Eldrazi, and its graceful dome and buttressed walls lie in ruin.

Coralhelm Refuge is the new merfolk capital, constructed inside a series of enormous conch shells suspended by a complex network of nets and lines between the walls of the Umara gorge near its mouth above Halimar. The refuge was founded by Noyan Dar, a clever lullmage and scholar who now wears the mantle of Coralhelm Commander. The merfolk rely on goods brought by human traders and elves from the inland forests, and the refuge draws merfolk refugees from across the plane.

Tikal Harborage

Some merfolk have set up small outposts tucked away in rocks near the Eldrazi-infested seas. Adept mages, these former scholars are turning their expertise to the task of capturing the Eldrazi and studying them up close, at great personal risk. They also study and experiment with hedrons that have tumbled from Emeria.

The largest such outpost is the Tikal Harborage, half-submerged in a pool farther upriver from Sea Gate. With the help of the kor, the merfolk anchored and pulled down a few of the largest hedrons from Emeria, which merfolk mages use to power the spells that drive back the Eldrazi and create a relatively safe refuge.

This settlement is led by Thada Adel, a former adventurer who shares her knowledge of Tazeem's ancient ruins with other explorers in exchange for information the explorers unearth—and a share of any profits.

159

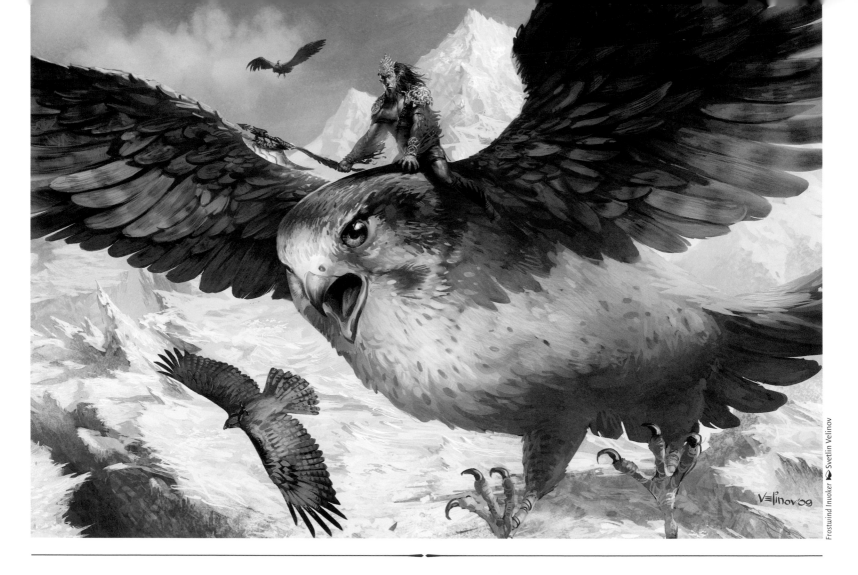

Frostwind Invoker ❧ Svetlin Velinov

> "I grew up in the cliff-caves of Wren Grotto, the most beautiful place in all of Zendikar. This is the training ground of the giant falcons, and we paint the temples gold to honor them. In the wild, their nests are woven with gold from the strands of treasure only they know how to find." —Ilori, *merfolk falconer*

Outpost at North Hada

Located in the northern highlands near the source of the Umara River, North Hada is a lawless, violent outpost run by cutthroats and thieves. No one goes there unless they have shady business or something stolen to sell. Slave traders run a burgeoning business in the outpost, and dark magic and artifacts are in ready supply. The nomads of the Calcite Flats and the raiders of the Bulwark visit North Hada frequently—the nomads to trade pathway stones for basic supplies, the raiders to secure weapons and armor.

Wren Grotto

Wren Grotto is an area of the Umara River gorge where small caves open into the cliff walls over a series of natural rock outcroppings and platforms. Merfolk mystics (formerly identified with the Emeria creed) have constructed elaborate gilded facades leading into the cliff walls, where they have expanded natural caves into comfortable homes. An elite group of merfolk live in the grotto, where they train giant falcons for riding. In the past, these mounts were used primarily for exploration, with the trainers coaxing the falcons ever higher through Emeria's Realm in hopes of reaching the highest layers. Now, the merfolk have shifted their emphasis to combat, turning the falcons and their riders into a formidable defense against flying Eldrazi.

Dojir Nomads

Wandering groups of humans live in the Calcite Flats on Tazeem's coasts. Though they are often called nomads, they are not tribal groups but are actually criminals and outcasts banished from Sea Gate and the settlements along the Umara River. The word "dojir" is a merfolk term used to describe heretics who are cast out of the community, but the humans of Tazeem, including the nomads themselves, have appropriated it to refer to these traveling bands.

The Dojir hunt herd animals or fish the coastal waters for food, and they barter for other supplies in North Hada or with other bands. They collect hedron shards and trade them as pathway stones, scavenge flotsam and jetsam on the shores, and gather rare and valuable herbs from the outcropping forests in the flats. They also sometimes sneak into settlements along the Umara River and steal the goods they need.

Since the fall of Sea Gate, many refugees have come to live among the Dojir bands, but "soft city folk" don't always receive a warm welcome among the nomads. The lucky ones are reduced to positions of servitude in the bands, while the unlucky are tortured and killed.

Vastwood Druid ➧ Raymond Swanland

Merfolk Mariners

Small groups of merfolk live on the Halimar surface in floating villages. These sturdy barges provide moorage for small boats traveling across Halimar. Their inhabitants are mainly fishers and explorers who preferred to avoid the larger settlements of Sea Gate or Coralhelm Refuge. With the coming of the Eldrazi, more and more of these Mariners, as they call themselves, are seeking shelter in other outposts and refuges, but others have become adept at fighting the aquatic Eldrazi that plague Halimar.

Elves of the Vastwood

Several small clans of Tajuru-nation elves live in Oran-Rief. They avoid the ground with its unpredictable vegetation, instead making their homes on the branches of the sturdiest trees or amid crumbling ruins. Their homes are connected by miles of rope bridges anchored on the trees and disguised by vines and ivy. Their shamans help deal with the oversized threats of the Vastwood by animating the land itself to protect the elves.

Nissa, Vastwood Seer ➧ Wesley Burt

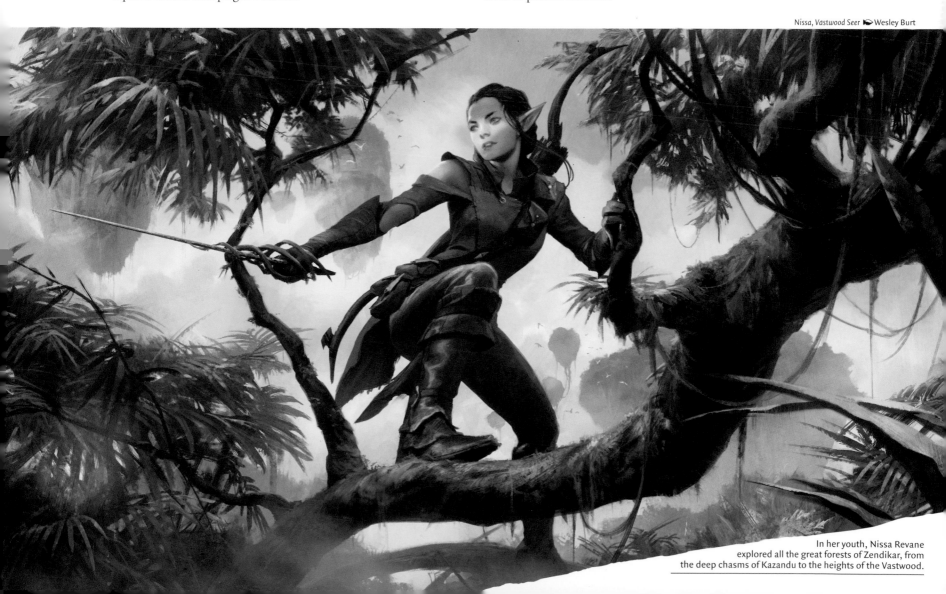

In her youth, Nissa Revane
explored all the great forests of Zendikar, from
the deep chasms of Kazandu to the heights of the Vastwood.

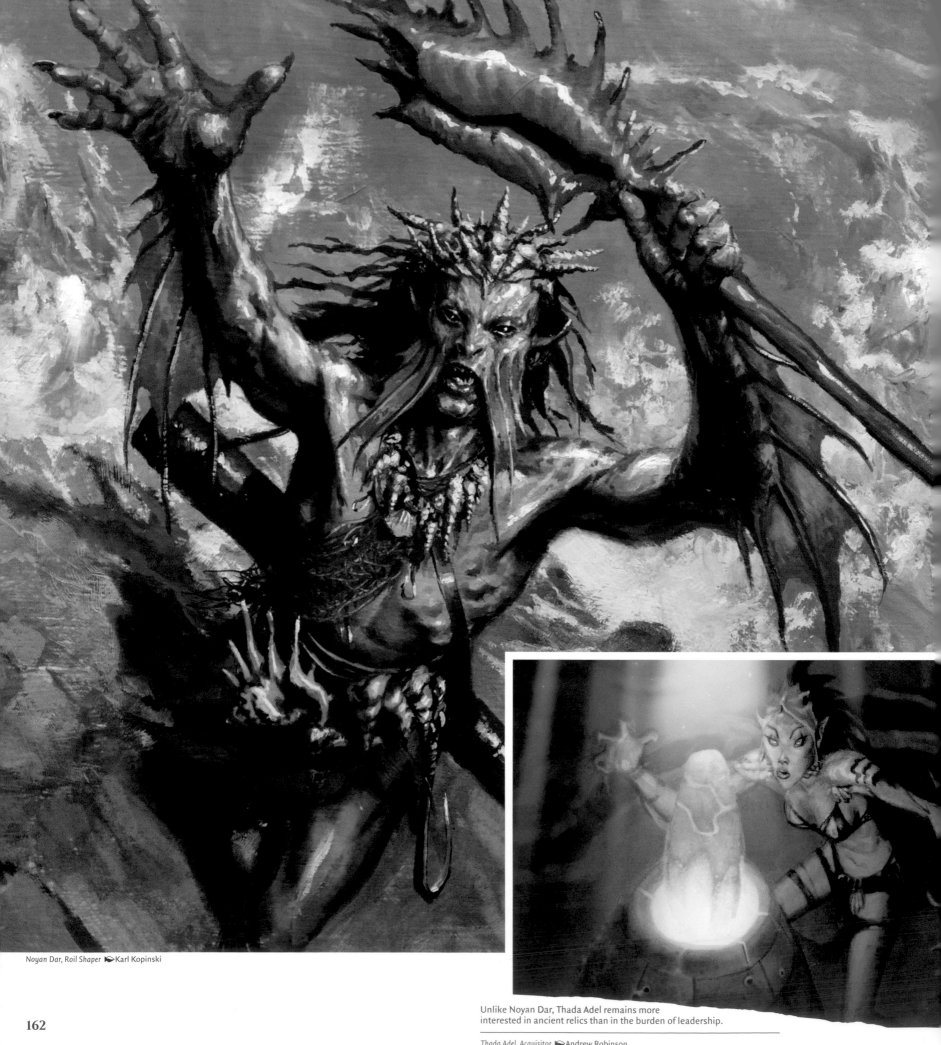

Noyan Dar, Roil Shaper ► Karl Kopinski

Unlike Noyan Dar, Thada Adel remains more
interested in ancient relics than in the burden of leadership.

Thada Adel, Acquisitor ► Andrew Robinson

NOYAN DAR, MERFOLK LEADER

Noyan Dar, the founder and leader of Coralhelm Refuge, is an unlikely hero. Born in Sea Gate, he studied with the Emeria-creed mystics at the original Enclave but secretly followed the creed of Cosi for most of his life. He showed great magical aptitude and became a powerful lullmage, while also secretly studying the rigorous methods of the Ula creed. He cultivated contacts in North Hada and among the Dojir nomads and personally spied on the workings of power in Sea Gate. He amassed a network of loyal supporters in the Enclave thanks to his charisma and his talent at manipulation. If his life had gone differently, he might have become a criminal mastermind, at the center of a vast spy network or blackmail ring.

Instead, the myths of the gods and the monsters they fought in the distant past caught his attention. He began using his contacts to acquire ancient relics, historical information, and long-forgotten magic. He hired out his services as a lullmage to explorers who were undertaking particularly significant expeditions. Eventually, long before the Eldrazi titans awoke, he developed a suspicion that the merfolk deities were not actually gods but destroyers. Then the Eldrazi did awake, and his suspicions were confirmed.

When Sea Gate and the merfolk Enclave fell to the Eldrazi spawn, he found himself thrust into a position of leadership by virtue of his knowledge and experience in the world. Somewhat unwillingly, he led refugees from the Enclave farther upriver to found Coralhelm Refuge. He has grown to accept his position—not least because of the personal power it gives him—while also retaining his interest in history.

Noyan Dar sees that the only path to survival is for all the merfolk and survivors of other races to work together. By coordinating their efforts to understand the ancient ruins and using hedrons to fight the spawn, the peoples of Zendikar can triumph—or so he believes. He now organizes the merfolk's expedition efforts and compiles the information they bring back to Coralhelm. He has also started training a new generation of lullmages to use their magic, not to calm the Roil, but to turn its power against the Eldrazi.

Ironically, Noyan Dar's greatest enemy is someone who shares his goals as well as his skills: Thada Adel, leader of the Tikal Harborage. The two merfolk first crossed paths when Thada was studying at the Enclave, and Noyan Dar attempted to recruit her into his circle of cronies. The younger merfolk took an instant dislike to him, which has persisted through the years since. They have often found themselves in conflict over information or ancient artifacts, and both harbor bitter grudges.

"My legs began running before I even knew what I was seeing. It was Dar, his arms in the air, his palms skyward, the way one might hold up a heavy curtain for another to pass through. Dust and pebbles rained down on our party as we dashed across the rocks, and the popping sound over our heads turned out to be the floating peak cracking, squeezed by shearing forces pressing in from all directions. I remember thinking there'd be no way he'd get out alive, lulling magic or no—and also that I should shout some sentiment of gratitude back at him before he died. To my regret, no words came. But when gravity asserted itself again, and we fell prone with the mountain's shaking, he stepped out of the dust cloud like an angel. And so, he had to endure my gratitude for the rest of the journey."

—Bebea, *Cliffhaven lightcaster, Tales of Noyan Dar*

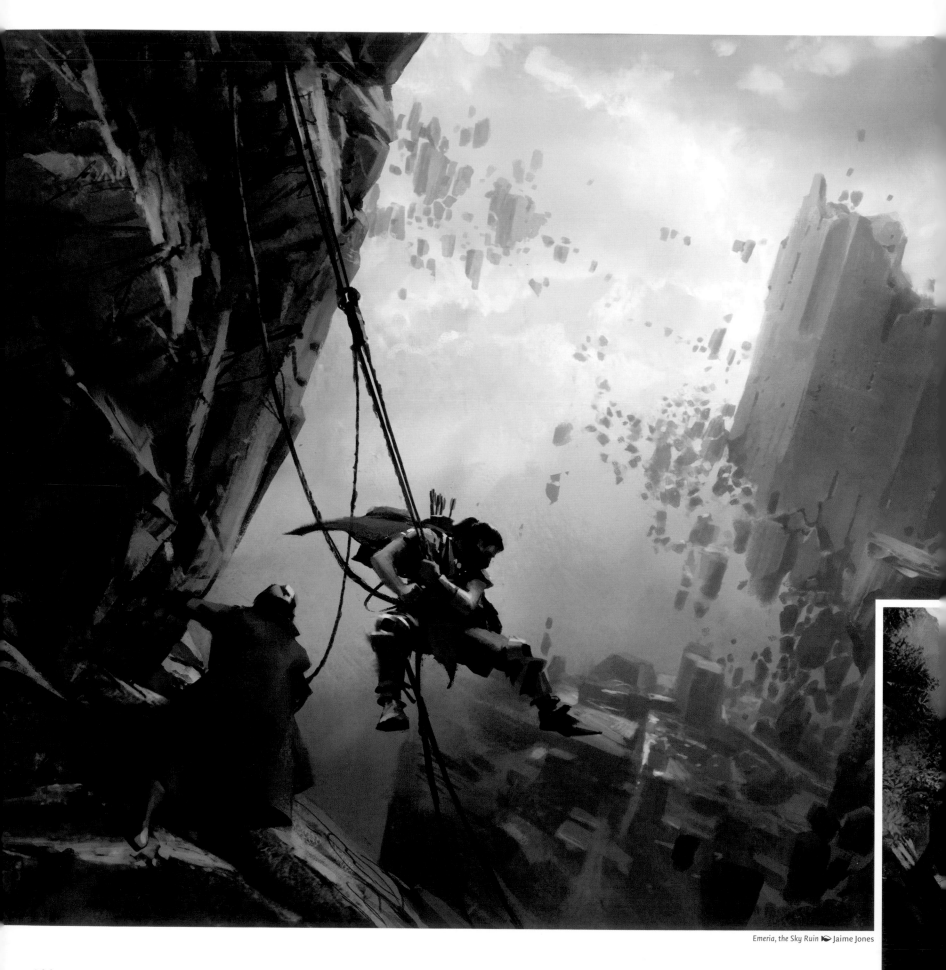

Emeria, the Sky Ruin ✍ Jaime Jones

ANCIENT SITES OF TAZEEM

Tazeem is dotted with ancient ruins that often serve as temporary or permanent shelters for humanoid settlers and refugees. Some of these ruins, though, are yet to be discovered and hold mysterious artifacts and forces that might yet prove to hold some power over the Eldrazi.

Emeria, The Sky Ruin

Many of Tazeem's expeditions travel upward, not downward, into ancient ruins. Explorers might scale a tall cliff or spike mountain and use harpoon lines to climb into the hedron field. The bravest explorers use skyhooks to climb to the higher levels, and some even set up camps on the larger hedron faces.

The lowest level of the hedron field is made up of mostly intact, enormous hedron stones, ranging from fifty to one hundred feet long. Some smaller hedrons and broken shards litter the field as well, and these are prized by explorers who sell them as pathway stones.

Above this level, not visible from the ground, is a field of rubble—broken pieces of worked stone, shattered hedrons, and chunks of earth. Some structure clearly did once float here, even if it was not the palace of a sky god.

No one has navigated above the rubble-filled second layer to reach the realm above, where the merfolk once believed that parts of Emeria's castle remained intact. This is partly because the passage is so treacherous and partly because the angel Iona, called the Shield of Emeria, has always prevented explorers from climbing too high. Iona knew the truth—that the goddess (or archangel, in human understanding) Emeria was a fiction. But the angel believed that faith in Emeria sustained her followers through the perils of life on

Zendikar, and she did not want that faith shattered. Now that the awful truth is revealed, though, Iona has joined the fight to defend Zendikar from the Eldrazi—including Emrakul, the true face of the goddess she was once believed to have served.

"You might find a way into the Sky Ruin, but you'll find its secrets well protected by shifting hedrons and Roil winds."
—Maizah Shere, *Tazeem lullmage*

Halimar Depths

The building of the Sea Gate dam raised the water level of the inland sea, drowning some structures that had previously been on dry land. Some of these ancient sites, lying in the relatively shallow depths near the shores of Halimar, have been thoroughly explored, but others have been buried in silt or swallowed in the earth through the activity of the Roil. Hedrons fallen from the Sky Realm also lie all across Halimar's floor, potentially holding undiscovered magical secrets.

The Ula Temple. Under Noyan Dar's direction, a merfolk expedition is working to explore a sunken temple near the mouth of the Umara River. Tradition links the temple's name to the merfolk sea god, Ula, so Noyan Dar believes that the site might be directly connected to the Eldrazi. So far, though, the divers have found large krakens and other aquatic beasts, but no Eldrazi.

The Sunspring

In a remote part of the Calcite Flats, under the looming Bulwark, stands a radiant oasis in the midst of the barren and treacherous landscape. No outcroppings provide solid ground anywhere near this site, and the ground is particularly unstable around it, so the Dojir nomads avoid it. A few travelers have found it, though, and returned with tales of the legendary Sunspring. It's a white marble fountain, fed by an underwater spring, whose pure waters glow with soft, greenish light. A great stone eagle, crusted with old moss, crowns the fountain, with the water spilling around its feet.

The waters of the Sunspring hold powerful healing magic, able to banish poison and disease, close even mortal wounds, wash away fatigue, and replace despair with a glimmer of hope—even in these most desperate times.

Sunspring Expedition Chris J. Anderson

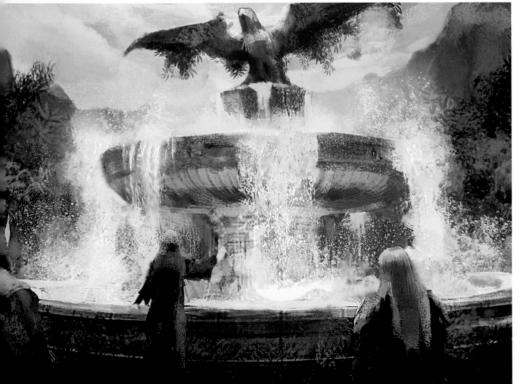

THE ELDRAZI WASTES

On five of Zendikar's continental regions, life and civilization still fight desperately against the Eldrazi. On two others, though, that battle has been lost. Shortly after the Eldrazi titans emerged from their prison, they rampaged through Bala Ged and Sejiri, leaving nothing but desolation in their wake.

Even before the appearance of the Eldrazi, Sejiri and Bala Ged were inhospitable and sparsely populated. That doesn't mean their loss isn't keenly felt, though, particularly by the elves—two of the three major elf nations were concentrated in Bala Ged. For most of Zendikar's people, these areas stand as a grim reminder of what is at stake in their struggle: without their strength and determination, all of Zendikar might be similarly reduced to ruin. Some enlightened souls also look at Sejiri and Bala Ged and find hope—hope that Zendikar might be able to regrow itself once the Eldrazi have consumed their fill and left the plane behind.

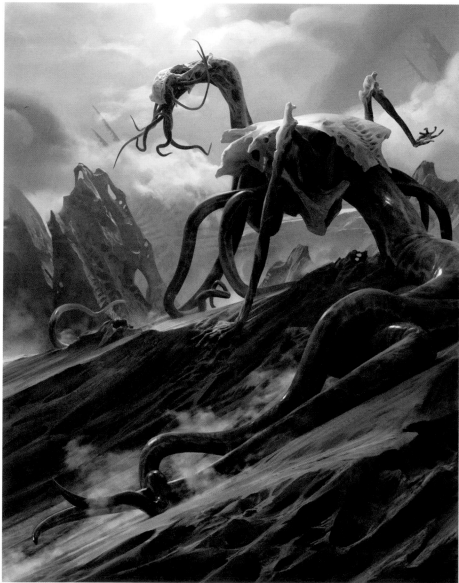

Bane of Bala Ged ▶ Chase Stone

Dust Bowl ▶ Florian de Gesincourt

Misty Rainforest ▶ Shelly Wan

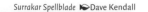

Bala Ged

Before Ulamog destroyed it, the subcontinent of Bala Ged was a moment frozen in time, a primordial throwback to the way Zendikar might have been eons ago. Damp, fetid air, thick vegetation, algae-choked marshes, and mold-covered thickets defined the environment of Bala Ged.

Guum Wilds. A dense, humid jungle boasting the largest array of carnivorous and poisonous plants on Zendikar covered much of Bala Ged. The flora of the Guum Wilds rivaled the titanic jurworrel and jaddi trees of Murasa, wrapping around every surface in a continuous, tentacular crawl.

Surrakar Caves. Deep within the Guum Wilds were slick, slimy limestone outcroppings of rock dotted with cave mouths. The reptilian surrakar nested there, never far from either their caves or a bog. They were very territorial, and even brave expedition groups knew to steer clear of the limestone hillocks. The surrakar spawned in deep tunnel systems underneath Bala Ged that remain uncorrupted, preserving a remnant of the monstrous race.

Bojuka Bay. This swampy inlet lay at the edge of the Guum Wilds, protected from the waves by the thousands of trees between it and the ocean. Fed by the Umung River and several waterfalls that cascaded down the surrounding cliffs, Bojuka Bay was a watery marsh of vast proportions. The Umung River flowed slowly through the bay but provided a clear and deep passage for boats going to or coming from the Guum Wilds. Those who passed through Bojuka Bay had to be prepared to bribe or fend off the savage marsh trolls that lived there. Fortunately, the Grotag tribe of goblins that lived in the trees could provide assistance in this regard, assuming they too were appropriately bribed or intimidated.

Umung River. The Umung River descended in steps from the interior to sea level as it wound through Bala Ged. Once explorers passed the dangers of Bojuka Bay, reaching the interior of Bala Ged was a matter of slow progress against the current and portaging small vessels around or pulling them up the many rapids and falls at each step. Small villages of humans along the Umung could usually be relied on to aid travelers at such points.

Tangled Vales. The Tangled Vales were interconnected jungle valleys that ran between steep hills, rippling across the southern portion of Bala Ged. Clans of Joraga elves made their homes in the vales, in uneasy coexistence with some human hunters and trappers. The jungles of the vales were a twisted and dangerous morass of predatory plants infested with bestial threats, but the Joraga made relatively safe zones by cultivating patches of deadly, nettled vines called bloodbriars as a defensive barrier around their paths and villages. Even the elves avoided the fungus-choked hilltops, knowing them to be even more deadly—the high points of the land were exposed to unpredictable winds and deadly flying hunters, such as gomazoa.

Ulamog's Devastation. Now the ground of Bala Ged is barren and lifeless. Many of the Joraga elves were killed by the titans, and the rest scattered to far-flung regions, and some believe that their absence is preventing the land from regenerating itself as other areas, such as Murasa, have done. The Joraga elves had a deep spiritual connection to the land, and it is possible that their careful tending of the wilds was essential to Bala Ged's continued survival.

However, Zendikar is actually attempting to reclaim Bala Ged. A new Khalni Heart, like the enormous flower that grows in Akoum, is now budding deep within a cave on Bala Ged.

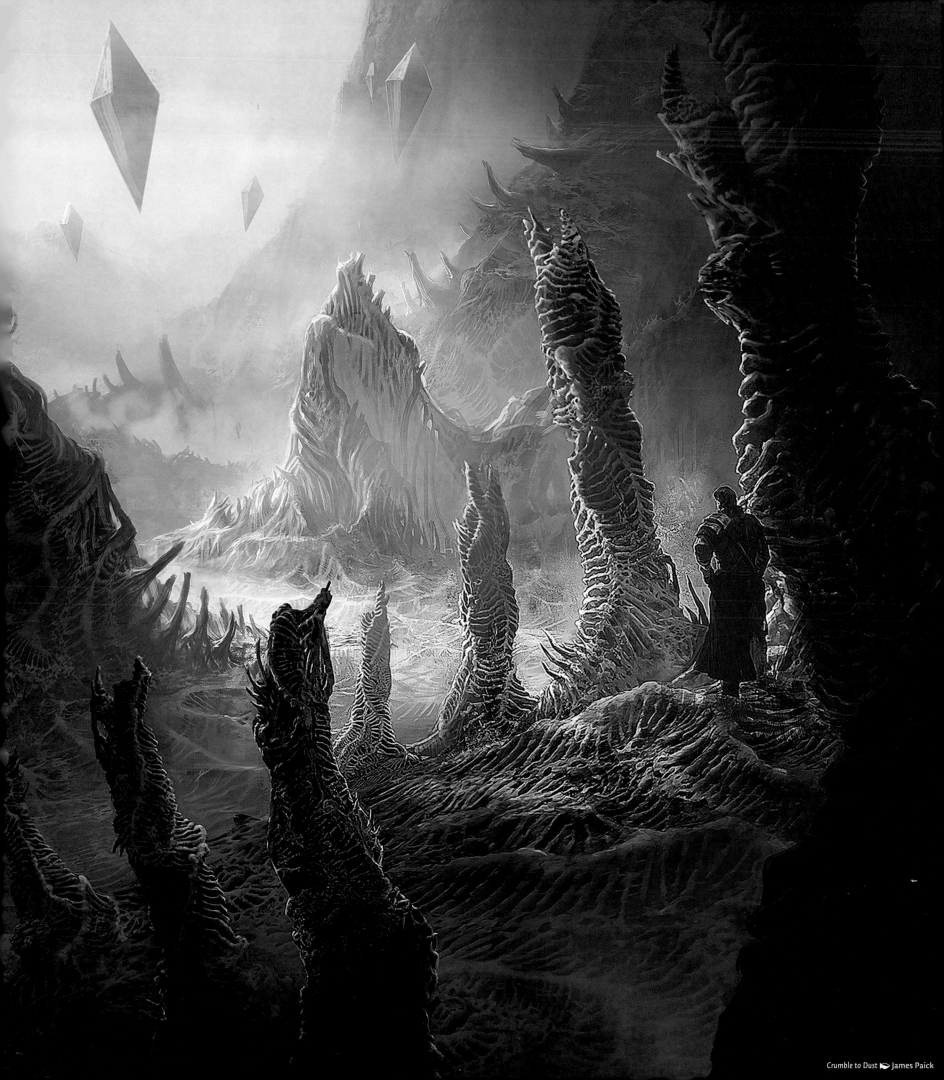

Crumble to Dust ▶ James Paick

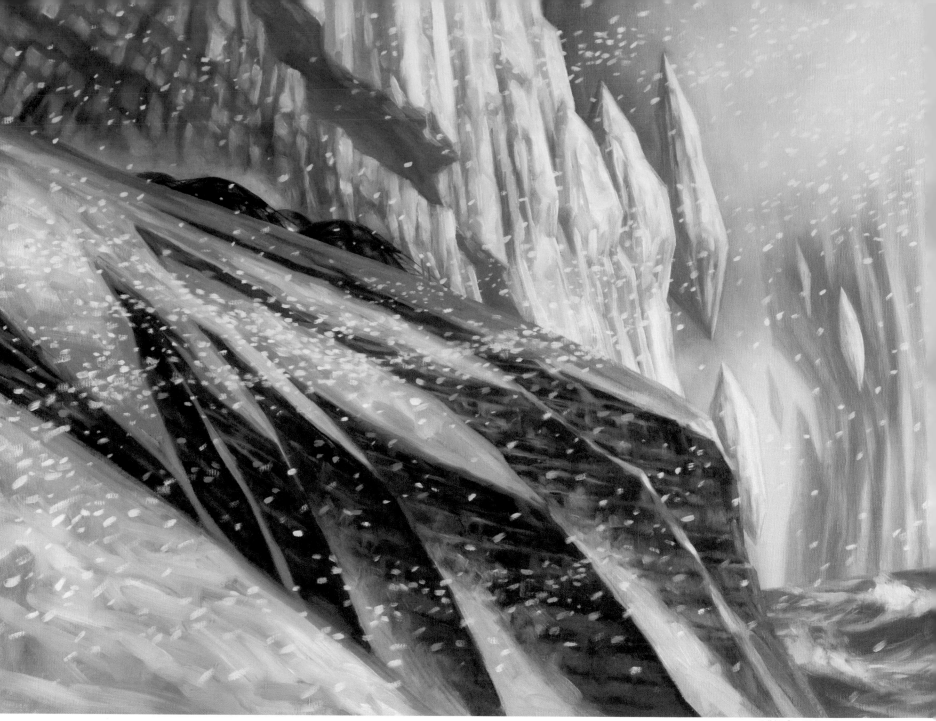

Sejiri Refuge ❧ Ryan Pancoast

Sejiri

Before the rampage of the Eldrazi titan Kozilek, Sejiri was an arctic expanse of elevated polar landscape. It was the least populated and most remote of Zendikar's regions. Soaring cliffs were topped by a rugged, mountainous plateau of snow, ice, and tundra. Its freezing wastes confronted travelers with gales of howling wind and stinging sleet, brittle ice bridges over rapidly-flowing rivers, frost-breathing predators, and enormous, floating stone bowls that spilled avalanches of ice and snow across the landscape.

Expeditions have explored this region, but almost no permanent settlements existed, even before the Eldrazi came. Most of the humanoids in Sejiri were independent tribes of goblins. Without shelter from the harsh elements, structures built by the humans, merfolk, and kor of the area were quickly destroyed by the exposure

to the harsh elements or by the marauding ice elementals themselves, keeping the humanoid population low.

Wildlife. In the thawing season, lichens and scrubby grasses appeared in patchy meadows across Sejiri. These resilient plants provided just enough sustenance to support its population of shaggy, velvet-antlered deer, which in turn fed Sejiri's population of drakes, wolves, yeti, and snow rocs.

Explorers. Despite the dangers, rugged Sejiri did support a handful of staunch explorers. Human and kor explorers bred a hardy line of gray-white wolves to pull their sleds across the snow.

The kor have mapped a substantial portion of Sejiri, but the winds and ice storms of the region tend to wipe out known landmarks after months or weeks, rendering most of their maps historical oddities rather than valuable guides. Some kor believe that the ice

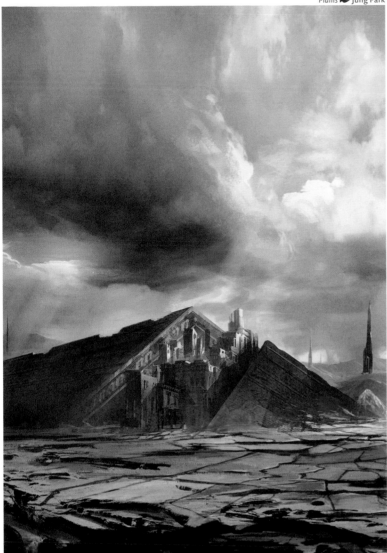

Plains ☛ Jung Park

shelves of Sejiri actually move in regular patterns and that their maps in fact point to a feasible model of the spiritual forces that lie beneath the tundra.

Ikiral. Outposts in Sejiri were few and far between, but in the ruins of an enormous stone hedron huddled the settlement and trading post called Ikiral. The hedron lay awkwardly on its side, partly sunken into the icy tundra, and split down the middle. In the crevice, partly sheltered from the elements, clustered the wind-scoured stone buildings of Ikiral. Frequented by wolf sledders, tundra scholars, and thrill-seekers, the outpost was the best place to find supplies, rumors, and an up-to-date map of the surrounding area.

Kozilek's Ruin. Kozilek's arrival in Sejiri altered the land into rippled formations, stripping off the snow and revealing bedrock warped into strange geometric shapes of unnatural color. It also revealed numerous ruins that had previously been lost under the ice, which are once again drawing explorers to Sejiri's barren wastes.

Benthidrix. An ancient underwater shrine lying under one of Sejiri's deep riverbeds is one of the ruins uncovered by Kozilek's passing. Called Benthidrix, it was originally built by a lost culture of arctic merfolk who dwelled there before the Eldrazi were ever bound on Zendikar. On the one hand, such a place promises a fantastic wealth of knowledge about an otherwise forgotten era of Zendikar's history. On the other, it probably can't offer knowledge of the Eldrazi, so exploring it is hardly a priority while the plane itself is under attack.

Unknown Shores ☛ Jung Park

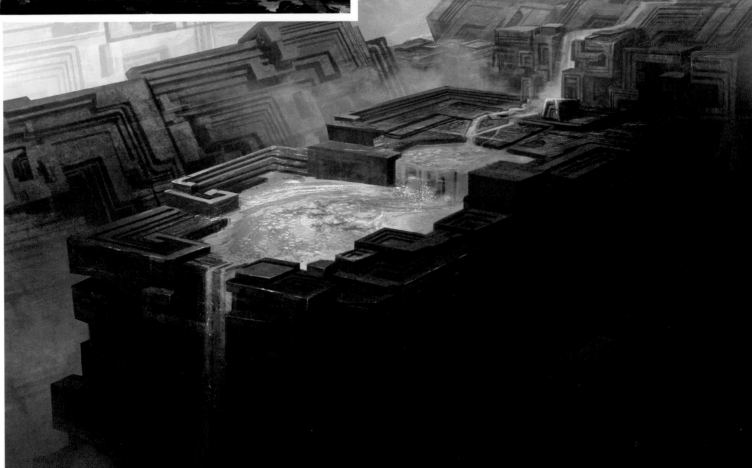

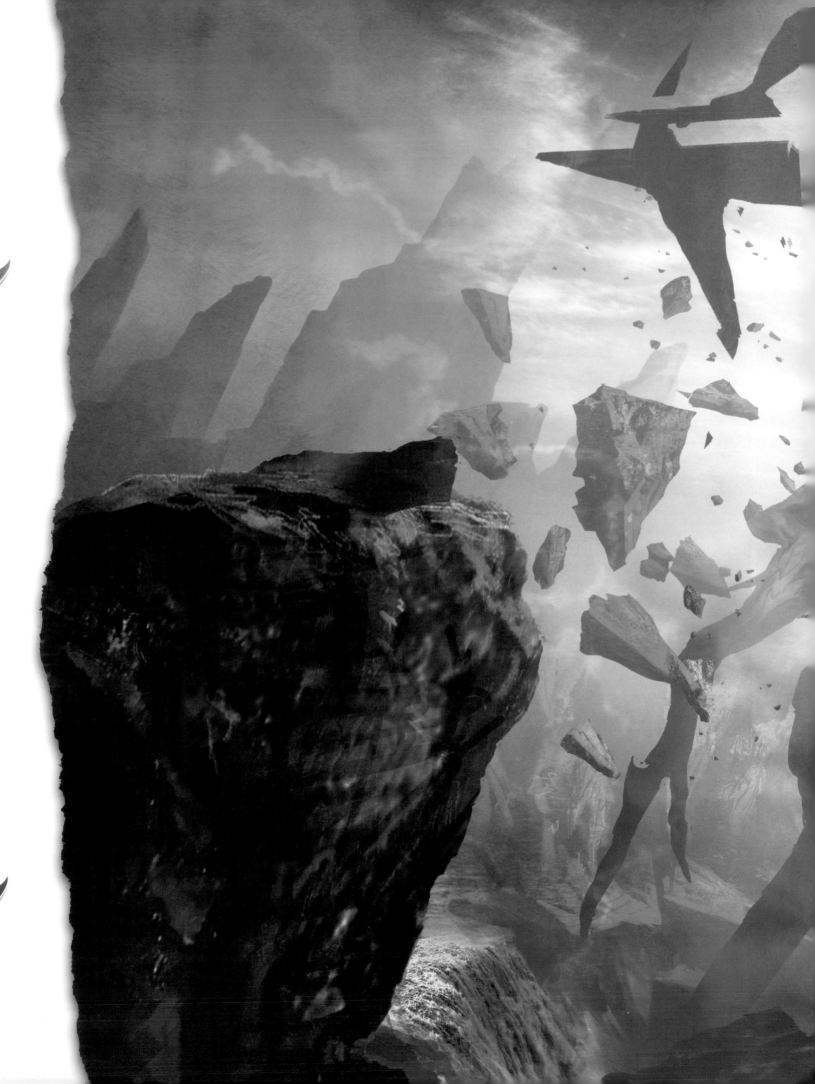

RISE OF THE ELDRAZI

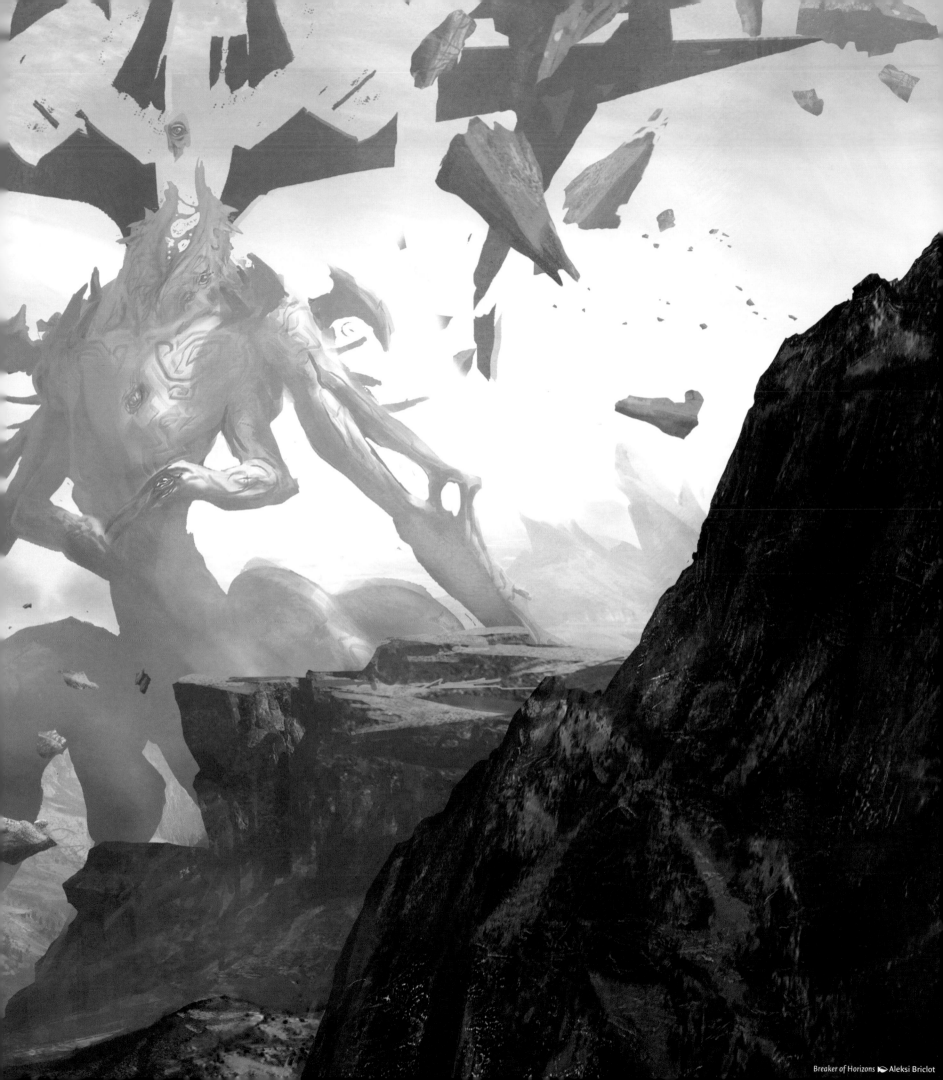

Breaker of Horizons ◆ Aleksi Briclot

◆ PLANESWALKERS

How should a Planeswalker use the power to walk between worlds? Since they have the perspective to understand threats like the Eldrazi in the larger context of the Multiverse, do Planeswalkers have a responsibility to face such threats? Different Planeswalkers have their own answers to these questions, and their answers might determine the fate of worlds. Ugin, Nahiri, and Sorin Markov bound the Eldrazi on Zendikar, and now the fate of Zendikar once again hangs on the actions of Planeswalkers.

Gideon Jura

Gideon Jura grew up on the plane of Theros, living on the streets. Even at a young age, he proved himself a natural leader, gathering a ragtag group of other young ruffians around himself. He took the fall for his so-called Irregulars when they were caught stealing food, and he was thrown in prison. But the prison warden saw something in Gideon and trained him in the magical art of hieromancy—the magic of law—helping him to hone his natural talent and skill.

Gideon was given the chance to earn his freedom when his city fell under siege by monsters. He returned to his Irregulars and led them to victory. But hubris led to his fall. He was sent by the sun god of Theros, Heliod, to destroy a rampaging titan serving Erebos, god of the dead. After he and his Irregulars killed the titan, Gideon went one step further and tried to destroy Erebos himself. The result of Gideon's hubris was the death of his Irregulars. This tragedy caused his Planeswalker spark to ignite.

Oath of Gideon ◗ Wesley Burt

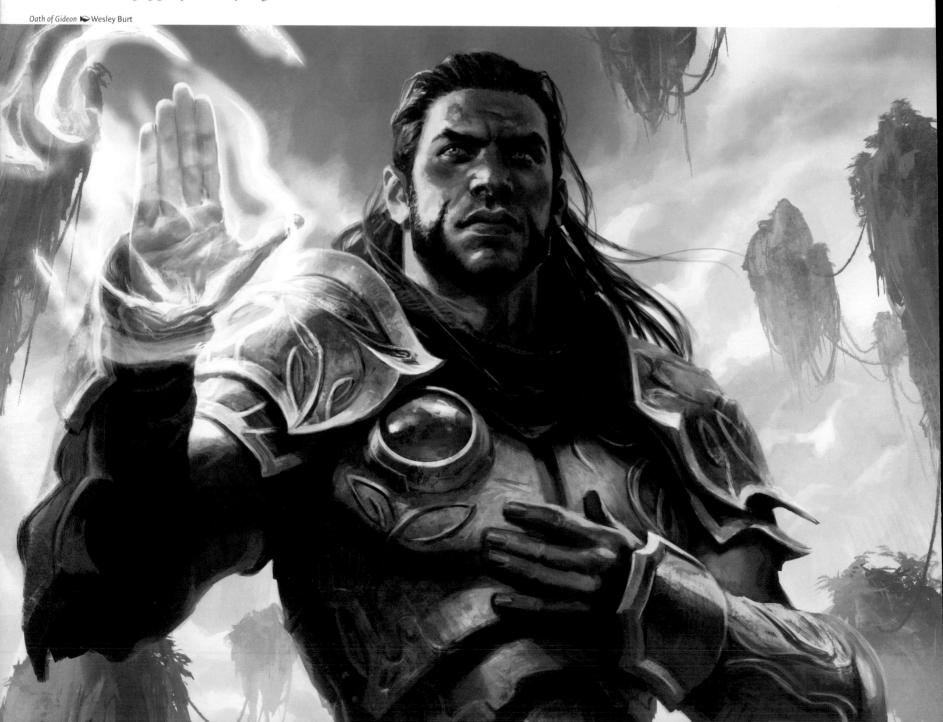

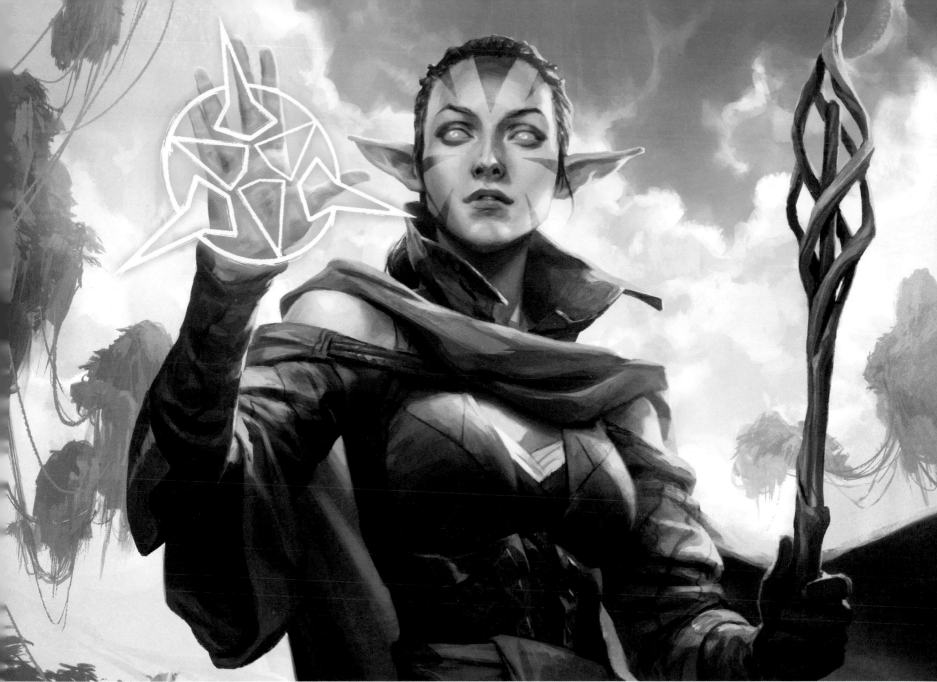

Oath of Nissa ▸ Wesley Burt

Gideon feels responsible for other people and believes that he must protect those who can't protect themselves. Though he is not from Zendikar and had nothing to do with the release of the Eldrazi, Gideon felt compelled to help the people of Zendikar.

Nissa Revane

Nissa Revane is an elf of the Joraga tribe, native to Bala Ged. In her youth, horrible visions haunted her, bringing suspicion on her from the other elves of her tribe. They believed that Zendikar was seeking vengeance on Nissa and the other druids of her ancient line, called animists. In fact, as Nissa came to understand, the visions were Zendikar's way of asking for her help. The plane itself was in pain, and Nissa's visions gave her a glimpse of that pain.

Nissa vowed to help Zendikar. She connected with the soul of the plane, and Zendikar sent a powerful elemental—a living incarnation of the plane's natural forces—to guide her.

This elemental led Nissa across the plane and into the mountains of Akoum. Her connection to the land helped her overcome the dangers she encountered on the way, bolstering her confidence, but she never could have prepared herself for the horror she encountered. A glimpse of Emrakul lying imprisoned beneath the mountains overwhelmed Nissa's mind, igniting her spark and hurling her away from her home plane.

To Nissa, planes are living beings inhabiting the Multiverse, not pieces that make it up. She can see the connections between all living things, and she believes these connections extend in a great pattern across the Multiverse. She can communicate with the souls of planes, and she sees it as her duty to convey their words to others who can't hear their voices. With the Eldrazi rampaging across the plane, Nissa was desperate to find help for Zendikar, to free it from the plague of the Eldrazi.

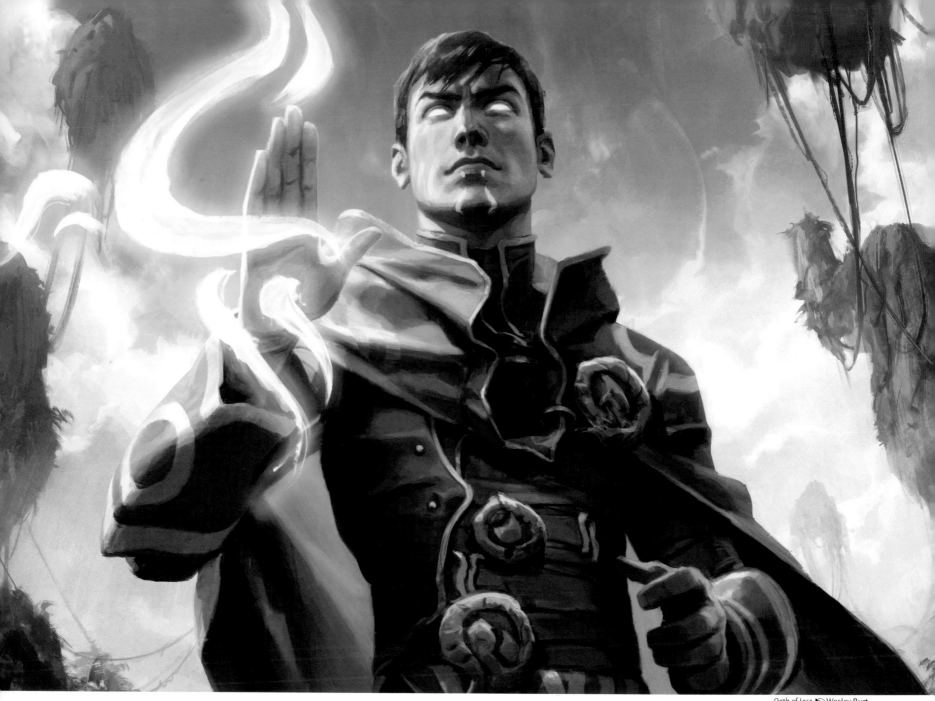

Jace Beleren

In his youth on the plane of Vryn, Jace's natural telepathic talents were misunderstood. He was alienated and harassed for being different and lacked the physical strength to defend himself. When cornered by bullies in a life-threatening situation, Jace seized control of one of his tormentors, damaging the young man's mind. He was beset by guilt and terrified of what other harm he might cause if he lost control of his power again.

A sphinx mind-mage, Alhammarret, took on the young telepath as his apprentice, promising to teach him how to control his magic. Jace assisted Alhammarret in his duties as Vryn's arbiter, spying on both warring factions in the conflict that beset the plane, hoping to help the sphinx bring peace. But Jace discovered that Alhammarret was actually colluding to prolong the war. The sphinx was tampering with Jace's mind to hide his duplicity—and to suppress Jace's knowledge of his own Planeswalker spark. Unwilling to be the sphinx's pawn, Jace confronted the more powerful Alhammarret, goading the sphinx into a trap in his own mind. He unleashed a blast of mental energy that destroyed Alhammarret's mind, badly damaged his own, and sent him hurtling to another plane as his spark finally ignited.

Jace can't walk away from an unsolved mystery. He believes everything that exists can be understood, and he dreams of one day knowing everything there is to know. He was present at the Eye of Ugin when the bonds of the Eldrazi's prison were loosed, which nagged at his conscience, but for a time he was torn between his desire to help Zendikar and his responsibility to his adopted home, the plane of Ravnica, where he is supposed to act as arbiter among that plane's ten guilds. Ultimately, though, his curiosity drove him to seek a greater understanding of the Eldrazi threat.

Chandra Nalaar

On her home plane of Kaladesh, Chandra Nalaar was the daughter of innovative artificers who were known for finding clever ways to circumvent the authoritarian Consulate. Chandra's greatest ambition while growing up was to become a smuggler, thwarting the Consulate in order to supply independent inventors with the magical Æther that artificers needed to power their inventions. But with her first effort to steal Æther, she found herself cornered by the soldiers of the Consulate. Her blood boiled at the thought of failure—and then her hands burst into flame, manifesting her innate magical talent. The situation went from bad to worse when Chandra fled into one of the Consulate's foundries. She unleashed her fire magic in an effort to escape, but she couldn't control her power and accidentally incinerated the entire foundry.

Chandra and her parents fled the city, but the Consulate soldiers hunted them down in a small village. The captain of the soldiers was determined to use Chandra as an example for other would-be rebel mages. He set fire to the village where she was hiding and blamed her for the blaze. When Chandra's father attempted to intervene, the captain killed him right before Chandra's eyes. Chandra lost track of her mother and, upon seeing the destruction of the village, believed she too must have died. Grief-stricken and in chains, Chandra was sentenced to be executed. But in the last desperate moment, her Planeswalker spark ignited, blasting her out of Kaladesh and leaving an inferno behind.

Impetuous and hot-tempered, Chandra has a fierce sense of justice. She hates to see figures and structures of authority suppressing people's rights to freedom and self-expression, and she tends to express her indignation with fiery actions first and words later. She felt that she was manipulated into coming to the Eye of Ugin and playing a part in the breaking of the Eldrazi's prison, and her efforts were initially directed at finding whoever exploited her. Eventually, she decided that she would feel better if she just dealt with the Eldrazi the way she handles most of her problems—by incinerating them.

Oath of Chandra ▶ Wesley Burt

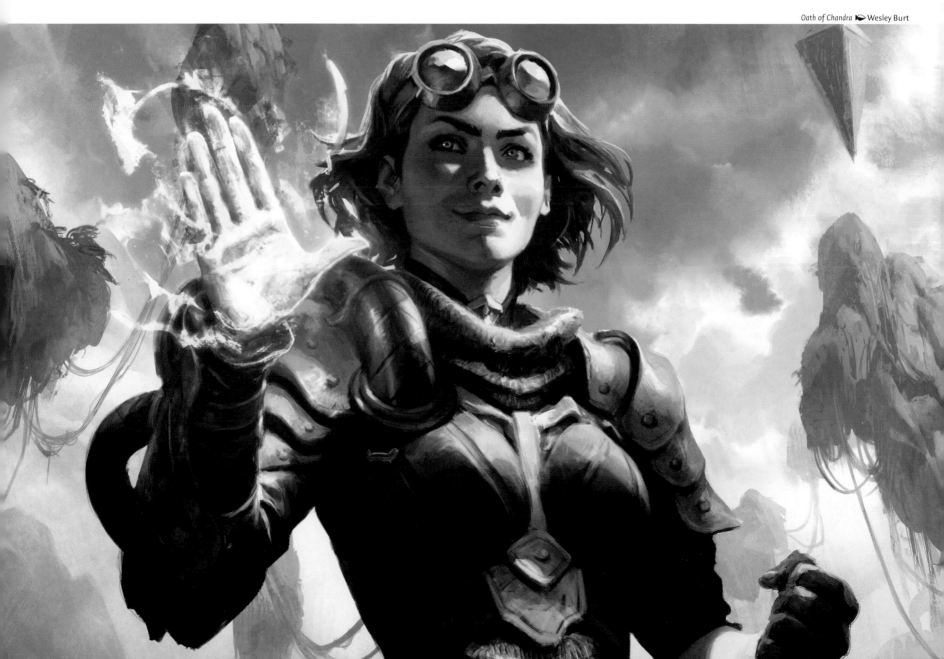

Sarkhan Vol

The dragon-worshipping Planeswalker Sarkhan Vol is a native of Tarkir, where dragons had gone extinct long before his birth. Obsessed with their fury and predatory majesty, Sarkhan learned as much as he could about his world's ancient dragons. He had a talent for battle and gained status as a warrior in the Mardu clan, but he soon tired of the territorial skirmishes of the battlefield. He traveled from plane to plane, looking for a dragon he could dedicate his life to. Eventually, he declared his fealty to the dragon Planeswalker Nicol Bolas.

As part of Bolas's inscrutable schemes, Sarkhan kept watch over the Eye of Ugin for a time, slowly descending into madness as the voice of the Spirit Dragon whispered in his mind. He bears partial responsibility for breaking the Eldrazi's prison, but thereafter he left Zendikar in search of Ugin and has not returned.

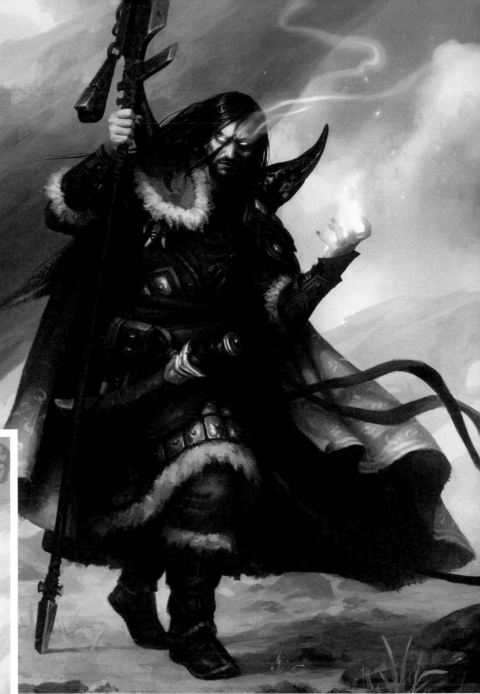

Sarkhan, the Dragonspeaker ▶ Daarken

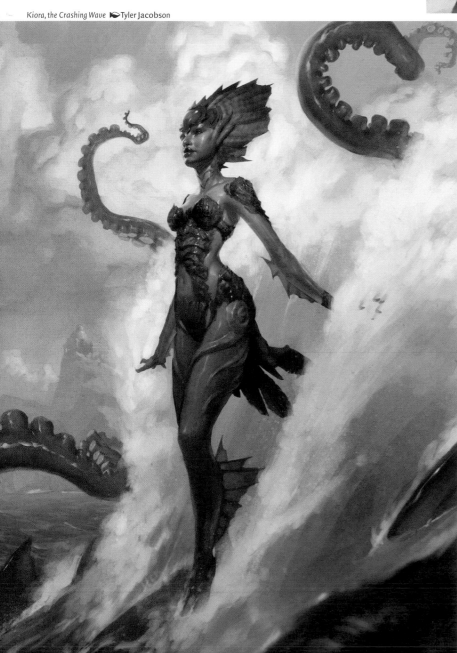

Kiora, the Crashing Wave ▶ Tyler Jacobson

Kiora

The merfolk Planeswalker Kiora, a native of Zendikar, has traveled the planes to strengthen her connection to the oceans' magic. She believed that only by summoning the fierce krakens, serpents, and other terrors of the deep could she defeat the titans that ravaged her home. She was single-minded in pursuit of her purpose, heedless of the chaos she might bring down on other planes in the course of her search. In particular, she brought a devastating wave on the city-state of Meletis on Theros, purely in hopes of attracting the attention of the leviathans of the deep. She happily accepted the misguided veneration of Theros's merfolk, seeing no need to disabuse them of the notion that she was an avatar of the sea-goddess Thassa. She was similarly dismissive of the other Planeswalkers she encountered on Zendikar, cooperating with them only insofar as it aligned with her own vision of how to combat the Eldrazi.

Ob Nixilis

The man called Ob Nixilis was a cruel, ruthless tyrant on a hellish plane of unending war. No tactics were too merciless, and no magic too dark, to secure his ascendancy. In the end, Ob Nixilis invoked an ancient demonic pact, ordering the demons to destroy his enemies. Finally freed to act out an eons-old prophecy, the demons killed every person on the plane except Ob Nixilis. He realized that he was the subject of a cruel and senseless joke: he was, at last, sole ruler of the world—and ruler of nothing at all. He began to laugh, and in that moment, his Planeswalker spark ignited, flinging him through the Blind Eternities where he would find new worlds to conquer. On these new worlds, Ob Nixilis would do what he had always done: betray any trust, commit any blasphemy, and pay any price for power. He thought himself invincible, but then he suffered a cruel defeat.

Ob Nixilis sought to seize the power of the legendary Chain Veil for himself but instead suffered its curse, which stripped him of his humanity, transforming him into a monstrous demon. At last, he found a price he was not willing to pay. In search of a cure for this curse, he made his way to Zendikar and its powerful mana. Before he could begin to draw on this power, however, he was met by Zendikar's self-appointed protector—the Planeswalker Nahiri, the Lithomancer. Nahiri bound Ob Nixilis with the same magic that imprisoned the Eldrazi, placing a hedron in his skull and suppressing his Planeswalker spark. Trapped on Zendikar, powerless, Ob Nixilis became obsessed with recovering his spark and escaping his imprisonment. After centuries of plotting, he finally removed the hedron that bound him to the plane. Finally unshackled, Ob Nixilis directed his energies toward his next goal: rekindling his spark.

Ob Nixilis, Unshackled ❧ Karl Kopinski

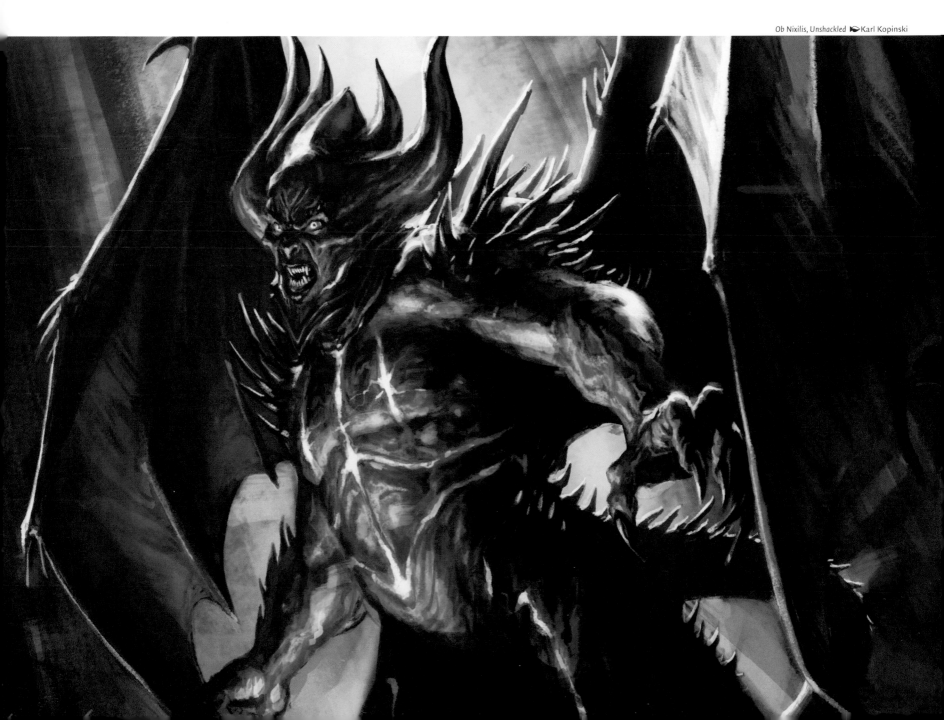

RISE OF THE ELDRAZI

The Eldrazi titans were imprisoned for thousands of years. Once—just once—they enjoyed the merest taste of freedom, and the results were cataclysmic: the race of vampires was created, and entire civilizations were devastated as their brood lineages swept across the plane. Since that first hint of escape, the titans have waited, if their alien minds can be said to wait, knowing that someday the bonds would be loosed again.

The three Planeswalkers who had bound the titans were gone. Nahiri had disappeared after the first escape, going in search of the other two who had abandoned her world and left her to deal with

Rise of the Eldrazi ▶ Michael Komarck

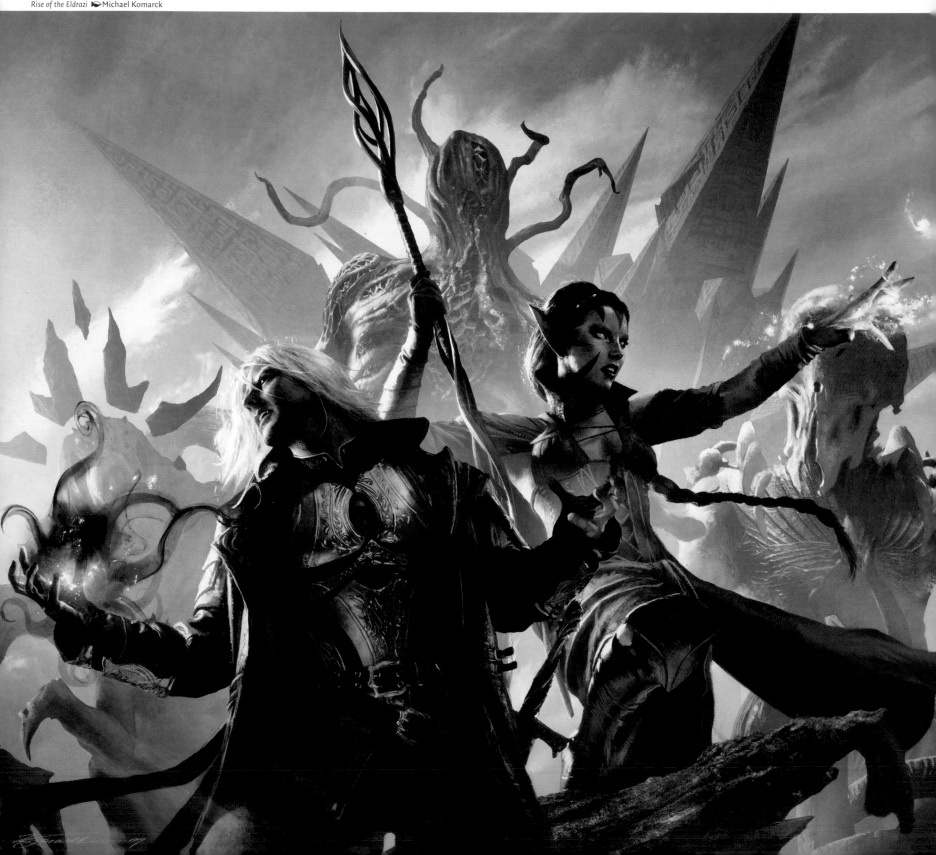

the Eldrazi alone. Ugin was bound in magical stasis on the plane of Tarkir, recovering over the course of twelve centuries from a grievous wound. And Sorin's location was unknown. Even in their absence, though, the magic of the Eye of Ugin held fast.

Then, for inscrutable reasons of his own, the elder dragon Planeswalker Nicol Bolas took an interest in Zendikar. He visited the plane, studied the Eye of Ugin, noted the Eldrazi in their prison, and disappeared again. Some time later, he sent one of his minions—the Planeswalker Sarkhan Vol—to keep watch over the Eye of Ugin.

Sarkhan spiraled into madness as he kept his lonely vigil in the ancient chamber. He heard voices and glimpsed mysterious visions, unable to discern reality from the imaginings of his mind. He fell into a pit of his own tormented thoughts.

And then two other Planeswalkers found their way to the Eye of Ugin.

Chandra Nalaar followed a mysterious scroll map to Zendikar, searching for the Eye of Ugin—which she thought was a valuable artifact. Jace Beleren tracked Chandra there and intercepted her inside the Eye of Ugin just as she encountered Sarkhan. Trying to defend the Eye, Sarkhan took the form of a dragon and sprang to the attack.

Thousands of years before, three Planeswalkers had come together in the Eye of Ugin to trap the Eldrazi on Zendikar. And now three different Planeswalkers found themselves in that same chamber.

The Eye of Ugin surged back to life. The colorless fire of Ugin's breath was the final piece to the puzzle of the chamber, a way of creating fire without drawing on red mana. Chandra discovered how to produce such ghostfire, accidentally opening the final lock. All the elements were present once again.

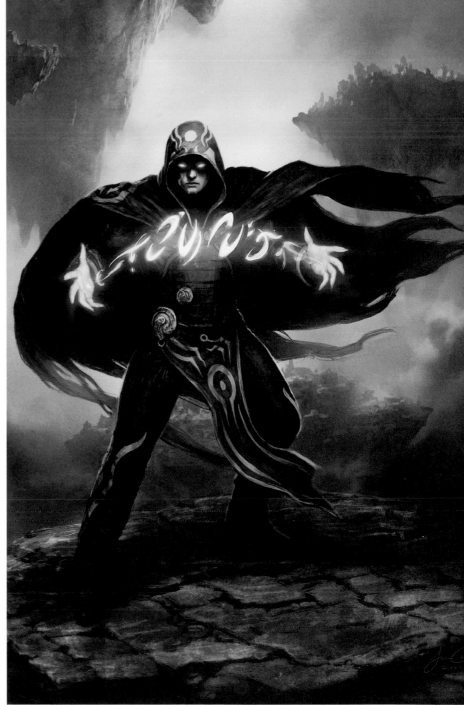

Jace, the Mind Sculptor ❧ Jason Chan

"From the moment the first Eldrazi spawn squirmed free, everything on Zendikar took on an adjusted meaning, a new slant toward or away from the waking giants." —Gideon Jura

The Prison Is Shattered

Even at this time, it might have been possible to undo the damage that had been done. The titans did not immediately burst their bonds—first their teeming broods were loosed upon the plane. Swarms of Eldrazi, from mindless spawn to towering monstrosities, began rampaging across the plane. The destruction of Sejiri and Bala Ged began early, and the slaughter of many Joraga elves precipitated the next series of events.

Nissa Revane was a Planeswalker of the Joraga. Attuned to the soul of the plane as her tribe came under attack, Nissa was keenly aware of the catastrophe that was looming for all of Zendikar. In a desperate effort to save her home, she sought out the source of the brood lineages. As she searched for the location of the titans' prison, she was joined by Sorin Markov, who had come at last to Zendikar, summoned by the catastrophe at the Eye of Ugin. Sorin was determined to seal the prison once more, as Nahiri had done the first time the bonds were loosened.

But Nissa had other ideas. When she and Sorin at last came to the Eye of Ugin, Sorin called on her to help him restore the titans' bonds. But Nissa believed that, given their freedom, the Eldrazi would flee the plane that had been their prison and wreak their destruction elsewhere. Instead of sealing the titans tightly into their prison once more, she broke the last bonds holding them in, and the three titans emerged into the world.

THE BATTLE FOR ZENDIKAR

But after so many eons in stasis, the titans were not able to immediately leave Zendikar. They needed to feed, gather strength, and restore themselves. They followed their broods in spreading out across the plane, destroying large sections of land. Sejiri and Bala Ged were reduced to wasteland. Accustomed to fighting for survival, Zendikar's people fought desperately, but the world seemed poised on the brink of annihilation.

But then the titans vanished, and it seemed that perhaps Nissa's hope had been fulfilled—that the titans might have left Zendikar. The lesser Eldrazi remained and were a constant threat, but they weren't multiplying at such a dramatic rate. The situation wasn't improving, but for a short period of time, it stabilized. The people of Zendikar adapted, survived, and fought on.

The fragile equilibrium didn't last long. Soon, new waves of Eldrazi began to emerge, and fleeing survivors reported that Ulamog was on the rampage once again. The Eldrazi ravaged the land, their first targets being the settlements where survivors had taken shelter. One by one, these refuges were overrun by relentless assaults, and more groups of survivors were scattered to the winds. Leaderless and hounded by their inscrutable enemy, the resilient Zendikari kept moving across the dangerous world, searching for safe places where they could regroup and try to reclaim their home.

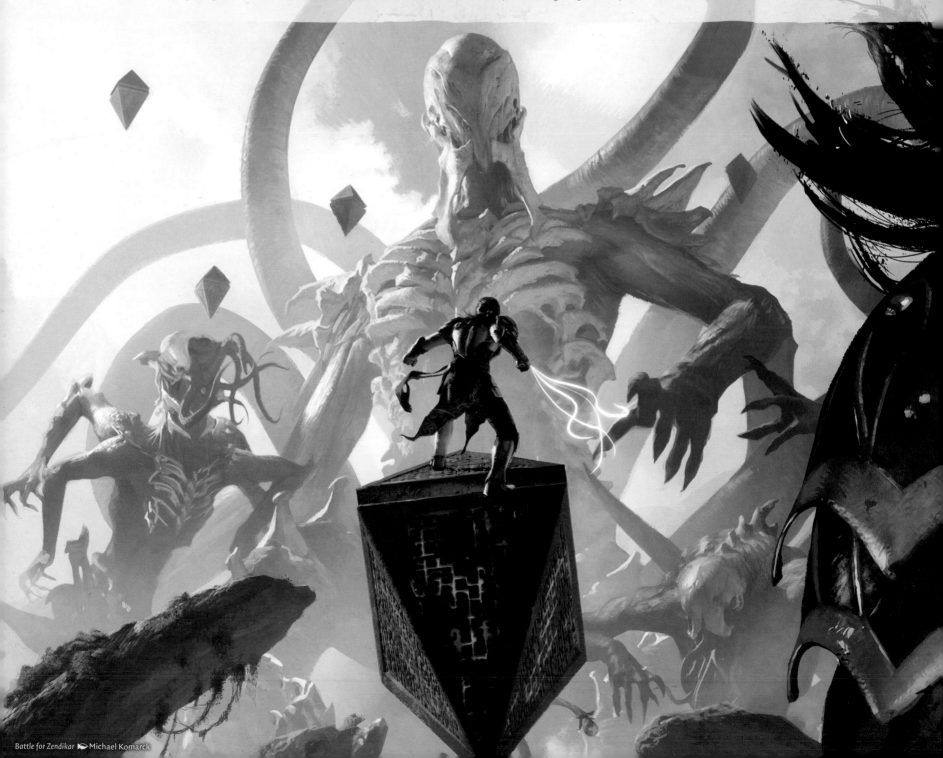

Battle for Zendikar ▸ Michael Komarck

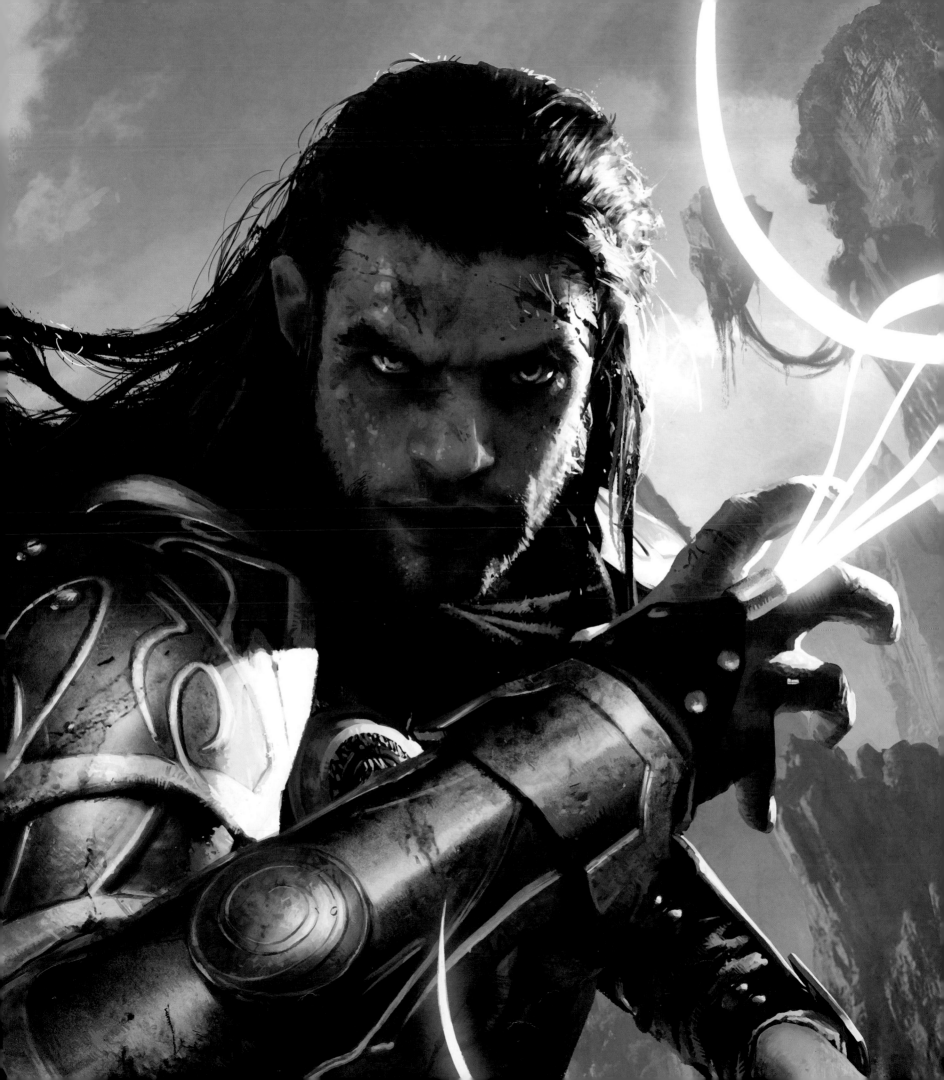

Gruesome Slaughter

Even as the Eldrazi broods surged across the land, the Planeswalker Gideon Jura came to Zendikar in search of Chandra Nalaar. He followed Chandra's trail through the mountains of Akoum, unaware of the scope of the Eldrazi threat, until he lost track of her movements. Frustrated in his search, he took shelter in a remote encampment called Fort Keff.

While he was there, the encampment came under attack. Waves of Emrakul's brood washed over the fort, crashing against the walls like a tidal wave. Gideon joined the soldiers in the battle and led them in routing the lesser Eldrazi—but when Emrakul's enormous form darkened the sky, Gideon told the survivors to flee. He had only the barest inkling of what he faced, but he knew that the Eldrazi titans were not a threat he could handle alone. Reluctantly, he traveled to the plane of Ravnica, where he hoped to find other Planeswalkers to help him save Zendikar.

> "If you won't listen to me, at least let me help. I've been around battlefields more than once."
> —Gideon Jura

Gruesome Slaughter 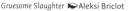 Aleksi Briclot

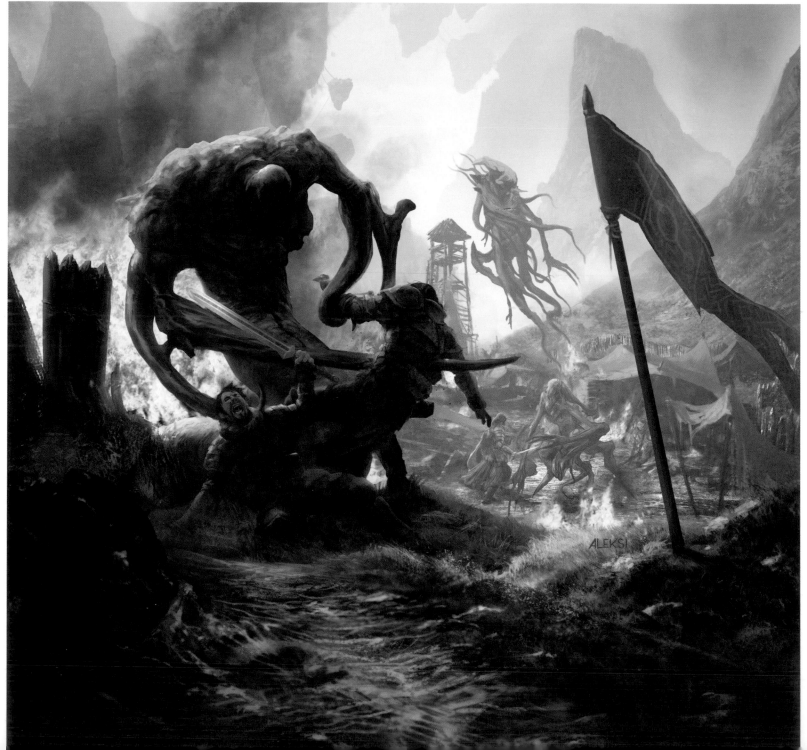

Near-Death Experience ➤ Dan Scott

Caught up in events on Ravnica, Gideon spent weeks traveling back and forth between the two planes, battling the Eldrazi by day and searching for Planeswalker aid while he fought unrest on Ravnica by night. With the fall of Sea Gate, however, he realized that he couldn't save Zendikar while his attention was divided. Though he managed to recruit Jace Beleren to help him solve the puzzle of the hedrons, he had to return without the aid he had sought—powerful warriors to fight beside him.

When he reached the edge of the Halimar Sea, he found that the area had been overrun by Eldrazi. He witnessed thousands of them moving across the hills and descending toward a narrow ravine. Gideon hurried to the ravine and found a small refuge under siege. A few dozen people huddled behind makeshift walls, fighting desperately to hold off the overwhelming tide of Eldrazi.

Gideon fought his way through the Eldrazi until he reached the refuge and then held the Eldrazi back while the exhausted survivors fled to the cliffs, narrowly escaping with their lives. When Gideon rejoined them, he led them up into the floating rubble field of Emeria to find shelter from the teeming masses of Eldrazi below.

Among the survivors was Nissa Revane. She had fought alongside the defenders of Sea Gate, drawing on her powerful connection to the land to help defend the city before it fell. But during the battle, she suddenly found her power cut off, her ties to the soul of Zendikar apparently severed. Still, she fought fiercely to help get survivors to safety, and together she and Gideon were able to carve a path through the Eldrazi to relative safety, where Jace awaited them.

With scouts reporting that Ulamog was approaching Tazeem, the three Planeswalkers decided to split up. While Gideon remained to prepare a defense against Ulamog's arrival, Nissa and Jace sought the keys to the magic that had bound the Eldrazi in ancient times.

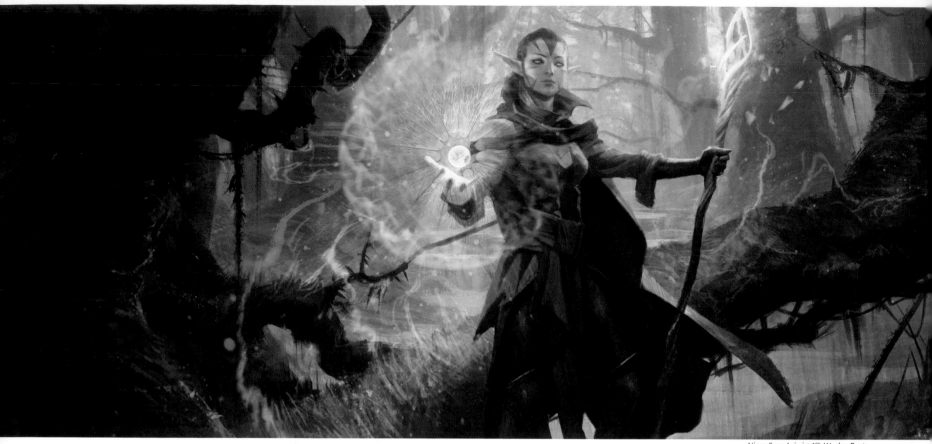

Nissa's Quest

In the wake of the battle, Nissa realized that the leylines that channeled magic throughout the plane had been disrupted. This accounted for the loss of her connection to the soul of Zendikar, but the implications were deeper than that. Research conducted at Sea Gate before its fall suggested that the hedrons that covered the plane could be used to bind the Eldrazi, but Nissa understood that this magic couldn't be activated as long as the leylines of mana were broken. So she set out to repair them.

Led by fragmentary visions as she was in her youth, Nissa made her way from Tazeem into the depths of Ulamog's devastation in Bala Ged. After weeks of travel, she found a great black rift in the midst of the chalky-white landscape, and Nissa had the sure sense that the object of her quest lay in the depths of the rift. She descended into the blackness, enfolded by the rock.

Wandering through a labyrinthine ancient ruin studded with hedrons, she discovered a glowing flower—a new expression of the Khalni Heart like the one that bloomed in the heart of Ora Ondar in Akoum. This new Khalni Heart, she realized, was an outgrowth of the soul of Zendikar, and through it she restored the leylines and rekindled her connection to the plane. As power flowed through her and Zendikar's voice murmured in her heart once more, her faithful elemental companion emerged from the rock to stand by her side again.

Then the demon Ob Nixilis appeared in the darkness and confronted her. Over the course of weeks, he had clawed and scraped at the earth to pry the Khalni Heart from the earthen womb that nurtured it, and he had been manipulating the hedrons within the ruin to

channel the Khalni Heart's power into himself. He planned to use the Khalni Heart to rekindle his Planeswalker spark, and his meddling with it had disrupted the leylines in the first place. Her presence threatened his plan—if she removed the Khalni Heart, he would have no source of power to fuel his spark. He unleashed his full fury upon her. Nissa's elemental leaped to her defense, blocking the brunt of the demon's dark magic and slashing at him with its wooden claws. Vines twisted out from the Khalni Heart to snag Ob Nixilis's limbs and coil around his neck. Zendikar itself seemed to pull at him, holding him back, blunting his ferocity. The demon was overwhelmed, unprepared to face the elemental might of the entire plane.

"As long as there is a single shred of life, there is hope." —Nissa Revane

Nissa gently lifted the Khalni Heart from its resting place and cradled it in her arms. The earth crumbled around her, but vague animal forms—the elemental forces of nature given the semblance of life—lifted her and her companion up to the surface while Ob Nixilis was buried below. Leaving the demon for dead, Nissa took the Khalni Heart to another cavern in Bala Ged where it could be safe again and continue its work of revitalizing the barren land.

Climbing atop her elemental's vine-wreathed form, Nissa turned back toward Tazeem.

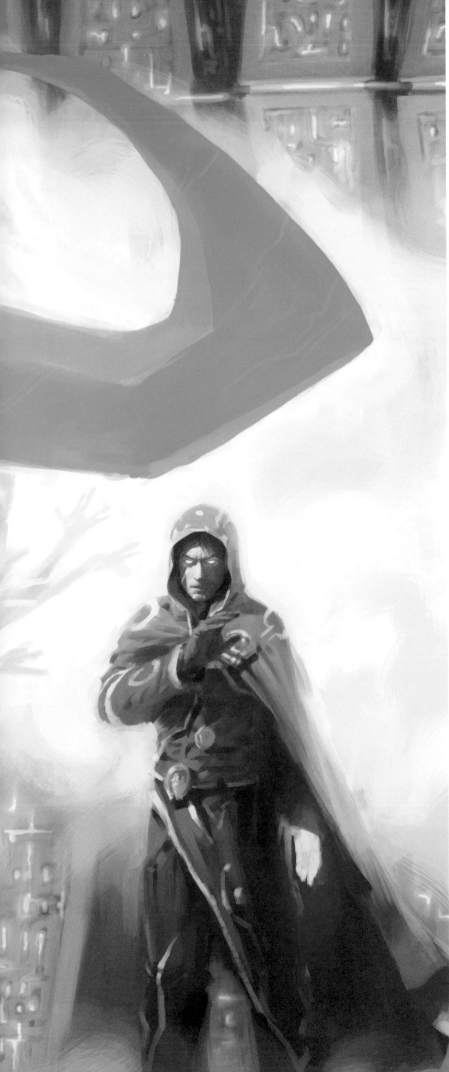

Ugin's Insight ♦Tyler Jacobson

Revelation at the Eye

As Gideon scoured the Multiverse for allies who would help him fight the Eldrazi, he met with Jace Beleren on the plane of Ravnica. He knew that the researchers at Sea Gate had been close to discovering a cure to the Eldrazi plague, but with the fall of the city he needed another keen mind to unravel the mystery. Wrestling with his own sense of guilt over his part in releasing the Eldrazi, and unable to resist such a challenging puzzle, Jace agreed to go with Gideon to Zendikar.

After the battle at the refuge, Jace found that the research of the merfolk at Sea Gate had been lost. So he visited the Eye of Ugin, where he, Chandra, and Sarkhan had unknowingly loosed the Eldrazi's bonds. When the Eldrazi had awakened, it appeared that the Eye of Ugin was destroyed, but as Jace ventured into the tunnels deep inside the mountain, he found that much of it was still intact. Soon enough, he discovered why.

Ugin, the spirit dragon who had helped construct the chamber thousands of years before, was there. After spending over a thousand years bound in a sort of cocoon on his home plane of Tarkir, Ugin had only recently returned to Zendikar and witnessed the destruction that was sweeping across the plane. He had sent Sorin Markov off to find Nahiri and begun working to repair the Eye of Ugin, which was the nexus point for the hedron network that had first bound the Eldrazi. Ugin was sure that, with the Eye repaired and Sorin and Nahiri returned, the Eldrazi could be safely imprisoned once more.

Then Jace appeared. He told Ugin that other Planeswalkers were looking for a way to kill the Eldrazi and cleanse their broods from Zendikar. Ugin was horrified. Killing the Eldrazi, he believed, would be a waste of a tremendous opportunity to study these interplanar travelers, to understand their strange magic, and perhaps to gain insight into the nature of the Planeswalker's spark. Worse, their death might upset some fragile Multiverse-wide ecosystem in which Ugin believed they might play some part. But if the Eldrazi titans could be trapped again, he argued, the threat to Zendikar would diminish—their broods would stop multiplying and the people of the plane could restore peace, as they had done in the past.

Jace wasn't convinced. He knew that no prison would hold forever, and the Eldrazi would always be a threat. He knew that the next time the prison broke, he might not be present to deal with them, and he couldn't rely on any other Planeswalker to have his knowledge and power. But he recognized that the Eldrazi were a foe unlike any other he had ever faced, and his knowledge was still incomplete.

Ugin explained how the hedron network could be used to immobilize the titans and eventually imprison them again. He and Jace agreed to combine their efforts: Ugin would continue his work restoring the Eye of Ugin so that Jace could tap into the power of the whole hedron network to trap the Eldrazi at Sea Gate. Jace left the Eye of Ugin and made his way to Sea Gate to pass this information on to Gideon.

The Liberation of Sea Gate

Setting out with the small band of survivors from the destroyed refuge, Gideon traveled throughout Tazeem and sent messengers across the plane to find soldiers for his war effort. Everywhere he went, he brought hope and inspiration, and both battle-hardened veterans and desperate new recruits flocked to his banner. Large numbers of kor came to him from the Makindi Trenches, and from Zulaport came many ruffians and scoundrels who were willing to turn their violent talents to a useful purpose.

Gideon also sought assistance from one more Planeswalker: a native of Zendikar, the merfolk Kiora. By winning her to his cause, he secured the aid of her own army of merfolk and colossal sea monsters. Gideon was able to overcome Kiora's pride and convince her to coordinate her efforts with his, forming an army like nothing that Zendikar had ever seen before. For the first time, the Zendikari wouldn't flee from the Eldrazi. Instead, they would launch an offensive against Ulamog and his teeming brood. The great host marching at Gideon's back soon reached the hills overlooking Sea Gate, while a second mighty force approached the city from the sea under Kiora's command.

Eldrazi teemed over the surface of the dam, destroying every remnant of the city, consuming every scrap left behind by the people who had lived there. The ancient dam was beginning to crumble into dust at the Eldrazi's touch. Gideon yelled orders and led his troops into the fray as a tide of leviathans, krakens, and watery elementals surged toward the city.

Battle at Sea Gate ❧ Slawomir Maniak

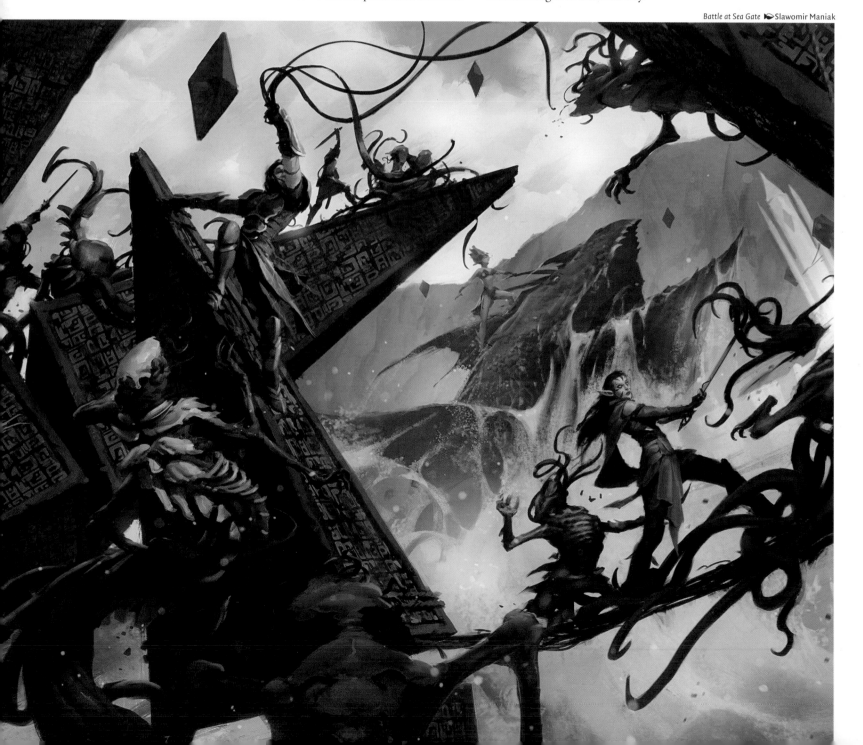

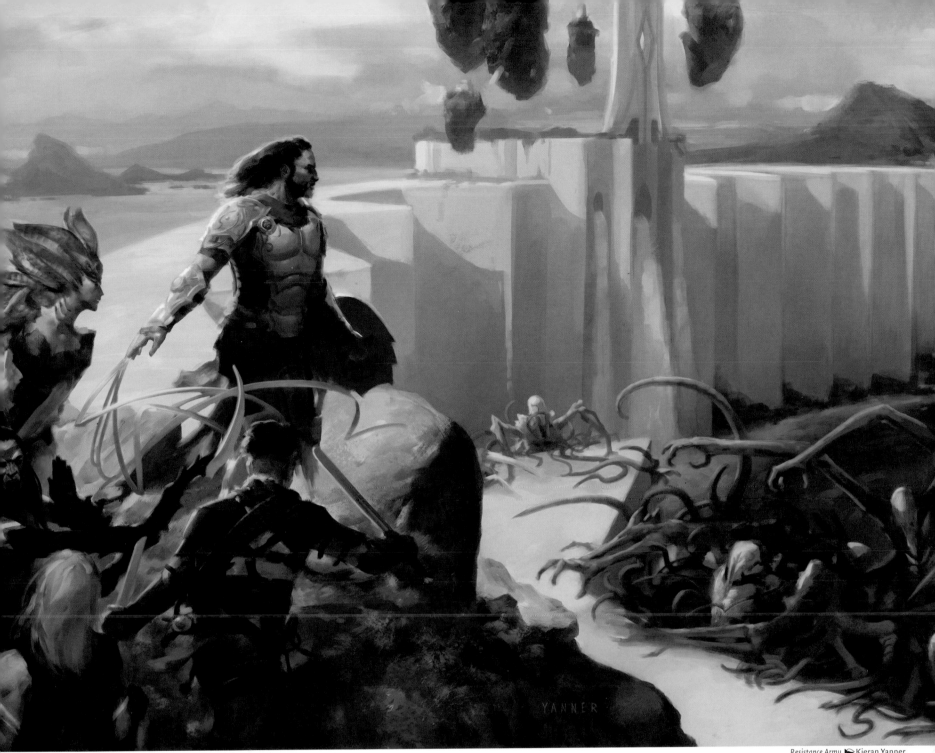

Resistance Army ► Kieran Yanner

> "Everyone who could still lift a weapon
> had a part in retaking Sea Gate."
>
> —from *The Halimar Chronicle*

Fighting the Eldrazi was not like any other battle Gideon had waged. There was no pause in the fray when the sun went down. The Eldrazi, vampires on both sides of the conflict, and many of Kiora's servants were unhampered by darkness and battled on. Gideon kept his soldiers fighting in shifts so some could rest while others kept up the struggle. The Eldrazi were utterly fearless, desperately clawing at any foe within reach until the last spark of life was driven from their flesh. They did not flee or break ranks, and they never retreated until they were beaten back. Only through Gideon's example and encouragement were the Zendikari able to fight on against such an implacable foe.

Nissa arrived as the battle wore on, and elementals under her command plunged into the fray. Their arrival gave new hope to the Zendikari attackers and turned the tide of battle. Still later, Jace arrived. And as the sun set after days of battle, the Eldrazi were driven from the city. Sea Gate's defensive ramparts were quickly rebuilt and fortified, and the soldiers of Zendikar celebrated a hard-won victory.

191

Hedron Alignment

At dawn after the liberation of Sea Gate, Gideon summoned his Planeswalker allies and key leaders of the Zendikari army to the Lighthouse to plan their next moves. Gideon's scouts had reported that Ulamog was active nearby, and Kiora confirmed that information. As far as anyone could tell, Kozilek and Emrakul had returned to their slumber—or perhaps already left the plane. Defeating Ulamog, then, would mean defeating the Eldrazi—at least as far as Zendikar was concerned.

Jace told the council about his meeting with Ugin and the spirit dragon's desire to imprison the Eldrazi again rather than killing them. Nissa and Kiora reacted with disbelief and anger, arguing that Zendikar had suffered long enough from the presence of the Eldrazi; it was time to be rid of them forever. Jace agreed but expressed his concern that attacking Ulamog would simply drive the titan from the plane, shifting the danger to some other world. Kiora was satisfied with that solution, but Gideon and Nissa were not. Then Jace outlined a different plan. With the knowledge of the hedron network that Ugin had given him, he could immobilize Ulamog before the armies of Gideon and Kiora attacked.

Kiora stormed out of the council, determined to attack Ulamog with or without the help of the other Planeswalkers. Jace and Nissa agreed to work with the hedrons as quickly as possible, hoping to trap Ulamog before Kiora's assault could drive the titan from Zendikar. Gideon and the Zendikari leaders agreed to delay their attack until the hedron network was in place, but Gideon warned Jace that if the hedrons were not ready in time, all their efforts could come to nothing.

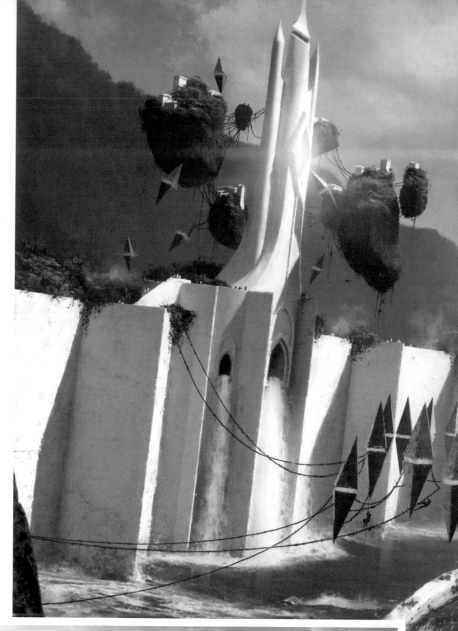

Ulamog Trapped ▸ Richard Wright

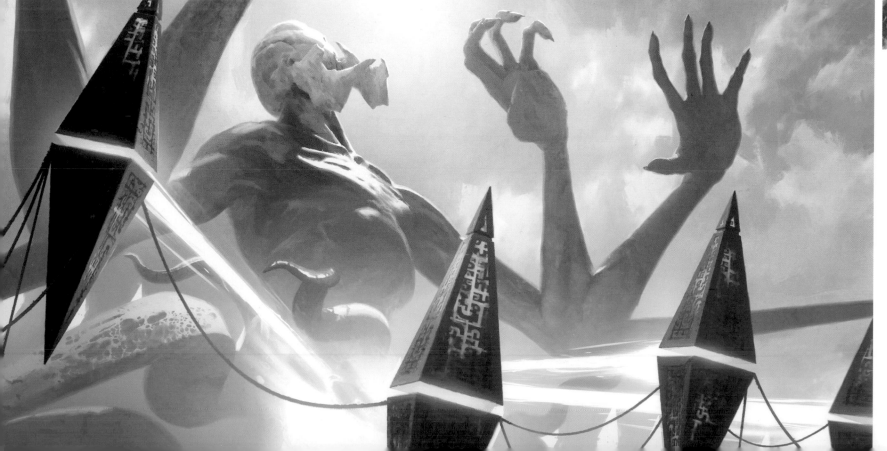

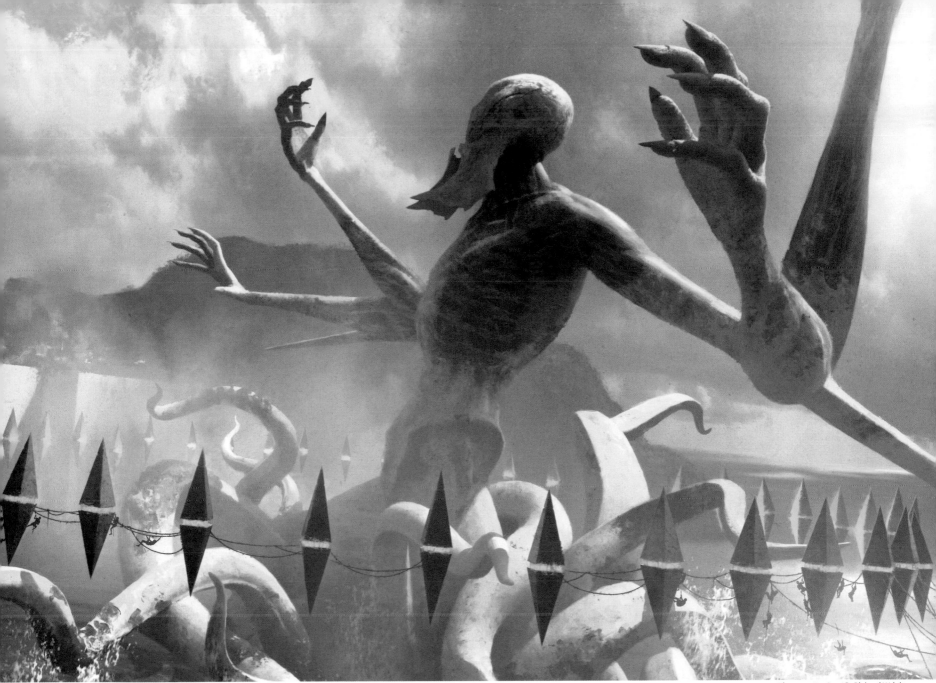

Ulamog at Sea Gate ▶ Richard Wright

> **"You've begun to understand the hedrons' true purpose. The Eldrazi can be imprisoned."**
> —Ugin, *the spirit dragon*

So a fragile plan was in place, dependent upon the coordinated actions of four willful Planeswalkers. And a fresh wave of Eldrazi broke upon Sea Gate as Ulamog drew near.

While Gideon's troops held the city against this fresh assault, Nissa helped the Zendikari raise sunken hedrons from the ground and move them into place. Jace began working to align the energy of the hedrons, laying the trap they hoped would hold the Eldrazi titan.

Jace and Nissa managed to get the hedrons aligned just as Ulamog surged forward into position. They activated the hedrons' magic, and glowing lines of magical force sprang to life in a ring around the Eldrazi titan. Ulamog was trapped!

Then everything collapsed. Ob Nixilis appeared, having followed Nissa from Bala Ged. He knocked the hedrons out of alignment to siphon their power for himself. The earth and sea trembled as the magic of the hedron network scattered. Ob Nixilis's Planeswalker spark reignited as power flowed into him. Rather than leaving Zendikar immediately, he lingered to watch the destruction of the plane he despised.

Gideon still thought victory was possible. Ulamog was still within the hedron ring and in reach of his army and Kiora's mighty followers. He urged his soldiers forward, leaping to attack the titan himself. For a moment, Ulamog was battered, off-balance, and apparently on the edge of defeat.

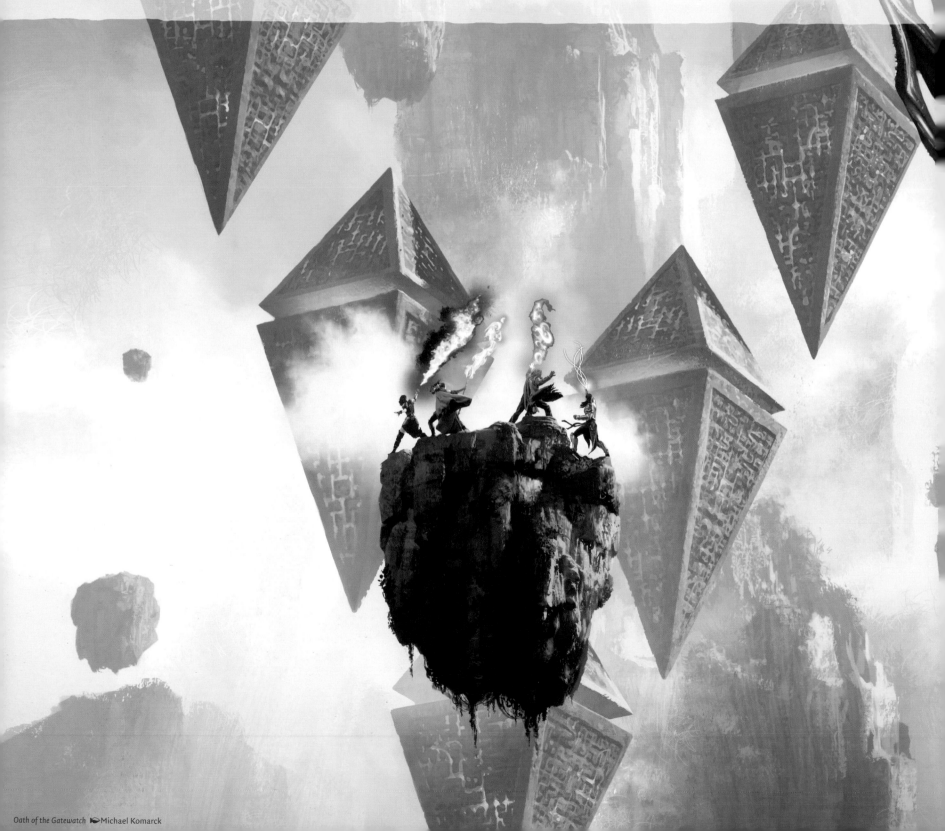

OATH OF THE GATEWATCH

In the battle of Sea Gate and the attempt to destroy Ulamog, four Planeswalkers—Gideon Jura, Nissa Revane, Jace Beleren, and Kiora—struggled to agree on a common goal and coordinate their efforts to achieve it. As Ulamog surged toward Sea Gate, they got a taste of success: Ulamog appeared to be trapped, and victory seemed near. Then their plans fell to ruin.

With Sea Gate destroyed, two Eldrazi titans rampaging across Tazeem, and an ancient and powerful demon Planeswalker determined to see Zendikar annihilated, all seemed lost. If there were to be any chance of saving Zendikar, the Planeswalkers would need to renew their commitment to work as a team toward a goal larger than their own interests, larger even than this one world.

From this crucible of imminent defeat, the Gatewatch would rise.

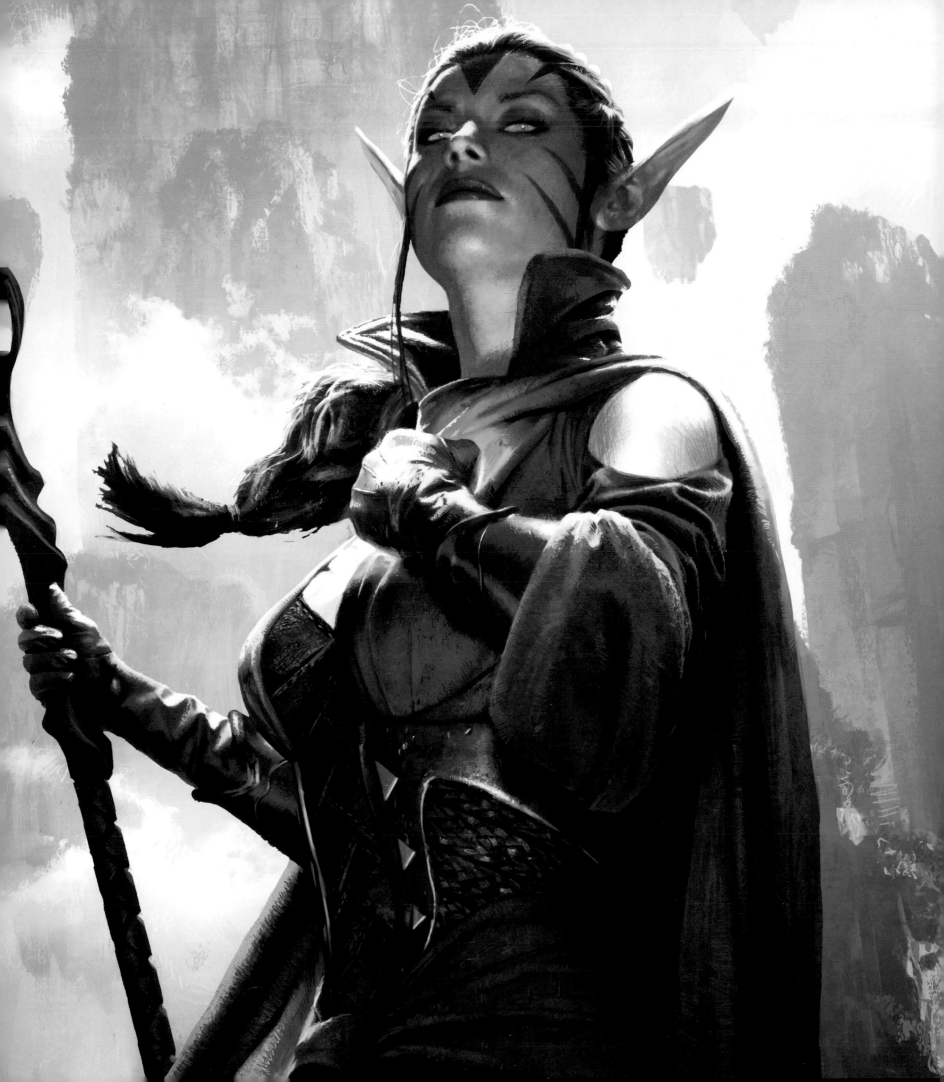

Tazri, Allied Commander ▶ Chris Rahn

Though she initially challenged Gideon for leadership of the Zendikari forces, General Tazri became his most trusted lieutenant.

Kozilek's Rising

Ulamog was trapped in a ring of hedrons drawn together by Nissa's elemental magic and activated by Jace's skill. The Zendikari army swarmed the titan from the land while Kiora's monstrous horde attacked from the sea. Gideon stood on a floating chunk of earth, face to alien face with the towering Eldrazi titan, the bittersweet taste of a hard-won victory in his mouth.

Then a fresh wave of Eldrazi surged up from the depths of the earth and sea. These belonged to Kozilek's brood lineage and numbered in the thousands. And in their wake came their horrible sire.

The Planeswalkers had believed that Kozilek was gone, already moved on from Zendikar to another feeding ground. In fact, the titan was merely slumbering in the earth, regaining his strength while his brood drained mana from the plane and channeled the energy to him. And something—perhaps the surge of mana as the hedrons aligned, perhaps Ob Nixilis's spark reigniting, or perhaps

the demon Planeswalker's own magic—had dredged Kozilek back up to the surface, where he joined Ulamog's rampage.

"The Eldrazi care nothing for conquest, but they have conquered. They have no concept of triumph, but their forces have overwhelmed their opposition." —Munda, the Spider

Kozilek shattered the hedron ring that had restrained Ulamog, and then crashed into the great dam of Sea Gate, which had already warped with his approach. The Lighthouse toppled, the dam crumbled, and the waters of Halimar crashed into the sea. Ulamog drove back the soldiers that surrounded him, turning what had seemed

like a near victory into a terrible massacre. The terrified Zendikari soldiers scattered, fleeing for their lives. Even Kiora abandoned her home plane to the Eldrazi in despair.

As the Eldrazi titans and their broods scoured the remains of Sea Gate and the surrounding land, surviving soldiers and refugees found themselves driven into the Halimar basin. With the breaking of the dam, the inland sea had begun to drain, leaving waterlogged shores littered with coral-crusted ruins and the bones of ancient sea creatures. In this unfamiliar landscape, scattered groups of survivors hunted for

shelter and fled before approaching groups of Eldrazi. Here and there, a band of brave or cornered souls made a desperate stand against the alien foe, but these bursts of resistance rarely lasted for long.

The Eldrazi advance was inexorable and all-consuming. The draining seabed was transformed in their wake, corrupted by the two Eldrazi titans into a mixture of crumbling white rock and iridescent geometric shapes. The Umara streams and pools of water turned to dust. More and more Eldrazi rose up through the desiccated landscape to join the horde, and all hope fled.

Ruin in Their Wake ◀ Jason Felix

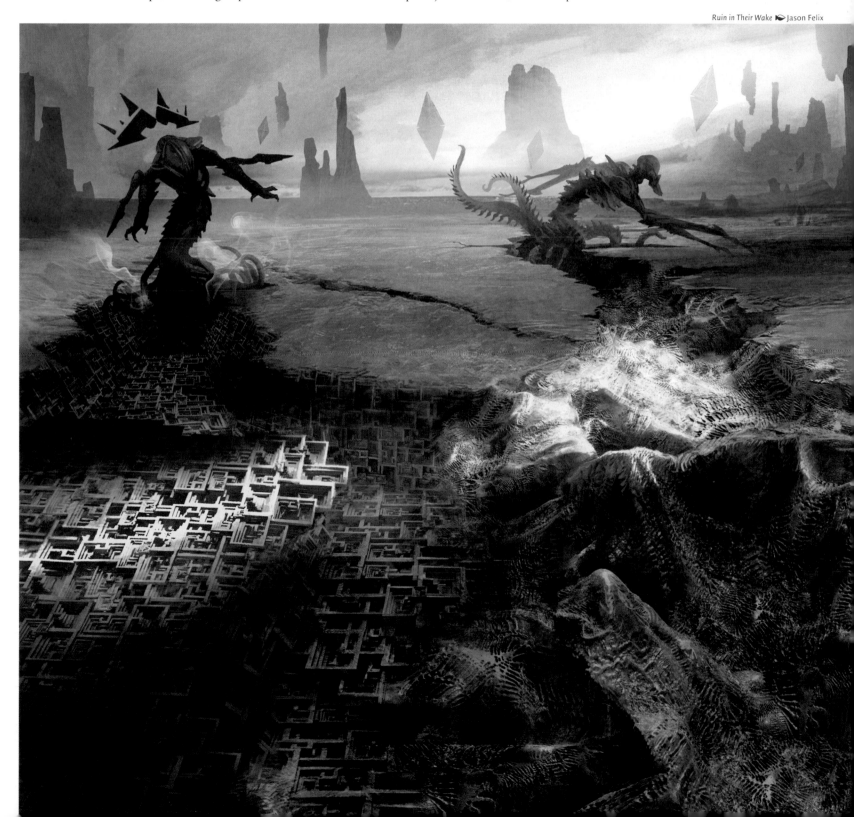

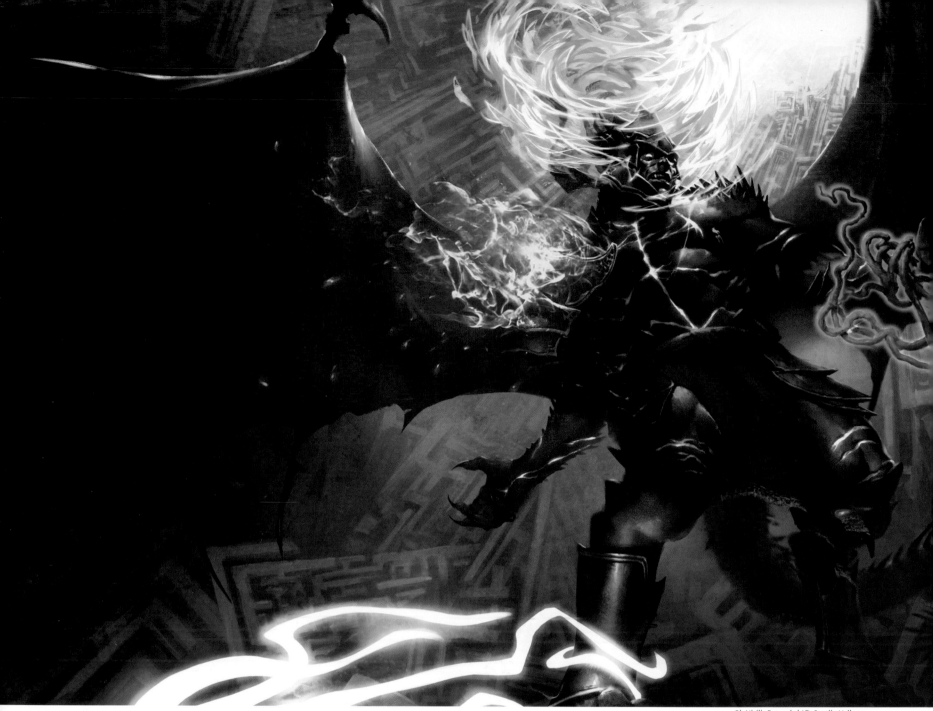

Ob Nixilis Entangled ◄► Svetlin Velinov

Retaliation of Ob Nixilis

In Zendikar's darkest hour, the demon Planeswalker Ob Nixilis was stronger than he had been in thousands of years. Having regained his spark, he could have left Zendikar, putting centuries of torment behind him and moving on to wreak havoc on some other plane. But he was obsessed with destroying the plane where he had experienced so much agony, and killing Nissa Revane in the process would be a delightful side benefit. She had foiled his original plan—to use the power of the Khalni Heart to restore his spark—and thereby earned a painful place in his ultimate scheme.

In the chaos of Kozilek's rising and the destruction of Sea Gate, Nissa became separated from her elemental companion. Fleeing along the crumbling dam, she found herself cornered by Ob Nixilis and a mob of Kozilek's brood that he had bent to his will. Jace and Gideon came to her aid, but the ancient demon overpowered all three Planeswalkers and took them into captivity.

Ob Nixilis brought Nissa, Jace, and Gideon to an underground prison he had used to torment other Planeswalkers who had visited Zendikar in the past. Eldrazi of Kozilek's brood were impaled on spikes around this prison, twitching in a mockery of life. Their alien nature created a field of energy in the heart of the cavern where the laws of time and space were suspended. The demon threw the three Planeswalkers into this field, where they floated in tormented stasis as the ebb and flow of Eldrazi energy ripped across them.

The demon planned to abandon the Planeswalkers there, letting them writhe in agony until the Eldrazi tore Zendikar to shreds. But in an unexpected blaze of glory, Chandra Nalaar appeared and attacked Ob Nixilis.

> "Take what solace you can in the knowledge that you will not be here to see Zendikar reduced to dust." —Ob Nixilis

Gideon had visited Chandra in his search for Planeswalker allies, but she had not come immediately. Bound by her responsibilities on the plane of Regatha, she rebuffed him—despite the role she had played in releasing the Eldrazi. But eventually, her conscience drove her to return to Zendikar. She arrived just as Kozilek appeared at Sea Gate, too far away to give her aid but close enough to see the horror unfold. Unable to sway the tide of battle there, she followed Ob Nixilis to his prison cavern so she could free Gideon and offer her help.

In the demon's prison, Chandra couldn't hope to defeat Ob Nixilis alone, but she held him back long enough to destroy the energy field that kept the other Planeswalkers in stasis. Several blasts of flame destroyed the Eldrazi whose energy fueled the field, and the Planeswalkers tumbled free. Now facing four angry Planeswalkers with no minions to aid him, Ob Nixilis fled to another plane, swearing vengeance on those who had robbed him of the satisfaction of watching Zendikar crumble into nothing.

Remorseless Punishment ▶ Ryan Barger

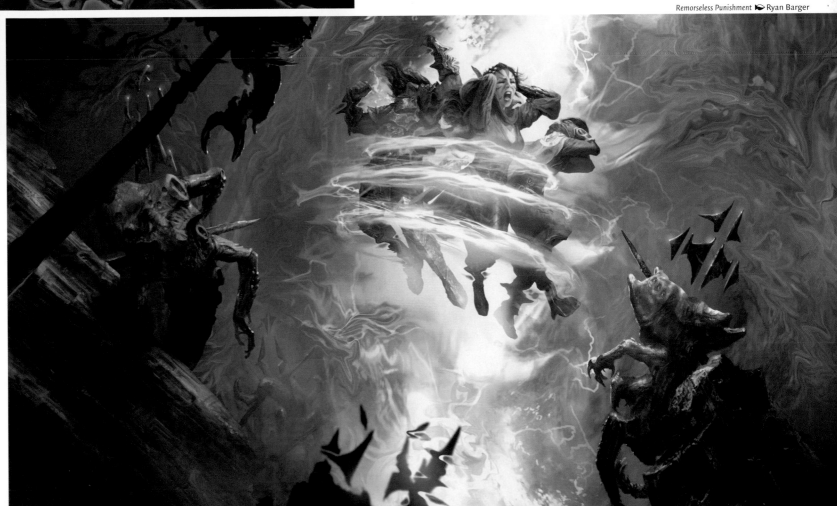

The Birth of the Gatewatch

Gideon, Chandra, Nissa, and Jace emerged from Ob Nixilis's prison and beheld the utter devastation, the ruins of Sea Gate, and the corrupted waste left in the wake of the Eldrazi titans. The Planeswalkers couldn't tell whether any of Gideon's army had survived the fall of the city. Tazeem seemed on the brink of annihilation, and all of Zendikar was sure to follow soon after.

Gideon turned to the other Planeswalkers and issued a challenge. They could leave as Kiora had done, saving their own lives while abandoning Zendikar to the awful predation of the Eldrazi. Or they could stay and work together to defeat the Eldrazi—and more. Instead of a loose band of independent Planeswalkers who cooperated only insofar as their personal goals aligned, they could make a commitment to support each other in constantly working to protect the Multiverse and its people from the threats that no one else could face. Gideon challenged them to take the gift that they had been given—the spark that made them Planeswalkers—and use it to keep watch against the forces that threatened all the planes.

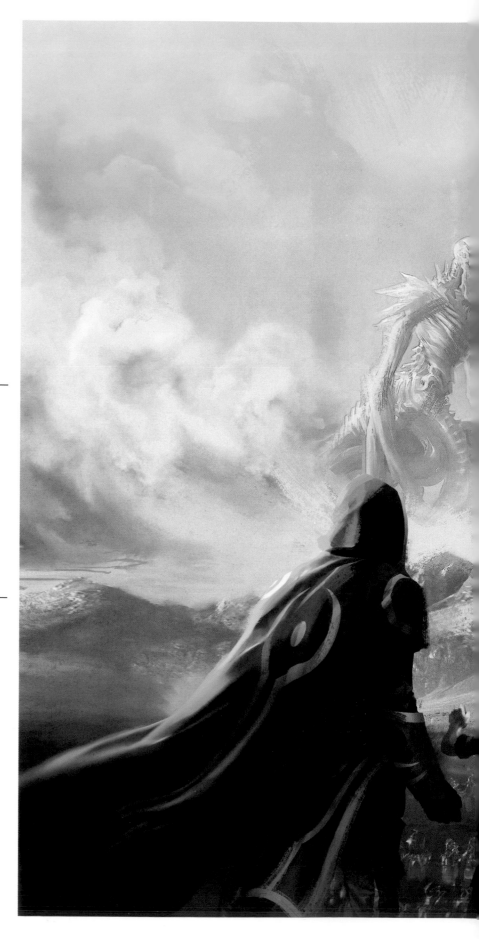

"I have seen civilization fall. When the Eldrazi destroyed Sea Gate, they threatened all I believe. The people of Zendikar were nothing more than stinging flies in their path. Never again. For Sea Gate, for Zendikar and all its people, in the name of justice and peace, I will keep watch." —Gideon Jura

Jace's concern for the plane of Ravnica had already spurred him in this direction, and Gideon urged him to expand his reach to other planes. Despite his apprehension that this effort might distract him from Ravnica, Jace readily agreed. Nissa, too, immediately promised her support. Her connection to Zendikar had awakened her to the soul within the plane—and the agony the Eldrazi caused to that soul. She was eager to protect other planes from the same fate.

For Chandra, though, the decision was not so easy. She had always resisted the burdens of commitment, responsibility, and belonging. But as she surveyed the carnage in the basin below, she began to glimpse a greater purpose. She agreed to join the group as long as it served as an instrument of liberation.

Each Planeswalker swore an oath to keep watch against the dangers that threaten the Multiverse, and the Gatewatch was born.

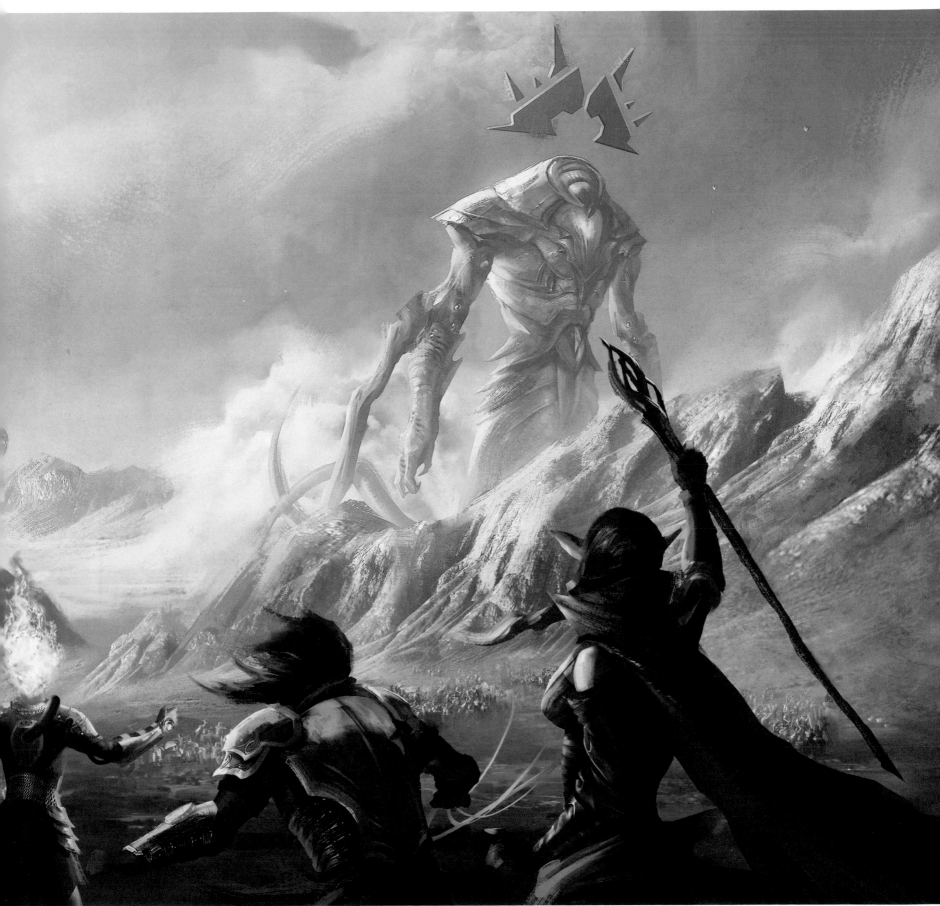

Survival Instincts ✒ Yefim Kligerman

Zendikar's Final Stand

Commitment and dedication, as Jace was quick to point out, quickly come to nothing in the absence of a solid plan. As they surveyed the chaos and destruction spreading across the Halimar basin, the four Planeswalkers charted a desperate course of action. How could they accomplish now what they had failed to achieve before, especially when the situation had grown so much worse?

Over the centuries, many hedrons had plummeted from the Sky Realm above Tazeem to the bottom of Halimar, and in theory the Planeswalkers could have used those to bind the Eldrazi in place again. However, the progress of the Eldrazi through the Halimar basin had left many of the hedrons crumbling, the mystic patterns wiped from their surfaces. The Planeswalkers might be able to raise them and activate them, but they doubted that the hedrons could be assembled into a prison large enough to bind the Eldrazi again.

But having studied the hedrons and learned their secrets from Ugin, Jace believed that he could re-create a pattern around the titans that would hold them in place even without the actual hedron stones. The glyphs on the hedrons reflected patterns in the ebb and flow of the Blind Eternities, and Jace was confident that those patterns could be used to form a prison the titans could not escape. With the help of the other Planeswalkers, he saw a way not just to imprison the titans again, but to destroy them forever.

Gideon led the advance across the Halimar basin. Wielding his four-bladed sural, he cut a path through the Eldrazi that trailed in the titans' wake, while Chandra and Nissa used their magic to destroy any that came at them from the sides. Jace walked calmly in the midst of the group, projecting a mental field that protected the Planeswalkers from the mind-warping magic of Kozilek's brood. The newly formed Gatewatch fought in perfect harmony, each member playing off the others' strengths and covering their weaknesses. Their energy and confidence built as they drew closer to the titans.

At last the Planeswalkers reached the area where the Eldrazi titans had cornered the last survivors of the Zendikari army. Gideon charged forward to engage the titans, planning to draw them together so his companions could work their magic. His shouts rallied the Zendikari soldiers to fight with renewed strength, and they helped force the two Eldrazi titans to face Gideon together.

The four Planeswalkers executed the plan to perfection. While Gideon kept the two Eldrazi titans focused on him, Jace shielded the minds of his companions from the reality-warping effects of Kozilek's presence. At the same time, Jace calculated the precise form of the pattern that could bind the Eldrazi, and guided Nissa in channeling the mana of the leylines to form the prison. Nissa's power held the Eldrazi in place, and she was also able to funnel additional mana to Chandra, fueling her magical fires.

The titans beat furiously against the walls of flame that enclosed them, but they could not escape the magical prison. The intense heat scorched the skin of the Planeswalkers and their allies as they watched the Eldrazi's death throes. At last, the flames tore through the titans and consumed them.

Ulamog and Kozilek were destroyed!

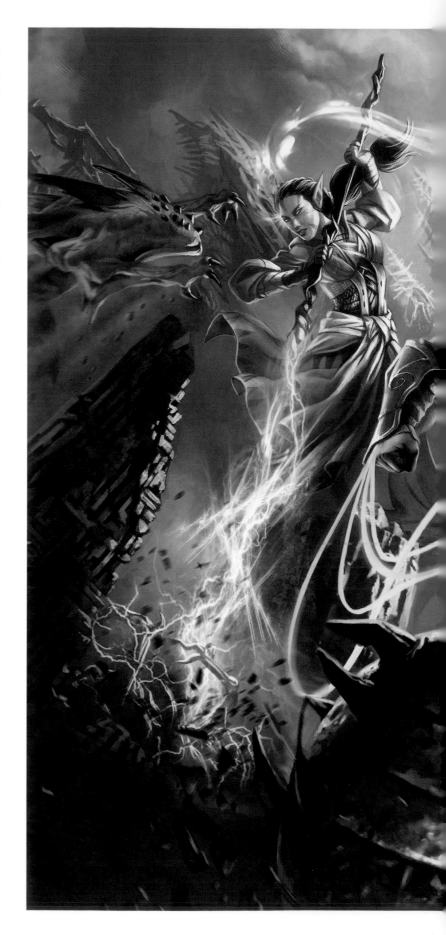

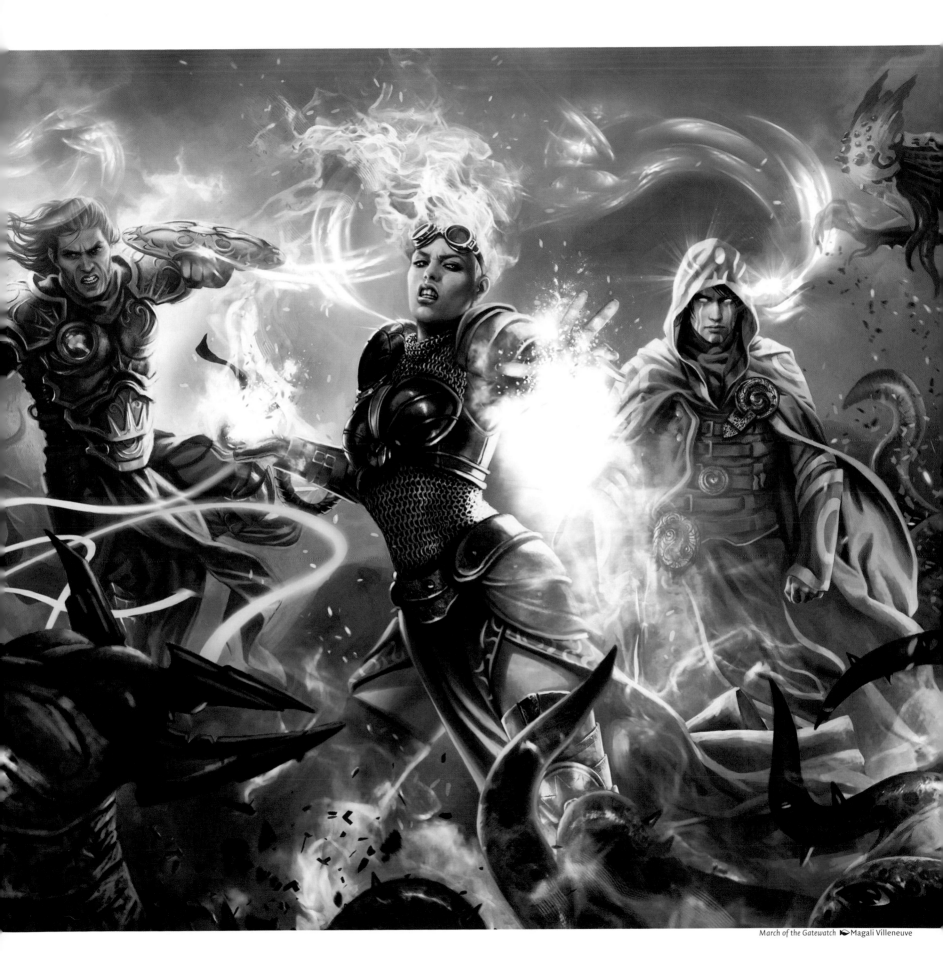

March of the Gatewatch ☞ Magali Villeneuve

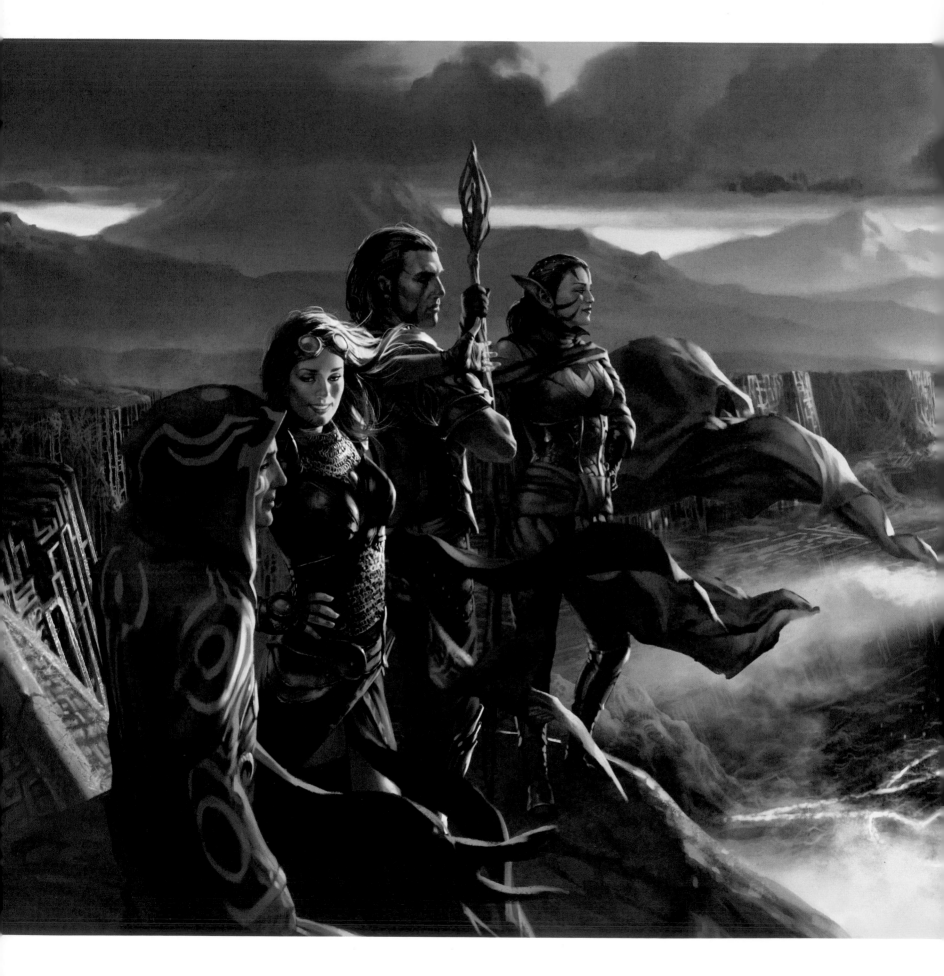

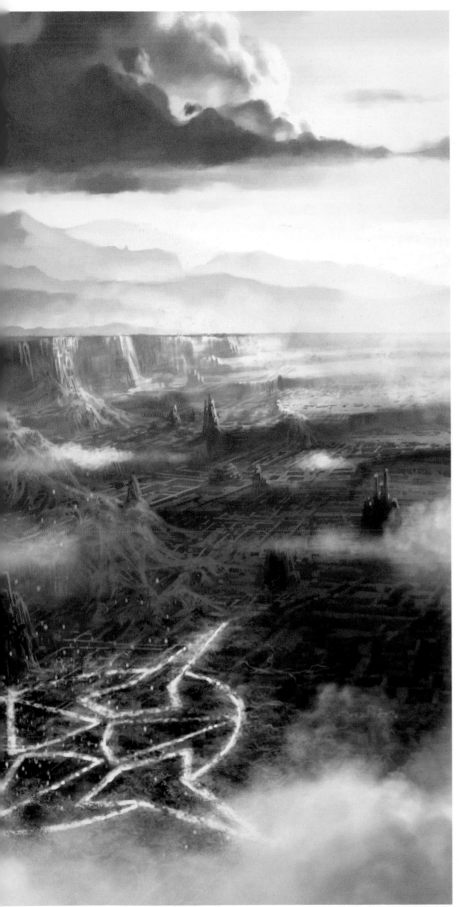

Zendikar Resurgent ▶ Chris Rallis

Zendikar Resurgent

The battle was won, though the war was far from over. Inspired by this victory, the soldiers of Zendikar fought with renewed courage against the teeming Eldrazi broods. For the first time, the Eldrazi showed something akin to fear. They were no longer willing to stand their ground in the face of certain death, and the hordes were soon scattered. All across Zendikar, the beleaguered people of the plane found new strength for the fight and drove the Eldrazi away from the remnants of civilization.

Exhausted, the four Planeswalkers looked down on the glyph they had seared into the ground, amid the ashes and charred remains of the Eldrazi titans. Even as they stood watching, the blackened lines of the glyph began to writhe and then erupted with verdant growth. Grass burst up from the blasted earth with unnatural speed, and twisting vines spread along the lines of the glyph. Nissa smiled at the knowledge that new life lay ahead for Zendikar.

"Lands ravaged, cities in ruins, so many lives sacrificed—and yet there was no other word for it but victory." —from *The Halimar Chronicle*

As glorious a victory as they had won, the members of the Gatewatch all knew that three Eldrazi titans had been unleashed upon Zendikar. Though Emrakul had not been seen in weeks, the third titan was still alive somewhere—perhaps slumbering in the earth or sea as Kozilek had been, perhaps on some other plane. The work of the Gatewatch was not yet done.

So the Planeswalkers formed a new plan. Jace would leave Zendikar in search of Sorin Markov and Nahiri, who had abandoned Zendikar to the Eldrazi. Perhaps they would know how Emrakul might be found or had heard some word of where the third titan had already gone. Gideon, Nissa, and Chandra, meanwhile, would split up and search Zendikar for any sign of Emrakul. Along the way, they would help the people of Zendikar eliminate the remaining Eldrazi broods and rebuild what the Eldrazi had destroyed. They agreed to reconvene at Sea Gate, for as long as one Eldrazi titan remained, the Multiverse still had need of the Gatewatch.

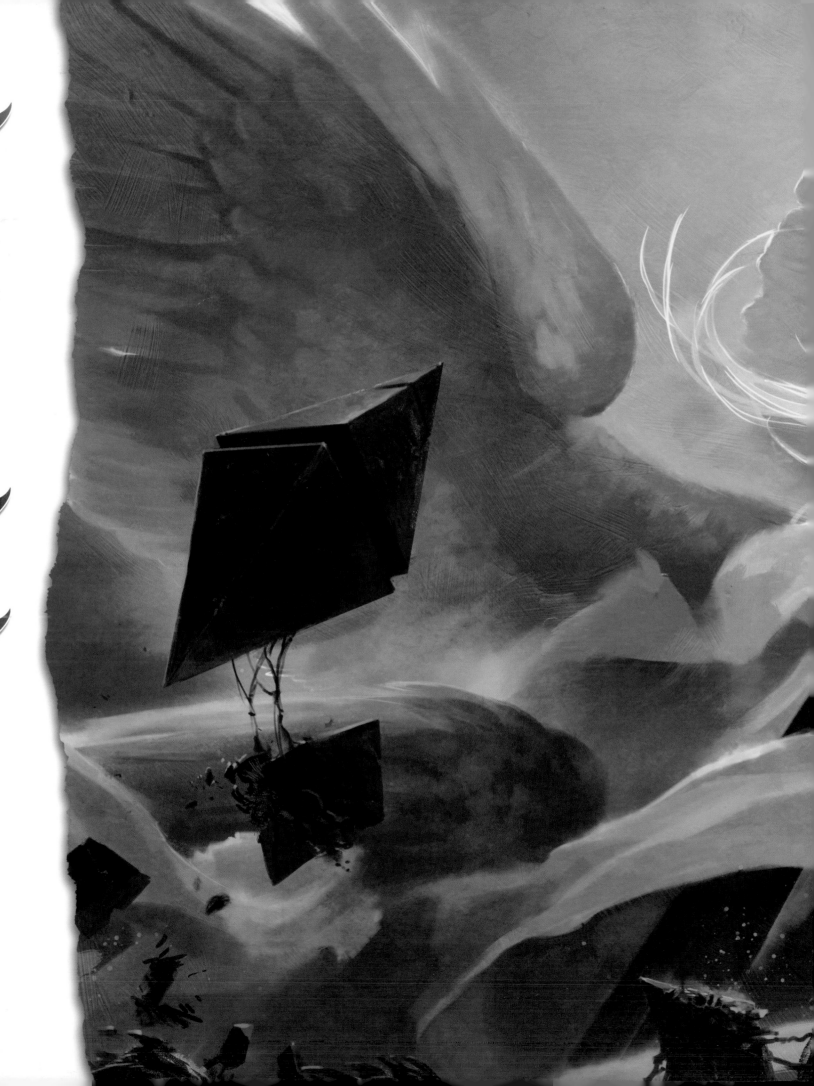

A ZENDIKAR BESTIARY

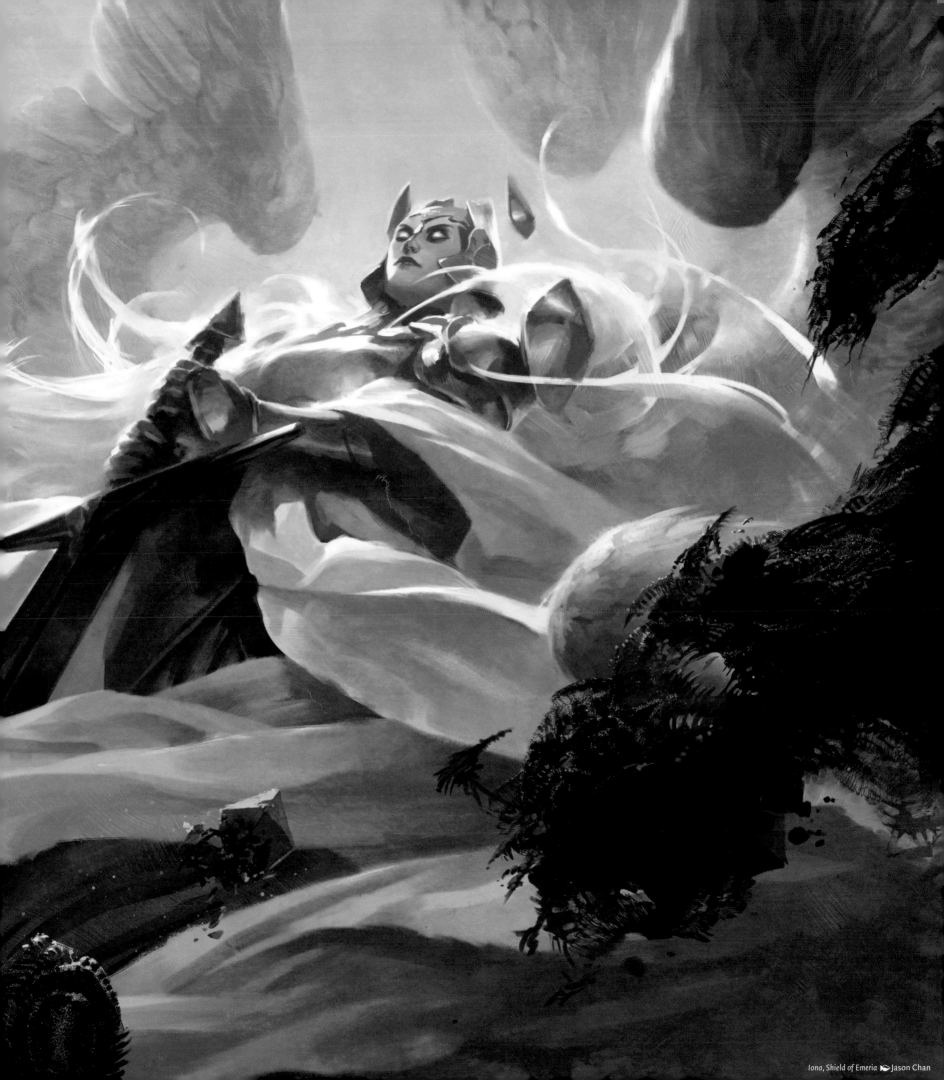

Iona, Shield of Emeria ◈ Jason Chan

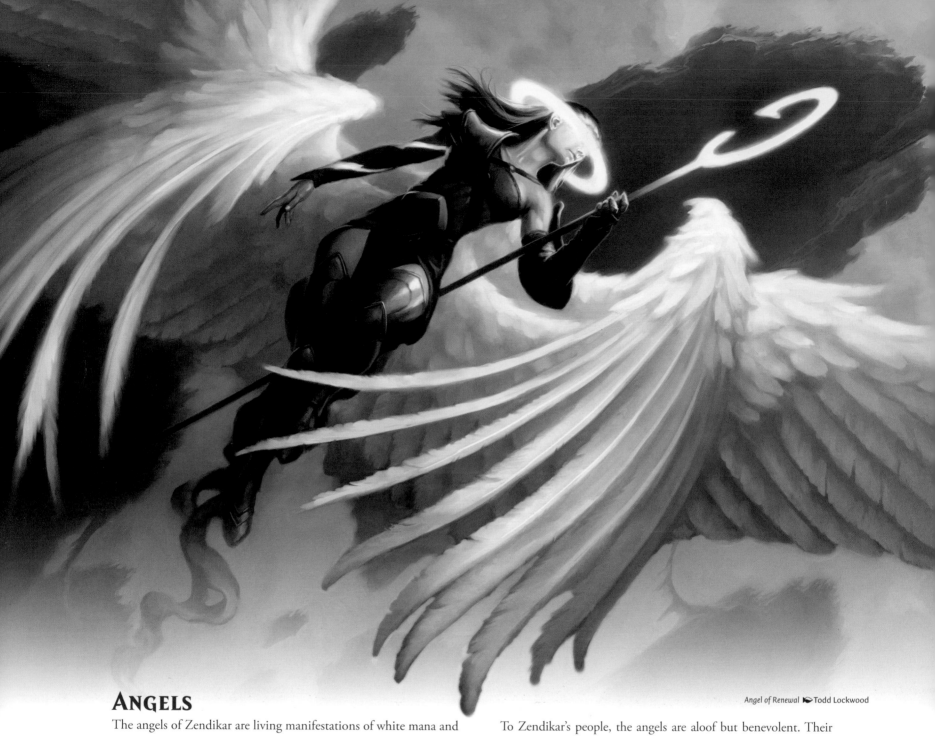

ANGELS

Angel of Renewal ✒ Todd Lockwood

The angels of Zendikar are living manifestations of white mana and embody its inherent tendencies toward morality and order. Peace and harmony are their goals, though they are more concerned with reestablishing the natural order of the plane than with interfering in disputes between the lowly mortal races. They appear similar to human women with two, four, or six feathered wings. Their eyes glow with inner light, and glowing golden rings surround their heads—usually positioned to cover their eyes.

"Should you fall in the wilds, lift your voice to the Sky Realm. The one who answers will be your salvation." — Emeria's Creed

To Zendikar's people, the angels are aloof but benevolent. Their resistance to the Eldrazi broods in the ancient past is vaguely remembered in the myths of the humans, kor, and merfolk, and humans in particular venerate angels as divine protectors because of those myths.

Slipped Halos

When Sorin, Ugin, and Nahiri first lured the Eldrazi to Zendikar, they warned the plane's inhabitants of the imminent arrival of these destructive monsters. The angels took upon themselves the responsibility of protecting the plane, helping to prepare defenses and refuges to ensure that its peoples survived. They led the fight against the Eldrazi broods while the Planeswalkers confronted and imprisoned the titans. Once the prison was sealed, they assumed the responsibility of standing watch against any attempt at escape.

Archon of Redemption ▶ Steven Belledin

ARCHONS

Like angels, archons are incarnations of white mana. They serve the archangels as embodiments of white mana's harsher aspects: a rigid sense of justice and a ruthless execution of punishment for those who defy the law. Their appearance is deceptive: they look like hooded humans riding winged lions, but they are single creatures with just one mind and will.

But over the centuries, their vigilance faltered. When the first escape came, the angels were not prepared. The Eldrazi broods spread far and wide across the plane before the angels marshaled an effective resistance, and only through Nahiri's efforts was the prison sealed so the titans could not emerge. The angels fought against the broods once the prison was sealed again, but they never forgot their early failure.

As penance for that lapse, angels wore their halos across their eyes, symbolizing their blindness and providing a constant irritation that reminded them to remain watchful. And when the titans at last did break free of their prison, the angels were ready for battle.

FELIDARS

Angels are supernatural embodiments of white mana, but even some natural animals of Zendikar are infused with the plane's wild magical power. The great cats called felidars are noble, fierce beasts charged with white mana. Standing fully ten feet high at the shoulder, felidars consent to be ridden by knights they consider virtuous. When they spring into battle, the crystalline horns that rise from a hard plate on their foreheads glow with white or golden light, sometimes brightly enough to blind their foes.

"If survival is a game, I've seen the winner."
— Hazir, *Sejiri cartographer*

GRIFFINS

Less intelligent and less magical than felidars, griffins share the great cats' noble nature and alignment with the principles of white mana. They have leonine bodies and tails, but the front legs of some species resemble an eagle's talons. Their heads also suggest the features of a bird of prey, with a sharp beak and swept-back feathers. Large wings sprout from their shoulders, allowing them to soar among the hedrons that are their preferred nesting grounds.

Larger griffin species are about the size of horses and can be ridden—indeed, they offer one of the only reliable means of reaching certain remote locations, particularly in Akoum. Smaller ones, the size of donkeys or even large dogs, are trained to carry messages or supplies without a rider. Griffins are most easily trained if they are reared in captivity from the time of hatching. This has created a lively trade for griffin eggs that can be lucrative for adventurers brave enough to reach their lofty nests.

Courier Griffin ▶ Kieran Yanner

Hero of Goma Fada ▶ Willian Murai

SPHINXES

Utterly inscrutable, sphinxes are mysterious creatures known for their wisdom and knowledge. Closely aligned with blue mana, they are utterly devoted to knowledge—but to having it, not to sharing it or acting upon it. They are content to search out the mysteries of Zendikar and then sit in quiet contemplation of what they have learned. To sphinxes, everything is an intellectual exercise, even conversation. They are famously oblique, answering questions with questions and posing riddles to test the acuity of others.

Sphinxes' bodies are similar to those of lions, tawny colored with darker-brown stripes along the back and hindquarters. They have feathered wings like an eagle's and a humanlike head crowned with thick hair. Sphinxes typically sport long, stiff braids, and males have bushy beards, also braided. They range in size from merely enormous, about eight feet at the shoulder, to truly colossal—towering over even giants.

Reclusive Sages

Sphinxes choose remote locations for their lairs, preferring sites of great natural beauty such as waterfalls, high promontories, and small islands. They jealously protect their lairs from other sphinxes and large predators, such as dragons, but they pay little attention to smaller visitors. A sphinx's lair is often difficult to reach without the ability of flight because it requires treacherous climbs. A visitor who can reach the spot is often rewarded with an audience—but a visitor who comes in search of answers is likely to leave disappointed.

DRAKES

Drakes are superficially similar to dragons, with reptilian bodies and large, leathery wings. They have only two legs, though, and they are strongly associated with blue mana, the air, and the sea rather than the dragons' mountains and fire. Many drakes are found in Akoum, but they tend to live at higher altitudes and farther north than the dragons there.

> "Even if the sphinxes do know the location of every relic, getting one to talk is harder than just searching yourself."
> — Sachir, *Akoum Expeditionary House*

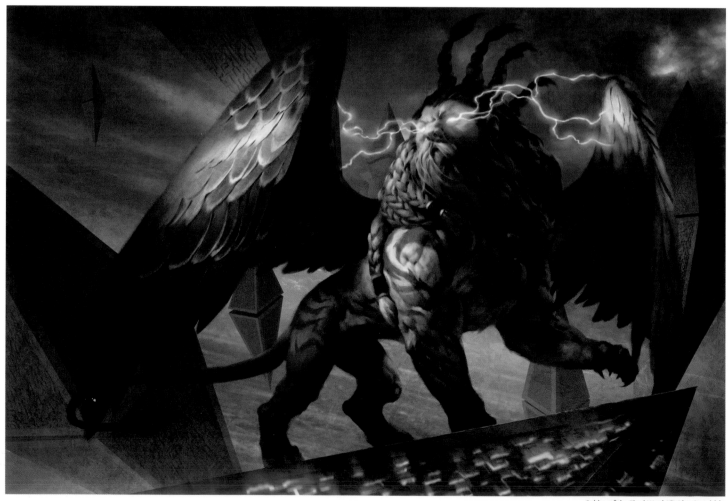

Sphinx of the Final Word ▶ Lius Lasahido

Champion's Drake ▶ Lars Grant-West

Life on the Wing

Drakes are roughly birdlike in form. Their wings serve as forelimbs that help in perching and climbing as well as allowing them to fly. Their legs have large talons suitable for gripping tree branches, cliff faces, hedrons, or prey. Their long, slender necks and tails make them resemble snakes almost as much as birds.

Using thermal updrafts and gravity currents, drakes eat and sleep in the air. Some never touch the ground from birth until death. They build their nests on floating chunks of earth or on hedrons drifting through the air. They are particularly drawn to coastal cliffs, where prey can often be found on both the land above and the sea below.

Training and Riding

Drakes can be trained, and they are raised in captivity in Tazeem and Ondu. Smaller drakes can carry messages to destinations they have learned, and some of the larger ones will accept riders. Some drakes can even be trained to carry travelers in their claws, though the ride tends to be both uncomfortable and terrifying. Drakes are also trained for guard duty, protecting caravans and settlements from predators and smaller Eldrazi.

Skypath Drake ▶ Kieran Yanner

> "'Fraid of heights? Ride a horse.
> 'Fraid of missing out? Rein up a drake."
> — Trinda, *Hada spy patrol*

KRAKENS

Lurking in the deepest reaches of Zendikar's seas, krakens are mysterious monsters of unpredictable wrath and terrible destruction. Though they may seem to be little more than rampaging brutes when they appear on the surface, the truth is more complex. They embody force of will, the drive for self-determination shared by all thinking beings. When their will is turned to destruction, they are capable of wreaking terrible havoc upon ships at sea or coastal towns. But they live most of their adult lives in utter isolation in the deeps, focused on their own probing of the seas' mysteries.

A kraken has a roughly humanoid shape, with two strong arms and a broad chest. Its head is encased in a rough shell that sprouts two large horns, and one hand is a bony claw. It has dozens of tentacles—a writhing mass below its toothy mouth, another mass at the end of one arm, and several long tentacles in place of legs. On its back is a huge conch-like shell.

Krakens are most often seen as hatchlings. Adults lay their eggs at sea, but they usually wash to shore and hatch on remote beaches. Hatchlings that emerge in the open water quickly become prey for other sea monsters. The ones that hatch onshore typically survive longer, and explorers often stumble upon them as the krakens hunt and grow. Some people prize kraken hatchlings as food, but most Zendikari believe that adult krakens will avenge their slain offspring.

Shoreline Salvager ▶ Igor Kieryluk

SURRAKAR

The surrakar are a race of hulking amphibian humanoids native to Bala Ged. Since the rise of the Eldrazi, the surrakar have spread around Zendikar seeking safe refuge, which has brought them into conflict with vampires and other swamp dwellers. They have broad shoulders and long arms that drag on the ground when they walk. Their splayed feet and hands are webbed, and long tusks protrude from their large mouths. They have little culture and no written language, and some members of other races believe they are merely animals with no true language at all.

Wrexial, the Risen Deep ▶ Eric Deschamps

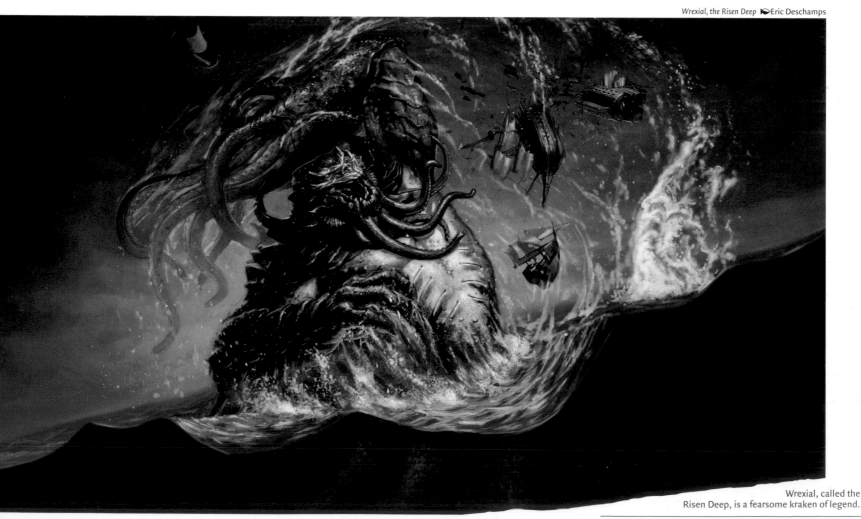

Wrexial, called the
Risen Deep, is a fearsome kraken of legend.

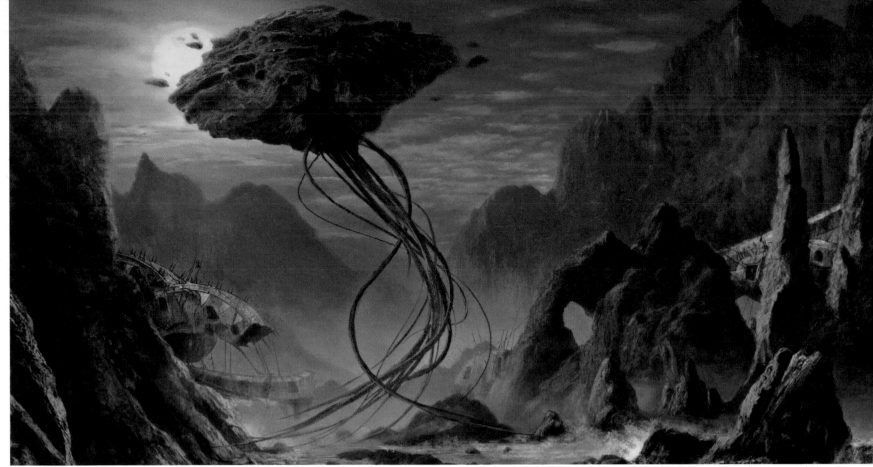

Guard Gomazoa ▶ Rob Alexander

GOMAZOA

Zendikar's seas and skies tend to blur together, and creatures typically found in the sea often find their way to the clouds, gliding through the plane's gravitational currents by consuming the mana infused in the wind. The windrider eels hunted by the kor and the cloud mantas sometimes ridden by Emeria-creed merfolk are two examples. The gomazoas found in Murasa and the Makindi Trenches are another.

Gomazoas are similar to aquatic jellyfish, but their bodies are encased in stony growth. Drifting among floating rocks or hedrons with their long tentacles dangling below, gomazoas spring to life when a tentacle brushes against another creature. They use their sticky tentacles to grab and constrict the creature, and they might haul larger prey into the air to slam it against a cliff face. Some species can withdraw their tentacles into their bodies, extending them only when grabbing their prey. Gomazoas almost never release prey once they've caught it.

Hedron Crab ▶ Jesper Ejsing

OTHER CREATURES OF THE SEAS

The oceans, bays, and swamps of Zendikar are home to a variety of aquatic creatures that are at least as deadly as those on land, including monstrosities that can face the largest Eldrazi on almost equal footing. Given the dangers of Zendikar, even mundane animals like octopuses, frogs, turtles, crabs, and crocodiles can grow to tremendous size. The crabs of Ondu, the crocodiles of Guul Draz, the tortoises of Tazeem, and the octopi of the deep sea (of which Lorthos the Tidemaker is but one giant specimen) are examples of these aquatic monstrosities. Enormous shoal serpents—sometimes compared to "a reef that runs aground on ships"—are a persistent danger to ships off the Onduan coast.

213

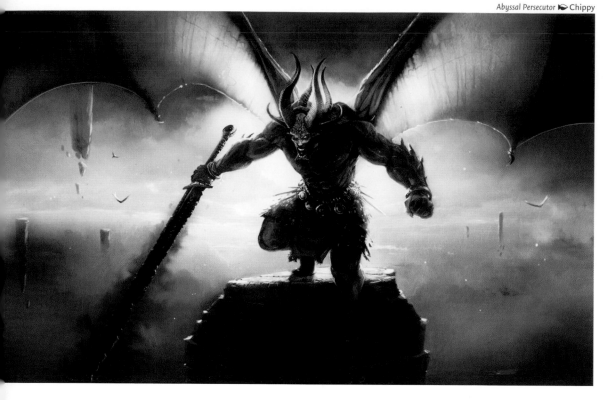

Abyssal Persecutor ↣ Chippy

Demon Cults

In the wake of the Eldrazi's rise, many people of Zendikar feel that their gods have turned against them. In desperation, those who are already inclined toward wickedness and depravity increasingly turn to the worship and service of demons. Small cults gather around the unhallowed places where demons dwell, beseeching the demons for protection against the Eldrazi. Demons sometimes respond by sharing a small taste of their magical power in exchange for the servitude of these cultists, confident that they are getting the better end of the trade.

Unholy Metamorphosis

Members of the mortal races who are utterly consumed by the pursuit of power have been known to transform into demons, losing all resemblance to their past forms. Human wizards who delve too deeply into demonic magical secrets are most prone to this corruption, but Ob Nixilis—who was a warlord and conqueror before his transformation—proves that anyone with sufficient selfish ambition and ruthless lust for power can be caught up in a demonic curse. Demons do not grow old, so becoming a demon offers unimaginable opportunities to achieve great power, but at the cost of any shred of compassion, affection, or mercy. Demons never retain ties to their old lives for long, as the transformation brings alienation from the trappings of the mortal world.

DEMONS

Demons are the dark reflections of angels, incarnations of black mana and all it represents—selfish desire and lust for power. Their forms are roughly humanoid, but distorted and bestial. Their grotesque heads bear elongated ears, spiky protrusions, and large horns. (The size and number of a demon's horns are an indication of its age and power.) Spikes protrude from their backs and arms, and their hands are warped into sharp claws. Most demons have large, leathery wings, and a few have long tails. Their skin has an inhuman texture—dry and leathery for some, stony and cold for others. Their eyes are small points of reddish or bluish light, as if revealing an inner inferno.

"Morality is just shorthand for the constraints of being powerless."
— Ob Nixilis

Lurkers in Darkness

Unlike angels, demons reject any form of society or alliance. They are utterly selfish and hoard power in many different forms, such as wealth, magic, territory, or slaves. Drawn to places where black mana flows freely, they often dwell in ancient crypts or in ruins deep in swampy terrain. Their presence defiles any remaining scrap of purity or goodness in the environment and often extends the bounds of a swamp or stirs up the restless spirits of the dead.

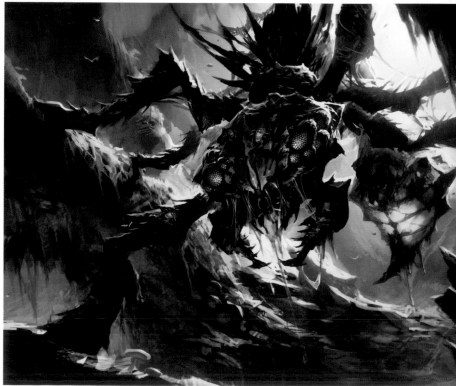

Caustic Crawler ↣ Raymond Swanland

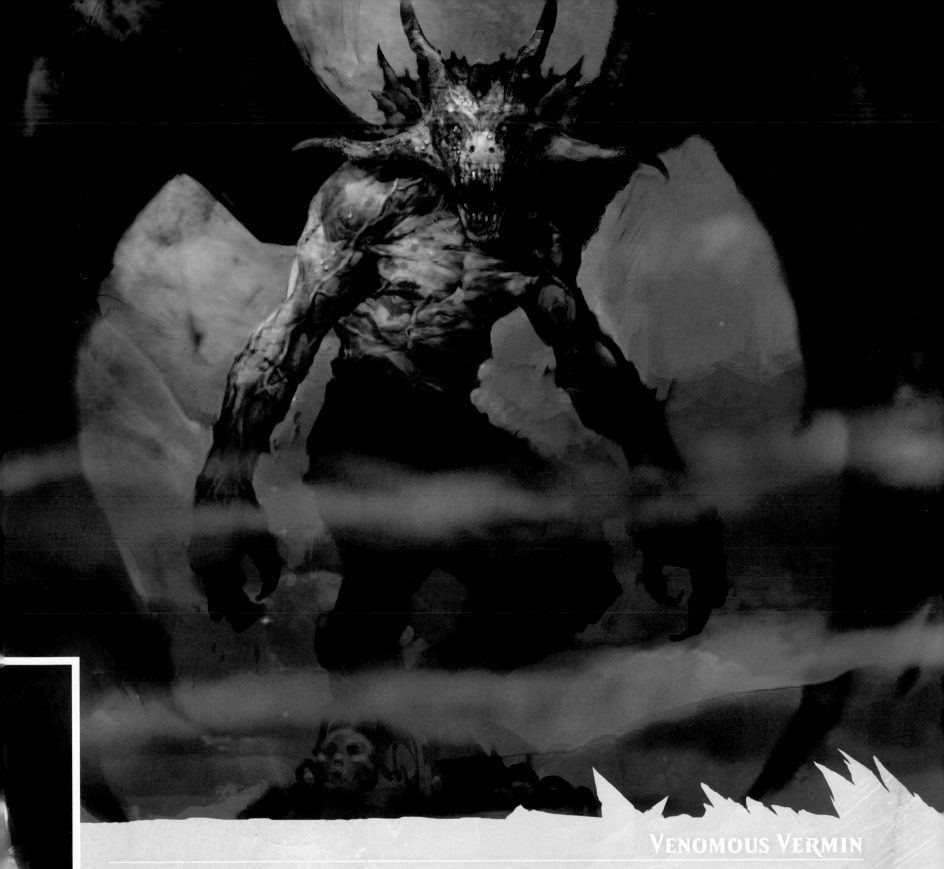

VENOMOUS VERMIN

The black mana that brews and festers in Zendikar's swamps infuses a wide variety of natural animals, creating large, deadly vermin—rats, bats, insects, scorpions, and spiders that spread death and decay with their bites, stings, or caustic saliva. The swamps of Guul Draz are home to many such creatures, from the enormous heartstabber mosquitoes to giant scorpions large enough to hold a struggling vampire in one claw. The gigantic, ant-like caustic crawlers shape burrows from the stone with their acidic saliva, creating strangely smooth walls easily mistaken for ancient construction. Gloomhunter bats, the size of griffins, have reservoirs of vaporous mana in their heads, causing their bite to tear at the spirit as well as the flesh.

Pestilence Demon ➤ Justin Sweet

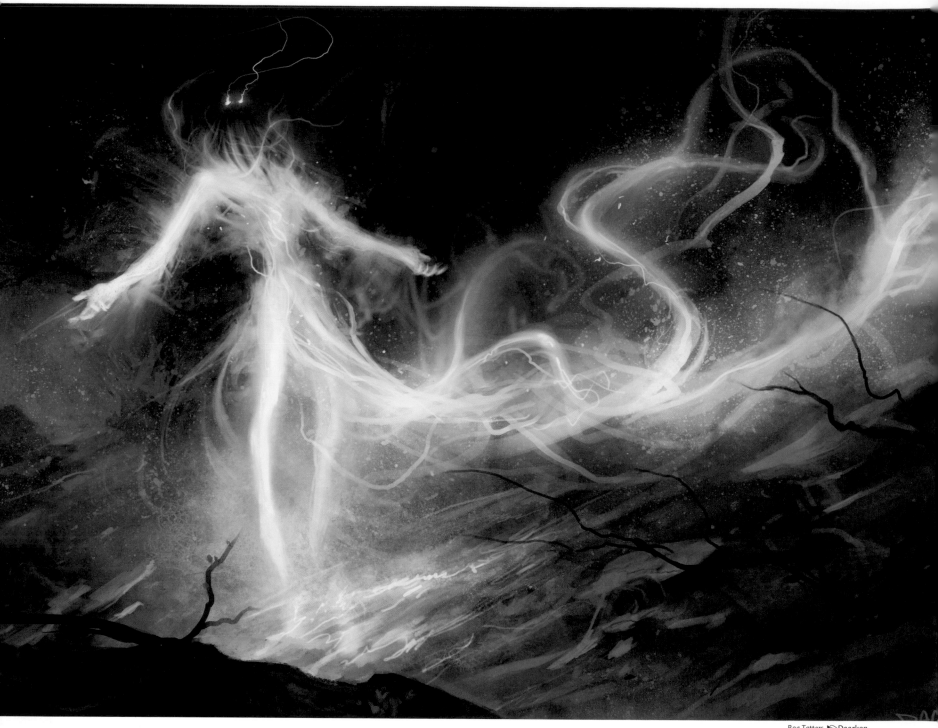

Bog Tatters ▶Daarken

THE RESTLESS UNDEAD

Magic fueled by black mana can alter the natural cycle of life and death. Whether the magic is wielded by a mortal wizard, a demon, or an environmental manifestation of black mana's flow through the land, it can create various forms of spirits that are trapped between the realm of the living and the mysterious fate of the dead. These ghostly undead are as destructive as the magic that calls them into being.

Shades

Shades are the malign spirits of hateful and murderous people. They are clouds of darkness that retain their basic shape but over time lose any features of their physical form except their glowing eyes. In their undead state, they are enraged by the presence of the living, which they perceive as almost blinding light and hence seek to extinguish as quickly as possible. They draw on black mana in their environment to empower their savage attacks, and the mana only intensifies their bitterness and hatred.

Noble Vestige ▶ Jason Chan

Vampire Null ▶ Kev Walker

Wraiths

Wraiths are the anguished spirits of the murdered, lingering in the world in a brutal cycle of killing as they seek to inflict on others the same torment that was dealt to them. They manifest as glowing humanoid shapes that vaguely suggest their mortal forms, with bright tendrils extending out into their surroundings, siphoning mana to fuel their continued existence. But they can also subsume themselves into ley lines, disappearing from one spot and reappearing elsewhere along the same flow of mana. They use this ability to strike terror and confusion in their foes before moving in for the slaughter.

Specters

Often compared to archons, specters are undead spirits that are saturated with black mana. The specters occasionally seen in Guul Draz are hooded figures mounted on withered drakes. Their flesh is translucent green, and wisps of sickly green vapor waft from under their hoods. Their freezing touch numbs the body and the mind, stripping their victims of thought and memory.

Other Spirits

Not all spirits are created with black mana, and not all are malevolent. The spirits of the dead sometimes linger in the world to protect their kin or communities, or to stand guard over sacred or important sites. These spirits can be dangerous but are not usually malicious. Both the kor and the Mul Daya elves remain in communion with the spirits of their dead kindred, entreating them for wisdom and protection.

VAMPIRE NULLS

The various forms of undead ghosts are the incorporeal remnants of life and personality left after the death of a mortal body. But sometimes the reverse is true: a body retains its animation and hunger while losing any trace of its soul. When a vampire who is not a bloodchief drains the blood from a living person, the person undergoes a horrible transformation, becoming a null. Somewhat like the Eldrazi brood of Ulamog, nulls are hunger incarnate. Their heads are featureless except for a gaping mouth filled with jagged teeth. Their bodies are shriveled and distorted but preternaturally strong. They are mindlessly loyal servants to the vampire nobility; the number of nulls under a vampire's control was a mark of status and power among the vampire houses of Guul Draz.

DRAGONS

Dragons are the ultimate representation of the chaos, the ferocity, and the reckless, irrepressible independence of red mana. They are found across Zendikar in mountainous regions where red mana is plentiful, particularly in Akoum, but never in great numbers.

> "The dragon has no pretense of compassion, no false mask of civilization—just hunger, heat, and need."
> — Sarkhan Vol, *Planeswalker*

Wings and Scales

A dragon is an enormous reptilian monster with thick, tough scales and leathery wings. Sharp spines or thick plates run down its back, and most have large horns. A dragon's body has a vaguely feline shape, with a long neck supporting a large head, and a long, thick tail lashing behind it. Its four legs end in sharp claws that are deadly weapons, and its mouth is full of sharp teeth. Even a young dragon is larger than a powerful warhorse, and the largest are on par with some of the larger Eldrazi (though not as mighty as the towering Eldrazi titans).

Dim Intellect and Fiery Temper

The dragons of Zendikar are not particularly intelligent, especially in comparison to the genius dragon Planeswalker Nicol Bolas. They are more aware than the average beast and perhaps slightly smarter than an ogre, but they are still driven primarily by their instincts—to hunt for prey and to guard their territory against any intruder. They are hot-tempered and ferocious, tending to rend or incinerate anything they perceive as an enemy before even thinking to ask questions.

Raging Flames

A dragon's most fearsome aspect is its ability to exhale a blast of fire from its mouth. As it draws breath, a red glow forms around its mouth, sometimes visible in its neck and chest as well, like the glow of heat inside molten metal. Then the fire erupts in a long stream or

Dragon ▸ Raymond Swanland

Tyrant of Valakut ☞ Steven Belledin

a broad cone, shaped by the dragon's mouth as it chooses. A dragon might strafe the ground with fire as it flies overhead, covering as much ground—and as many foes—as possible. A grounded dragon turns its head back and forth as it breathes, blanketing its foes in flame or creating a barrier of burning earth to cover its retreat.

Dangerous Allies

As wild and fiercely independent as dragons are, it is still sometimes possible to tame, control, or appease one. The Kargan tribes of Akoum capture dragon eggs and raise the hatchlings in captivity to serve as allies and mounts for their leaders. These dragons are certainly more tractable than any others, but they are stubborn and capricious, and they occasionally eat innocent members of the tribe instead of the enemies they're supposed to consume. A powerful mage can force a dragon into servitude, but usually only temporarily, and maintaining control requires a tremendous effort of will.

It is also possible to buy a dragon's forbearance. Dragons are strangely drawn to precious metals and stones—they have no use for such things but seem to crave the satisfaction of owning items they know are valuable. An offering of treasure can convince a hungry dragon to leave a traveler alone for a time, although the dragon might decide to eat the traveler and take the treasure instead of accepting payment. More rarely, a dragon has been known to act as a sort of mercenary—turning its destructive wrath against a specified foe in exchange for payment.

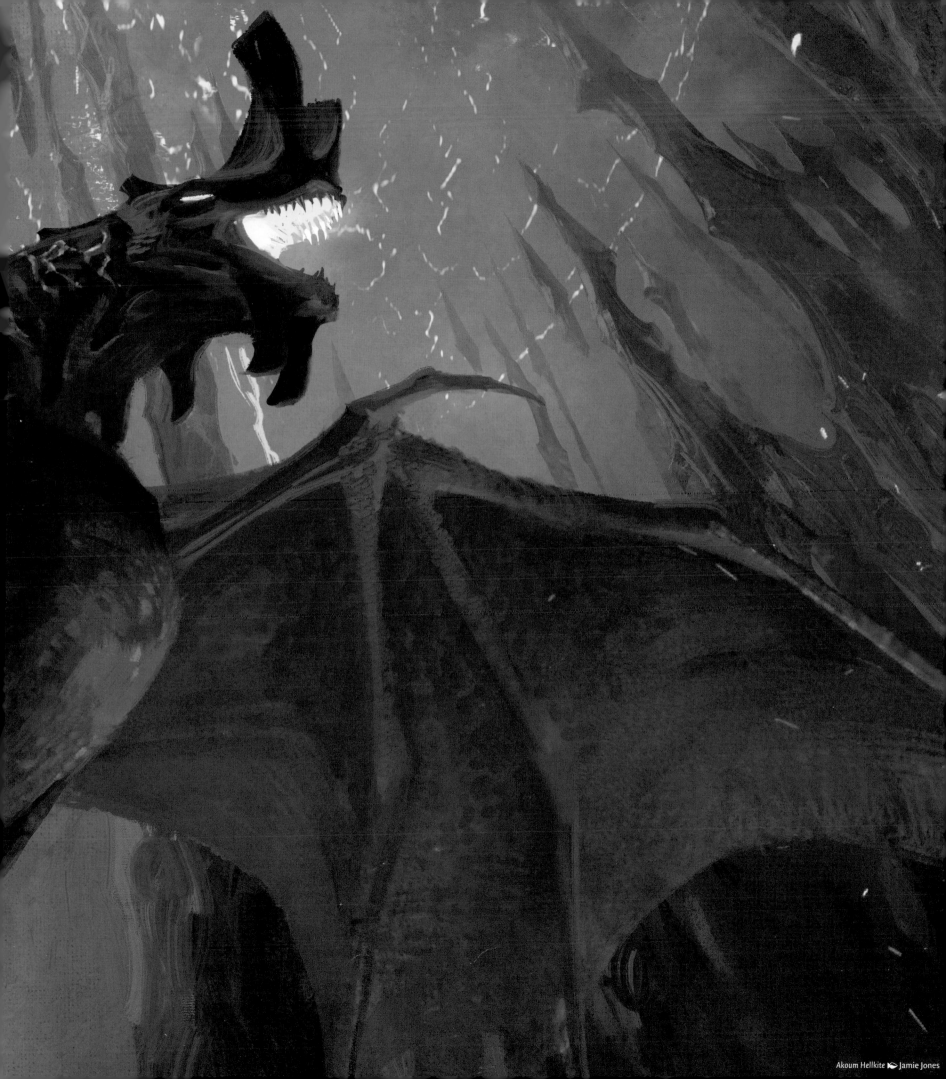

Akoum Hellkite · Jamie Jones

Shatterskull Recruit David Palumbo

Ondu Giant ▸ Igor Kieryluk

GIANTS

Zendikar's giants are enormous humanoids who live in tight-knit tribes as far as possible from the settlements of other races. Compared to ogres and minotaurs, they are civilized and intelligent, though they are wilder than the smaller humanoid races.

True to Their Name

Giants are about the same height as ogres and minotaurs, between 15 and 20 feet tall, but they are more slender, built much like oversized humans. They are usually bald, but males often grow bushy beards. They tend to wear minimal clothing, draping or wrapping themselves in hides or occasionally stitched leather. They favor the bones of their prey—and their enemies—as ornamentation.

From the Savage to the Sublime

Three major groupings of giants inhabit three of Zendikar's continents. In the mountains of Akoum, the giants of the Boulderfoot tribe have a well-earned reputation for trampling their enemies underfoot, hence their name. They hunt geopedes and other giant, insect-like creatures that tunnel in the mountains, and occasionally venture into the forest of Ora Ondar in search of other game.

In the Skyfang Mountains of Murasa, the giants of the Shatterskull tribe are rough brigands who often extort "tolls" from travelers trying to navigate the treacherous pass that shares the tribe's name. To their credit, they often provide invaluable assistance to those explorers willing to pay the exorbitant toll, helping them to avoid the great hunks of stone that float in the air and then hammer down at irregular intervals. To those who refuse to pay the toll, however, the giants can prove no less dangerous than the falling rocks.

In Ondu, the giants of the Turntimber tribe live in the forest of the same name. They hunt baloths and similar large game, living in close harmony with the woodland. Their druids are the only giants of Zendikar that are inclined toward magic at all. Some legends hold that they are unrelated to the other giant tribes, but were druids first and giants only after years of living among the twisted trees.

Misshapen Outcasts

Elsewhere on Ondu, in the Makindi Trenches, a handful of deformed giants called trench giants scale the canyon walls looking for prey. They are solitary and do not think of themselves as members of a tribe. In fact, they are outcasts of the Turntimber tribe, banished because the mana of the forest warped their bodies and their hearts. They are grossly misshapen, with asymmetrical proportions and distorted features. Barely capable of rational thought, they are simple hunters, living on whatever food they can catch in the trenches.

HURDAS

Hurdas are huge, semihumanoid creatures thought to be distantly related to giants. They are primarily employed for heavy labor—hauling stone, shifting earth, and drawing the huge carts of the Goma Fada caravan, for example. They are essentially beasts of burden, no more intelligent than a baloth or terastodon—and significantly more pliable. Murasan hurdas, though, are significantly more aggressive than their calmer Onduan kin, and they serve as protection for the caravans instead of drawing the carts.

Hurdas are bipedal, but they walk on hugely developed arms, while their tiny, vestigial legs dangle beneath them. Thick tails keep them balanced. Their massive bulk allows them to carry tremendous loads in addition to pulling carts and wagons behind them.

Battle Hurda ▸ Christopher Moeller

OGRES

The ogres of Zendikar are towering brutes driven by cruelty, greed, and savage ferocity. They favor the jagged mountains of Akoum but can be found on every continent. Their size and strength help protect them from the dangers of Zendikar, so they have little need of walls or roofs—which is good, since they have little skill at building.

Burly Brutes

Ogres stand between twelve and fifteen feet tall, with strong, stocky builds. Their heads seem small for their large bodies, which reflects their dim intellects. They wear a minimum of clothing—rough furs and makeshift armor made from metal plates. Ogres who work with members of other races might wear clothing and wield weapons made by skilled artisans, setting them apart from their kin.

Slaver Gangs

Ogre society, such as it is, revolves around leaders who gather small gangs of about six to ten other ogres to join them in pillaging, extortion, or the slave trade. Slavery is an accepted and important part of ogre life; by convention, an ogre who loses a fight with another ogre is enslaved to the victor. Ogre leaders extend this practice to enslave members of the smaller races as well. They don't view these slaves as particularly useful, for the most part, but find that they can be sold or traded in some of Zendikar's seedier towns, including Nimana, Zulaport, and North Hada.

Ogre ◆ Paul Bonner

> "You have to appreciate the genius of it. Why bother building defenses when you can just fill the pass with angry ogres?"
> — Javad Nasrin, Ondu relic hunter

Dark Magic

Despite their low intelligence, some more clever ogres master the use of certain kinds of magic. The use of red mana complements an ogre's fierce and angry tendencies, and some ogres channel that mana to produce fiery spells and to manipulate the volcanic forces of Akoum. Other ogres channel black mana to immerse themselves in necromancy and diabolism, accentuating their amoral nature and their willingness to enslave others for their own benefit.

MINOTAURS

Minotaurs are often savage and cruel, much like ogres, but they are also capable of fighting with discipline, cooperating with members of other races against a common foe, and carefully following orders—if the pay is good enough.

Heads of Beasts

Minotaurs are enormous, ranging from fifteen to eighteen feet tall, and covered with dark fur. Their fur is short and fine over most of the body but long and bristly around the neck, over the shoulders, down the spine, over the belly, and on the legs—particularly the back of the leg, from hock to hoof. Their heads are often compared to those of cattle or oxen, a comparison which is not entirely accurate and is considered greatly insulting by minotaurs themselves. They have protruding snouts and large mouths filled with sharp teeth. Their heads are crowned with horns that sometimes extend several feet forward, making them useful as weapons. They have long, tufted tails, which minotaurs sometimes adorn with spiked metal rings, though the function is purely decorative.

> "On expeditions, minotaurs are worth their weight in gold. Fortunately for their paymasters, most minotaurs don't know how much they weigh."
> — Sarchir, AKOUM EXPEDITIONARY HOUSE

Mercenary Ferocity

Minotaurs are strongly associated with red mana. Their fierce tempers, passionate emotions, and lust for battle align with the characteristics of red mana, and their shamans (who are rare) favor the mountain magic of earth and stone. They are often reckless and unpredictable, throwing their opponents off-balance and then pressing their advantage. They enjoy new challenges and experiences, particularly if those experiences come with financial gain. They enjoy wealth, not for its own sake, but because of what it can buy—all the fine pleasures of life they enjoy to the fullest. The best experiences afford them an opportunity to wade into battle and get paid for it, so they often join mercenary bands or serve as hired guards on exploratory expeditions.

Some minotaurs, though, forgo all the trappings of civilization and live in the wilds, embracing their bestial nature. They live as predators, feeding on whatever animals they can catch—or on humanoids if no other prey is available.

Ruinous Minotaur ▶ Raymond Swanland

HYDRAS

Hydras are dragon-like reptiles with no wings and multiple heads. Relatively small hydras, such as those found in Tazeem's Vastwood, have only five heads, but the largest hydras in Ora Ondar have eight. A hydra's heads come together on long, thin necks to a four-legged body with wide shoulders and narrow hips. Frilled crests adorn the heads and upper necks and run down the creature's long tail. For all their great bulk, hydras can move quickly and with surprising agility through their forest homes.

> "In ages past, bargains were struck and promises were made. Now we must collect on our debt. Begin the hymns."
> — Moruul, *Khalni druid*

Khalni Hydras. The hydras of Akoum's forest of Ora Ondar are the largest found on Zendikar, and the druids who tend the so-called Khalni Garden regard them with an almost religious reverence. According to the druidic tradition, the first ones who tended the forest made a pact with the elementals that inhabit the forest and embody its will. By the terms of this pact, the druids and their descendants would protect the forest's heart against any destructive force. In return, the forest would shelter them when the end of the world drew near. With the rise of the Eldrazi, the druids of Ora Ondar decided it was time to call upon the forest for the protection it had promised—and the hydras emerged to fight the teeming Eldrazi broods.

WURMS

The wurms of Zendikar are gigantic creatures with features akin to both snakes and insects. They dwell in almost every region of Zendikar—they wind through the lava tunnels of Akoum, coil around the vast tree branches of the Vastwood in Tazeem, lurk in the caves of the Pelakka Karst in Guul Draz, burrow through the cliffs of the Na Plateau in Murasa, and dig beneath the crags of Beyeen, off the coast of Ondu.

A wurm's serpentine body is covered in heavy bands of scales, giving it a segmented appearance. Its misshapen head is crowned with at

Oran-Rief Hydra ‣ Chris Rahn

A hydra with only five heads is considered "small."

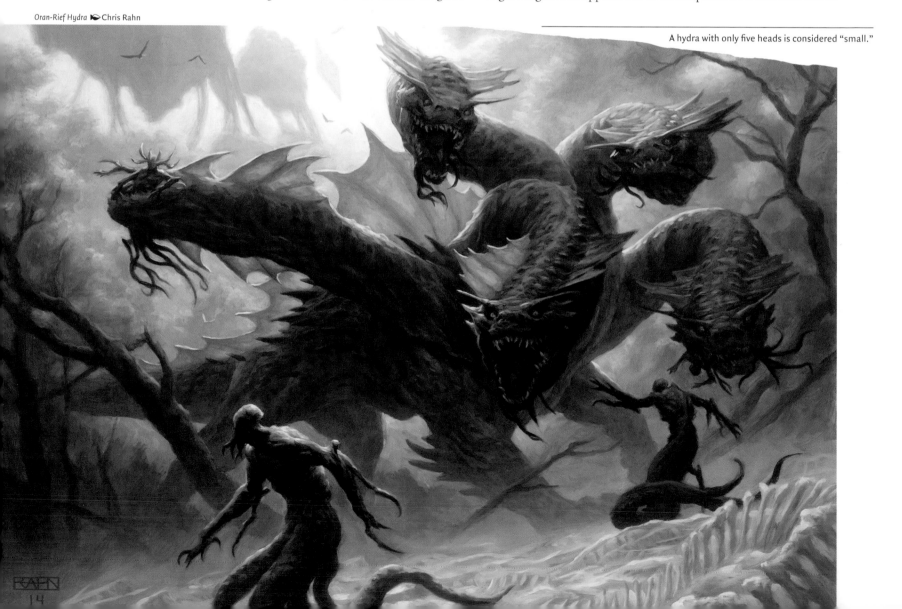

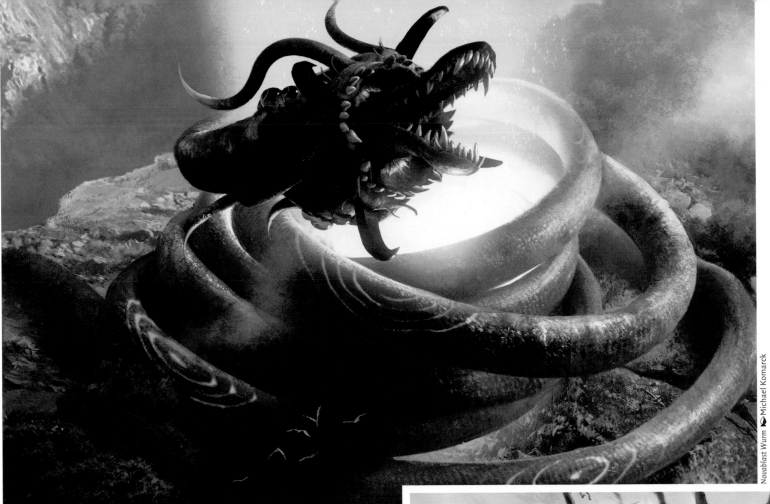

least eight eyes but is dominated by a ring of four or five enormous, hooklike fangs surrounding the mouth. When it is ready to feed, the creature's jaws extend like a tube from its mouth, accompanied by a horrendous carrion stench and a nauseating squelching sound.

> "The sun was born within its coils, but it fled to the sky. The wurm hungers for its child, and the world will bear its loss."
> — Screed of the Mul Daya

The Myth of the Novablast Wurm. The Mul Daya elves of Bala Ged had a myth about the birth of the sun. According to this tale, the world lay in utter darkness when it first came into being, and it was an enormous wurm that first dreamed of light. The wurm slumbered in a tight coil until light began to shine out from the center of the coil. The wurm awoke and relaxed its body, and the sun sprang up from its birthplace, giving light to the world. The wurm feared the light it had birthed, for the sun burned its many eyes, and it tried to swallow the sun and drench the world in darkness once more. The sun fled into the sky, and the wurm's insatiable hunger for the sun still keeps it in ceaseless motion, eating everything in its path.

Hellion Eruption ❧ Anthony Francisco

HELLIONS

Similar to wurms, hellions are enormous serpentine creatures that dwell in the lava deep beneath the surface of Akoum. When an eruption brings lava to the surface, occasionally hellions emerge as well. Thrust into what seems to them like freezing air, the hellions begin a rampage of devastation, like an extension of the lava flow.

A hellion bears a certain resemblance to both millipedes and crustaceans. Small legs tucked close to its body help propel it through its tunnels. Six long, jointed limbs protrude from its head, allowing it to drag prey into its mouth. Its body exudes infernal heat, and its movements shake the earth like a tremor.

Terastodon ▶ Lars Grant-West

TROLLS

The trolls of Zendikar are rare, reclusive, giantlike creatures that live in remote forests and marshes. Savage and ill-tempered, they are made particularly dangerous by their regenerative abilities, which let them quickly heal even apparently mortal wounds. They are fiercely territorial, often demanding bribes from people who pass through their lands and slaughtering those who refuse to pay.

Hunched and Green

Trolls stand nearly twenty feet tall from the bottoms of their flat feet to the tops of their great spine-covered humps. Their heads are thrust forward and downward, and stringy manes of hair run from the top of the hump down to the top of the skull. Their mouths are full of sharp teeth, and two large tusks protrude from the sides of their mouths. Sharp bristles cover their backs and upper arms, which provide a useful protection against baloths and other giant predators. Their lumpy hides are typically various shades of green, which offer some camouflage in the verdant areas where they dwell.

Trolls assemble clothing from found items, more in imitation of other races than out of any sense of modesty. They use weapons made from the bones of their prey, such as the scythe-like blades of the predatory cats found in the thick forests where they dwell. They strap plates of metal to their lower legs and arms to protect their limbs from smaller enemies.

BEASTS

Green mana is the magic of natural growth and hunting prowess, and so it is the color most commonly associated with the wide variety of natural animals that inhabit Zendikar's wilds. Many of these animals have some rudimentary ability to draw on the mana of the forests, while others are simply infused with it—and have grown to incredibly large sizes because of it.

Harvester Troll ▶ Greg Staples

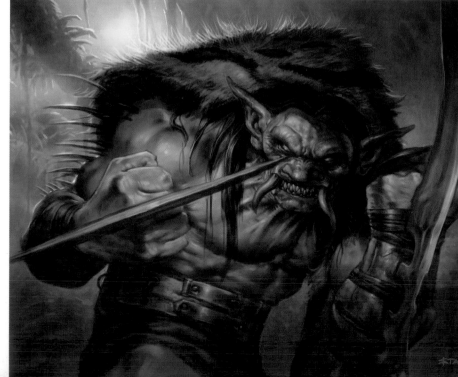

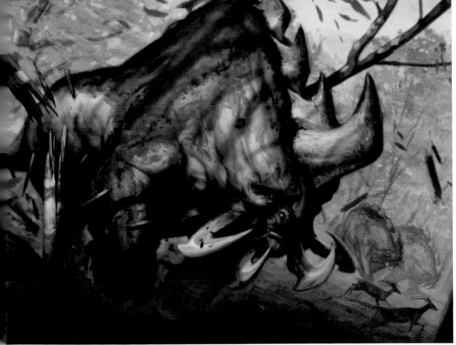

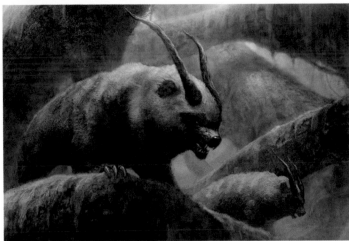

Gnarlid Pack ▶ Johann Bodin

Gnarlids

Gnarlids are about the size of a large dog and resemble something between a bear and a wolverine. They have horns with distinctive shapes that vary by species, and some varieties have similar spikes elsewhere on their bodies. They have an innate ability to grow larger by drawing on green mana in the environment, nearly doubling in size as well as ferocity.

Other Beasts

The oxen of Murasa's Pillar Plains are renowned for their stubbornness but are still used as pack animals thanks to their tremendous strength. A terastodon is an enormous elephant with four tusks and an armored hide. A bony plate on its head, sharply pointed on the edges, extends back to protect its neck. Terra stompers are six-legged behemoths that can grow as large as the trees in the Vastwood of Tazeem. Timbermaws dwell in the hollow trunks of floating trees, emerging with deadly speed when prey wanders near. And at least two varieties of great cat sport enormous blades jutting back from the forelegs, which help them cut through heavy undergrowth and take down much larger prey.

Scythe Leopard ▶ Winona Nelson

Rampaging Baloths ▶ Eric Deschamps

Baloths

Baloths are perhaps the most distinctive of Zendikar's beasts. They are muscular, omnivorous hunters with horns, spines, and plates of various shapes and combinations. The woodcrasher baloths of the Turntimber forest are surprisingly agile, leaping from tree to tree while using their great claws to clutch the spiraling trunks. The leatherback baloths of Ora Ondar are heavier and keep to the ground, where their thick, plated hide protects them from danger. Baloth herds occasionally stampede across the Onduan plains—more frequently since the rise of the Eldrazi, as if they share in Zendikar's anger.

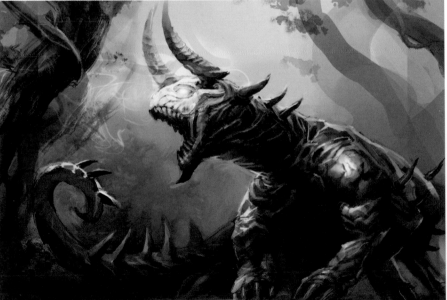

Turntimber Basilisk ▶ Goran Josic

Basilisks

Basilisks are six-legged lizard-like reptiles with large horns and long tails. A creature that meets the gaze of a basilisk turns instantly to stone. They are common in the wooded regions of Guul Draz as well as the Turntimber forest of Ondu.

Living Tsunami ✒ Matt Cavotta

ELEMENTALS

Elementals are physical incarnations of the primal natural forces that make up the plane of Zendikar. Some of them are living creatures, with natural life cycles of birth and death, that are infused with elemental energies. Others are animate plants that embody the vital force of growth. Many others are pieces of the plane—plateaus, islands, or expanses of water that have awakened to fight the Eldrazi. The longer the Eldrazi rampage across the plane, the more active and violent these elementals become.

Awakened Lands

The plane of Zendikar is a living organism with natural defenses that have struggled for centuries to protect it from the infection of the Eldrazi. Under the right conditions, the raw materials of the plane

itself—earth, magma, storms, water, or wind—awaken to battle the forces that threaten its existence. Sometimes humans or elves are responsible for waking the land with their magic, but often the land simply comes alive of its own accord. The sea might erupt in a gaping maw or a mass of writhing tentacles. A volcanic region might grasp like a giant fiery claw or form itself into a beast-like shape glowing with internal heat. Mesas, canyon walls, or muddy geyser fields might suddenly sprout legs and trample Eldrazi underfoot.

Fiery Beasts

Volcanically active regions of Zendikar, particularly Akoum, are home to a variety of creatures that fuse the energies of elementals with the natural life of animals. The winged geyser gliders of Pelakka, the blazing fireboars of Beyeen, and the hound-like hellfire mongrels

Rage Nimbus ❧ Vincent Proce

Hellfire Mongrel ❧ Dan Scott

of Akoum are examples of these strange hybrids. They are driven by predatory hunger combined with the elemental rage of the volcano, and they attack people, beasts, and Eldrazi with equal fervor.

Animate Plants

Many of the plants found in Kazandu and Ora Ondar, among other places, can seem to move with purpose and sometimes destructive intent. But elementals of this category are supernatural incarnations of the drive to grow and flourish, woven together of various natural materials. They often combine leafy vines, boulders, living wood, and moss together into a single shambling form. Some take distinctively humanoid forms, others resemble four-legged beasts, and some resemble walking trees or shrubs.

Other Elementals

Stranger incarnations of primal forces occasionally appear on Zendikar, brought into being through the plane's wrath, the meddling of mages, or unusual events. Rage has manifested as a cloud churning with grasping hands that hovered over a village and led to a deadly outburst of violence. The life force of an army once took shape as a huge spirit-like elemental drawing its strength from the people around it. And the Roil itself sometimes seems to incarnate into a discernible shape that moves with direction and purpose.

AVATARS

Avatars are rare beings similar to elementals. They are aspects or projections of a larger, abstract power, which might be anything from the looming shadow of death to the soul of the plane itself. A few human devotees of Emeria have achieved a state of transcendence that transformed them into avatars of white mana, akin to the angels themselves. The soul of Zendikar sometimes manifests as a huge, shambling creature that spawns beasts, as if mimicking the Eldrazi with their broods. At other times it takes on a gigantic humanoid form that appears to do battle with Eldrazi and then quickly vanishes when the foe is defeated.

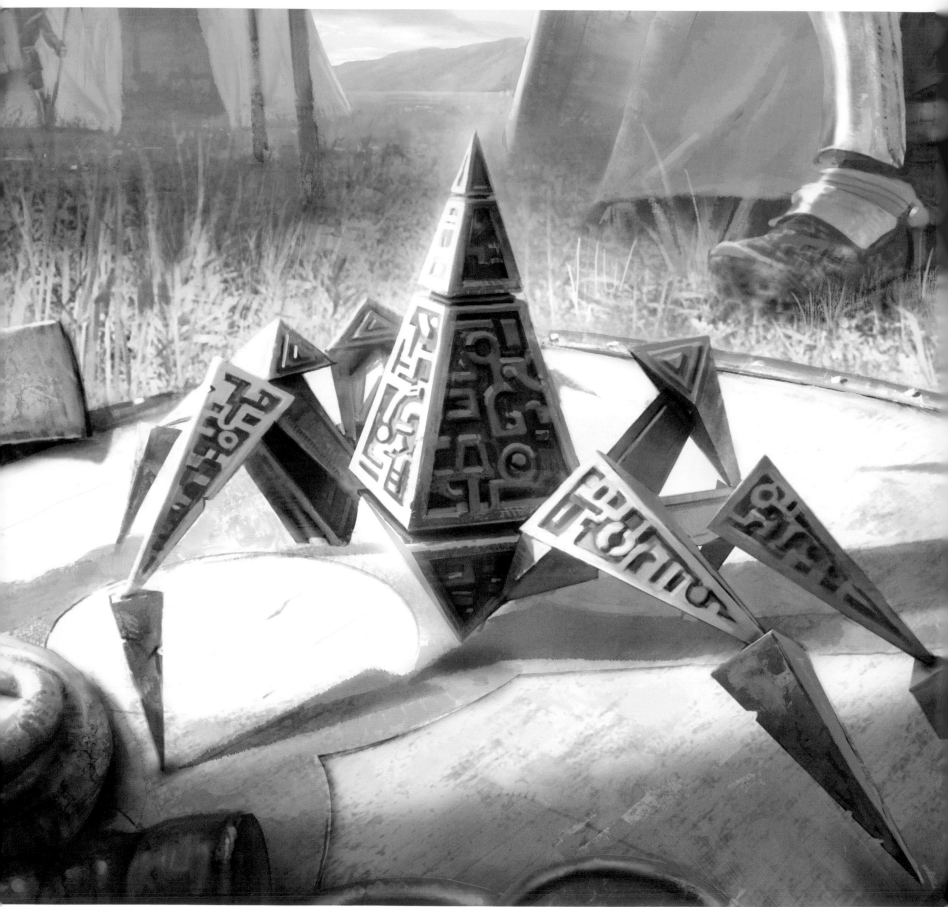

Hedron Crawler ✒ Daniel Ljunggren

ARTIFICIAL CREATURES

With the power of magic at their disposal, mages both in the ancient past and in Zendikar's present have been able to create objects with at least the semblance of life, capable of carrying out orders and even acting independently.

Hedron Constructs

In a number of ancient sites associated with the Eldrazi, stone creatures have been found standing eternal guard. Either created from fragments of hedrons or carved to resemble them, these constructs were as mysterious as the hedrons themselves were before the Eldrazi titans awoke. The awakening of the hedrons and the rise of the Eldrazi has done little to clarify their origins and purpose.

The most ancient hedron constructs were actually the creation of Nahiri, who sometimes worked in concert with the kor stoneforge mystics she trained shortly after the Eldrazi were imprisoned. These animated hedrons were intended to help the people of Zendikar eliminate the brood lineages after the titans were imprisoned, and they were implanted with a fragment of the power to bind and imprison the Eldrazi. They fell inert when Nahiri left the plane, but some of them rose to action again when the Eldrazi titans escaped their prison. They have served as useful allies in battling the Eldrazi broods, and some mages have had limited success in prying some of the secrets of their magic from their artificial minds.

Other hedron constructs are of more recent (but still ancient) make, fashioned in imitation of Nahiri's originals. These have no power over the Eldrazi beyond what their physical strength gives them, and their creators used them for menial tasks. They are most often found in ancient ruins of kor or merfolk cities.

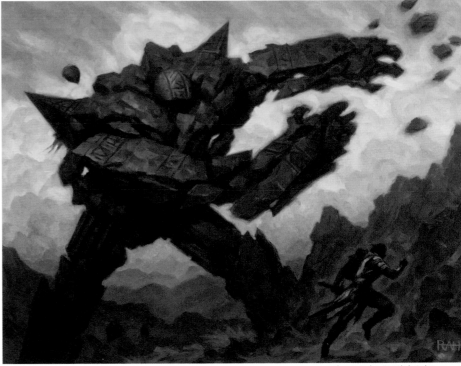

Lodestone Golem ➤ Chris Rahn

Golems

The golems of Zendikar are, in effect, artificial elementals. Mages fashion bodies from special stone and infuse them with the power of movement and limited understanding. Golems are rare and powerful, especially when shaped from stone that already possesses magical power. For example, one human mage crafted golems from the rubble at an ancient ruin called Enatu, forming a sturdy first line of defense against the Eldrazi when they arose. A merfolk mage at Sea Gate experimented with making golems from a special stone that inhibited the flow of magic, hoping to dampen the power of the Eldrazi. She enjoyed limited success but found that the "lodestone golems" impaired her own magic as much as it did that of the Eldrazi.

Illusions

Illusions are a different sort of magical life—short-lived creatures wrought of pure magic given a tenuous physical form. They exist partially in the world and partially in the mind of the viewer, where fear is their greatest weapon. Since they have no physical substance, they ignore barriers and move implacably toward their intended foes. Some mages who master blue mana—including the Planeswalker Jace Beleren—are experts at creating these powerful illusions.

> "It's as strong as you believe it is, and it's very convincing."
> — Jace Beleren

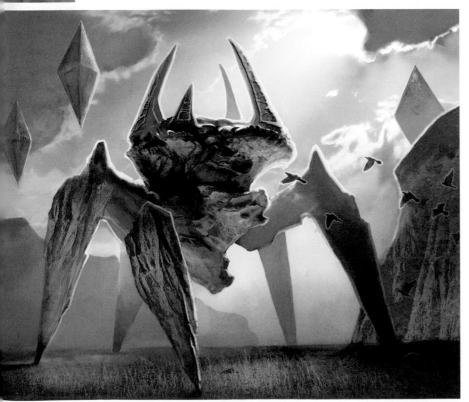

Hedron Rover ➤ Jason Felix

APPENDIX: FINDING ZENDIKAR

by Mark Rosewater

I had the honor of designing both the original *Zendikar* card set and the return, *Battle for Zendikar*. For each set, I worked with the creative team to create a seamless integration between the design and the world. While both sets took place on the plane of Zendikar, the two experiences couldn't have been more different.

The original Zendikar design started far, far away from any creative elements. I was asked by my boss at the time to put together a five-year plan—to help map out where I planned for Magic to be going. I turned in a six-year plan. Why six? Because my final idea was a little out there, and I wanted to make sure I had five usable years if the sixth year got rejected.

The sixth year was what I call an experimental design. It wasn't based on an existing world or a mechanical theme that we had explored before. It was me saying, "I have a weird idea that I want to try out." That weird idea was an entire block based upon a mechanical theme that I felt had a lot of untapped potential. That idea? A block all about lands.

Everyone I pitched the idea to made the same awkward face, usually followed by some version of "So what else do you have?" but I was determined to make it work. My boss really liked my proposals for the first five years, so he decided to let me run with my sixth idea and see what I could do with it.

I put together my design team, and we started designing mechanics based around land. Many of them didn't play well, but little by little we started finding ones that did. Enough so that it became clear that "Landsapalooza" (the nickname I gave the set after all the negative reaction I got to calling it "the land set") was going to become a reality. It was during this period that we came up with things like landfall, lands that animated themselves, and lands with spell-like effects when they entered play. This was also the period when we decided to bring back the kicker mechanic, which lets you get a greater effect from your cards by using the extra mana you get from all these lands.

How to Build a Plane

The process of creating a world for a Magic card block begins years in advance of the block's actual release. The creative team plans story arcs stretching out as much as seven years, with at least a basic idea of the world that will be the setting for each block. As the process unfolds, each world gets its own concentrated period of attention in a process that looks roughly like this:

1. *Exploratory World Design.* Work on fleshing out that basic idea begins long before the block will eventually release. Starting from a core concept—like Zendikar's "adventure world" idea—the team explores tropes and ideas connected to that core. The goal of this stage is to provide inspiration for the design team to do its own exploratory work, testing out rough concepts for what rules mechanics might appear on cards in the block.

2. *Prewriting.* Next, the creative team fleshes out the exploratory concepts into the bare bones of what will eventually become the world and story guide.

3. *Concept Push.* When prewriting is done, art directors bring artists into the building to translate those ideas into the visual look of the plane. Over the course of a few weeks, these concept artists generate hundreds of images, exploring the look and feel of every aspect of the world—its people, its places, and its monsters.

4. *World Guide.* Taking the prewriting and the visual concepts, the creative lead and the art director for the block put together the world guide. This collaboration results in art and text that fit seamlessly together and reinforce each other and the card mechanics, creating a totally coherent world. The finished world guide goes to every artist, writer, designer, and developer who works on cards in the block.

Landfall abilities give you benefits whenever you put a new land into play.

Some Zendikar lands turn into elementals, spontaneously animating to combat the Eldrazi.

And other lands give one-time effects when they enter play.

I put a member of the creative team, Doug Beyer, on the design because I knew that at some point we'd have to figure out what exactly the world was. Doug was in the trenches with us so that he could help figure out a world that delivered on what the set was doing mechanically. Doug's idea was that we do an "adventure world" inspired by things like *Dungeons & Dragons* and *Raiders of the Lost Ark*. The inhabitants of this world would be adventurers who traveled in parties and were constantly exploring this strange world. It would be a plane where the land itself took on a strong, aggressive personality. Doug felt that this was the best way to capture, in creative terms, the essence of the design.

Once we had a sense of the world, we then turned our attention to making additional mechanics that reinforced it. We designed three mechanical components that at the time we called traps, maps, and chaps. Traps, which kept their name, played into the idea that there was danger around every turn for our adventurers, placed there by other adventurers or at times by the land itself. In game terms, the traps allowed the players to surprise one another with spells that became much cheaper to play if certain conditions were met.

Maps, which were eventually called Quests, played into the idea that adventurers had to be sent on adventures and that these cards would create a goal for the players to accomplish to get a reward.

Chaps, which would eventually be called Allies, represented the members of the adventuring party. They ended up being modeled mechanically after Slivers, which had been a longtime fan favorite. Allies grew stronger the more Allies you had. Every time an Ally entered the battlefield on your side, it would either help out all your other Allies or create a large effect based on how many Allies were on your side. We also made sure to create a number of equipment cards that represented the adventure gear you would need on your quests. We made things like Grappling Hook, Trusty Machete, and Explorer's Scope.

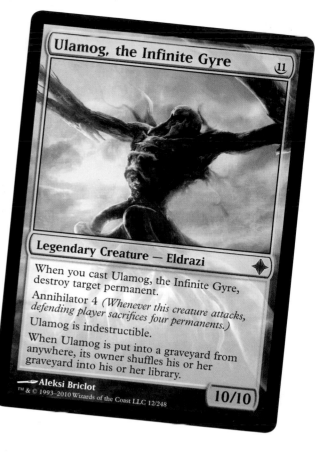

The original plan when we had begun design was that we would have a large fall set and a small winter set, and then there would be a large spring set with all new mechanics that would take place on a completely different world. This plan, as you will see, soon changed. As they were creating Zendikar, the creative team realized that they had uncovered a puzzle. To capture the sense they wanted of a living world gone wild, they realized that the land of Zendikar was reacting strongly to something. What was it?

The world-building team, including our in-house creative team and a collection of freelance artists, had independently stumbled upon these eight-sided geometric hedrons that were littered around the world, floating in the air. In trying to solve the origins of the hedrons, the creative team realized that the mystery of the world and the hedrons could be tied together. The hedrons were a prison locking in something primal and very, very powerful.

This idea would lead to the creation of the Eldrazi and the suggestion that perhaps the large spring set didn't have to change worlds. What if a catastrophic event justified why the last set would get a mechanical reboot? What if the Eldrazi escaped their prison?

This led to the *Rise of the Eldrazi* set, where lead designer Brian Tinsman mechanically brought the Eldrazi to life. He made the choice to do three things to convey their "Cthulhu meets Galactus" sensibilities. First, he made them giant, mostly 7/7 or larger to convey their huge size. Second, he made them colorless, as they were so ancient they predated colored magic. Third, he gave them an ability called annihilator that mechanically showed them devouring the world.

Brian also warped the environment so that players would have the ability to get these giant creatures onto the battlefield. He slowed down play and gave the players tools to help speed up playing the Eldrazi, the most flavorful of which was Eldrazi Spawn, 0/1 colorless creature tokens that could be sacrificed for colorless mana.

The Zendikar block was very popular. So much so that many of the people who were initially skeptical about the idea of the block were asking about when we'd be going back. The answer would be six years later.

The design of the *Battle for Zendikar* set started from the opposite end of the spectrum. We had ended the original *Zendikar* block with the release of the Eldrazi, but we never really explored the aftermath. We had ended on a cliffhanger, which meant that the design for the return had to address this looming question. Rather than starting from a mechanical jumping-off point, *Return to Zendikar* design started by asking the question: What happened? The Eldrazi were freed from their prison, and then what?

After examining all the different options with the creative team, we decided that we wanted to create a structure where the Eldrazi had assumed control, and the Zendikari were the rebels trying to free their home world from these unfathomable, giant invaders. The creative team mapped out the story, and we realized that each of the two sets in the block was going to be focused on a different one of the Eldrazi titans. (*Rise of the Eldrazi* had three titans, but one appeared to have left Zendikar.)

Battle for Zendikar would focus on Ulamog, while the second set, *Oath of the Gatewatch*, would focus on Kozilek. Ulamog was the titan that consumed, so the design team of *Battle for Zendikar* searched for a mechanic to represent Ulamog's hunger. We ended up creating a mechanic called ingest, which allowed players to exile large amounts of the opponent's deck, and then a series of cards called processors, which could take advantage of everything that had been ingested. Kozilek was the titan who warped reality, so the *Oath of the Gatewatch* design team messed with mana in a way that had never been done before.

The Eldrazi spawn also got a mechanical facelift, changing from a harmless 0/1 to a more aggressive 1/1. Design and development worked very hard to play up how alien the Eldrazi felt, creating individual card designs that would feel a little *off* to players. Included in this was the decision to have all Eldrazi be colorless. Some Eldrazi and Eldrazi spells would cost colored mana even though they were colorless. This would result in us creating the "Devoid" keyword to convey the strangeness of these new cards.

Ulamog's brood "ingests" sustenance for the titan by exiling cards from your opponents' libraries.

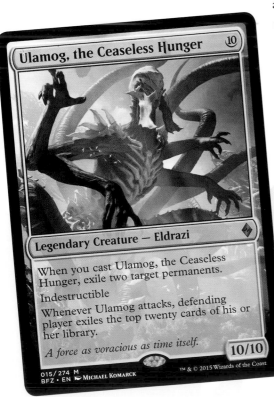

Then the processors turn the exiled cards into new magical effects.

But the Eldrazi were not the only returning creative element. The Zendikari, the natives of the world, were also back. We brought back the very popular landfall mechanic and returned the Allies, although with a few tweaks (including an entire new mechanic in *Oath of the Gatewatch* called teamwork). To convey the involvement of the land of Zendikar itself, which was also fighting against the Eldrazi, we made a new mechanic called Awaken that allowed players to bring lands to life and attack or block with them.

It's interesting that our goal for the *Battle for Zendikar* block was to recapture the feel of *Zendikar* block while advancing the story. We wanted both blocks to feel as if they occurred on the same world, yet behind the scenes, the act of making the sets was reversed. *Zendikar* block was about crafting a world to fit the mechanics, while *Battle for Zendikar* block was crafting mechanics to fit the world. In Magic-design speak, we went from bottom-up design to top-down design.

Hopefully, though, all of this was invisible to the consumer. *Zendikar* block visited a fascinating new world, and *Battle for Zendikar* block allowed everyone a chance to revisit it. I'm just happy looking back that "Landsapalooza" ended up being something so cool.

Awaken is another way of reflecting the way the world is coming to life to fight the Eldrazi.

ABOUT THE AUTHOR

JAMES WYATT is a Senior Game Designer on the creative team for *Magic: The Gathering*. Over the course of more than fourteen years working on the *Dungeons & Dragons®* roleplaying game, he wrote five novels and contributed to dozens of game sourcebooks, including *Oriental Adventures*, the *Eberron® Campaign Setting*, and three different *Dungeon Master's Guides®*.